Il Bel Paese

定格·意大利

邓予立摄影集
Yu Lap Tang

中華書局

自序

即使我已走过大半个地球，依然经常有人问我为什么还要继续旅行，我也无数次的回答过这个问题，每次都是同一个答案：人总要走出去，看不同的风景，见识与了解不一样的人类历史文明，见证世界多彩多姿，才能认识到自己的渺小，才会抱持更加谦虚、更加开放的态度对待世界的异见。

二〇二〇年七月开始，至二〇二三年二月，在疫情阴霾不时笼罩的三年间，我放开心情，尽情畅游古国意大利，累计起来，总行程超过了一百多天，全国二十个大区里的重要代表城市都曾游历过，更包括许多鲜为游客熟知的城镇，到目前为止是我欧洲各国游历中时间最长的国家。为什么我对她情有独钟，百游不厌呢？

几年前我看过一个电视节目，嘉宾说不管世界怎么发展，一定要去欧洲旅行。作家阿城则说过这样一段话："不要先去意大利，要先去德国之类的国家，看工业文明和现代发展，然后再去法国、英国，看两百年前的建筑，最后再去意大利。如果把这个游览顺序倒过来的话，就没意思了。"言下之意，一旦游过意大利后，再游欧洲，又有什么能入眼呢？他又说："意大利是物质和精神都'任你求'的一个地方。"他所言极是！意大利作为"欧洲的文明之光"、"欧洲文化的摇篮"以及"文艺复兴发源地"，她保留无数的文化遗产，到处都是延续两千余年的古老文明，她的地位不只在欧洲，几乎在世界范围内都没有对手。朋友们可以通过我这本意大利摄影集明白我并非盲目夸赞，这并不是对我们的东方文明有丝毫的妄自菲薄之意，期待透过我的照片和文字，与读者们分享这个人文历史丰富的意大利。

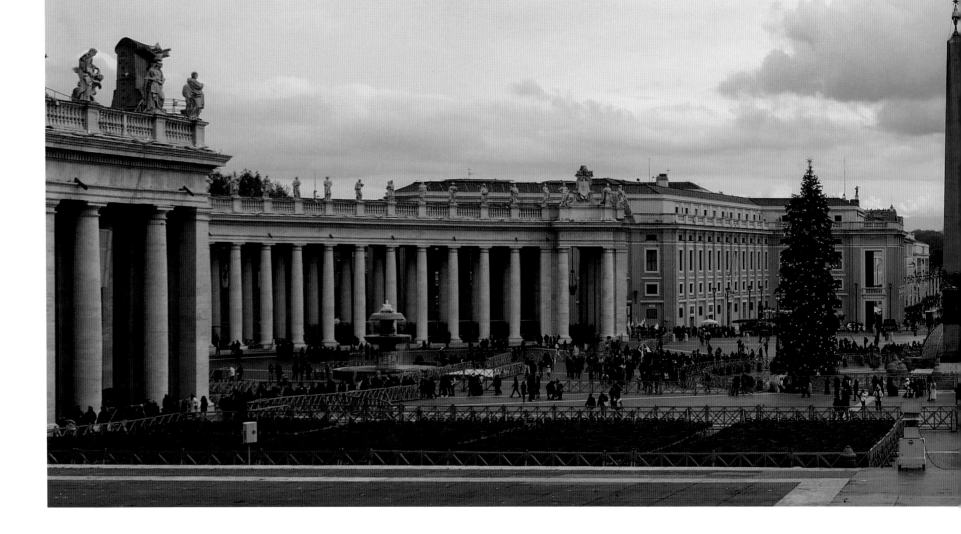

After exploring much of the world, I am frequently asked about my enduring love for travel and what motivates me to keep on journeying. My response, which I have given many times, remains unchanged: we must venture out to enjoy different landscapes, immerse ourselves in various splendid cultures and civilizations, and appreciate the colorfulness of the world. This enables us to realize our own insignificance and hold a more humble and receptive attitude to embrace the great diversity of the world.

During the span of three epidemic-raging years from July 2020 to February 2023, I had the incredible opportunity to explore the ancient nation of Italy, thoroughly indulging in its innate charms. In total, my travel lasted over one hundred days and took me to major cities in over twenty regions of the country, also including many towns and cities off the beaten path. This rewarding experience has been the longest I have spent in a single country on my European tour so far. Why do I have a special fondness for this enchanting nation and what keeps bringing me back to its embrace?

Years ago, I watched a TV show where a guest strongly recommended traveling to Europe, regardless of how the world developed. A Chinese writer, A Cheng, shared a similar perspective, 'Instead of visiting Italy first, it is better to head to countries like Germany to learn about its industrial civilization and modern development. Subsequently, journey to France and Britain to admire architectural wonders with over two centuries of history before concluding the tour in Italy. Reversing this itinerary would render the experience less enjoyable'. The hidden meaning between the lines was that a trip to Italy would overshadow an exploration elsewhere in Europe. He further emphasized that 'Italy is a destination that satisfies both the material and spiritual requirements', for which I could not agree more! Often referred to as the 'splendor of European civilization', the 'cradle of European culture' and the 'birthplace of the Renaissance', Italy treasures a wealth of cultural heritage and ancient civilizations that have endured for over 2,000 years, enjoying an unparalleled status not only in Europe but also across the world. All my laudatory words will be backed up by my travelogue, which will elaborate my in-depth travels in Italy and which, I must make clear, is not the slightest attempt to humble our wonderful Eastern civilization. I sincerely hope that through my writings I will be able to share with you, my dear readers, the richness of Italy and its fascinating culture and brilliant history.

Yu Lap Tang

Author's Preface

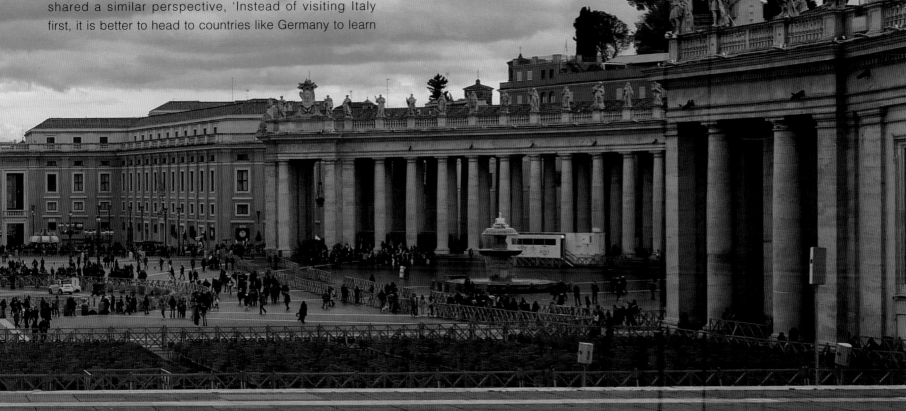

作
者
简
介

邓予立先生是一位企业家、金融家、收藏家及旅游家。

他在金融业累积超过 50 年经验，曾于数家本地及国际银行担任高级行政人员。于 1990 年在香港创办亨达集团，带领亨达成为香港交易所首家以单一外汇业务上市的香港企业，亦曾于 97 年亚洲金融风暴时配合香港政府击退海外的量子基金，素有"外汇教父"之称。

邓先生热心公共事务，曾出任多项公职，包括中国人民政治协商会议北京市委员会港澳台侨工作顾问、亚太台商联合总会永远荣誉会长及瑞士华商会会长等等。另外，他对慈善事业亦不遗余力，曾在内地兴建多家亨达希望小学及捐赠图书馆、捐助中国华东水灾及台湾台风风灾等。

邓先生的成就不限于金融业，他对文化创意同样有很高追求，多次以收藏家及文化人的身份接受媒体访问，展出稀有的收藏品。同时，邓先生亦是著名的旅游家及作家，目前已到访接近 150 个国家及出版了 19 本书刊。

亨达集团继承了邓先生的理念，用以人为本的精神，培养众多金融人才；用以诚待客的精神，打造一家有诚信、有社会责任的公司；用开拓创新的精神，成功在全球十多个国家建立了据点；用文化创意的精神，创办了一家金融与文化兼备的综合企业。

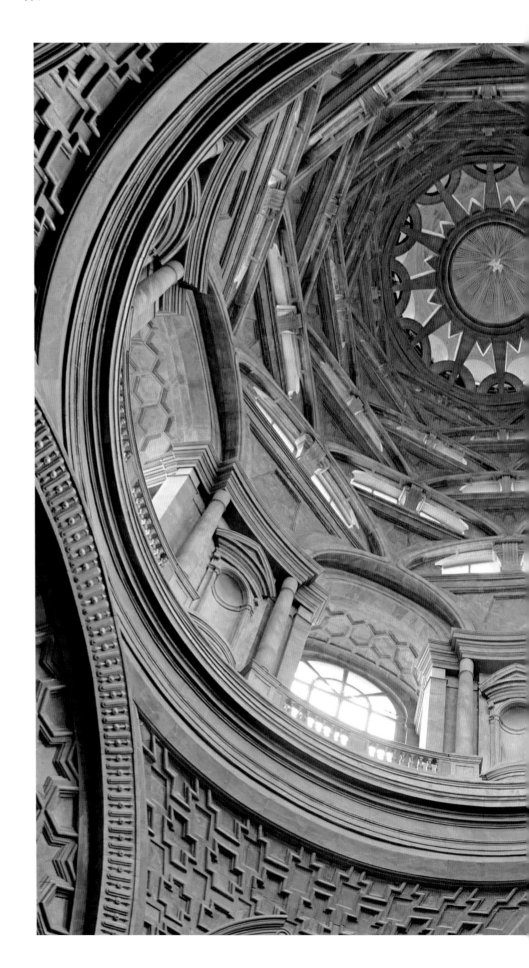

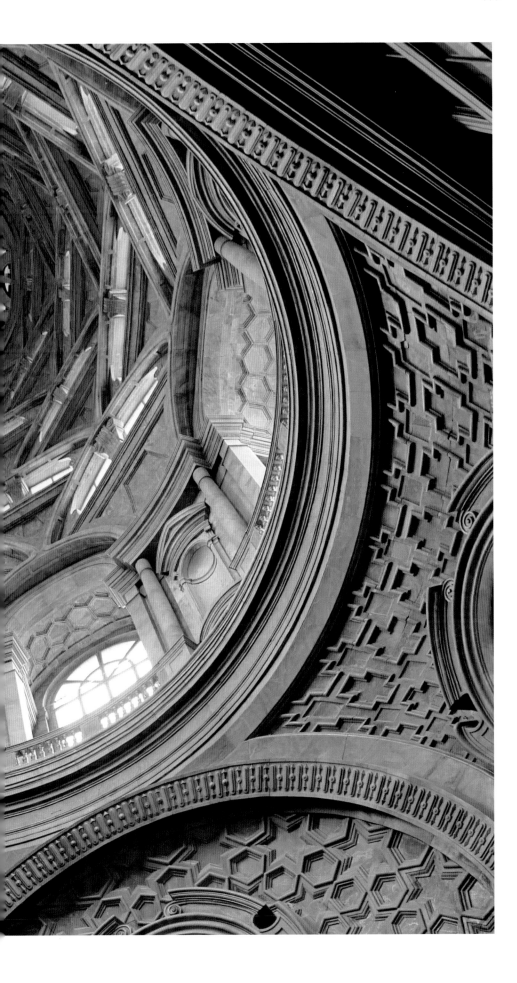

About the author

Mr. Tang is an entrepreneur, a financier, a collector and a traveler.

He enjoys over 50 years of rich experience in the financial industry and has worked as a senior executive in several local and international banks. In 1990, he founded the Hantec Group in Hong Kong and led Hantec to become the first public Hong Kong company with a pure foreign exchange business. He also worked with the Hong Kong government to repel overseas quantum funds during the Asian financial crisis in 1997 and is known as the 'Godfather of Foreign Exchange'.

Mr. Tang is a keen public servant, holding a number of public offices, including Advisor to the Beijing Municipal Committee of the Chinese People's Political Consultative Conference on Hong Kong, Macau, Taiwan and Overseas Chinese, the honorary chairman of Asia Pacific Taiwan Federation of Industry & Commerce and the chairman of Association Suisse des Commercants d'Orignine Chinoise. He has also spared no effort in charity work, constructing a number of Hantec Hope Primary Schools, donating libraries in the Mainland, and offering financial assistance to the disaster victims from the floods in East China and the typhoon damage in Taiwan.

Mr. Tang's achievements are not only in the financial industry, but also in his pursuit of cultural creativity, and he has been interviewed publicly on many occasions as a collector and cultural figure, exhibiting rare collectibles. He is also a renowned traveler and author, having visited nearly 150 countries and published 19 books.

Hantec Group has inherited his philosophy, nurturing a large number of financial talents; forging a company of complete integrity and social responsibility by treating customers with sincerity; establishing branches in more than 10 countries around the world in a pioneering and innovative attitude; and founding a comprehensive enterprise combining financial and cultural qualities by virtue of cultural creativity.

目录 *Catalogue*

雷焦卡拉布里亚
及周边地区

*Reggio di Calabria and
its fascinating neighbouring regions*

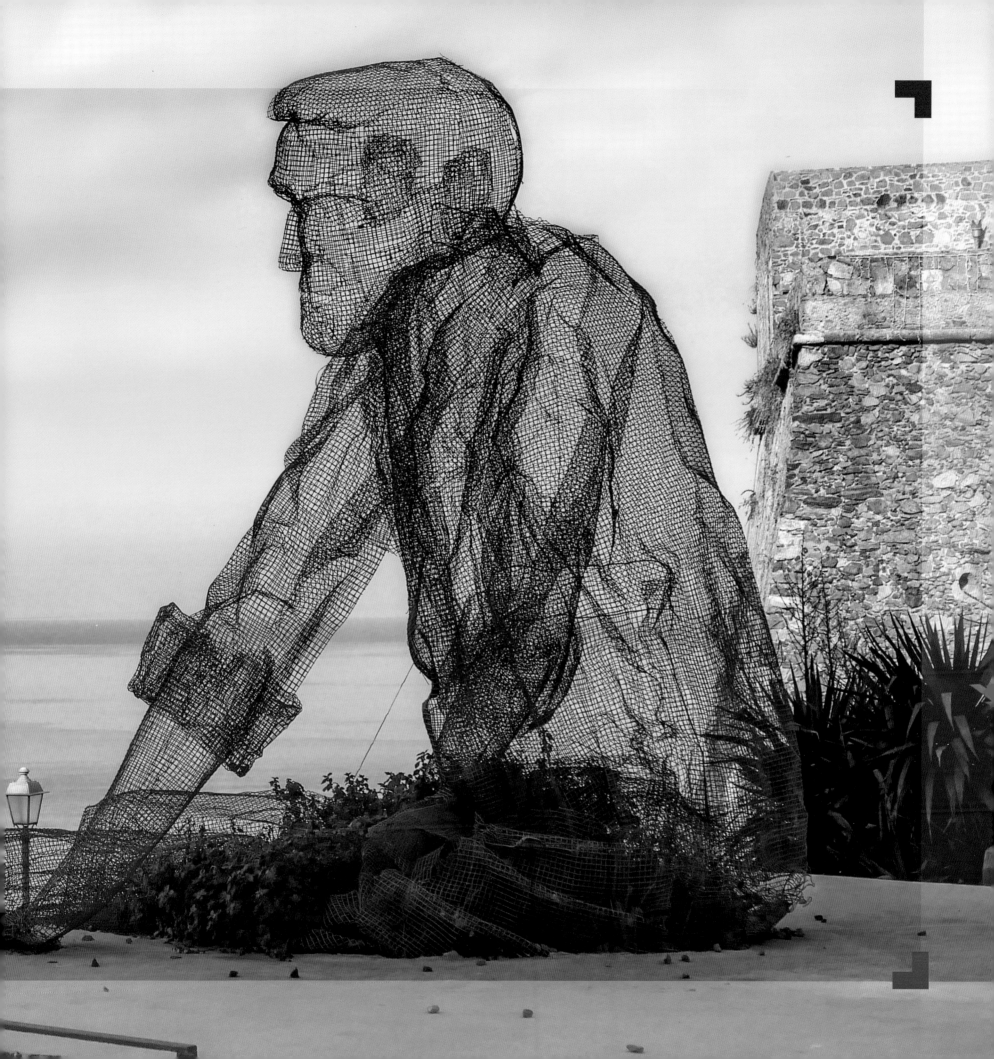

意大利的阿玛尔菲海岸在欧洲名气很大，是梦幻般的美丽海岸线，被誉为一生非游不可。对比之下，位于意大利本岛最南端的卡拉布里亚大区在名气上就不免稍显落寞。实际上，它有着绵延达七百公里、不逊于阿玛尔菲的海岸线。其中鲜为旅客所知、却也最令人惊艳的，是一条长约五十五公里的优美海岸线——"众神海岸"。早在古罗马文明之前，希腊人就迁居到此，同时也把璀璨的雅典文明传过来，也因此在这个地方能欣赏到很多古希腊原汁原味的庙宇、精美的雕像和青铜文物，不知道"众神海岸"的名号是否由此而来？

卡拉布里亚大区的位置正是意大利靴子的脚趾部分，其面积达一万五千多平方公里，人口两百多万人，在全国二十个大区中的人口与面积的排行皆列为第十位。意大利大部分地区都属于地中海气候，夏季炎热干燥，冬天温暖多雨。

维博瓦伦蒂亚国家考古博物馆一隅

A corner of the National Archaeological Museum in Vibo Valentia

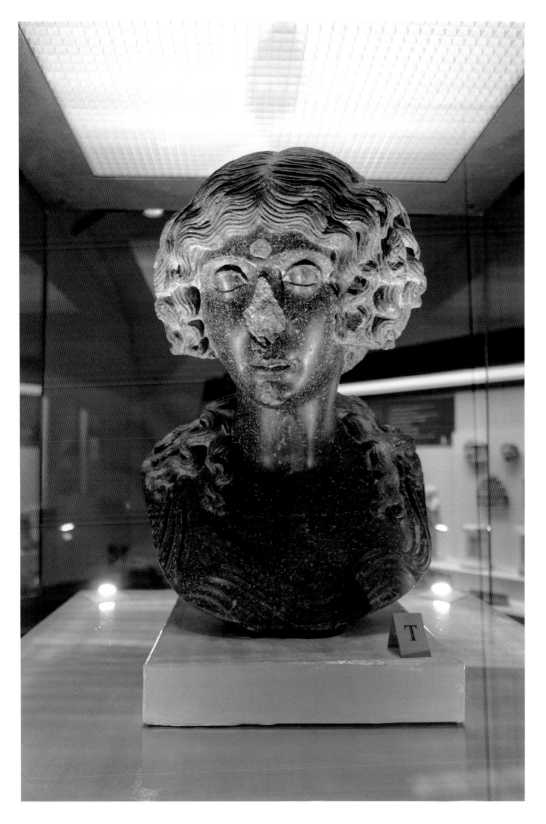

The Costiera Amalfitana (Amalfi Coast) in Italy enjoys widespread popularity throughout Europe for its stunning beauty, often referred to as a dreamlike coastline and a must-visit destination for a lifetime. In comparison, the region of Calabria, situated at the southern tip of mainland Italy, may be somewhat less familiar. However, it boasts a coastline stretching over seven hundred kilometers that rivals the splendor of the Amalfi Coast. The most breathtaking yet lesser-known part is the approximately fifty-five kilometer stretch of beautiful coastline known as the 'Costa degli Dei (Coast of Gods)'. Even before ancient Roman civilization, Greek settlers migrated to this place and preserved the brilliant Athenian culture. Therefore, visitors are able to admire many authentic Greek temples, exquisite statues and bronze artifacts in this place. Perhaps the name 'Coast of Gods' also originated from this.

The region of Calabria is situated exactly at the toe of Italy that resembles the shape of a boot, covering an area exceeding fifteen thousand square kilometers and with a population surpassing two million. Among the twenty regions in Italy, it holds the tenth position in both population and size. The majority of Italy experiences a Mediterranean climate characterized by scorching, arid summers and mild, rainy winters.

维博瓦伦蒂亚国家考古博物馆馆藏

The collections of the National Archaeological Museum in Vibo Valentia

1. 雷焦卡拉布里亚及周边地区 Reggio di Calabria and its fascinating neighbouring regions

加利亚 Caria 的加洛比城堡
The Galluppi Castle of Caria

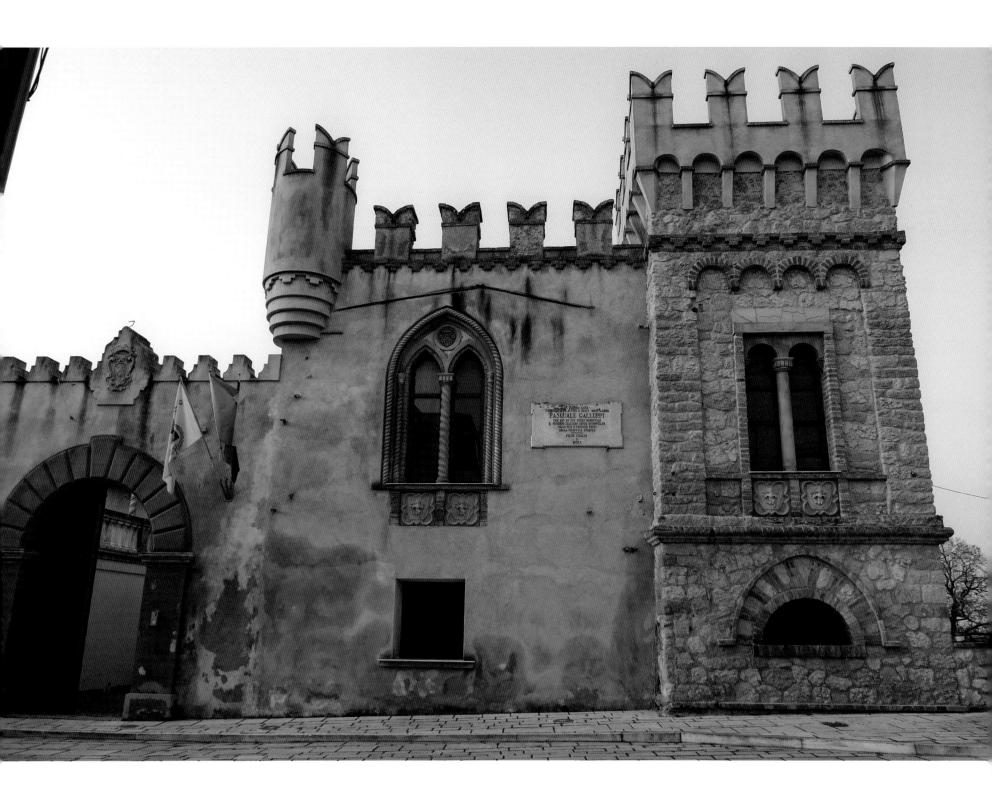

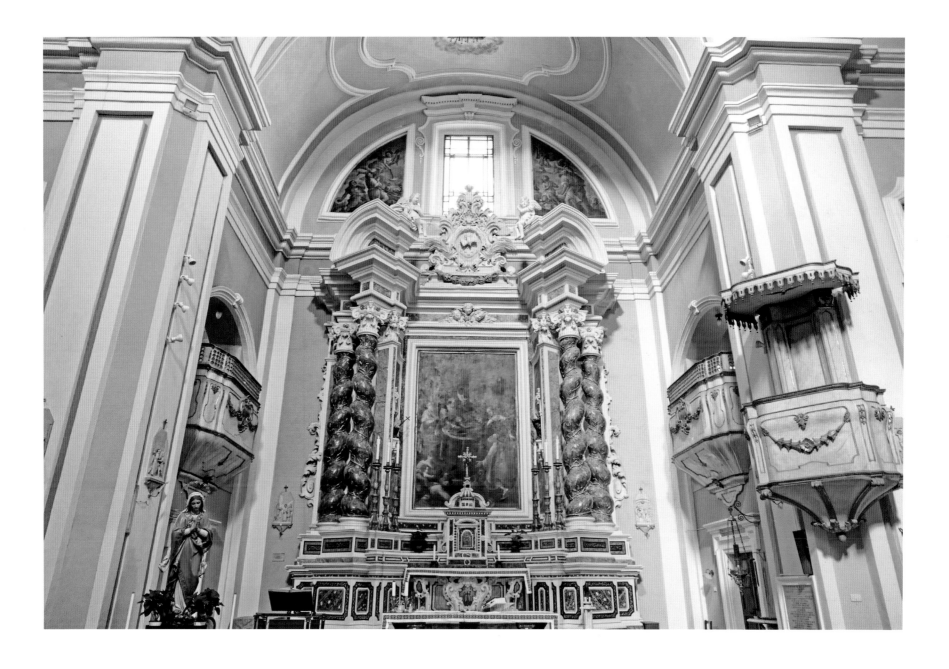

特罗佩亚耶稣教堂内部

Inside the Christian Church of Tropea

特罗佩亚以彩绘瓷砖装饰的阶梯

The stairs of Tropea are
decorated with painted tiles

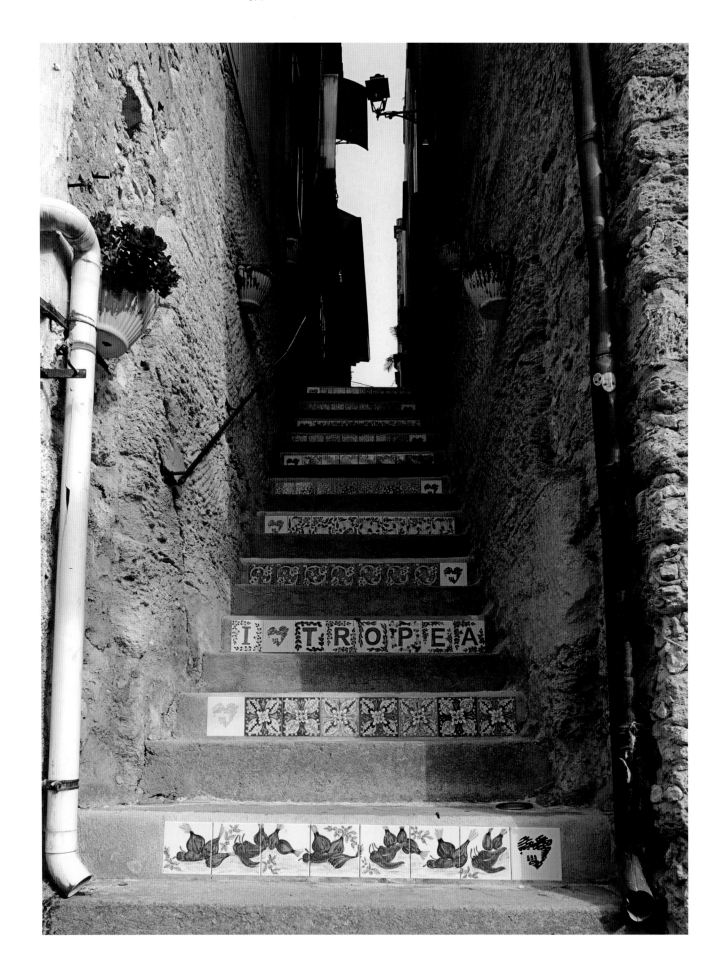

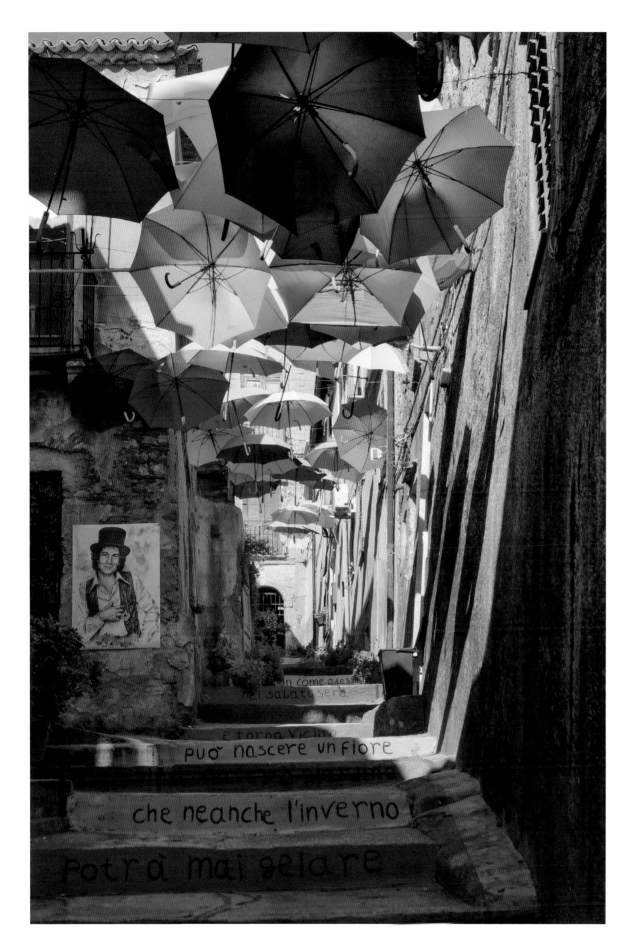

尼科泰拉挂满彩伞的阶梯

The staircase in Nicotera hung with a beautiful display of colorful umbrellas

1. 雷焦卡拉布里亚及周边地区 Reggio di Calabria and its fascinating neighbouring regions

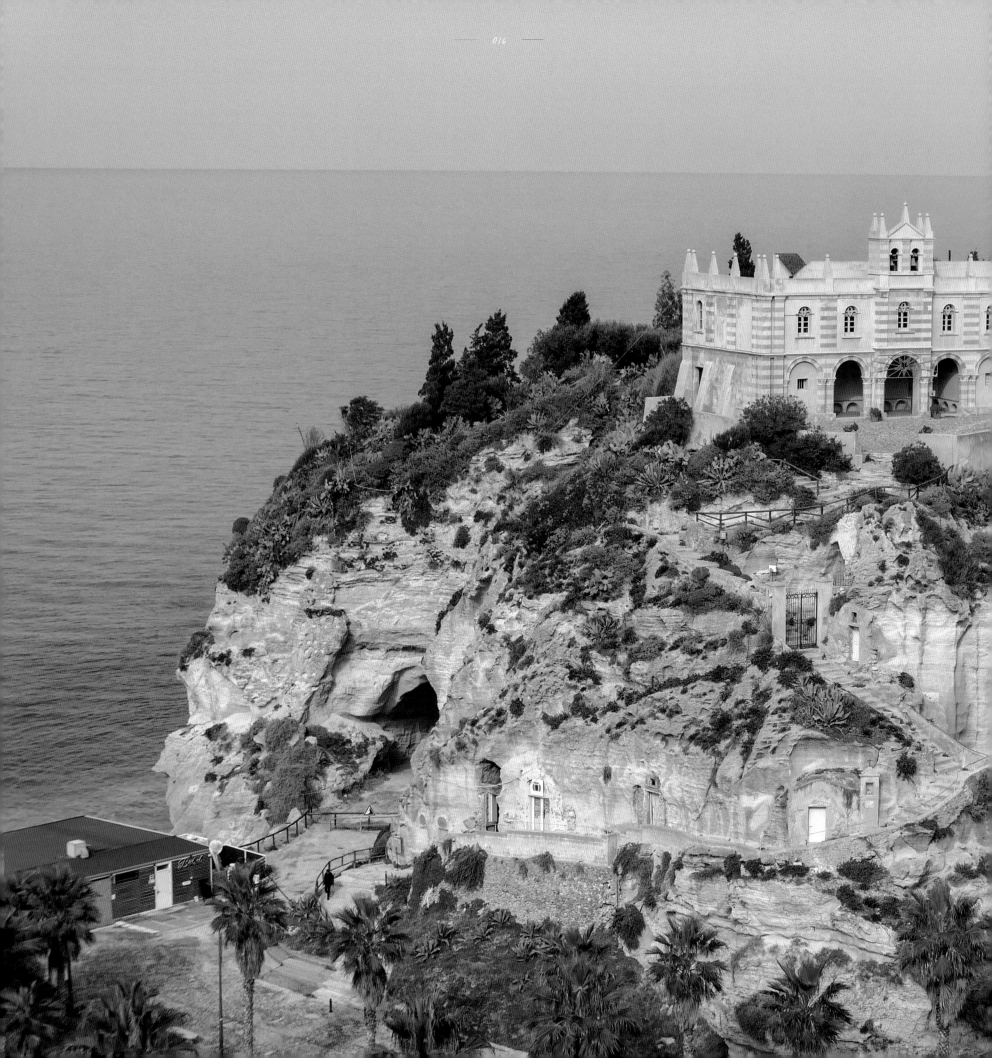

特罗佩亚圣玛利亚教堂，建于中世纪，过去曾有隐士居住。前往教堂，必须拾级而上，走过一条似乎已有两百岁的长楼梯。

Basilica di Santa Maria (Basilica of St. Mary) in Tropea, constructed during the Middle Ages, was once inhabited by hermits. Accessing the church requires climbing an ancient staircase that seemingly spans two hundred years in age.

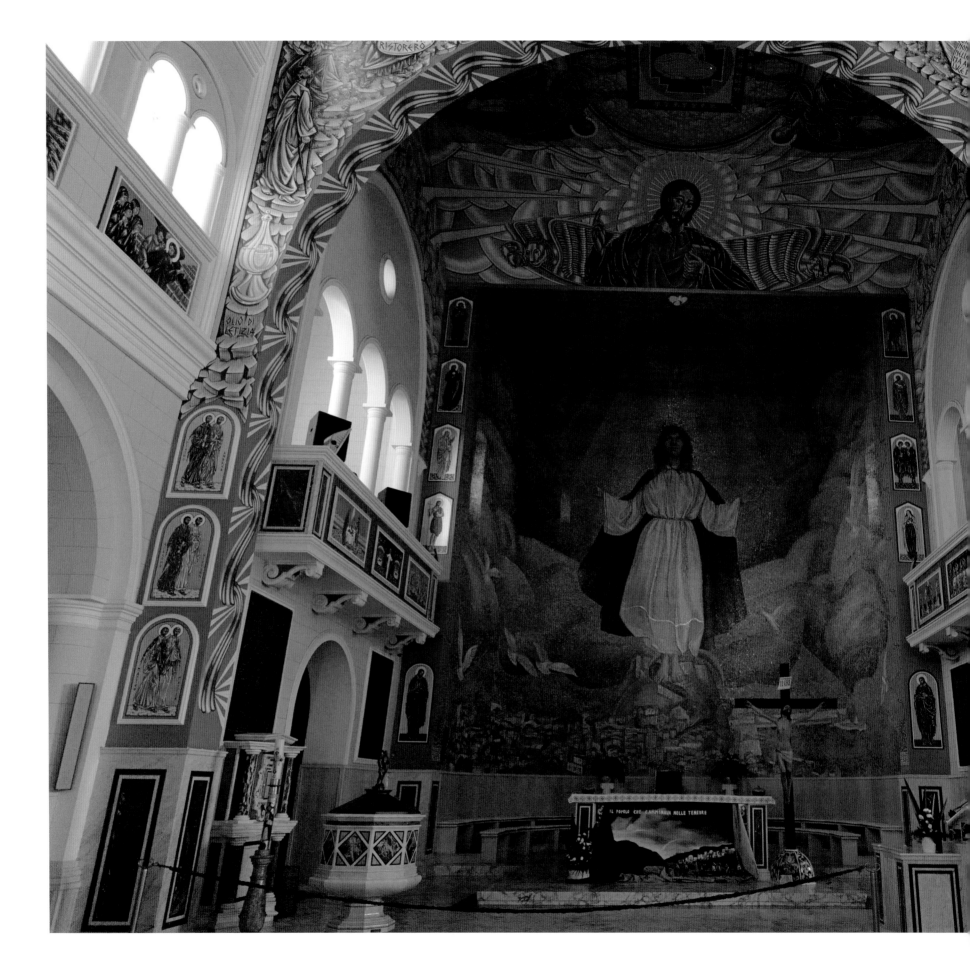

希拉的主教堂及内部

The Cathedral of Scilla and its interior

雷焦卡拉布里亚海滨大道旁的装置艺术

The installation art along the seafront promenade in Reggio di Calabria

1. 雷焦卡拉布里亚及周边地区 Reggio di Calabria and its fascinating neighbouring regions

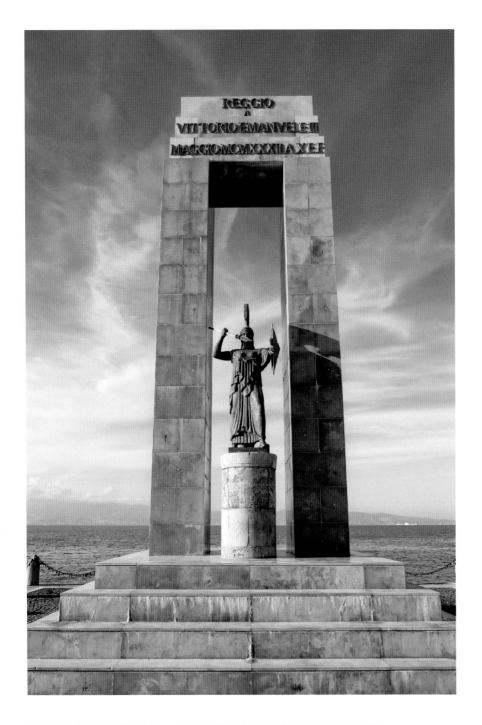

滨海公园内的阿西娜女神像，她张开双臂，像是保佑着这座灾后重生的城市。

The statue of the goddess Athena graces the coastal park, with her arms outstretched as if to bless the city that has risen anew from disaster.

希拉海岸

The seaboard of Scilla

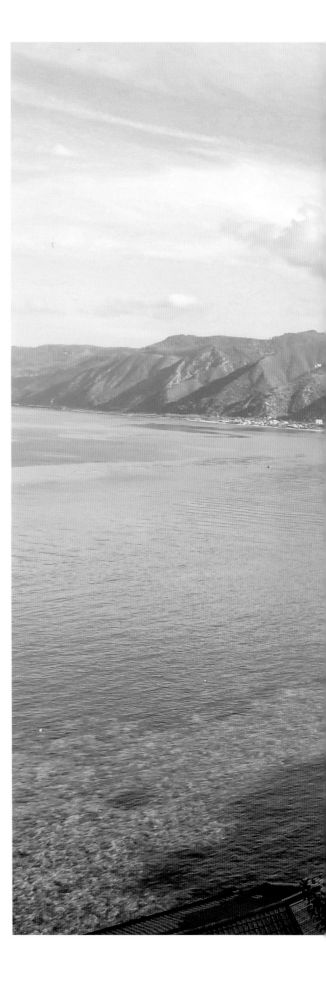

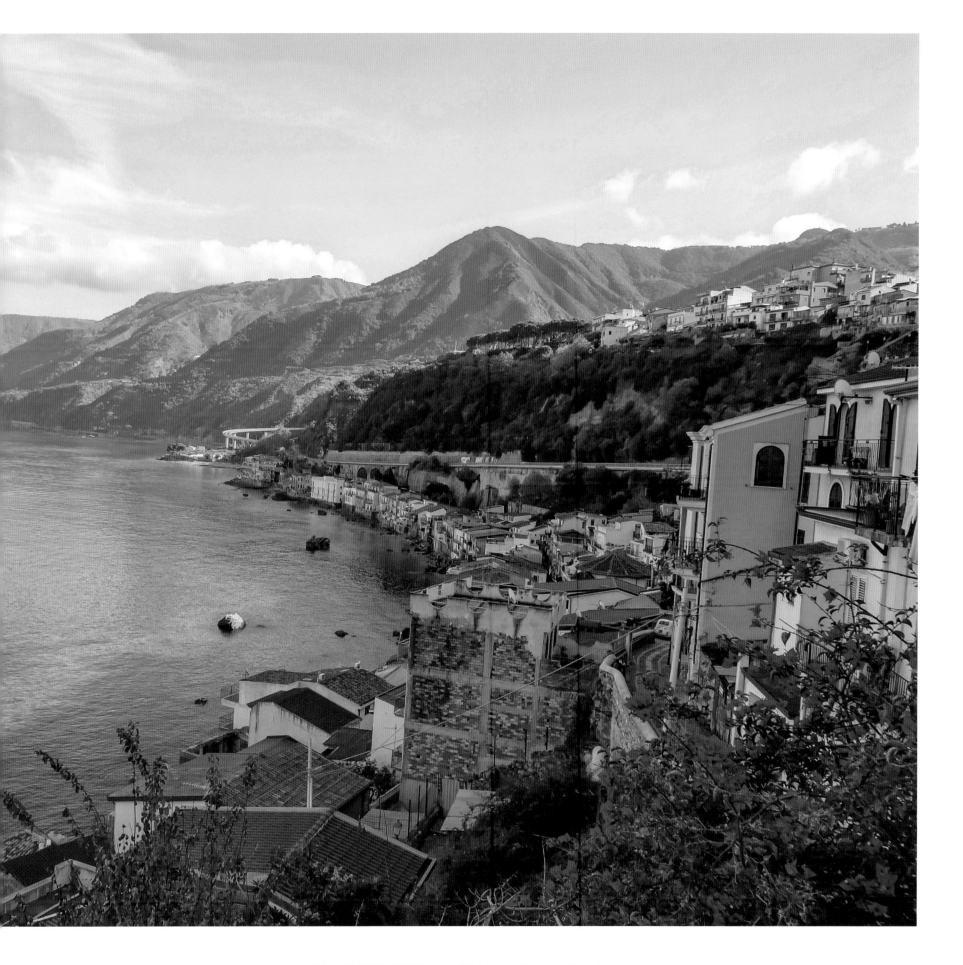

1. 雷焦卡拉布里亚及周边地区 Reggio di Calabria and its fascinating neighbouring regions

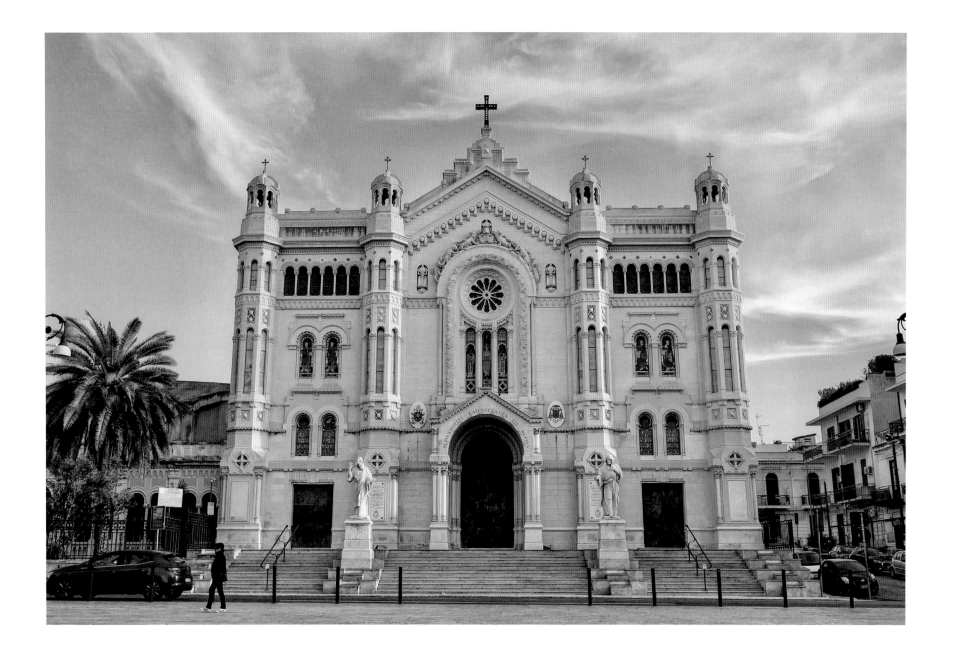

雷焦卡拉布里亚的圣母升天圣殿主教座堂。一九〇八年，西西里岛曾经发生一场大地震，并引发恐怖海啸，对西西里岛及这座城市造成毁灭性的破坏，其中也包括这座教堂。如今的外观是在大地震之后重新修建的。

The Basilica Cattedrale Metropolitana di Maria Santissima Assunta (Cathedral of Saint Mary of the Assumption), which suffered devastating destruction in 1908 due to a major earthquake and a consequent terrifying tsunami that struck Sicily, now stands in its current magnificent appearance as a result of reconstruction efforts following the natural disaster.

希拉一隅

A corner of Scilla

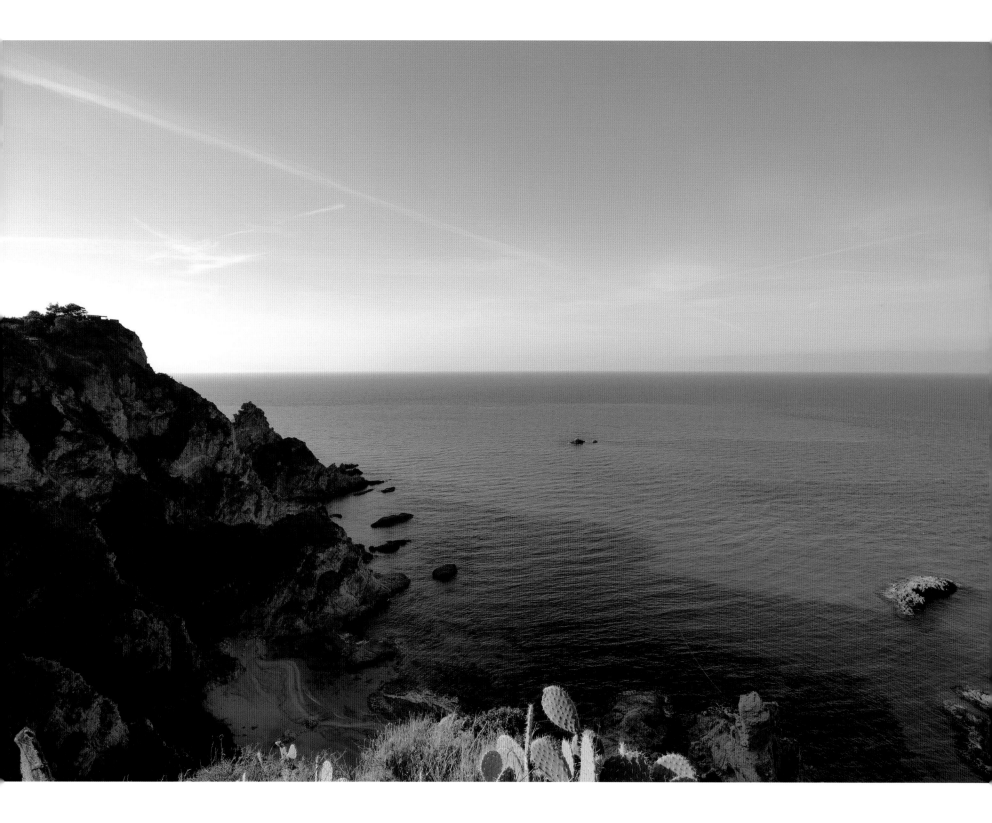

众神海岸的美丽景致

The breathtaking scenery of Costa degli Dei (Coast of Gods)

皮佐的石窟教堂。教堂内圣母一直保佑出海的旅人和渔民，就像华人所信奉的天上圣母妈祖一样，年复一年地护佑出海的渔民平安归来。

In the Grotto of Pizzo Calabro, the Virgin Mary has long been blessing the sailors and fishermen venturing out to sea, much like the Heavenly Mother Mazu in Chinese beliefs. Year after year, she watches over the fishermen who brave the waters and ensures their safe return home.

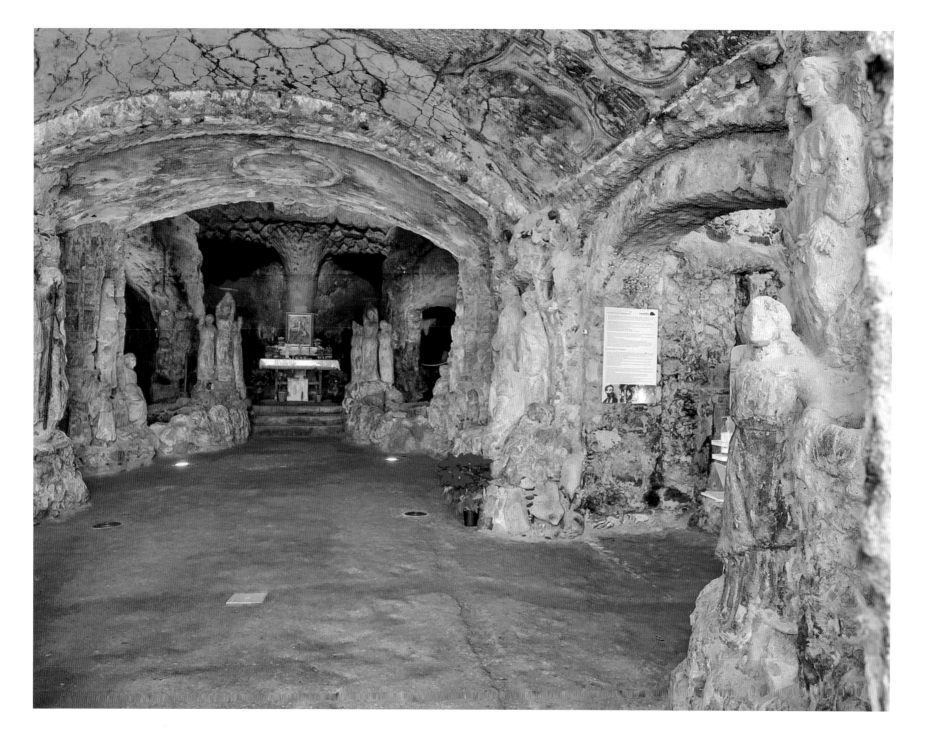

1. 雷焦卡拉布里亚及周边地区 Reggio di Calabria and its fascinating neighbouring regions

皮佐的圣母无染原罪教堂

The Church of the Immaculate Conception in
Pizzo Calabro

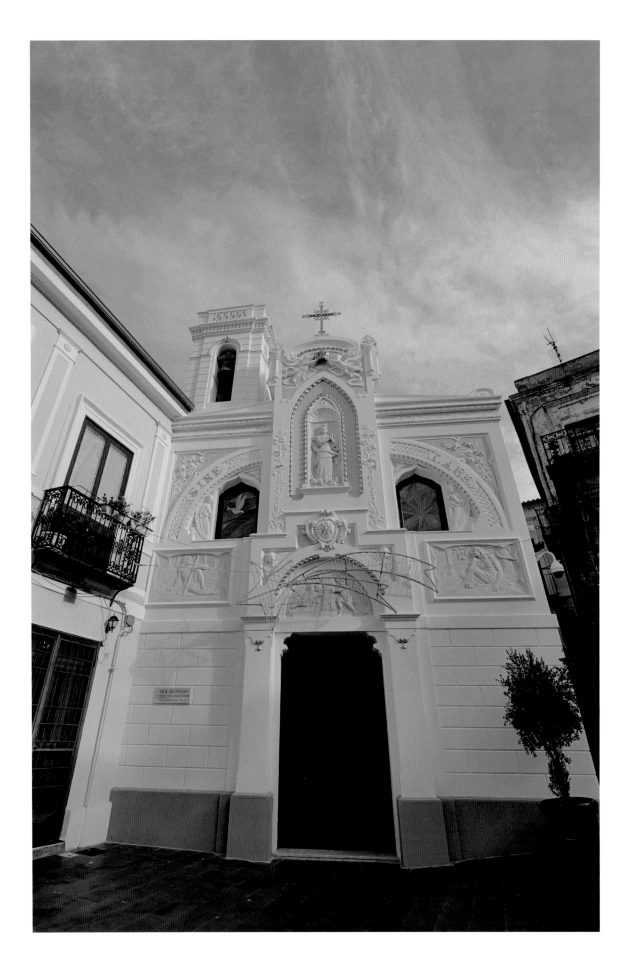

皮佐小镇一隅

A corner of Pizzo Calabro

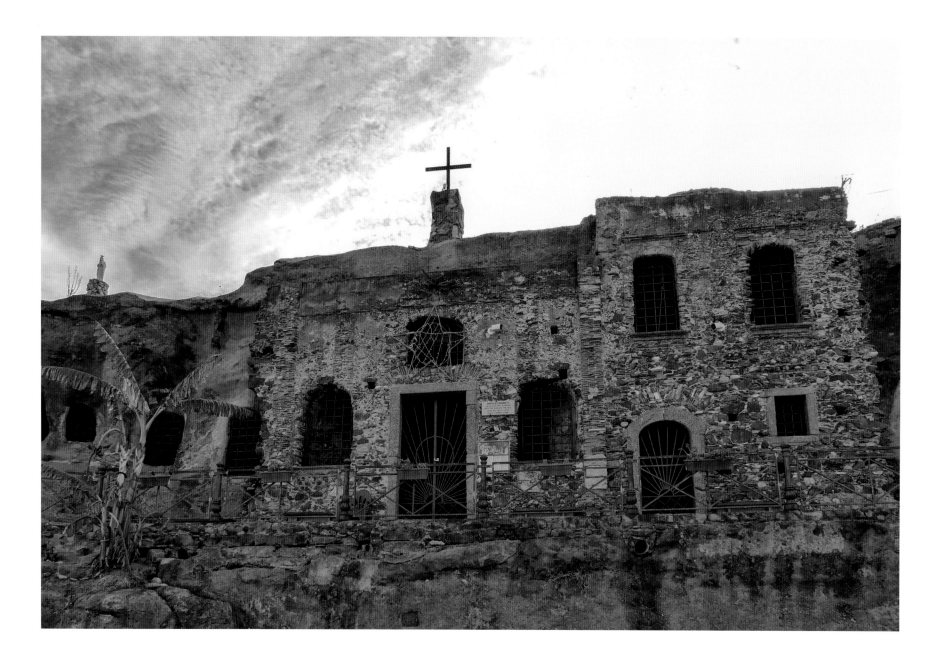

皮佐的石窟教堂。教堂的入口就在海岸边，来自海上的风雨经年累月地不断侵蚀着海岸的岩石，却丝毫无损洞内的教堂。圣母一直保佑出海的旅人和渔民，平安归来。

The Grotto of Pizzo Calabro is located by the coast, enduring the relentless erosion of wind and rain from the sea over the years, yet remaining unscathed. It is believed that the Virgin Mary has always blessed travelers and fishermen to return safely from their voyages at sea.

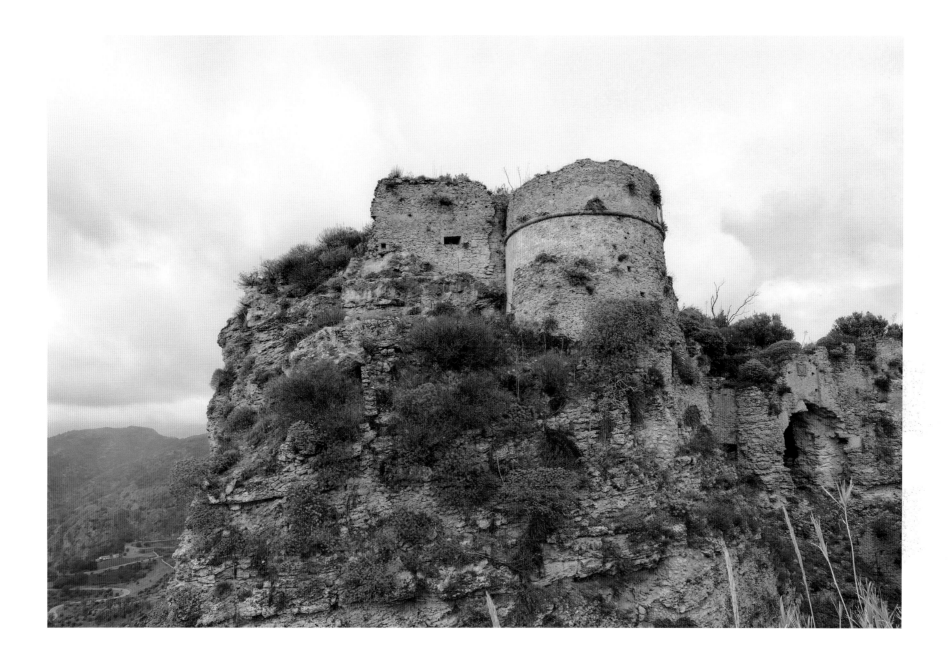

杰拉切的诺曼城堡，它矗立在悬崖顶，过去是一处居高临下的防御城堡。

The Norman Castle of Gerace stands on the top of a towering cliff, once serving as a defensive stronghold occupying a commanding position.

杰拉切主教座堂内部

Inside the Cathedral of
Gerace

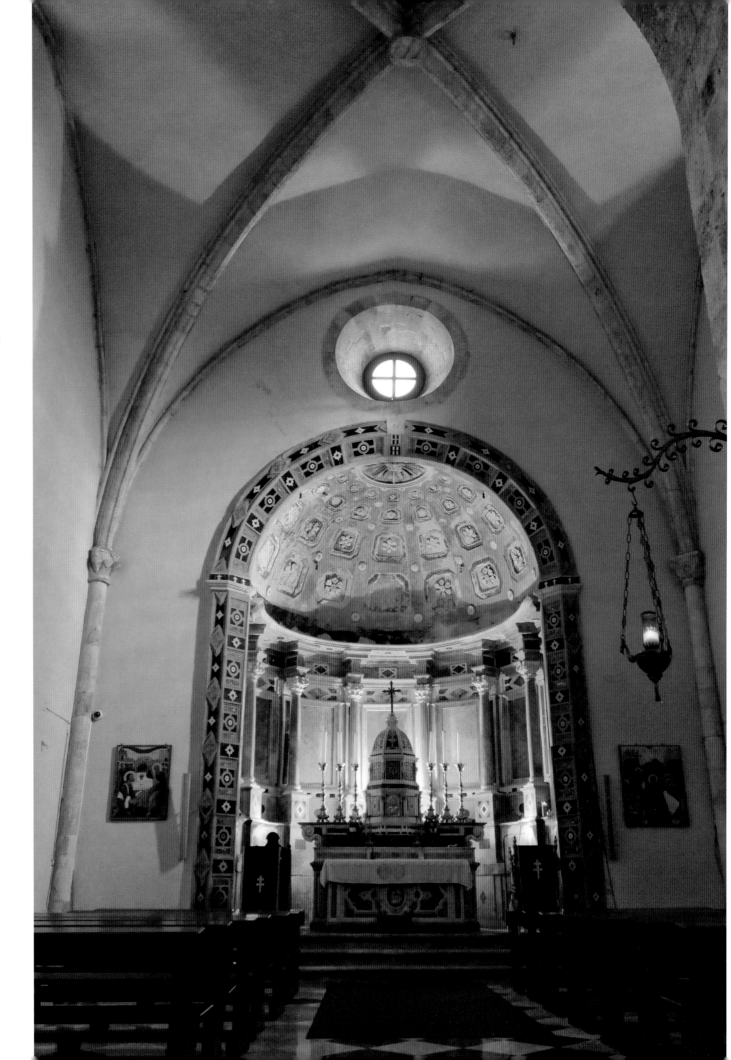

杰拉切小镇一隅

A corner of Gerace

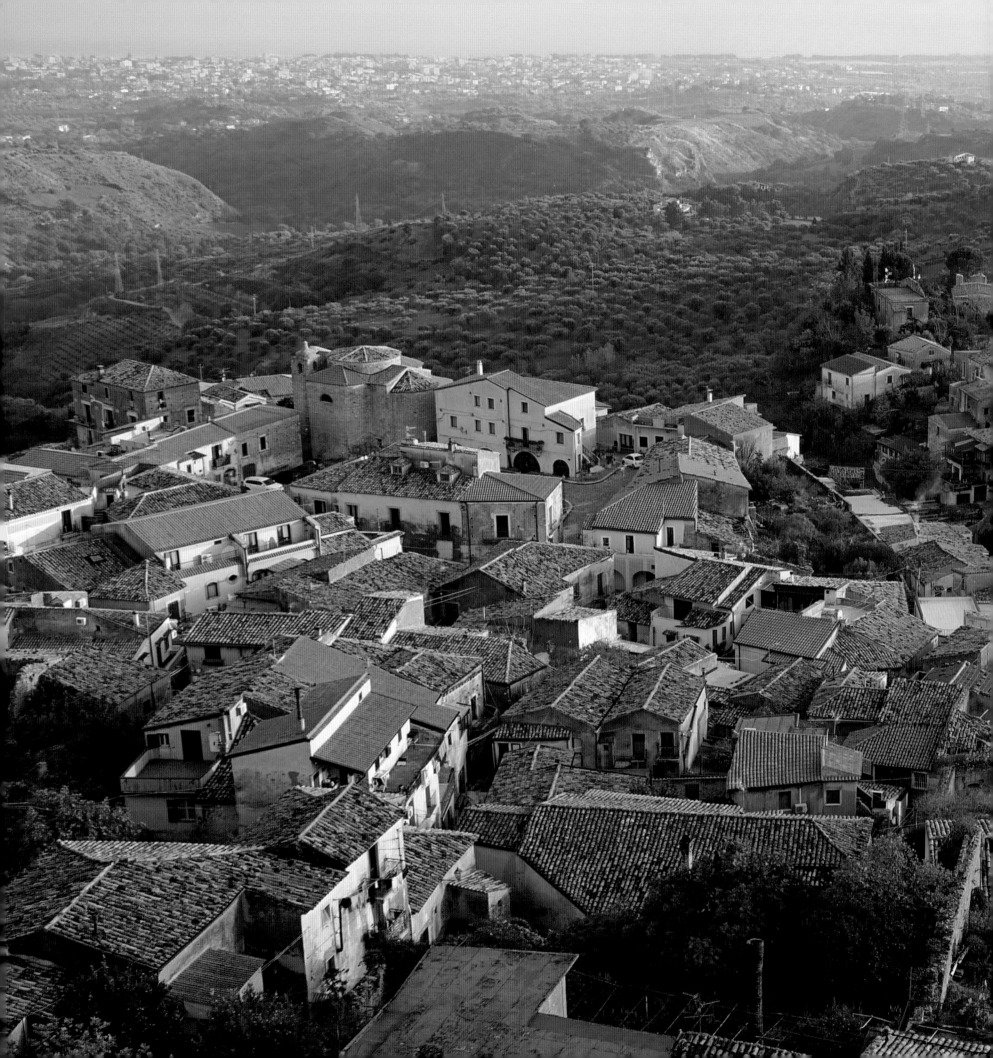

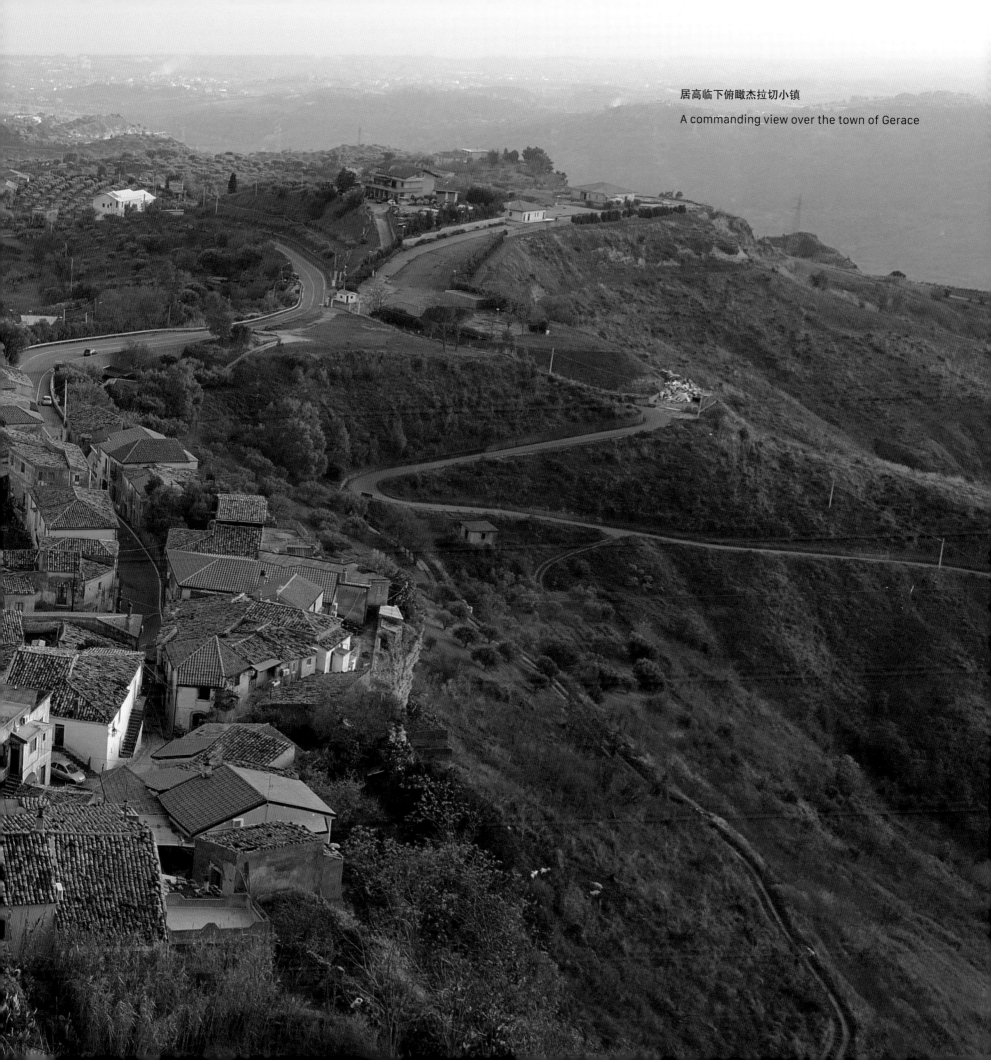

居高临下俯瞰杰拉切小镇

A commanding view over the town of Gerace

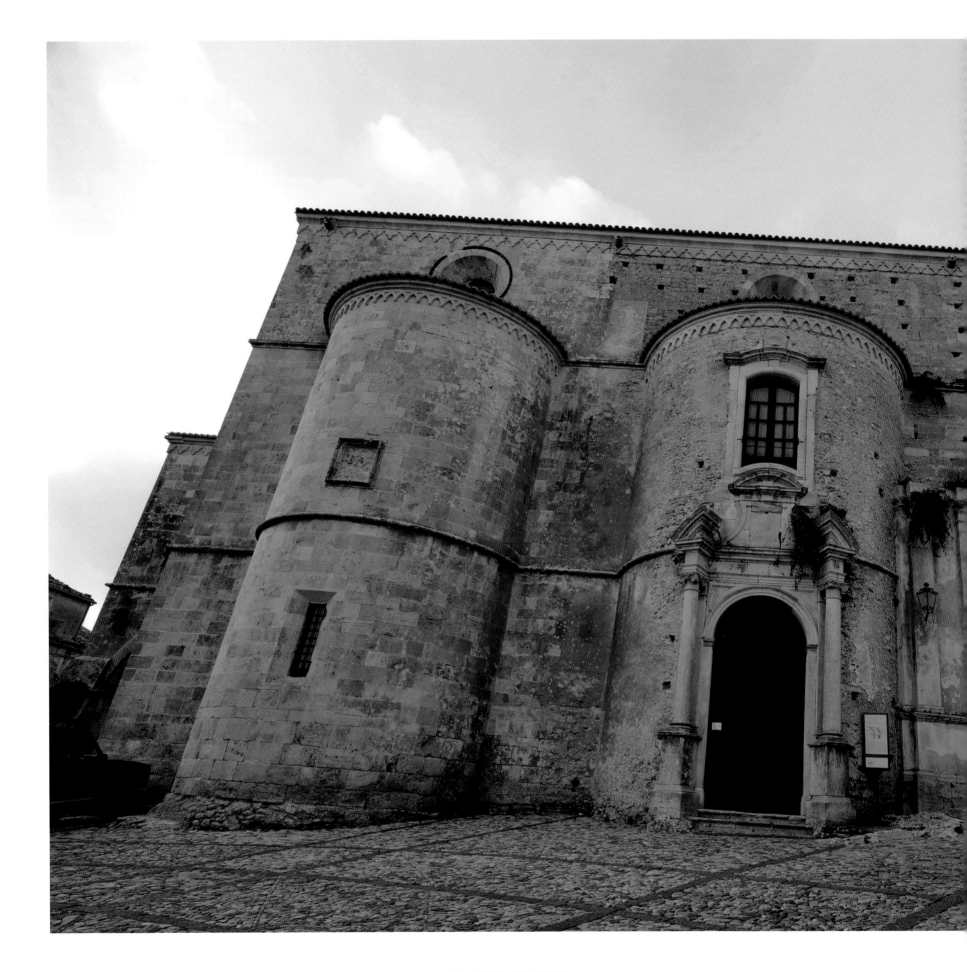

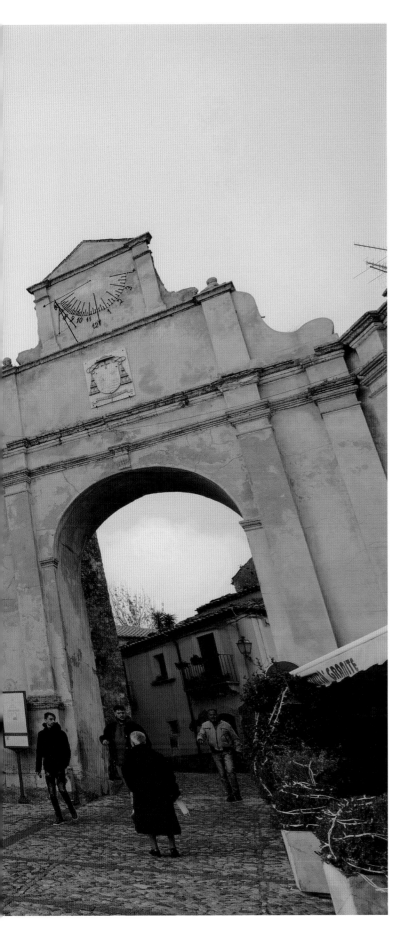

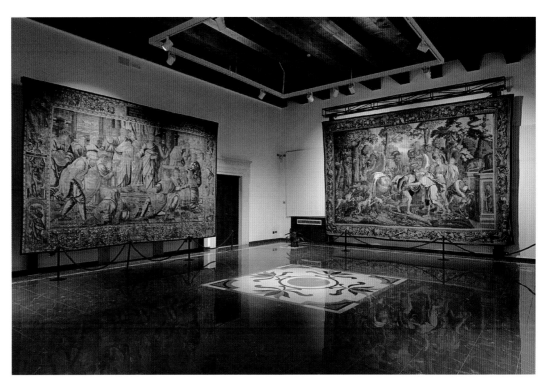

杰拉切主教座堂的挂毯藏品

The tapestry collection of the Cathedral of Gerace

外观看似城堡的杰拉切主教座堂

The Cathedral of Gerace, with its castle-like appearance.

特罗佩亚街景

The street view of Tropea

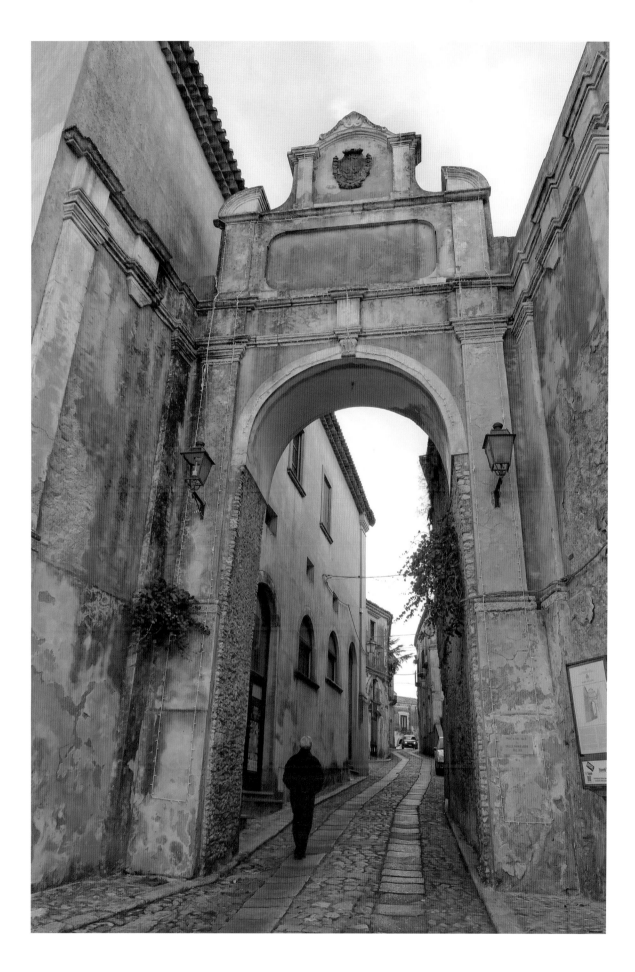

位于杰拉切的太阳之门。杰拉切人口不到三千，在这个朴实无华的古镇上，仍然保留着中世纪的氛围，不论横街窄巷，所见之处都是逾百年或数百年的民房建筑。

The Sun Gate of Gerace is situated in a quaint, ancient town with a population of fewer than three thousand. This unassuming yet charming place retains an ambiance of the Middle Ages, with its narrow streets and winding alleys lined with houses and buildings steeped in histories spanning hundreds or even thousands of years.

雷焦卡拉布里亚内海滨大道旁的热那亚泽尔比别墅。在这条笔直的海滨大道上，无数新、旧高楼，包含巴洛克式、文艺复兴式等林林种种的建筑，俨如一条建筑博物馆长廊，引人入胜。

Villa Zerbi along the seafront promenade in Reggio di Calabria. There are a collection of new and old high-rise buildings of various architectural styles from Baroque to Renaissance, like a fascinating corridor of an architectural museum.

雷焦卡拉布里亚的圣乔治阿尔科尔索教堂
The Church of San Giorgio al Corso in Reggio di Calabria

1. 雷焦卡拉布里亚及周边地区 Reggio di Calabria and its fascinating neighbouring regions

那不勒斯及周边地区

*Naples (Napoli) and
its sunny neighbouring regions*

提到那不勒斯总是离不开几个标志性的词汇：阳光、海水和美食，这里气候温暖，物产丰富，又有良好的海港，更有欧洲最大的活火山——维苏威火山，加上当地居民友善热情，"朝圣那不勒斯，夕死可矣"这句意大利的谚语，就足以说明它有多大的魅力。要说罗马是罗马文明的发源地，米兰是时尚商业中心，那不勒斯则充满活力、热闹和美丽的风景，是不折不扣的一座"阳光、快乐之城"。

这座古城拥有跟许多欧洲城市一样的标配建筑，那就是城堡。我到达当天，下榻的酒店前方正对着一座蛋堡。它傲然耸立在海上的梅加里德小岛，如今已有道路从意大利本岛直接通往小岛和城堡。它是那不勒斯最古老的城堡，最初是古罗马贵族兴建的别墅，亦曾改为防御要塞，甚至是皇室居所，还一度是囚禁犯人的监狱。疫情期间城堡正进行修复，并不开放，我只好远观，而不能内进。听酒店的经理介绍，登上城堡的城楼，是远眺那不勒斯海湾和维苏威火山的最佳位置之一。不过这次我住在与城堡仅一马路之隔的酒店，住的楼层比城堡高出更多，视野更好。下榻的这几天，我多番站在酒店房间毫无遮挡的露台上，尽情欣赏港湾多变的景色，除了日出东方和夕阳西下的壮丽，还有夜色低垂时的点点星光、万家灯火，令人陶醉万分。

从保罗圣方济教堂看那不勒斯王宫。王宫外观看上去相当朴实，毫无奢华感，最初是西班牙总督的王宫，后又成了法国波旁王朝以及萨伏依家族的居所。

Admiring the Naples Royal Palace from the Basilica of St. Francis of Paola. The appearance of the palace looks quite simple, without any sense of luxury. It was originally the palace of the Spanish viceroy, and later became the residence of the Bourbon Dynasty of France and the House of Savoy.

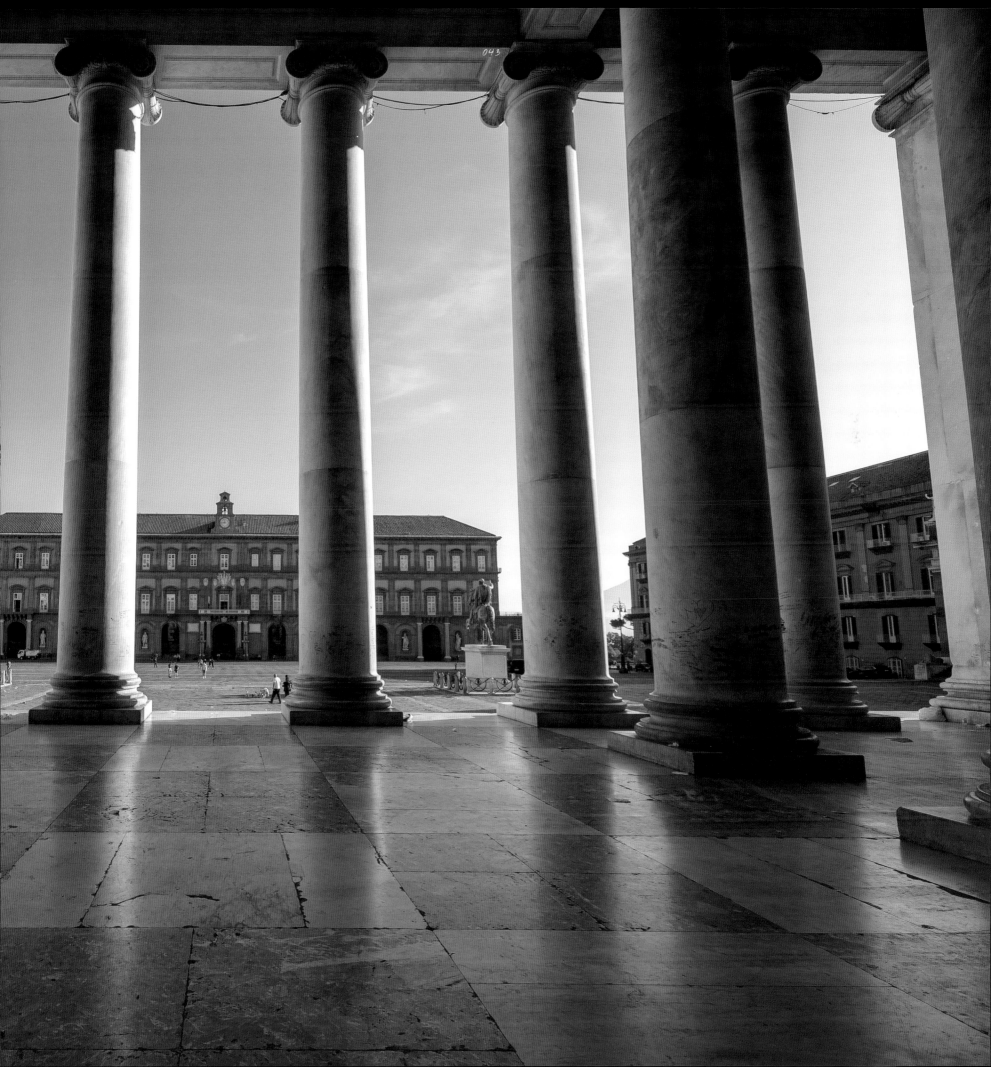

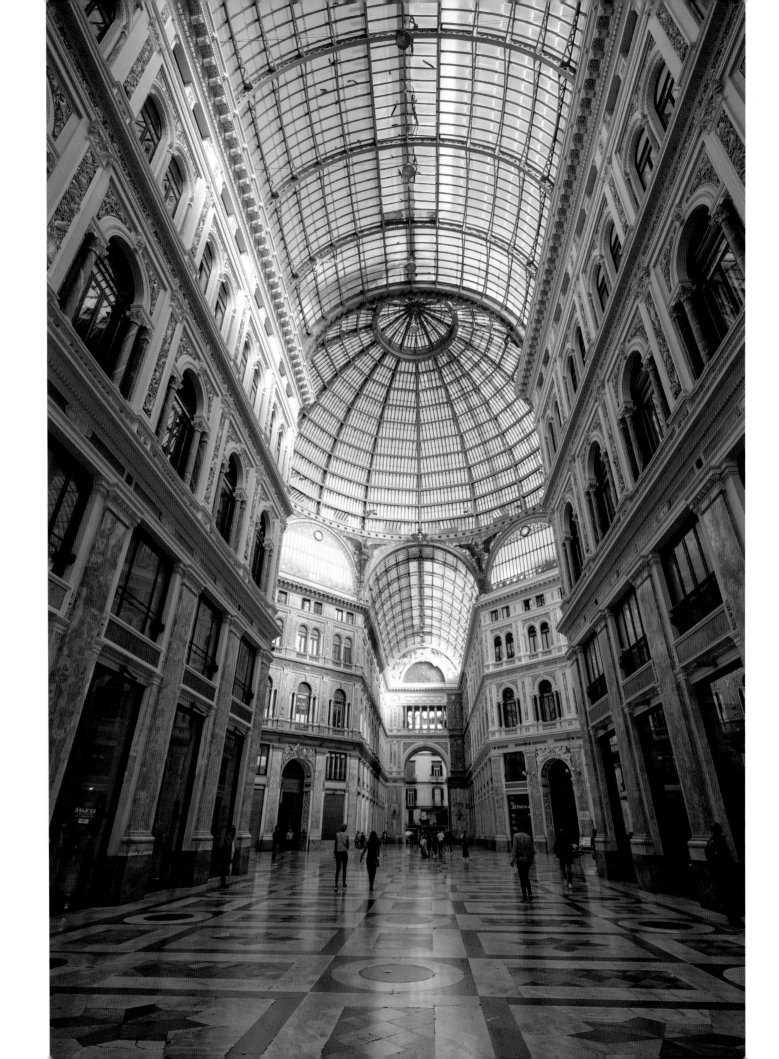

When Naples is mentioned, it conjures up images of sunshine, crystal-clear seawater and delicious cuisine. The place enjoys balmy weather, has substantial natural resources, boasts a bustling sea port as well as Europe's largest active volcano, Mount Vesuvius (Vesuvio), and is home to warm and passionate locals, so the Italian proverb 'Vedi Napoli e poi muori (See Naples and then die)' perfectly encapsulates its irresistible charm. While Rome gave birth to Roman civilization and Milan reigns as the fashion capital, Naples features an infectious energy, vibrant atmosphere and breathtaking scenery, which truly deserves the commendation as a 'city full of sunshine and happiness'.

The ancient city boasts the iconic structure, the castle, just like many other European cities. Upon my arrival, I was delighted to find that the hotel where I stayed overlooked the Castel dell'Ovo proudly situated on the Megaride islet in the sea. Although currently undergoing repairs and not accessible to visitors due to the pandemic, it was fascinating to learn about its rich history as a former villa for Roman nobles, defensive fortress, royal residence and even a prison. According to the hotel manager's introduction, ascending to the tower of the castle offers an unparalleled panoramic view of Naples Bay and Mount Vesuvius, truly a sight worth admiring. However, on this occasion, I stayed in a hotel just one street away from the castle, even higher than the castle itself, providing superior panoramic views. I often stood on the open-air terrace outside the room, reveling in the ever-changing scenery: from the magnificent sunrise in the east to the captivating sunset in the west, and at nightfall, being mesmerized by a canopy of shining stars in the sky and a myriad of twinkling lights in the ancient town.

翁贝托一世拱廊，玻璃的穹顶让自然光透射下来，照在地板上精致的马赛克图案，成为旅客争相打卡的景点。

Galleria Umberto I. The glass dome allows the gentle caress of natural light to shine on the exquisite mosaic patterns on the floor, making it a popular spot for tourists to take photos.

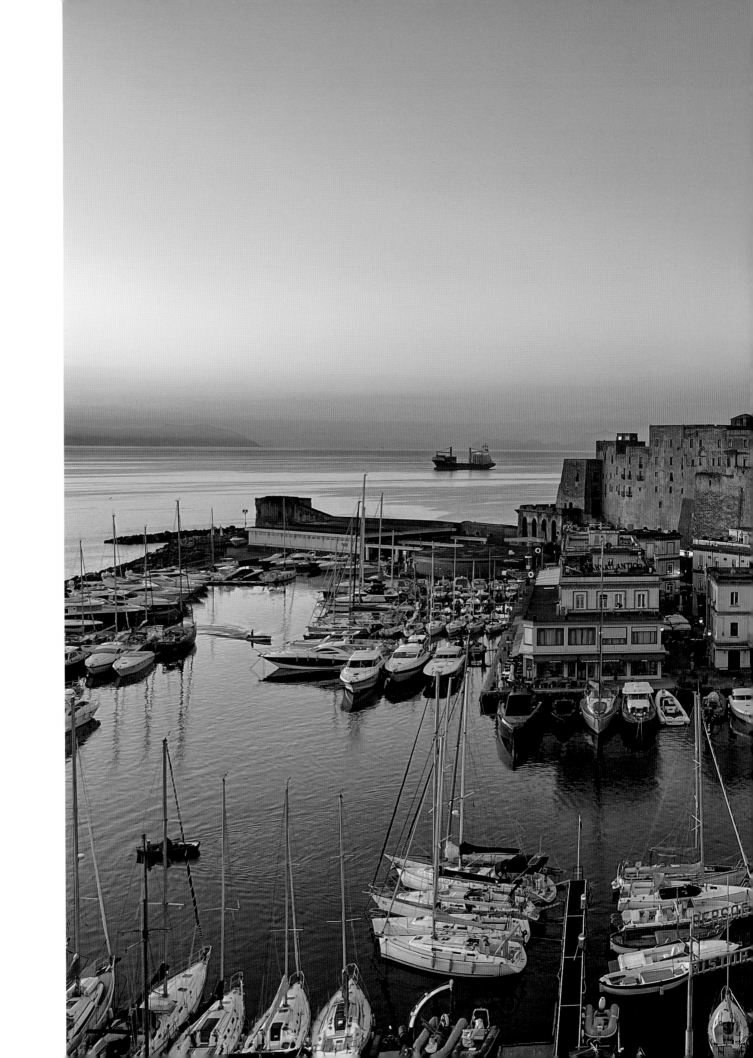

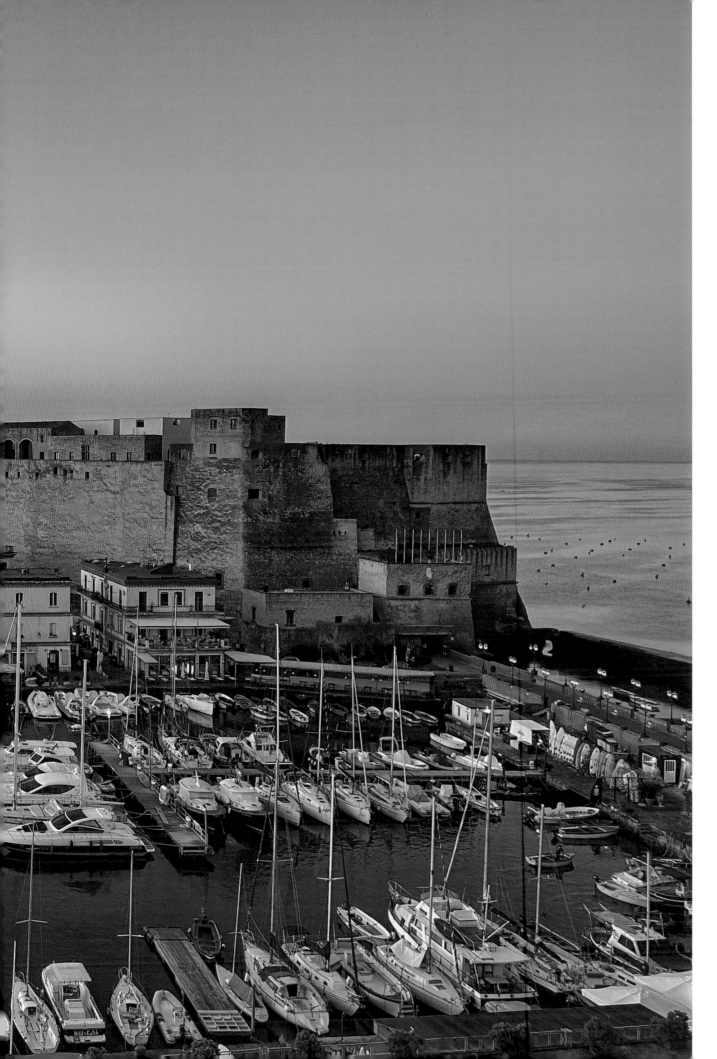

远眺那不勒斯海湾及蛋堡。蛋堡傲然耸立在海上的梅加里德小岛，是那不勒斯最古老的城堡，如今已有道路从意大利本岛直接通往小岛和城堡。

Overlooking the picturesque Bay of Naples and the Castel dell'Ovo. As the oldest castle in Naples, the Castel dell'Ovo stands proudly on the Megaride islet in the sea, and now a direct road connects the mainland of Italy to this historic islet and its magnificent castle.

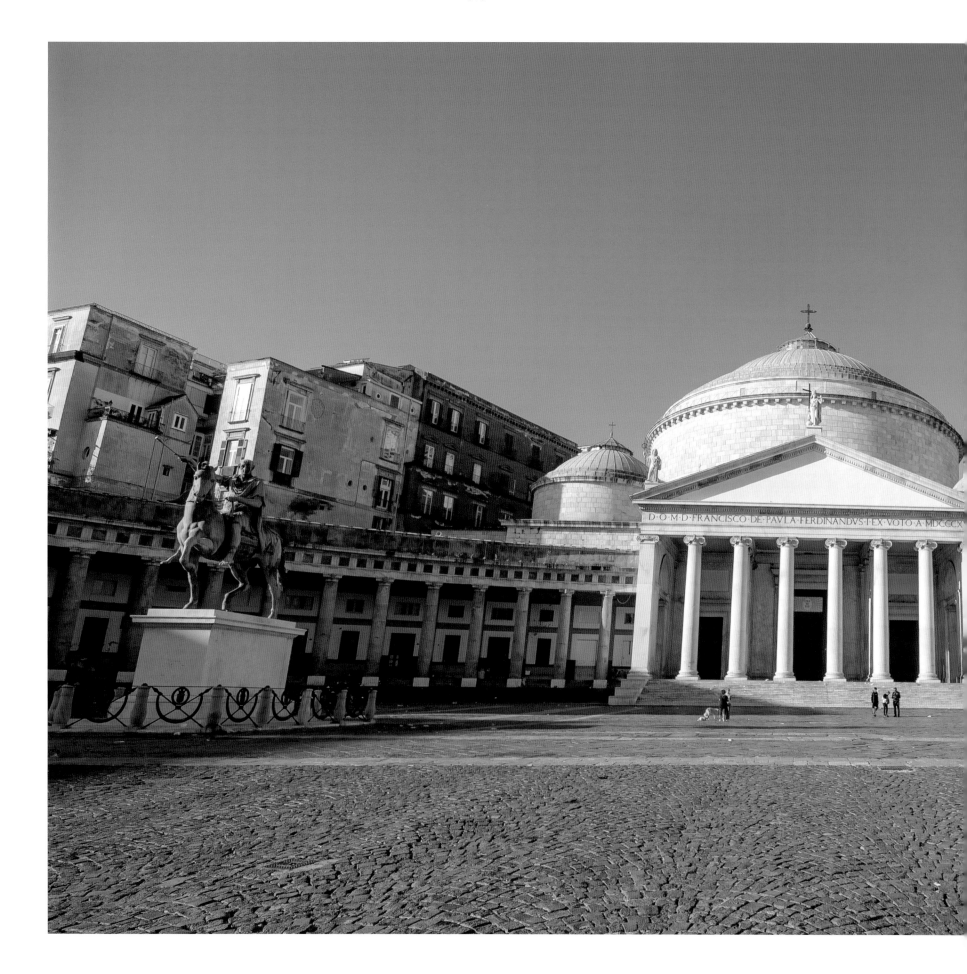

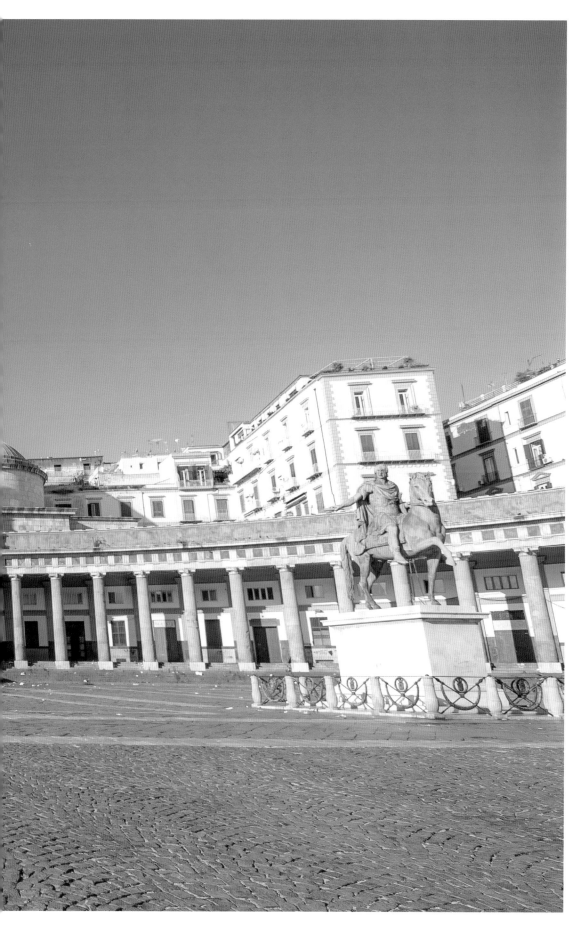

保罗圣方济教堂

Basilica of St. Francis of Paola

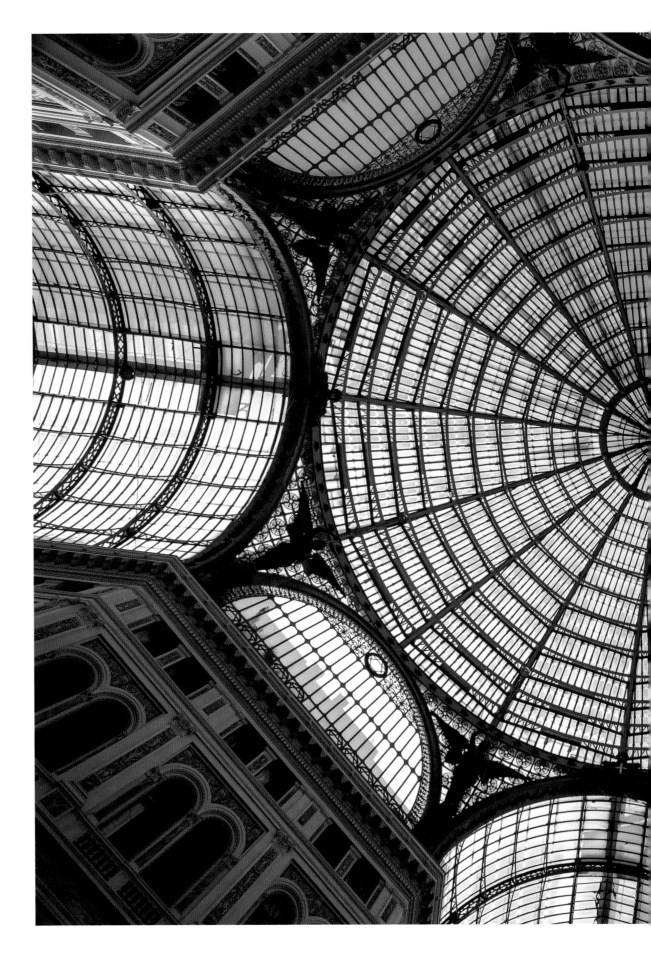

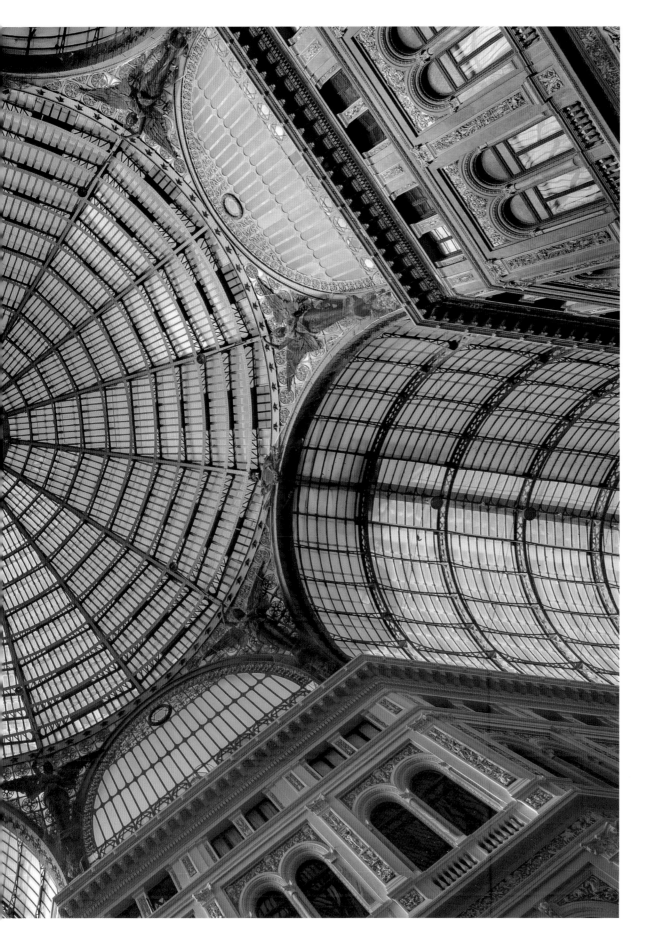

翁贝托一世拱廊的玻璃穹顶特写
Close-up of the glass dome of the Galleria Umberto I (Umberto I Gallery)

那不勒斯市中心的里雅斯特与特伦托广场及喷泉

The Piazza Trieste e Trento (Trieste and Trento Square) and the fountain in downtown Naples

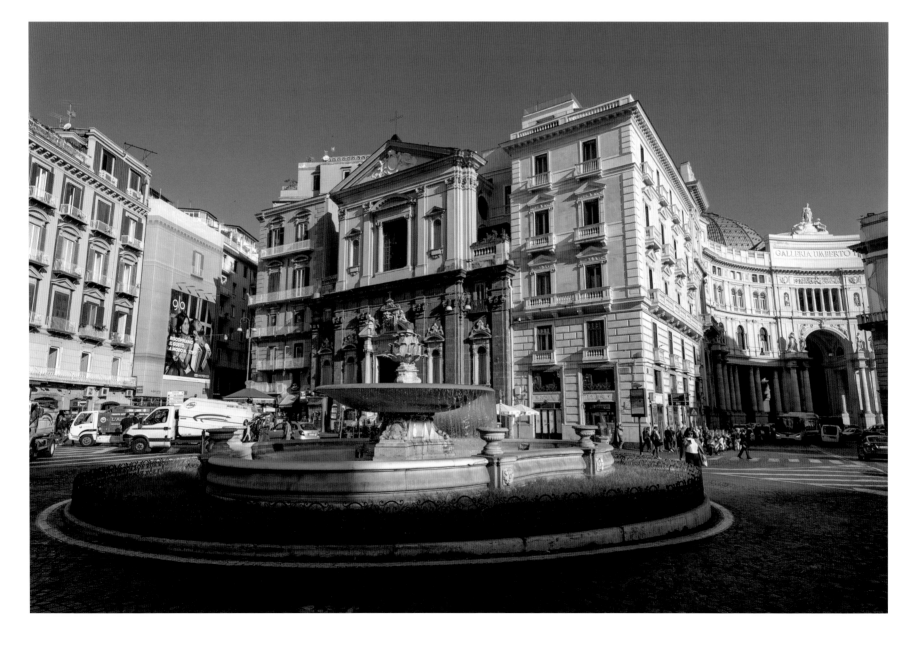

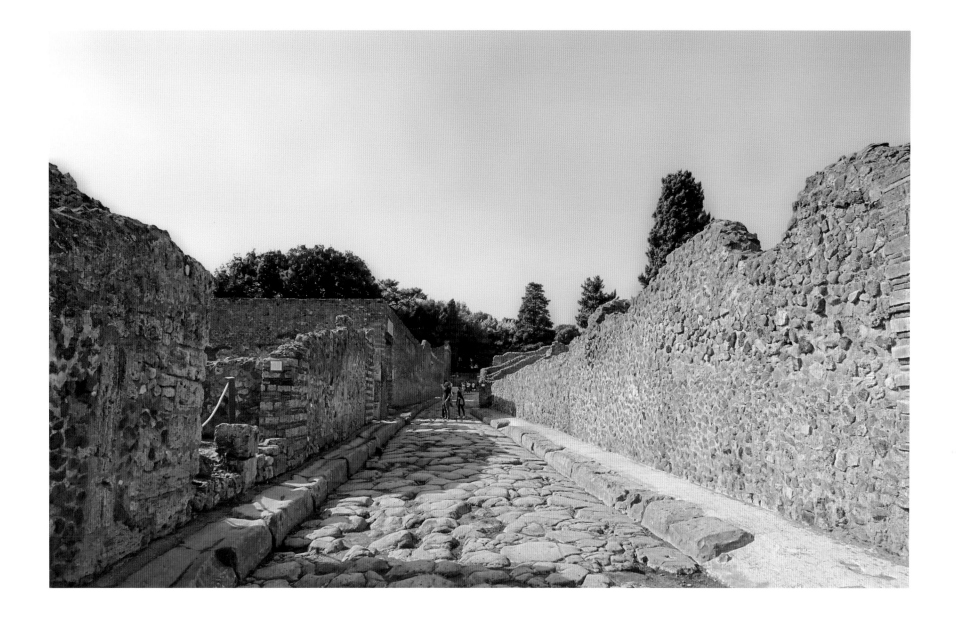

庞贝遗址路上的跳石。当时的庞贝由于车、马混行，导致交通拥挤堵塞。为解决这个问题，庞贝人不仅加高了人行道，还在接近马路口的地方，砌起一块块凸出路面的石头，连接两边的人行道，这些石头被称为"跳石"。

The stepping stones on the path to the ancient ruins of Pompei were a response to the traffic congestion caused by a mix of cars and horses in that era. In an effort to alleviate this issue, the people of Pompei not only raised their sidewalks but also built stones with protruding surfaces at street corners to connect both sides of the walkway. These features are known as 'stepping stones'.

波西塔诺小镇美得仿佛梦境一般，美国田园作家暨诺贝尔文学奖得主约翰·斯坦贝克将这里形容为"梦乡"。

The charming town of Positano is exquisitely beautiful, like a fantastical dream, as acclaimed American pastoral writer and Nobel Prize winner John Steinbeck described it as 'a dreamland'.

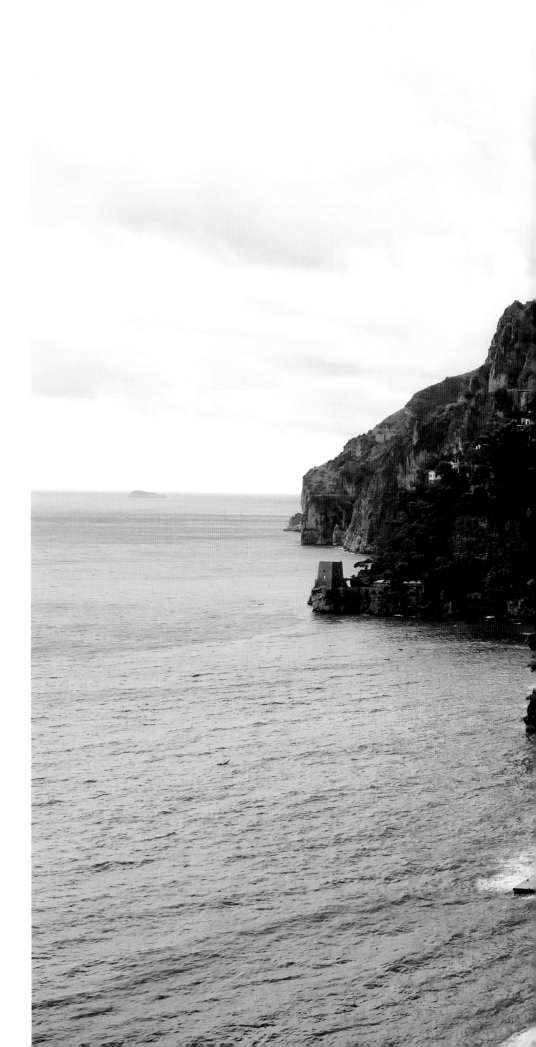

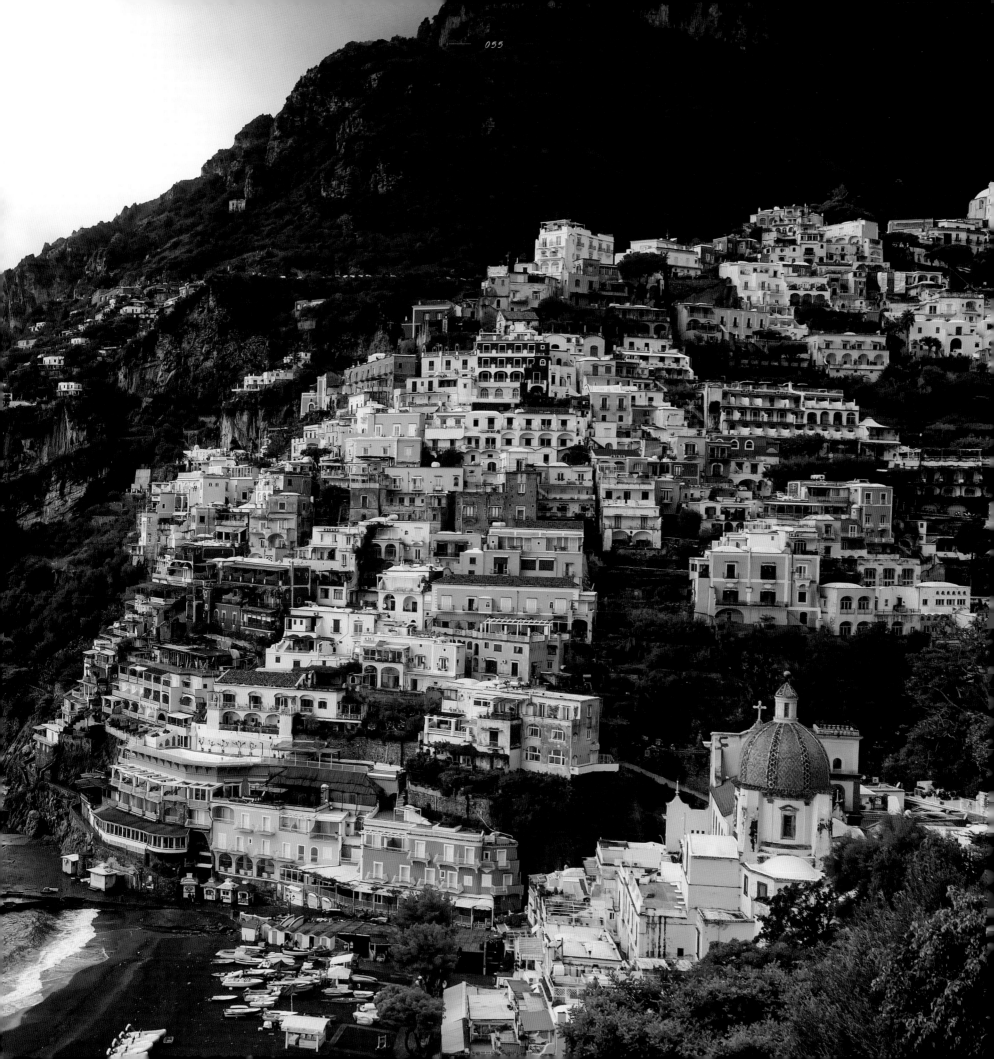

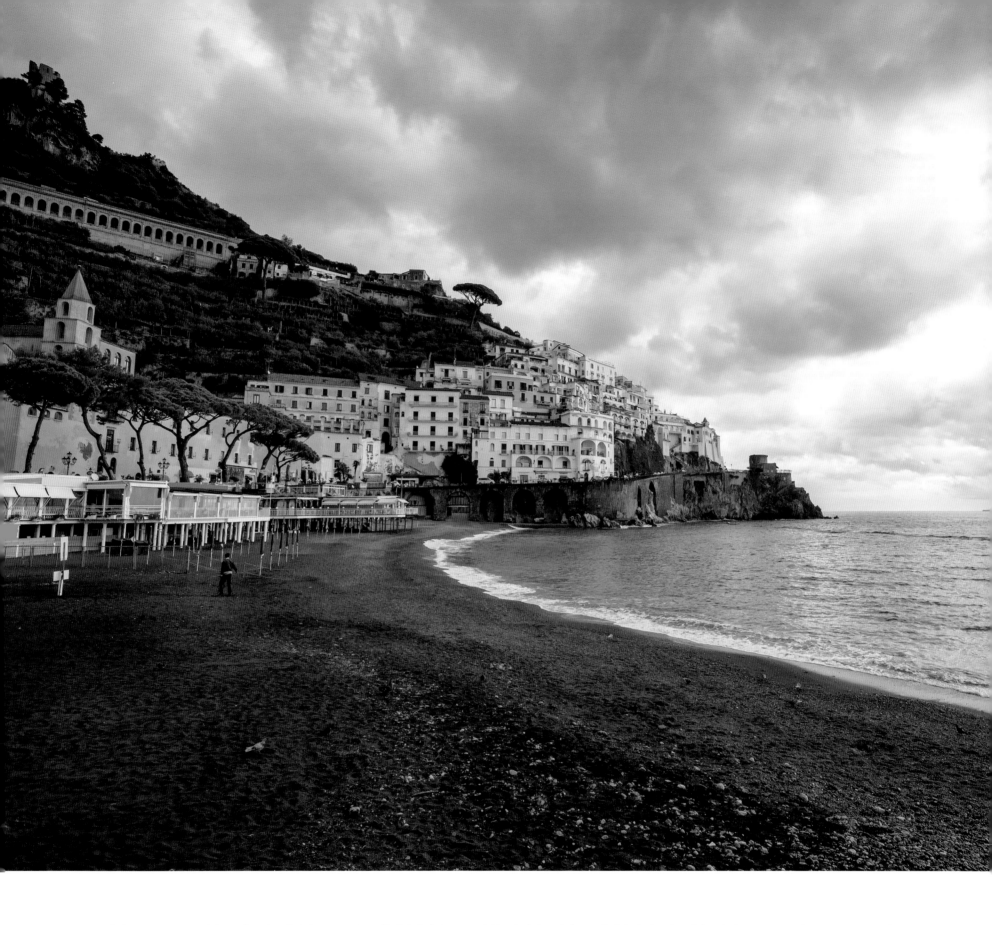

阿玛尔菲海岸风光，远处为撒拉逊塔，瞭望塔过去是为了防御阿拉伯人从海上侵入而建的，每当发现敌人进入古城水域时，瞭望塔会燃起烽火，通知城内居民作好防御准备。

The scenery of the Amalfi Coast is breathtaking, with the Saracen tower in the distance. This watchtower was built to prevent Arab invasions from the sea. Whenever enemies were spotted entering the waters near the ancient city, the watchtower would light signal fires to alert the residents to prepare for defense.

从酒店看阿玛尔菲海景，居高临下，可以俯瞰整个海岸线，景色美不胜收。

The hotel offers a breathtaking panoramic view of the entire Amalfi coast, showcasing its stunning beauty in all its glory.

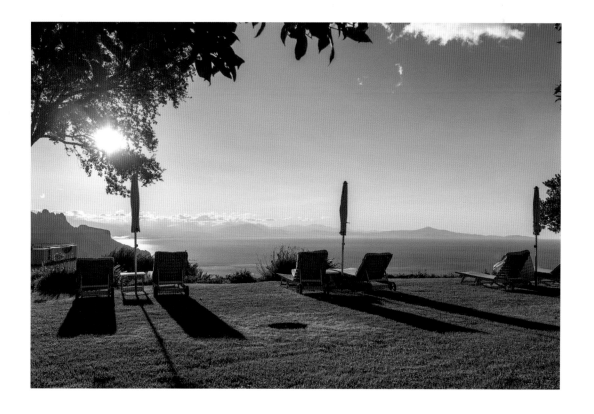

2. 那不勒斯及周边地区 Naples (Napoli) and its sunny neighbouring regions

阿玛尔菲海岸拉维罗一隅

A corner of Ravello along the Amalfi Coast

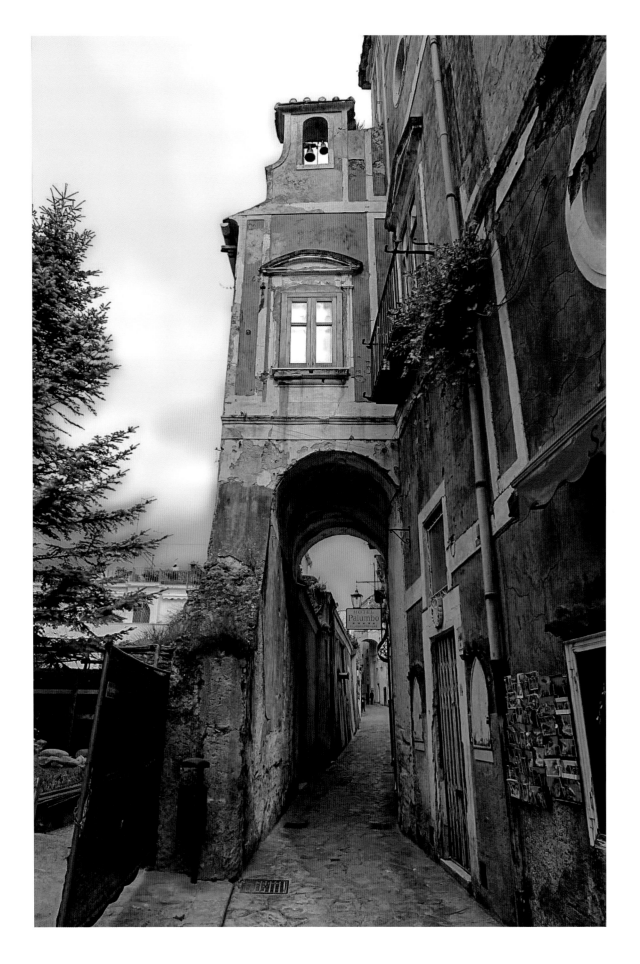

阿玛尔菲海岸拉维罗的陶瓷店铺

A ceramic shop of Ravello along the Amalfi Coast

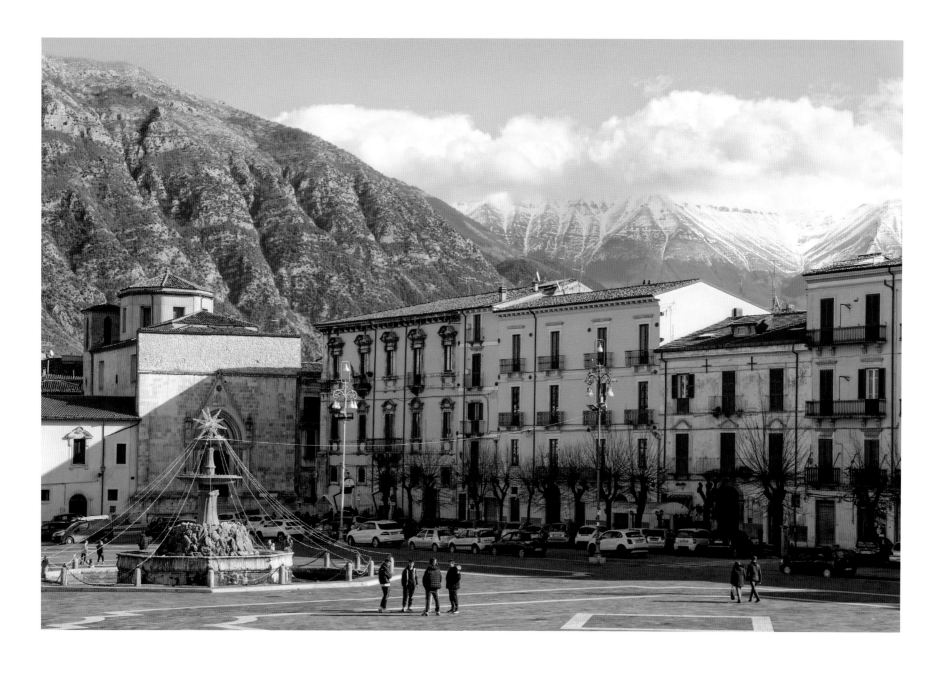

苏尔莫纳的加里波第广场

The Piazza Garibaldi (Garibaldi Square) of Sulmona

从苏尔莫纳的水道桥拱洞看加里波第广场

Looking from the arch of the Aqueduct Bridge towards Piazza Garibaldi (Garibaldi Square)

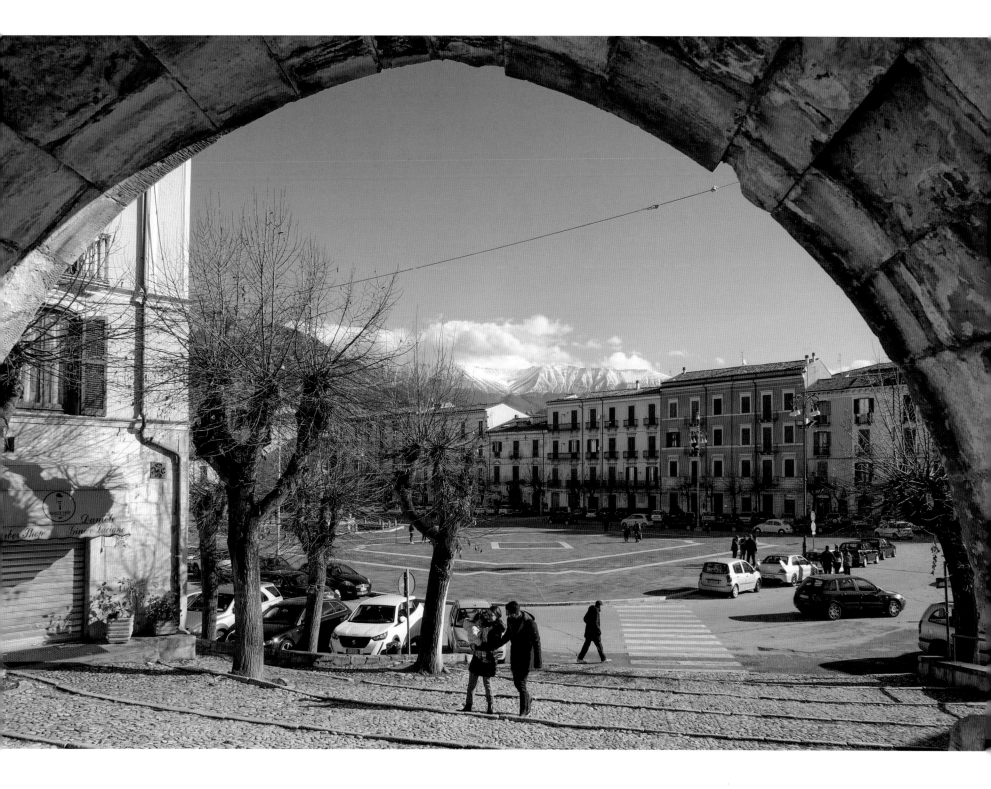

2. 那不勒斯及周边地区 Naples (Napoli) and its sunny neighbouring regions

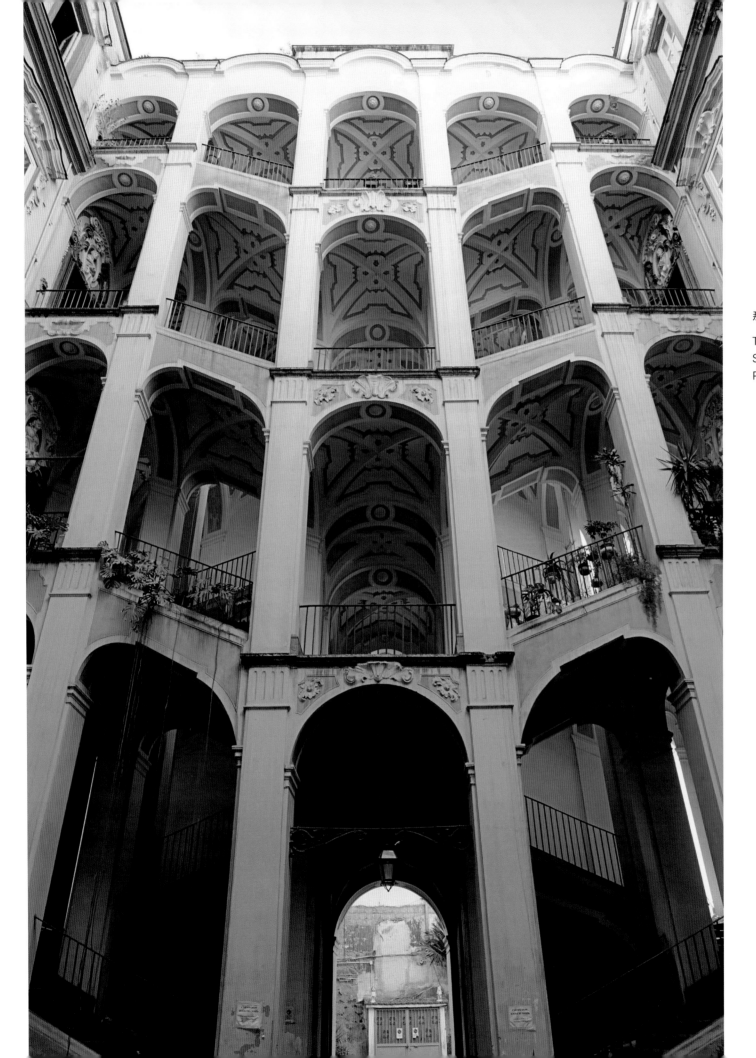

那不勒斯的西班牙宫

The Palazzo dello
Spagnolo (Spanish
Palace) in Naples

苏尔莫纳一隅

A corner of Sulmona

兰恰诺一景

A view of Lanciano

2. 那不勒斯及周边地区 Naples (Napoli) and its sunny neighbouring regions

索科索圣母教堂可算是塔利亚科佐的宗教中心

Chiesa Santa Maria del Soccorso (Church of St. Mary of Succour) is considered the religious center of Tagliacozzo

2. 那不勒斯及周边地区 Naples (Napoli) and its sunny neighbouring regions

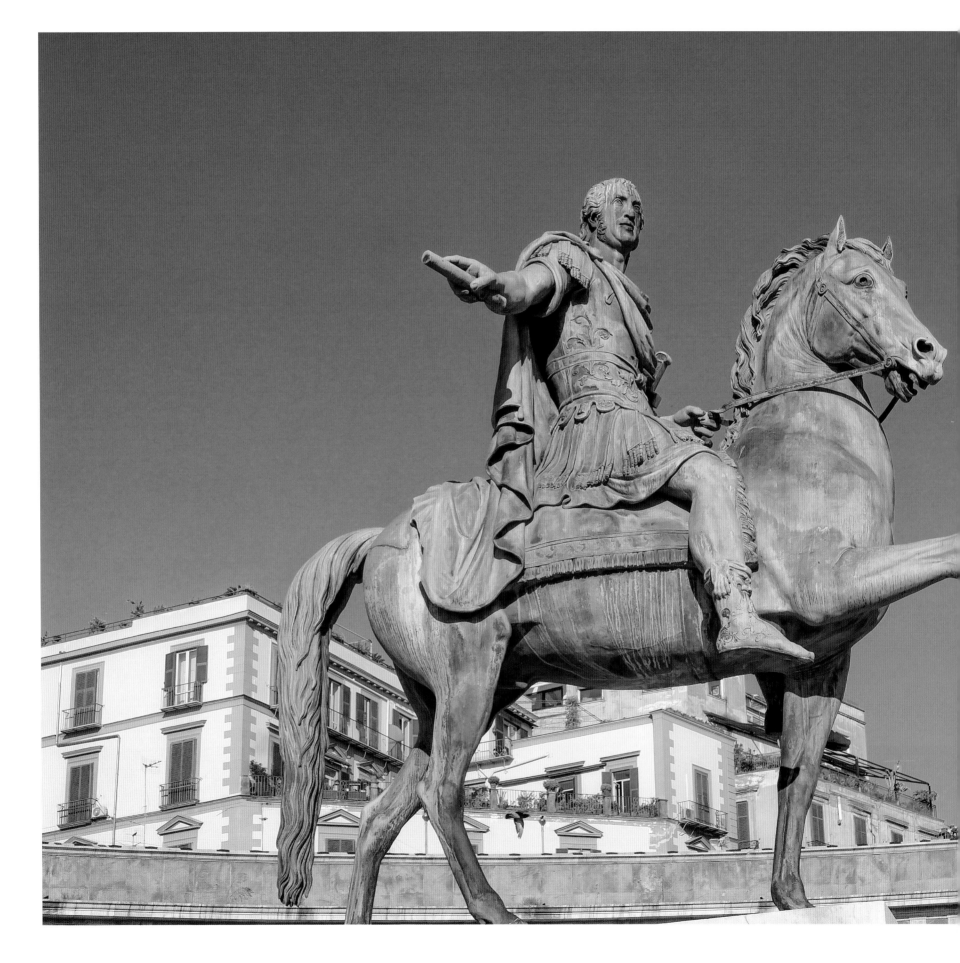

那不勒斯平民表决广场上的斐迪南多一世骑马雕像

A statue of Ferdinando I astride a horse in the Piazza del Plebiscito (Plebiscite Square) of Naples

苏尔莫纳的街头艺人

The street performer of Sulmona

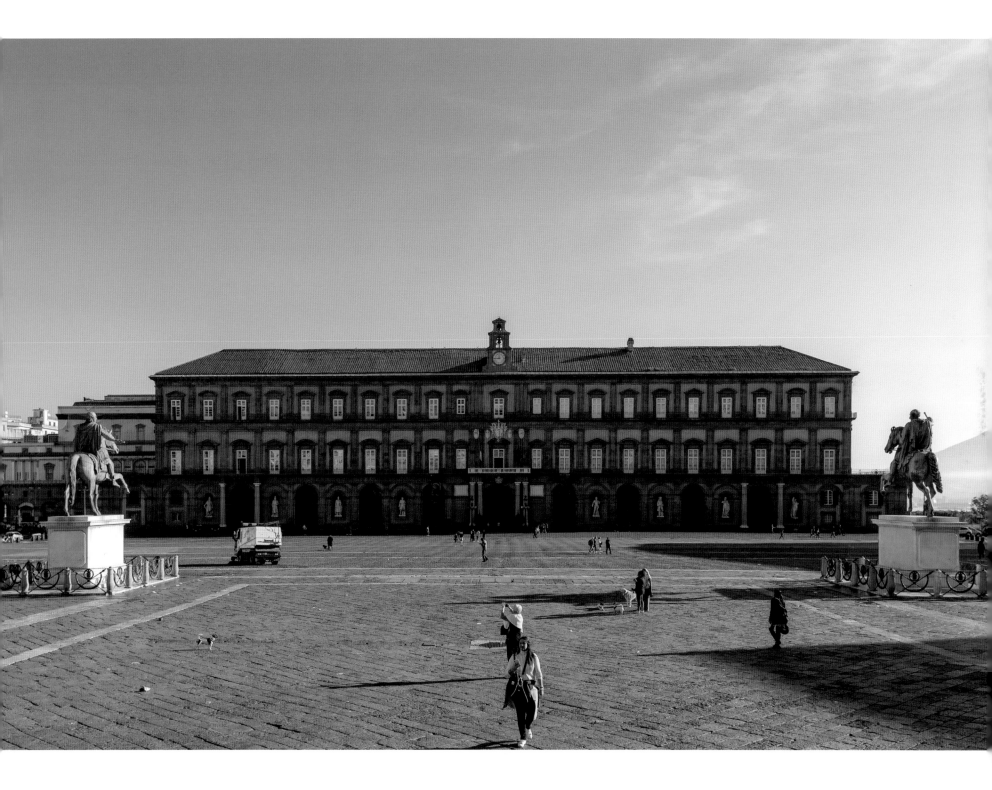

那不勒斯王宫

Palazzo Reale di Napoli (Royal Palace of Naples)

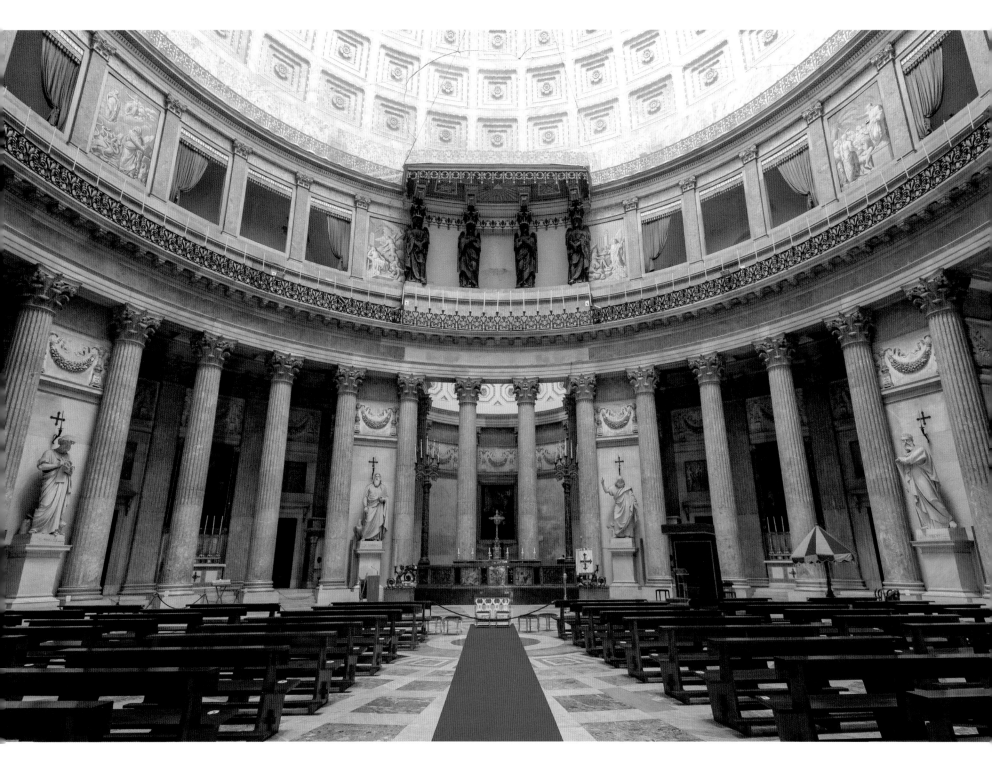

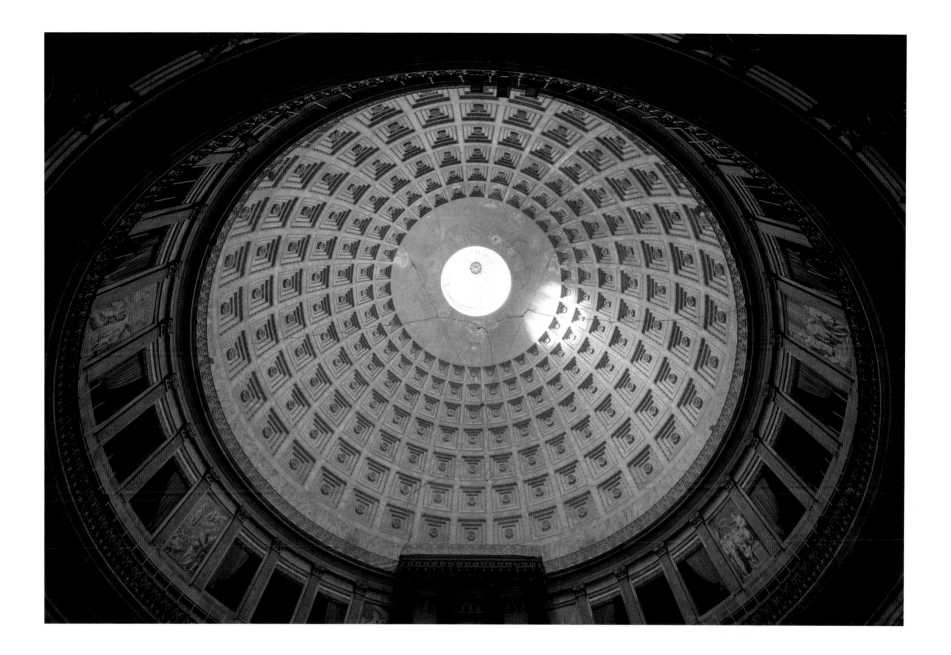

恍如迷你罗马万神殿的那不勒斯保罗圣方济教堂，主殿上有巨大的圆形穹顶，非常壮观。晨光从穹顶洒落在大殿上，更增添一份庄严气氛。

The Basilica of St. Francis of Paola in Naples, with its impressive circular dome topping the main hall, resembles a smaller version of the Roman Pantheon and evokes a sense of wonder. The morning sunlight shining through the dome adds to the peaceful and solemn atmosphere of the grand hall.

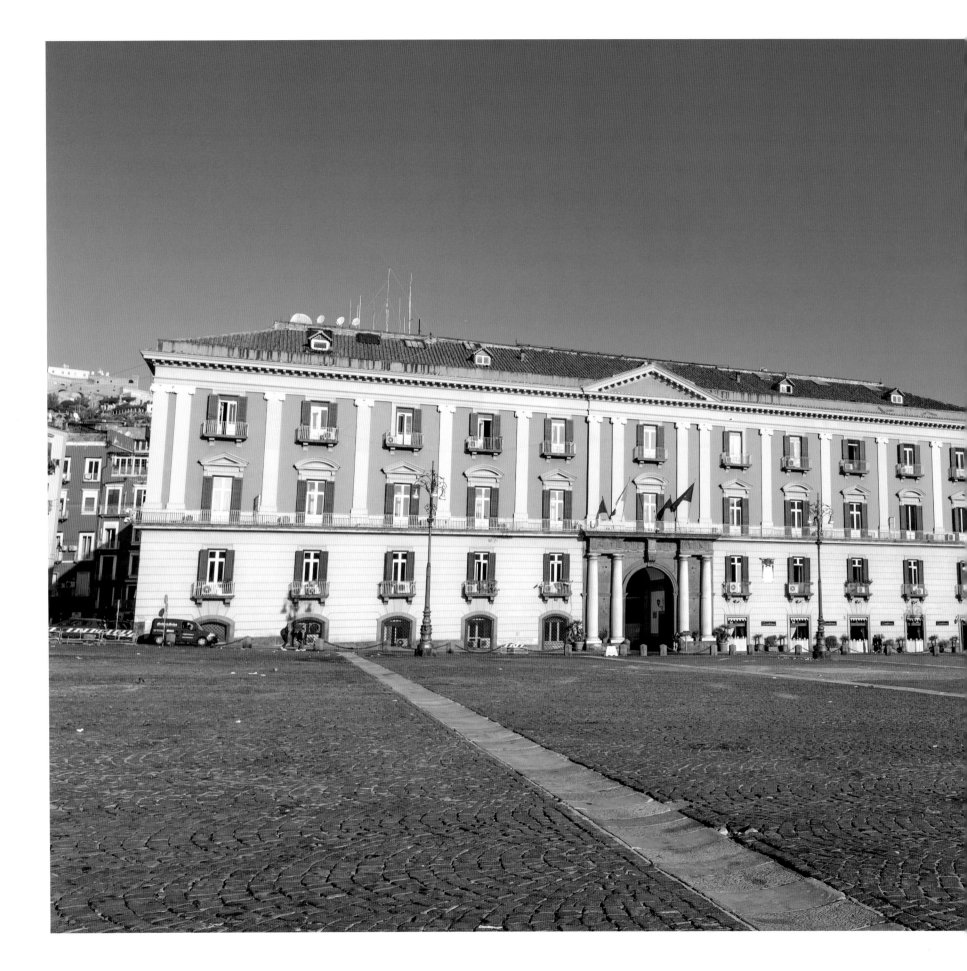

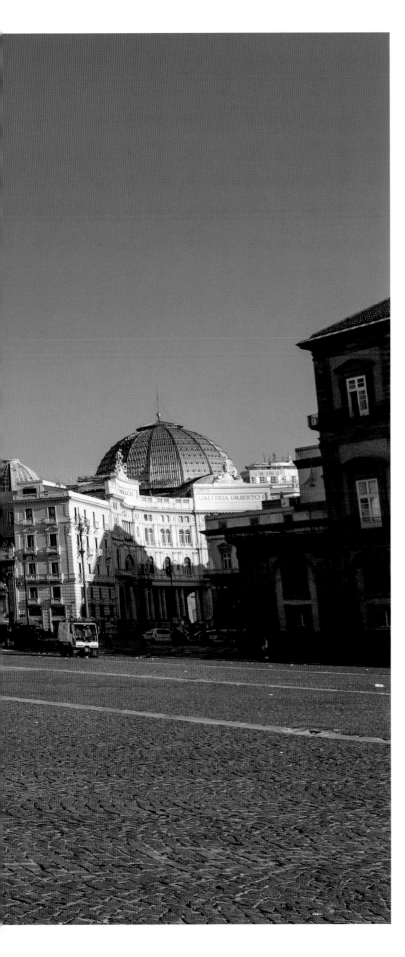

那不勒斯平民表决广场上的萨勒诺宫

The Salerno Palace in the Piazza del Plebiscito (Plebiscite Square) of Naples

塔利亚科佐小镇的石板路被时光打磨得发亮

The stone paths of Tagliacozzo have been beautifully polished over time

从高处俯瞰卡帕多西亚小镇

A view of the small town Cappadocia from above

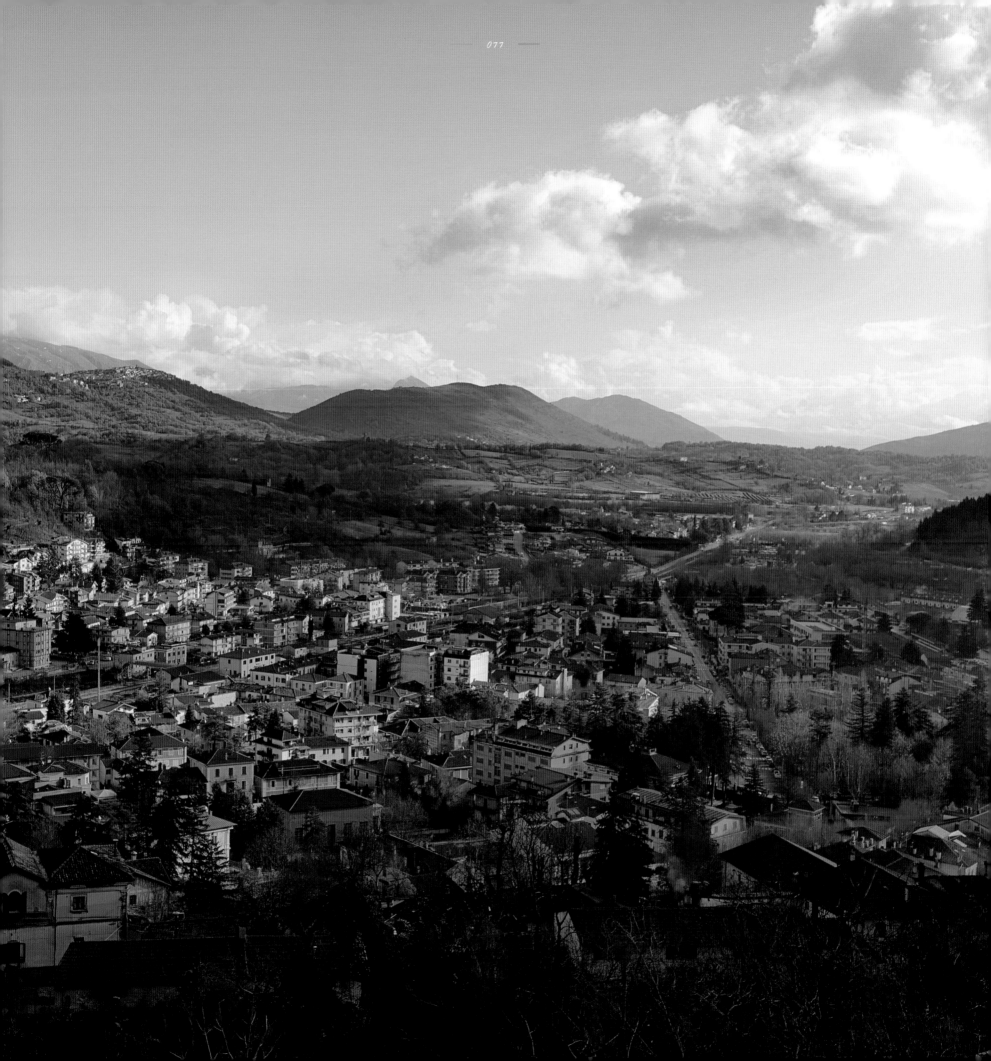

巴里及周边地区

有人说意大利南部与北部恍如两个不同的天地，无论是人文风情，或是地理环境，都有着"南辕北辙"的感觉。这里历史悠久，自公元前已陆续有古意大利人、希腊人聚居于此，后被罗马人占领和统治。罗马帝国覆亡后，又先后被东哥特人、伦巴第人和拜占庭帝国统治过，所以在这里保存不少各王朝、各民族的古文化、遗址等，并出现这样的说法："地中海中心的古老土地"。

从地图看来，普利亚大区就像鞋跟的位置，上端的加尔尼诺半岛则成了鞋跟上的"马刺"。普利亚大区上方是阿布鲁佐大区和莫利塞大区，这几个大区当中，以普利亚大区最为繁荣，在意大利南部的经济地位仅排在那不勒斯之后。当地大部分为非常平坦的田园地形，仅有少数和缓的山丘，盛产橄榄油和葡萄酒。主要城市除巴里外，还有莱切和布林迪西等历史古城，都包含在我此次"鞋跟"行的行程内，可说是既紧密又充实，不仅可以沿着蔚蓝的亚得里亚海岸，探访一座接着一座魅力无穷的小城镇，风光旖旎，更离不开地中海美食。不过，参观的古城小镇数目之多，让我在行程结束准备着手撰写游记时，光是整理照片，就因为太多的资料而感到昏头转向、手忙脚乱。

我在二○二二年十月和十二月两度来到巴里，事前听说在意大利南部城市中，它与那不勒斯一样名声不佳，治安不太好。然而经过了两次到访，却完全颠覆这些负面传言。总体来说，老城区比较安静祥和，而新城区完全就是一个热闹大城市。

其实巴里最美之处在于它长长的海岸线，闲坐滨海长堤上乘凉，放眼望去是无边的亚得里亚海，白天海风习习，美得纯粹自然；夜晚华灯初上，滨海风情尽在眼底。这时不妨到附近的鱼市场来一盘意式刺身，一边喝啤酒，一边迎着海风，不失是一个休闲好去处。

斯瓦比亚城堡，城墙厚实，气派十足。城堡的下方则可以看到一些拜占庭时期建筑的遗迹。

The Castello Normanno-Svevo (Normanno-Svevo Castel) boasts massive and imposing city walls, while beneath it lie remnants of buildings dating back to the Byzantine period.

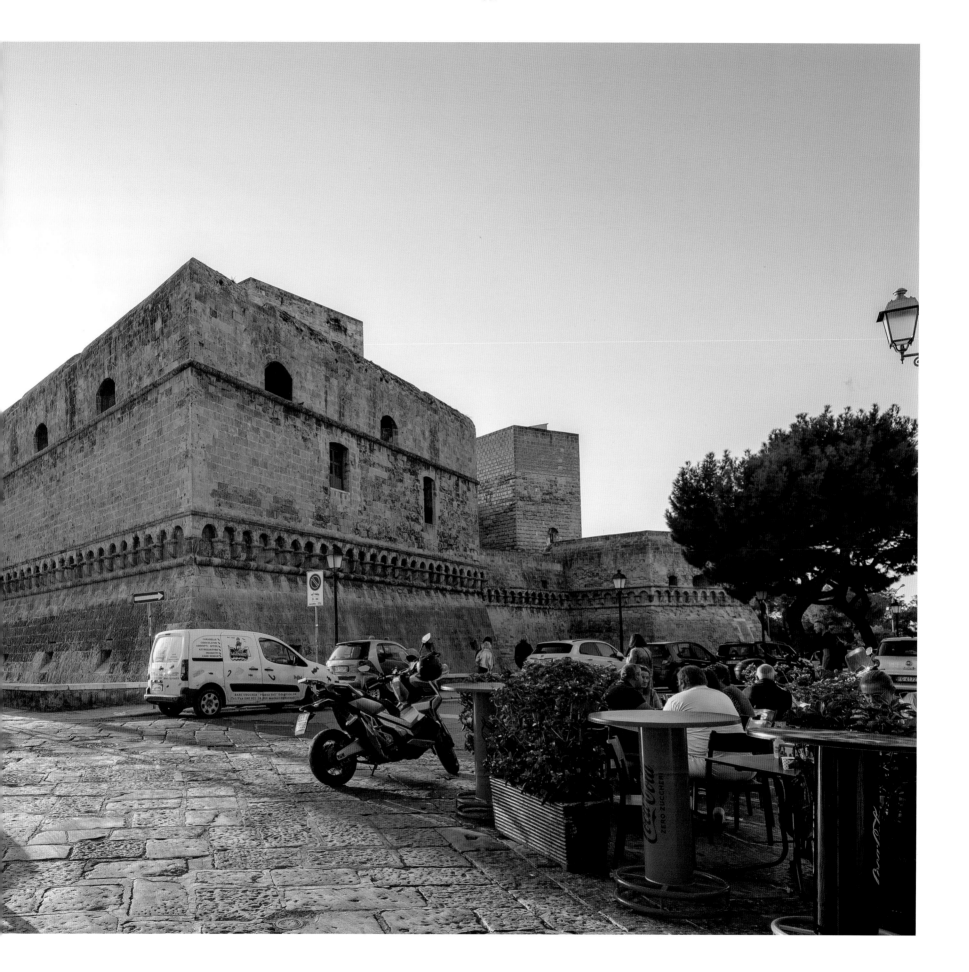

3. 巴里及周边地区 Bari and its bewitching neighbouring regions

Some argue that the southern and northern regions of Italy boast entirely distinct styles and geographical landscapes. This place boasts a rich history, with ancient Italians and Greeks inhabiting the area since the antiquity, subsequently coming under Roman rule. Following the decline of the Roman Empire, it was successively governed by the Ostrogoths, Lombards and Byzantine Empire. Therefore, cultures and sites of different dynasties and nationalities are preserved here, justifying the recognition as 'an ancient land in the heart of the Mediterranean'.

From the map, it is evident that Puglia is situated at the shoe heel of Italy, with the Gargano Peninsula becoming a 'spur' on the heel. Puglia stands as the most prosperous region in southern Italy, second only to Naples in terms of economic status, surpassing Abruzzo and Molise which are located above it. The local terrain predominantly consists of flat countryside with gentle hills, yielding olive oil and wine. Alongside Bari, my itinerary includes visits to historical cities such as Lecce and Brindisi for this 'shoe heel' trip, promising a journey both compact and enriching. Not only can I explore charming small towns along the stunning Adriatic coast one after another but also indulge in delicious Mediterranean cuisine. However, the abundance of ancient towns visited has left me feeling in a great bustle when preparing my travelogue due to having too much information to sort through while organizing photos.

During the months of October and December 2022, I had the pleasure of visiting Bari twice. Despite its prior poor reputation like Naples, known for its lack of security among southern Italian cities, my firsthand experience completely dispelled these negative rumors. The old town exudes a sense of tranquility and peace, while the new town pulsates with the energy of a bustling metropolis.

The most beautiful part of Bari is found along its extensive coastline, where you can leisurely sit on the waterfront promenade and admire the boundless Adriatic Sea. During the day, you are enveloped by the natural and fresh sea breeze; at night, you can be enchanted by the coastal charm as the city lights illuminate. You may also take a walk to a nearby fish market to enjoy an authentic Italian sashimi dish and have a refreshing beer while embracing the sea breeze, making it an ideal place for relaxation.

巴里海滨区

The coast of Bari

巴里的 Niccolò Piccinni 像

The statue of Niccolò Piccinni in Bari

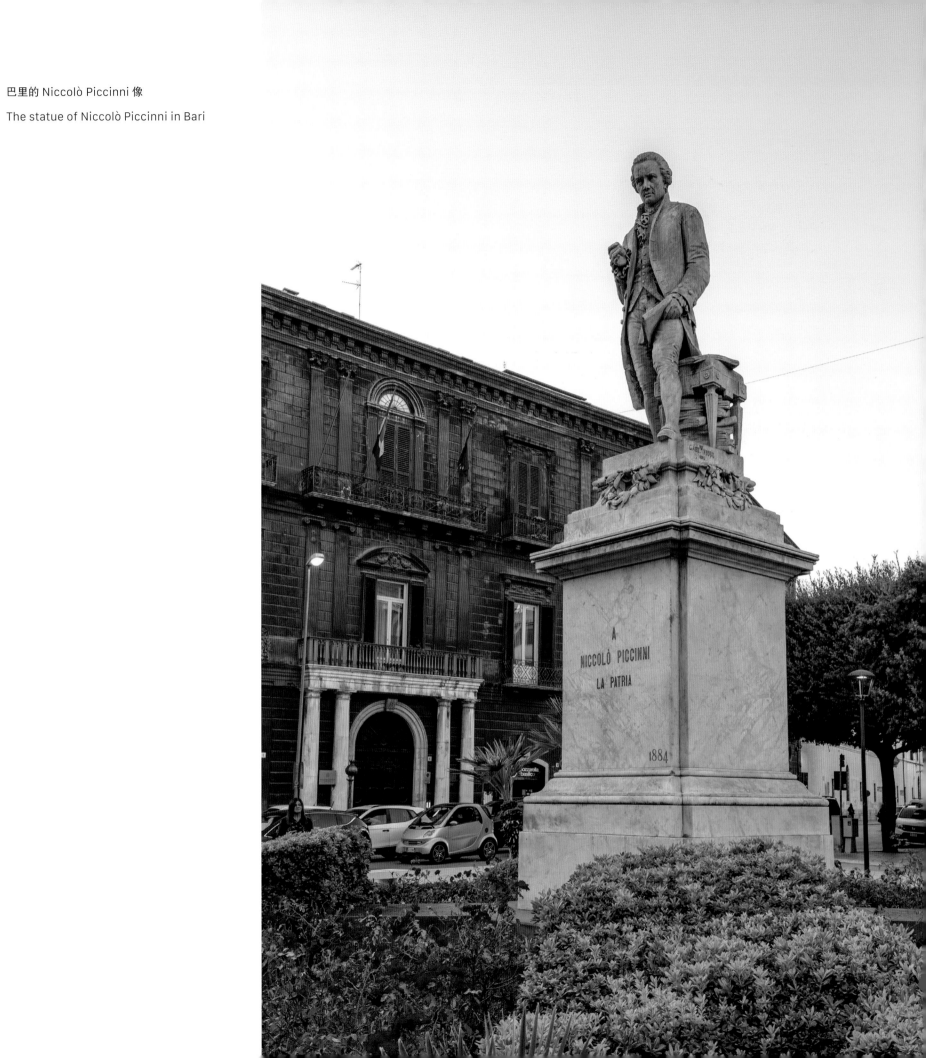

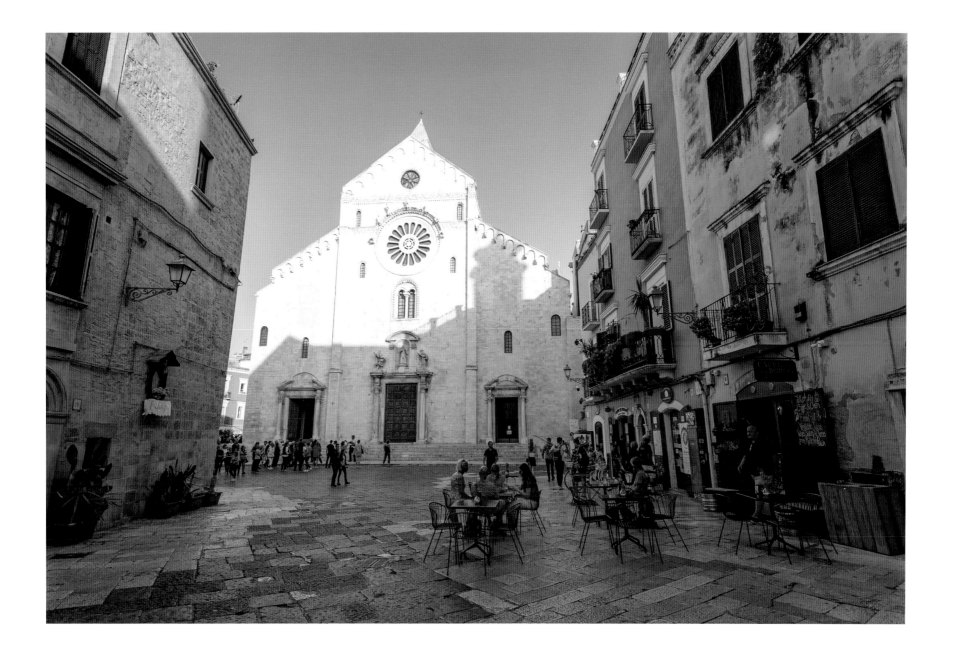

巴里大教堂，又叫圣撒比诺主教座堂，教堂立面有个巨大的玫瑰花窗，耀眼的阳光透过墙面上的玫瑰花窗射入教堂内部，显得绚丽夺目。

Cattedrale di Bari (Bari Cathedral), also referred to as the Cathedral of Saint Sabino, boasts a magnificent rose window adorning its façade. The radiant sunlight streams through the window, casting a brilliant glow in the cathedral.

巴里圣尼古拉大教堂内部一隅

A corner inside the Basilica of St. Nicholas in Bari

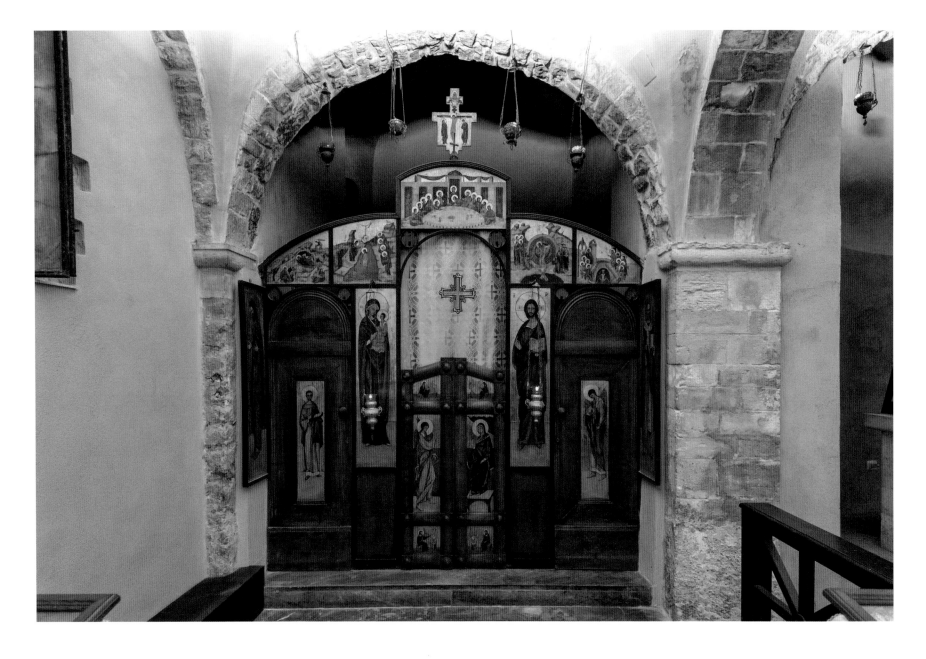

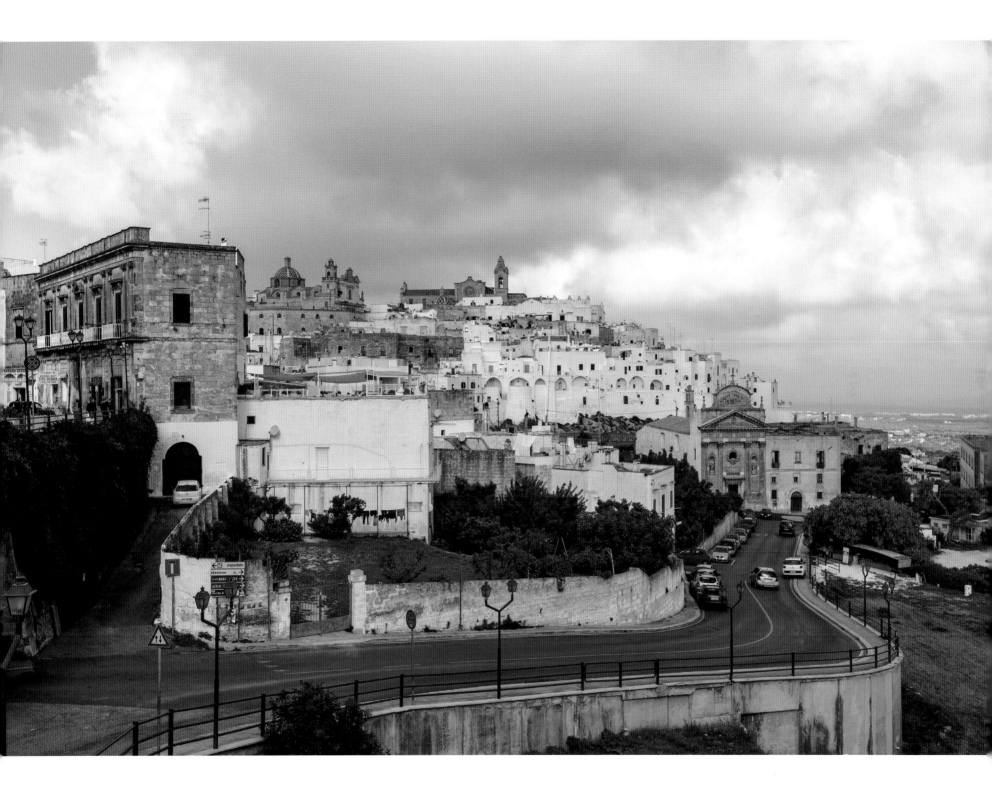

远观奥斯图尼。奥斯图尼小镇以白色建筑见称，所以有"白城"之美称。居民认为，以白色的石灰岩砌建房屋，既可改善卫生条件，同时可以"白色"来克制病菌的袭击。

View of Ostuni from a distance. The small town of Ostuni is known for its white buildings, hence the nickname 'White City'. The locals believe that building houses with white limestone can improve hygiene conditions and at the same time, the 'white color' can help to ward off bacterial attacks.

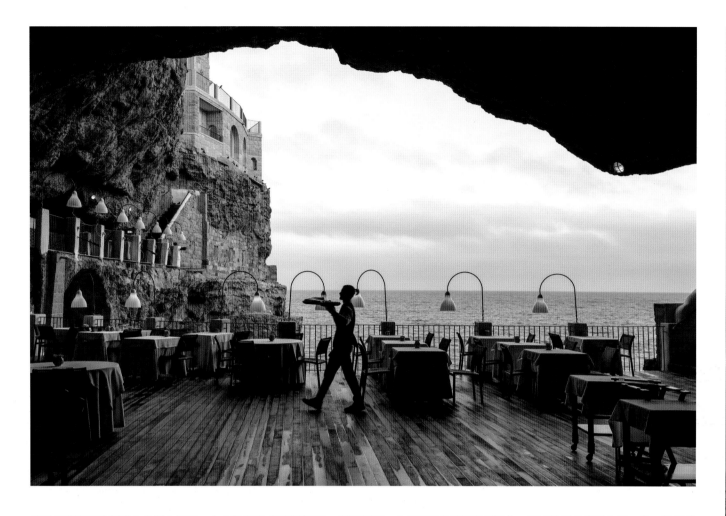

格罗塔帕拉奇赛酒店内的洞穴餐厅，中文译名是"石窟宫殿"。餐厅设在一个天然的拱形石灰岩洞内，三面被天然岩壁包围，唯一敞开的"窗口"正面对美丽的亚得里亚海，环境极其特别，被誉为"世界上最浪漫的餐厅"。

The grotto restaurant in the Hotel Grotta Palazzese is called the 'Grotto Palace' in Chinese and is ensconced inside a natural arched limestone grotto, surrounded by natural rock walls on three sides. The only open 'window' faces the beautiful Adriatic Sea, making the environment extremely special, hence the praise 'the most romantic restaurant in the world'.

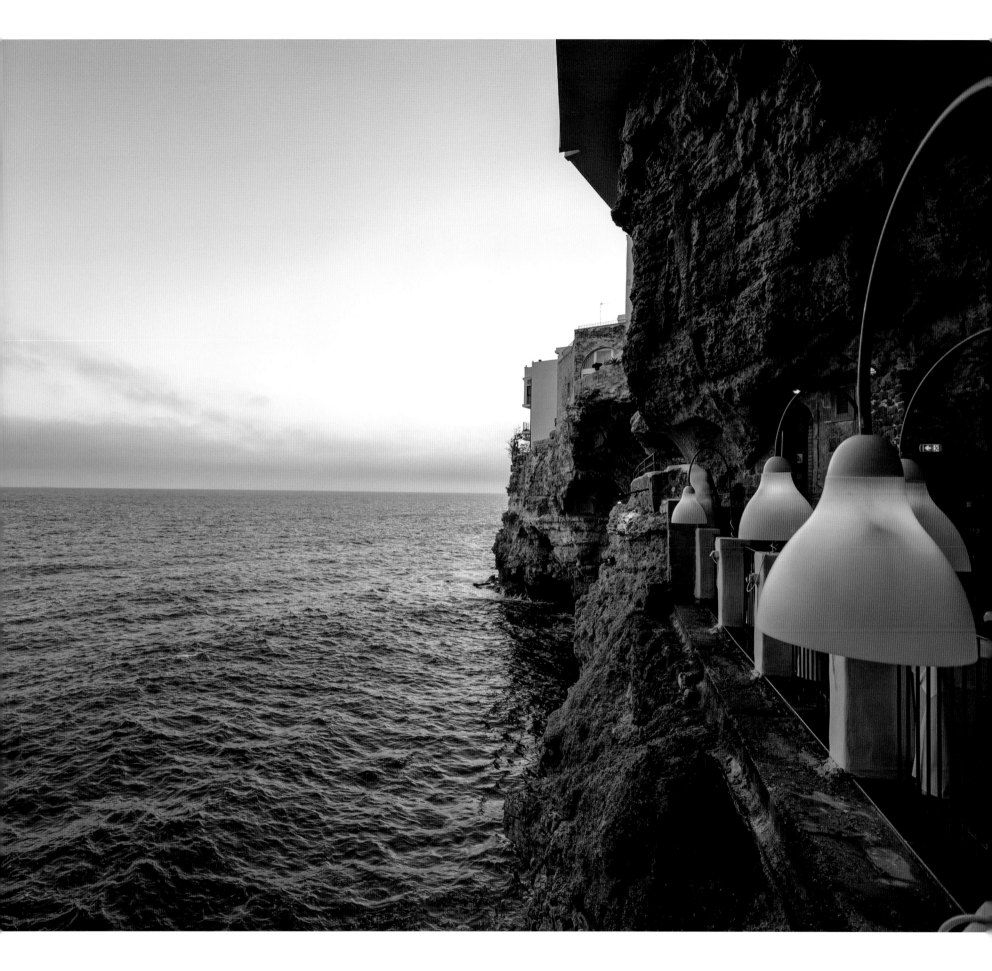

3. 巴里及周边地区 Bari and its bewitching neighbouring regions

滨海波利尼亚诺的 Lama Monachile 石滩，仿佛镶嵌在两面峭壁之间，迎着亚得里亚海，景致非常特别。

The Lama Monachile Stone Beach in Polignano a Mare appears to be cradled between two cliffs, facing towards the Adriatic Sea, creating a distinctive and breathtaking scenery.

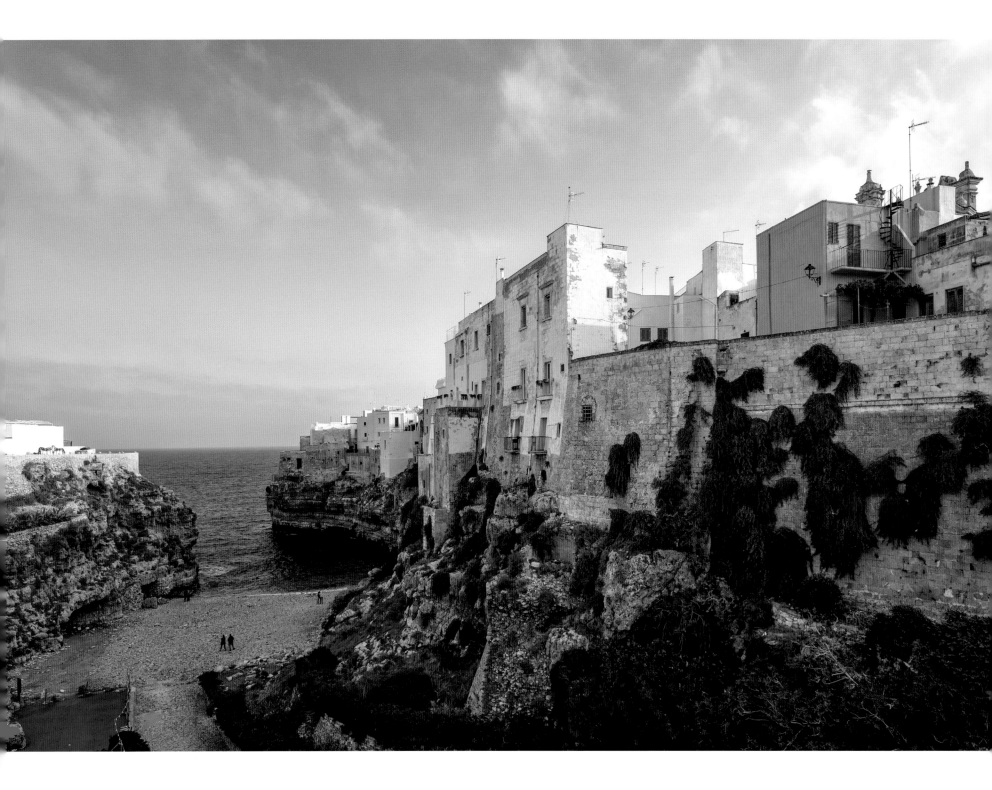

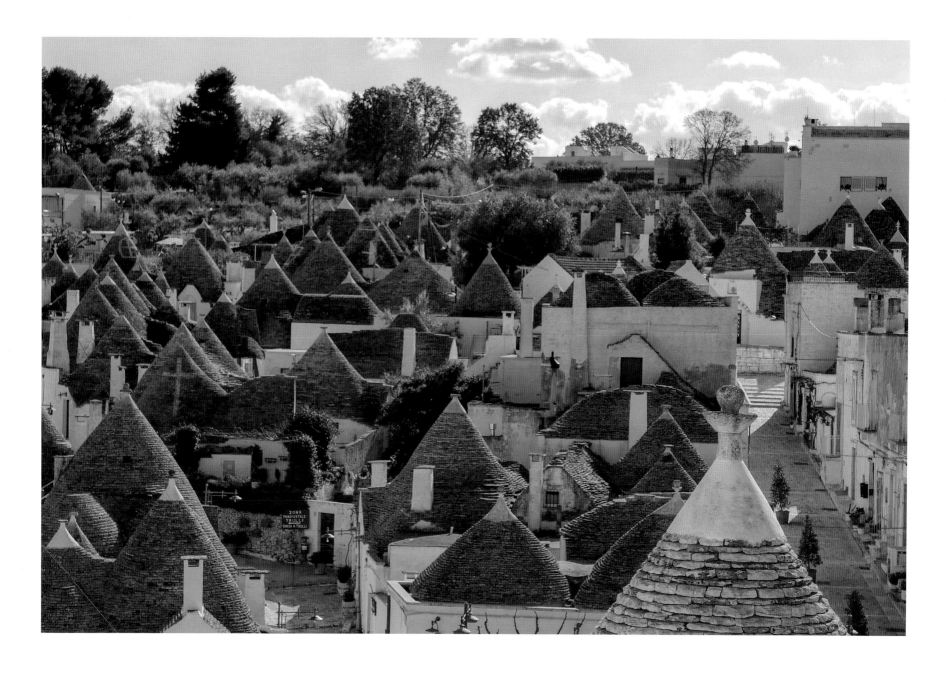

阿尔贝罗贝洛蘑菇村，从观景台看蘑菇屋。这些小屋门窗很小，墙壁又很厚实，夏天可隔热，冬天又可御寒。而且屋内没有梁柱，空间相当充裕。

The Mushroom Village of Alberobello, and the delightful view of the mushroom houses from the observation deck. There are very small doors and windows, as well as thick walls that offer respite from summer heat and winter chill. Furthermore, with no beams or columns in the interior, these dwellings boast a spacious area.

白城一隅。奥斯图尼小镇以白色建筑见称，所以有"白城"之美称。

A corner of the White City. The town of Ostuni is well known for its white buildings, hence the nickname 'White City'.

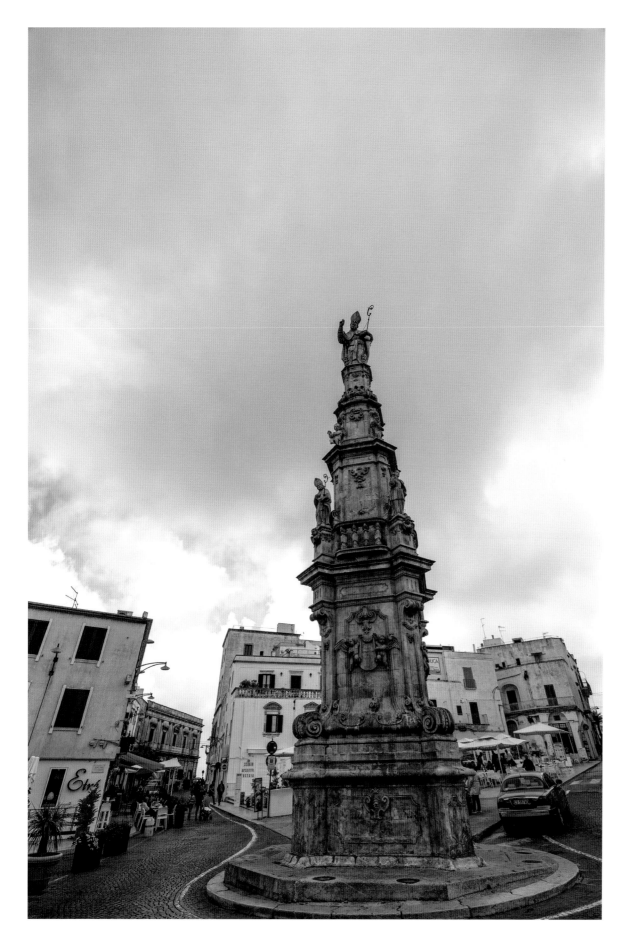

奥斯图尼的圣奥伦佐纪念柱，位于自由广场上。

The San Lorenzo Column is located on the Piazza Libertà (Liberty Square) of Ostuni.

布林迪西海滨步道，以及远处用钢筋混凝土制成的意大利水手纪念碑。

The Brindisi waterfront promenade, and the Monumento al Marinaio d'Italia (Monument to the Sailor of Italy) made of reinforced concrete in the distance.

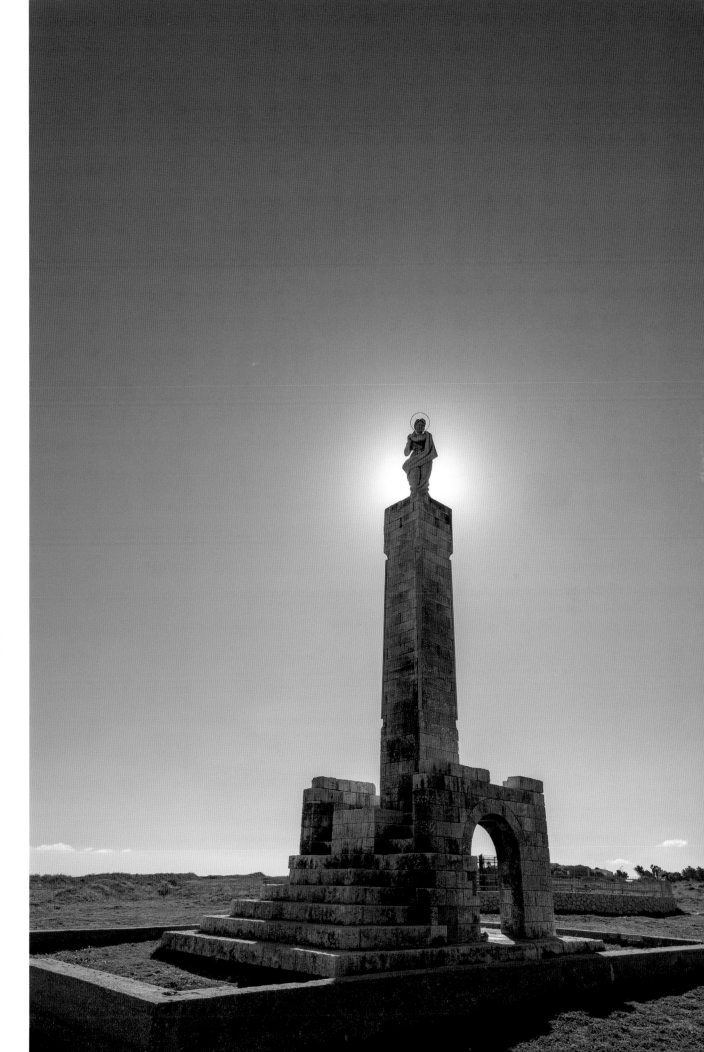

仿佛散发圣洁灵光的罗卡韦基亚圣母像

The statue of the Virgin Mary in Roca Vecchia appears to radiate a divine and pure glow

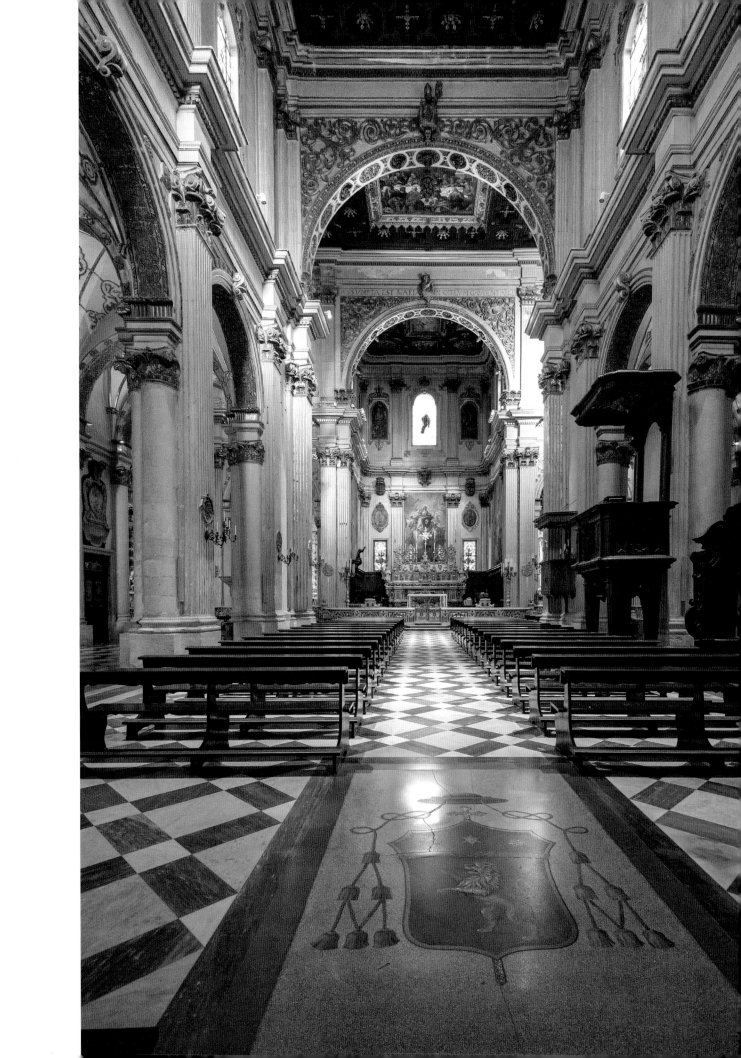

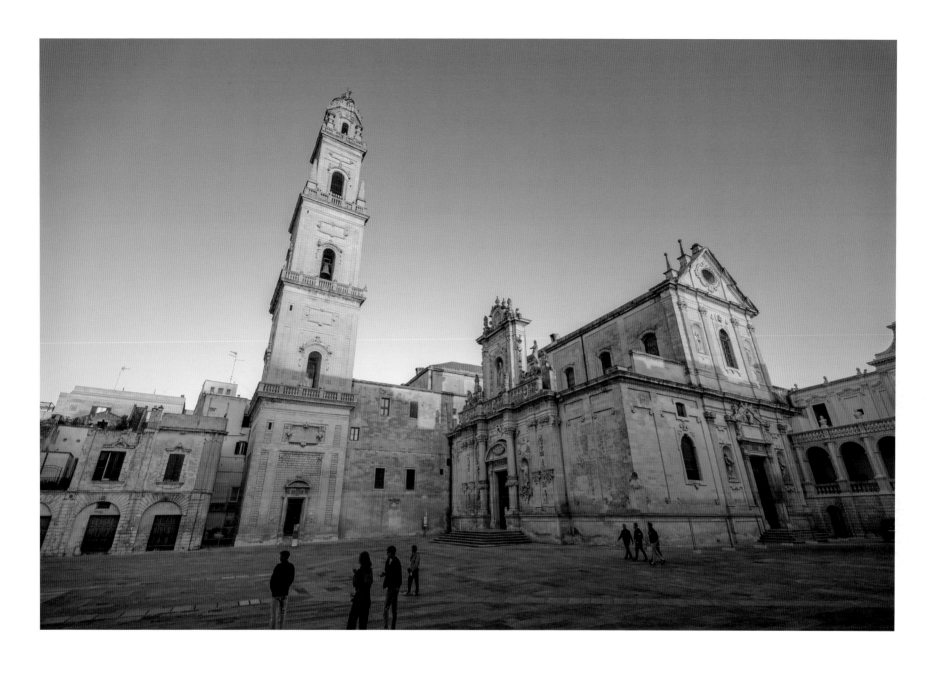

莱切大教堂和钟楼。大教堂为巴洛克建筑风格，钟楼有七十二米高，是老城最高的建筑，已在城中矗立了三百多年。

Lecce Cathedral and the bell tower. The cathedral is in Baroque architectural style, and the bell tower is seventy-two meters high, making it the tallest building in the Old Town, which has stood in the city for over three centuries.

圣奥伦佐广场旁的古罗马剧场遗址，它见证了古罗马的昔日荣光。目前广场只显露出三分之一，其余部分隐藏在广场与周围的建筑物下方。剧场据说能容纳一万五千人。

The ruins of the ancient Roman theater next to Piazza Sant'Oronzo (St. Oronzo Square) once witnessed the glorious history of ancient Rome. Currently, only one-third of it is exposed above ground in the square, with the rest being covered by surrounding buildings. It is said that this theater could accommodate fifteen thousand spectators.

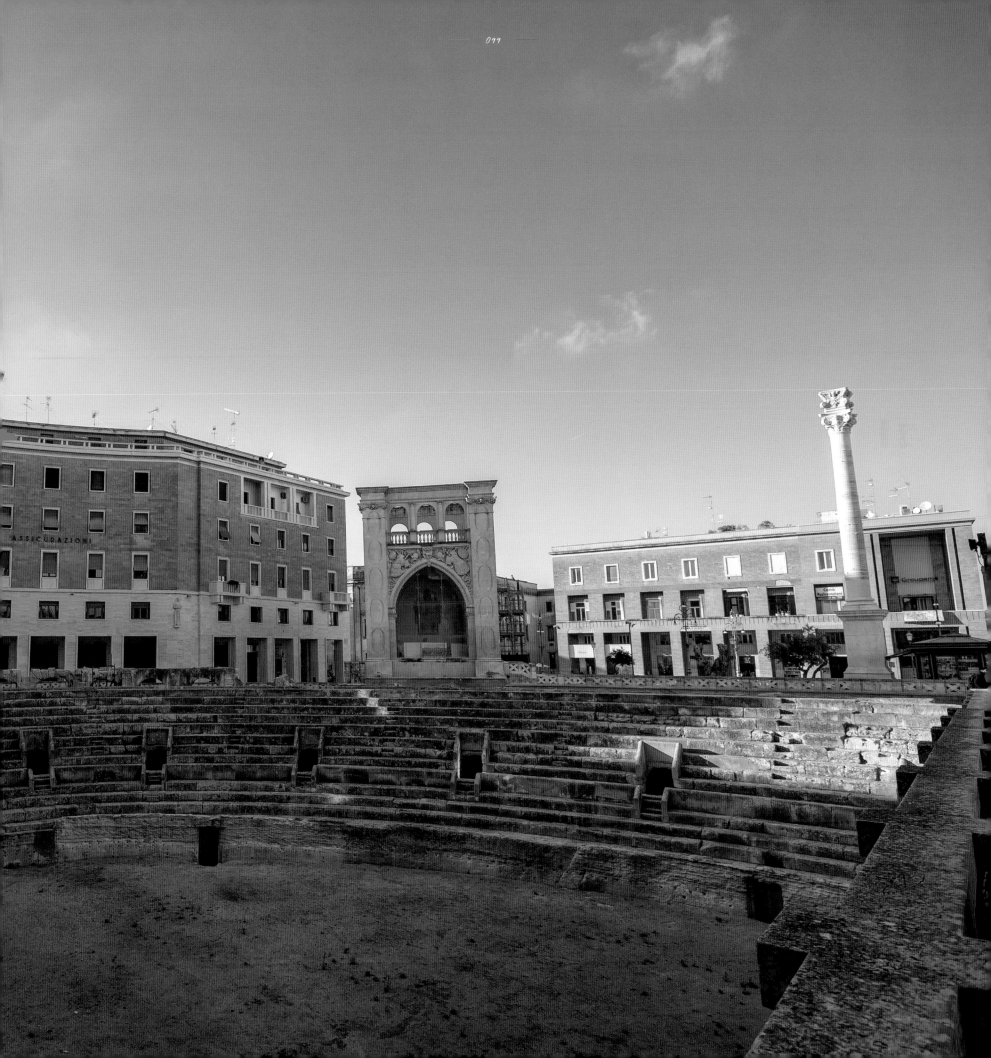

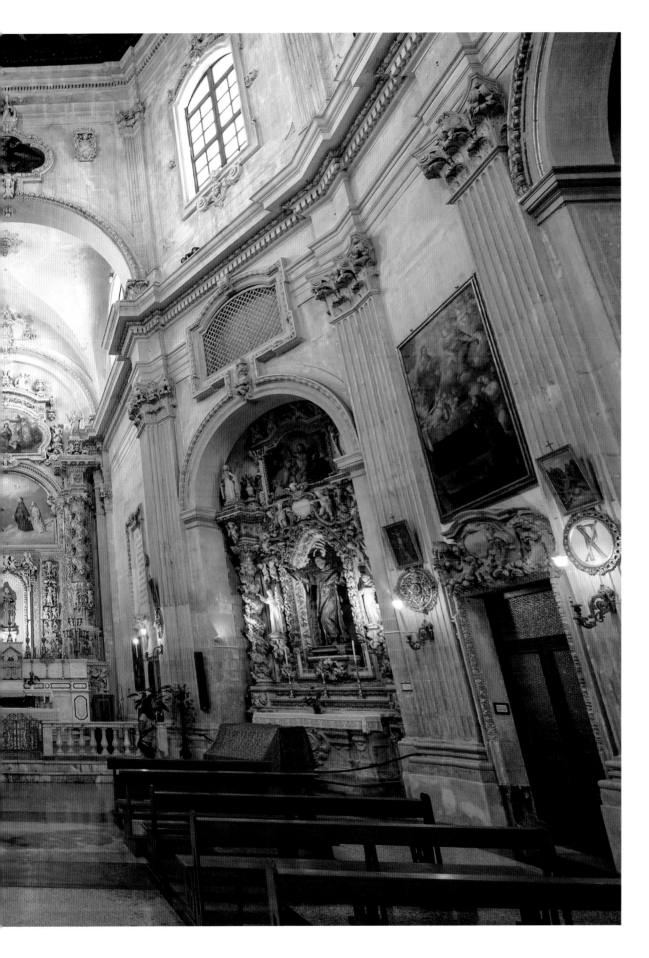

莱切的圣嘉勒堂

The Chiesa di Santa Chiara (Church of St. Chiara) in Lecce

崔边的岩石长期被海水冲击侵蚀，形成了一个很大的冲蚀水潭，海水呈现鲜艳美丽的祖母绿，当地人称为"诗歌之洞"。

The rocks at the edge of the cliff have gradually been worn away by sea water, forming a large erosion pool with sea waters shimmering in a bright and beautiful emerald hue, locally known as 'Grotta della Poesia (Grotto of Poetry)'.

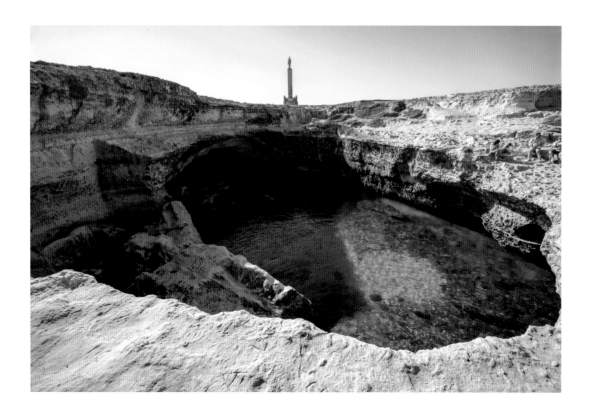

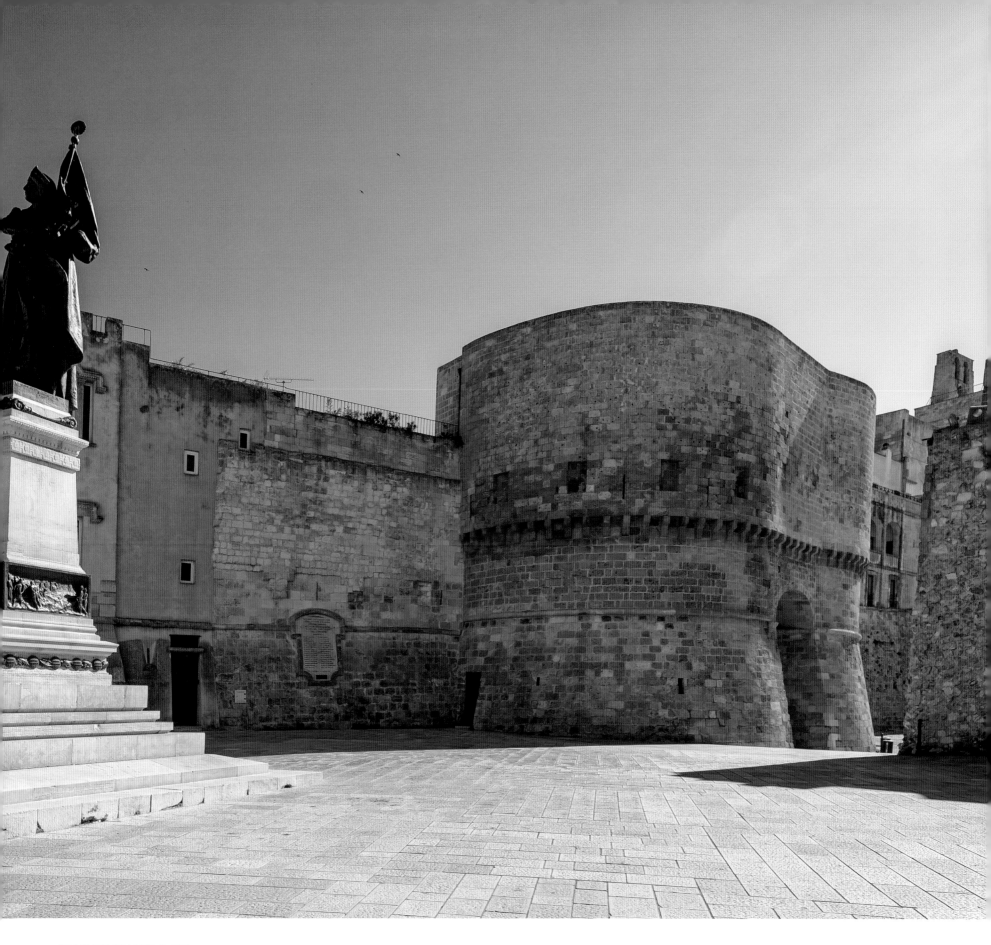

奥特朗托的阿方西纳门广场

Alfonsina square in Otranto

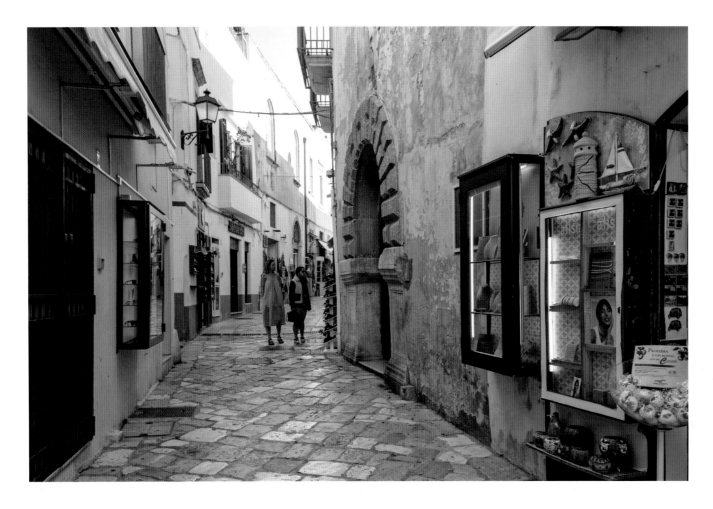

奥特朗托街景

Street view of Otranto

奥特朗托城堡面对意大利最东面的奥特朗托海峡，最容易受到外国的侵略和攻击，今天屹立在我们眼前的城堡，就是经过围城战役后重建的模样。

The Otranto Castle, situated in the easternmost region of Italy at the Otranto Strait, was historically a prime target for foreign invasion and subject to frequent attacks. Today, the castle has been reconstructed following a siege battle.

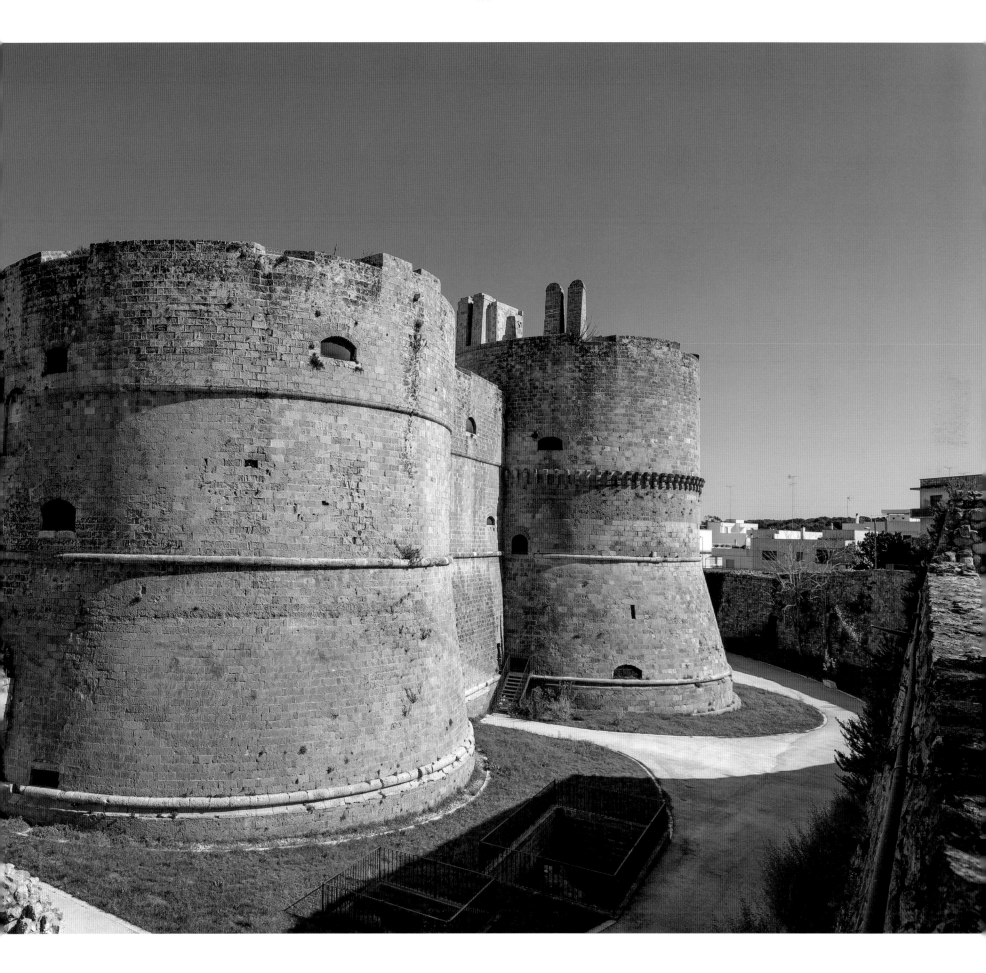

3. 巴里及周边地区 Bari and its bewitching neighbouring regions

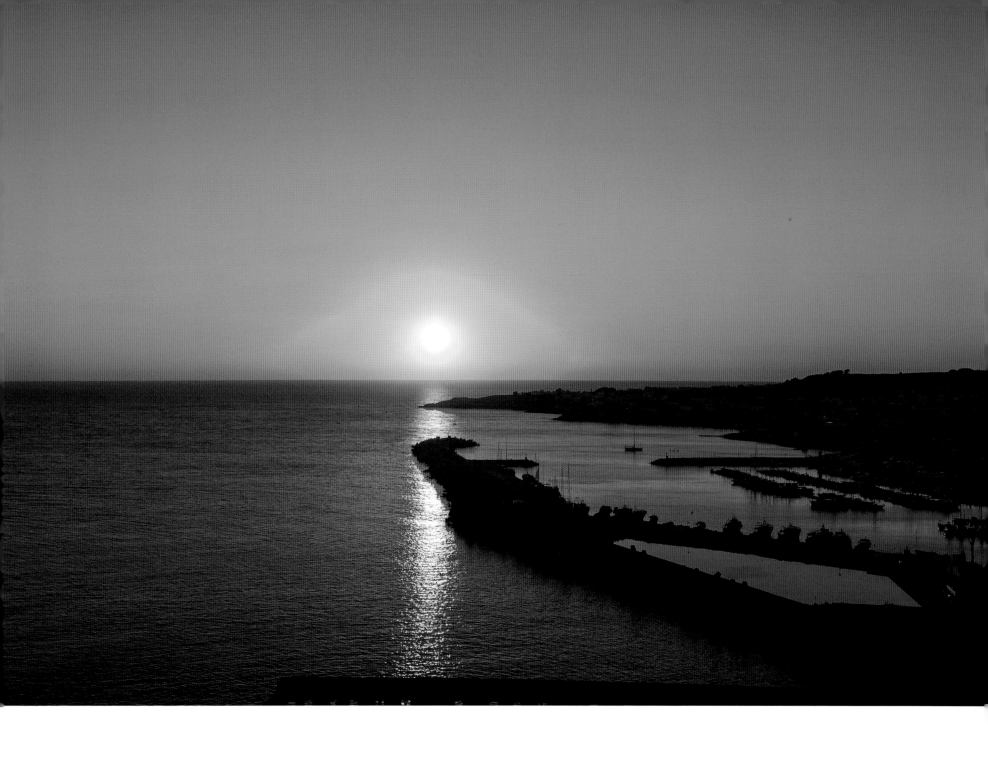

唯美的莱乌卡落日景致，原本的翠绿染上了玫瑰红，继而变换为金色，太阳徐徐下降，逐渐收敛光芒，最终完全隐没在大海中。

The sunset scenery in Santa Maria di Leuca is truly breathtaking, with the bluish green turning into rose red and then golden yellow. As the sun slowly descends, its brilliance gradually fades until it finally disappears into the sea.

3. 巴里及周边地区 Bari and its bewitching neighbouring regions

蒙特堡的意思为"山上的城堡"，又有"高地上的金王冠"之称，建材主要使用黄褐色的砂岩，恍如与世隔绝地昂然挺于五百三十米高的山岗之上。

The meaning of Castel del Monte (Monte Castle) is 'castle on the mountain', also known as the 'golden crown on the highland'. The castle, built of yellow-brown sandstone, proudly stands on a 530-meter-high hill, seemingly isolated from the rest of the world.

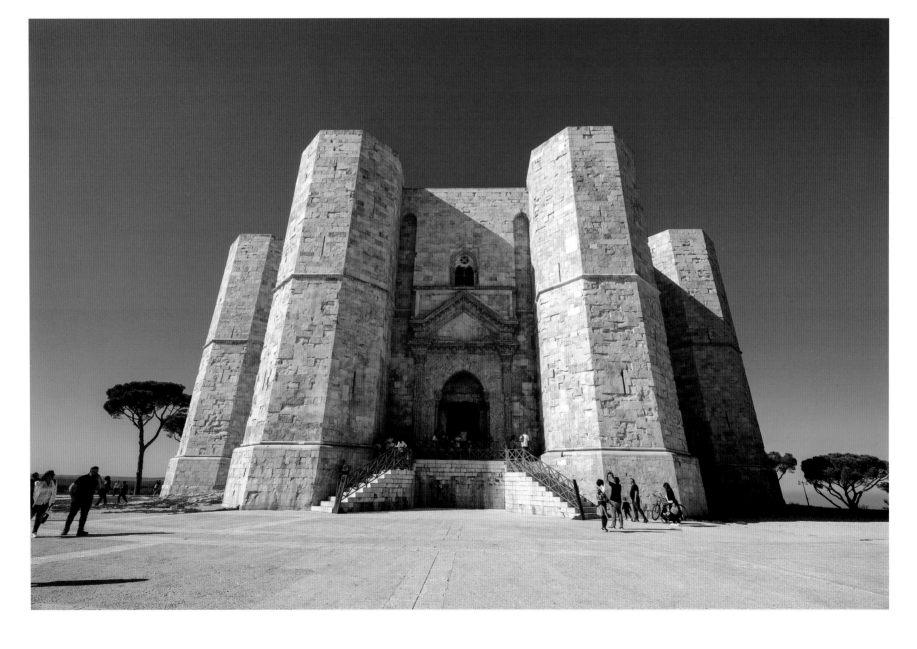

马泰拉古城一隅，阿西西圣方济各教堂。

A corner of the ancient Matera, and the Basilica of St. Francis of Assisi.

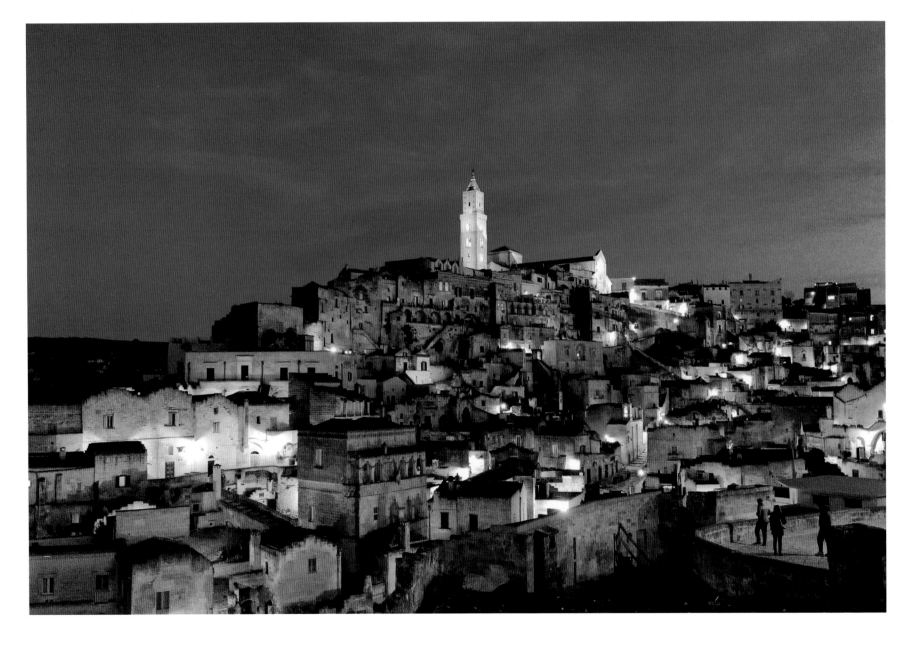

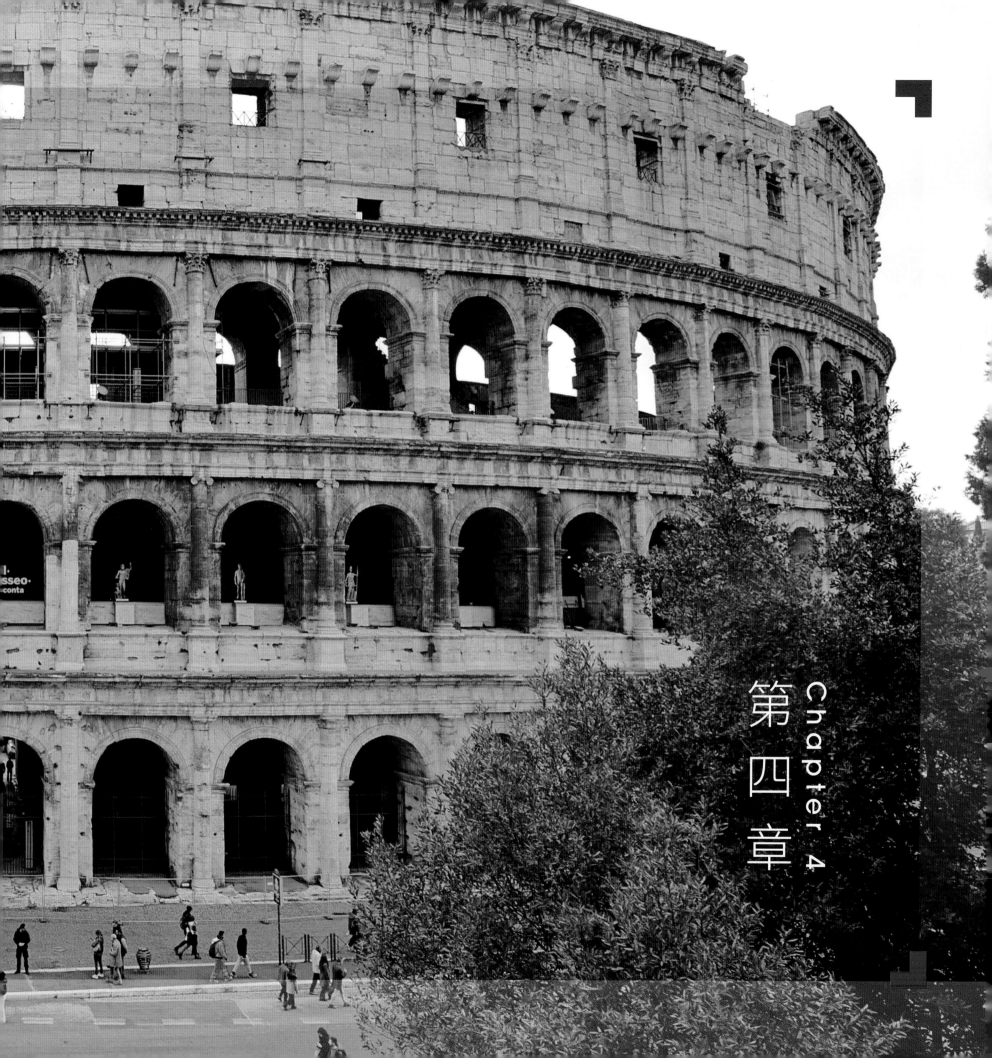

Chapter 4 第四章

作为罗马帝国、乃至如今意大利的首都城市，罗马也是该国最大、人口最多的城市，是全国的政治、经济、文化、旅游和交通中心，亦是宗教中心梵蒂冈城国的所在地。然而她的魅力不仅体现在帝国全盛时期展现的繁荣，更体现在其产生的影响对后人的帮助。她的存在就像一部真实的时间机器，过去和现在可以任意穿梭，但又不同于一般意义上的古城。罗马是真正的"永恒之城"。

一九八○年是我与这座城市的初会，之后又数次造访，每每因为它太过美好而无从下笔。在我看来罗马是经得起任何赞美之辞的，它代表着从古至今的荣耀和伟大，意大利也因为罗马在欧洲的国家中有着十分特殊的地位。这次藉着疫情期间在意大利的深度旅游，我又与罗马重逢，重温和她的美好回忆。

罗马除了被称为"永恒之城"，还有一个名字叫做"七丘之城"，因为相传罗马城是从七座山丘上发展起来的。根据传说，有一对双胞胎罗慕路斯和雷慕斯是战神玛尔斯和一位女祭司的孩子，两人被当时篡位的国王抛弃在野外，由母狼哺养长大。兄弟长大后推翻了国王，并打算建立新城市，罗慕路斯希望建于帕拉蒂诺山，雷慕斯则想建在阿文提诺山，经过一番斗争，罗慕路斯成为赢家，在公元前七五三年四月二十一日建立了新城池，并以他自己的名字命名为"罗马"。虽为传说，但直到今天，这个日子依旧被视为"永恒之城"的诞生日，每年的这一天，罗马都会隆重庆祝"建城日"，不仅市内各大博物馆免费向公众开放，广场也会举行各式各样的活动，人们以古罗马的扮相游行、表演，并举办一系列相关学术研讨会，甚至持续数周，非常热闹。

威尼斯广场上的维托里奥·埃马努埃莱二世纪念堂，为了纪念开国国王埃马努埃莱二世对意大利统一的贡献，它凝聚了当时建造工匠们的毕生心血。

The Monument to Vittorio Emanuele II in Piazza Venezia (Venice Square) was built to commemorate the founding king, Vittorio Emanuele II, for his great contribution to the unification of Italy. It represents the culmination of the painstaking efforts of all the craftsmen who built it at that time.

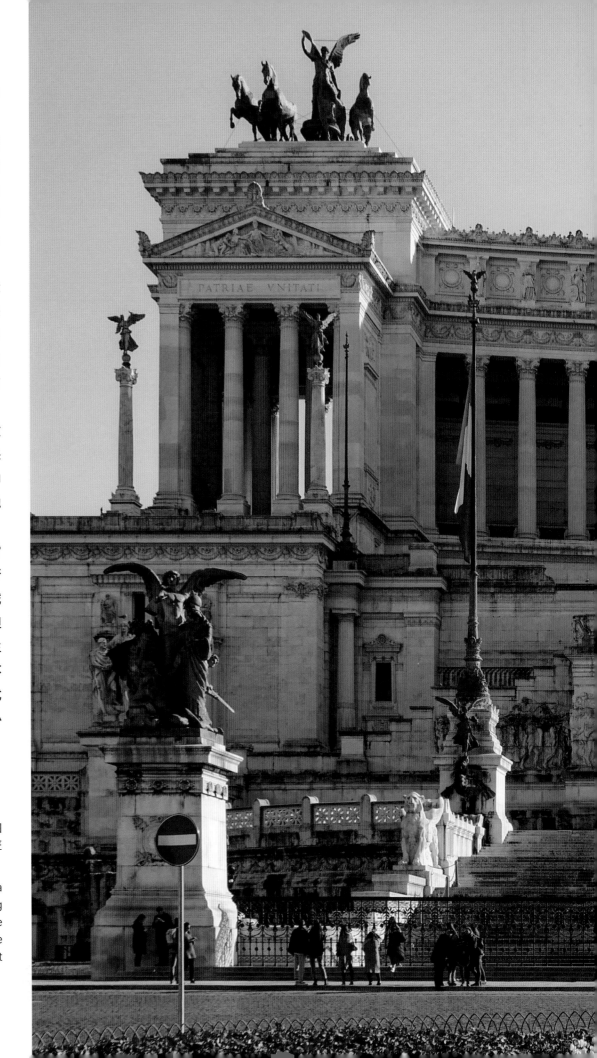

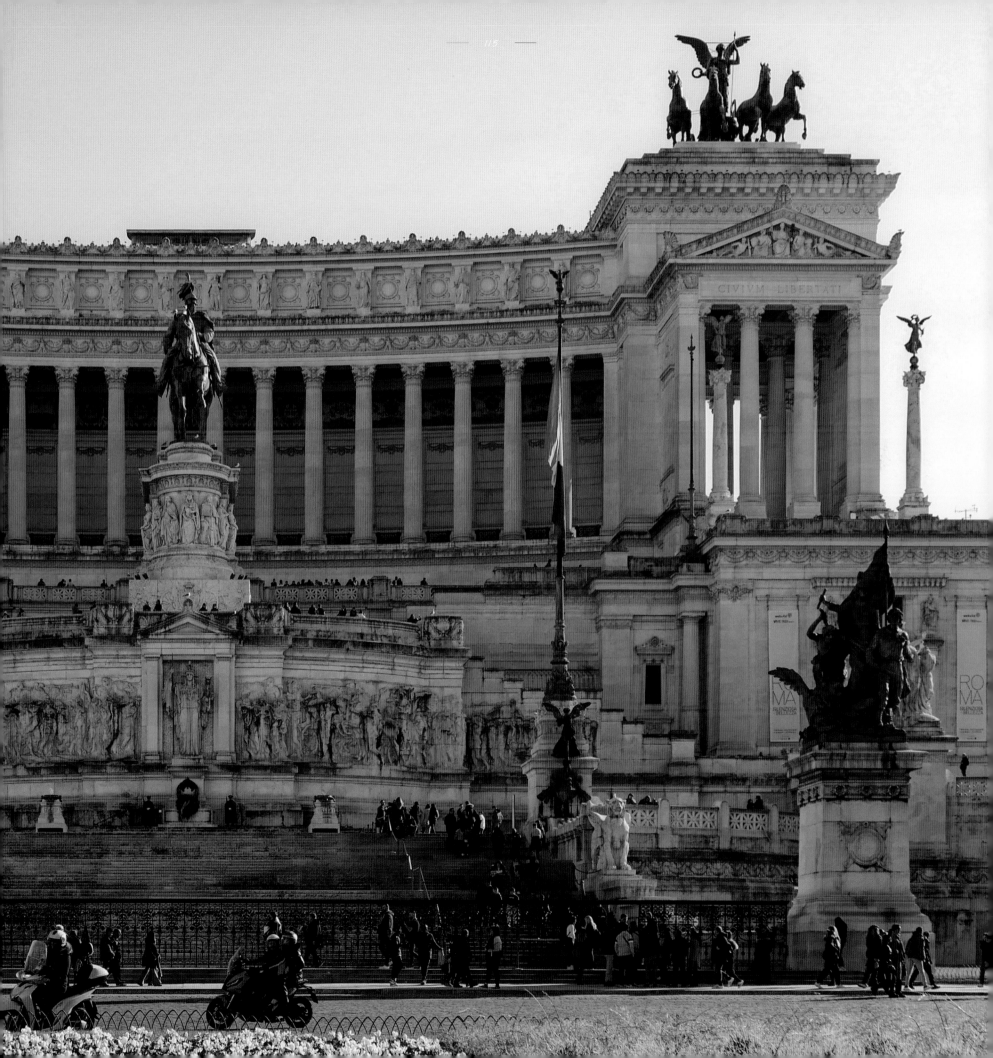

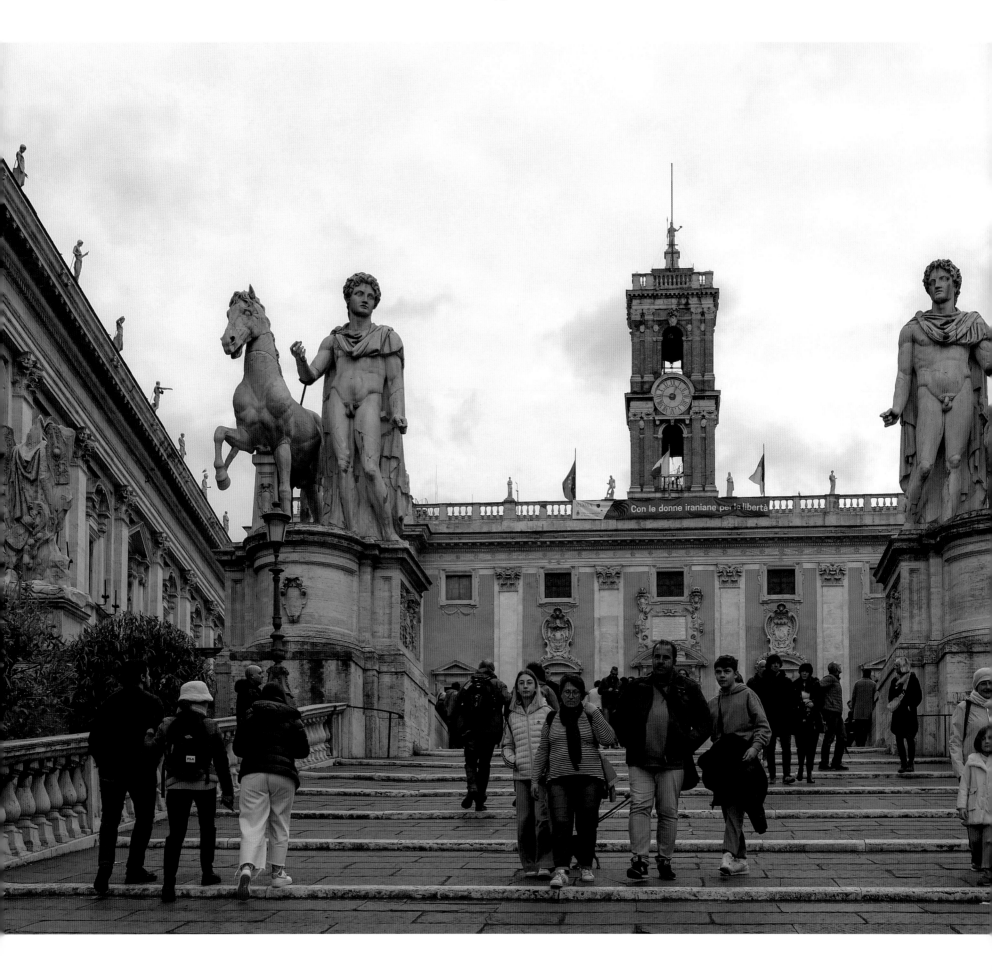

The capital city of the Roman Empire in antiquity and of Italy today, Rome stands as not only the largest and most populous urban center in the country, but also serves as the nation's political, economic, cultural, tourist and transport hub. Additionally, it is home to the Vatican City State, a religious center of paramount significance. Rome's appeal was not only evident in the prosperity of its heyday, but continues to exert an enduring influence that will benefit future generations. Its presence is like a veritable time machine where past and present coexist harmoniously, yet it distinguishes itself from conventional ancient cities. Undoubtedly, Rome truly deserves its title as the 'Eternal City'.

In 1980, I had my first encounter with the charming city, and ever since, I have been drawn to its embrace many times, often finding it too beautiful to be described in words. In my opinion, Rome deserves all accolades as it encapsulates the grandeur and splendor of both antiquity and modernity. Italy holds a unique position among European nations due to the presence of Rome. During my in-depth tours around Italy during the epidemic, I was reunited with Rome and relived cherished memories of yesteryear.

Not only known as the 'Eternal City', Rome is also named the 'City of Seven Hills', as legends say that it was developed from seven hills. According to ancient legend, it is said that Mars, the god of war, and a priestess conceived twins Romulus and Remus, who were abandoned in the wilderness by a usurping king. However, fate intervened when they were miraculously nurtured by she-wolves. As time passed and the brothers grew into courageous warriors, they joined forces to successfully overthrow the ruler. In their pursuit to establish a new city, Romulus favored Mount Palatino while Remus was captivated by Mount Aventino. After a fierce struggle, triumph finally smiled upon Romulus as he founded what we now know as Rome on the 21st of April 753 BC, naming the city after himself. While the date may be rooted in legend, it is still celebrated as the birthday of the 'Eternal City', and Rome comes alive with joyous celebrations to honor its founding day. Not only do museums throw open their doors for free, but bustling squares overflow with lively festivities that last for weeks on end. Citizens dress in ancient Roman costumes, parade and perform, and hold a series of related academic seminars, infusing every corner of this lovely city with vibrant energy.

通往卡比托利欧广场的科尔多纳塔台阶。台阶顶端两侧各竖立一座巨型雕塑，是神话中成为双子座的双生兄弟卡斯托和波路克斯。

The grand Cordonata ascends to the expansive Piazza Capitoline (Capitoline Square), with towering colossal sculptures of Castor and Pollux standing proudly on either side of the top, embodying the legendary twin brothers as Gemini.

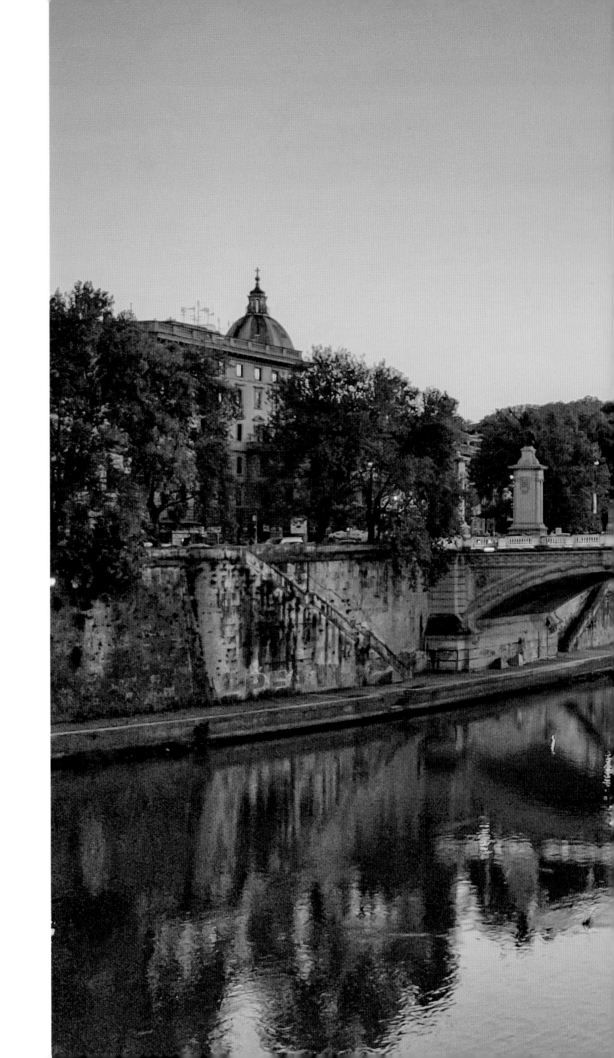

罗马的维托里奥·埃马努埃莱二世桥

The Bridge of Vittorio Emanuele II in Rome

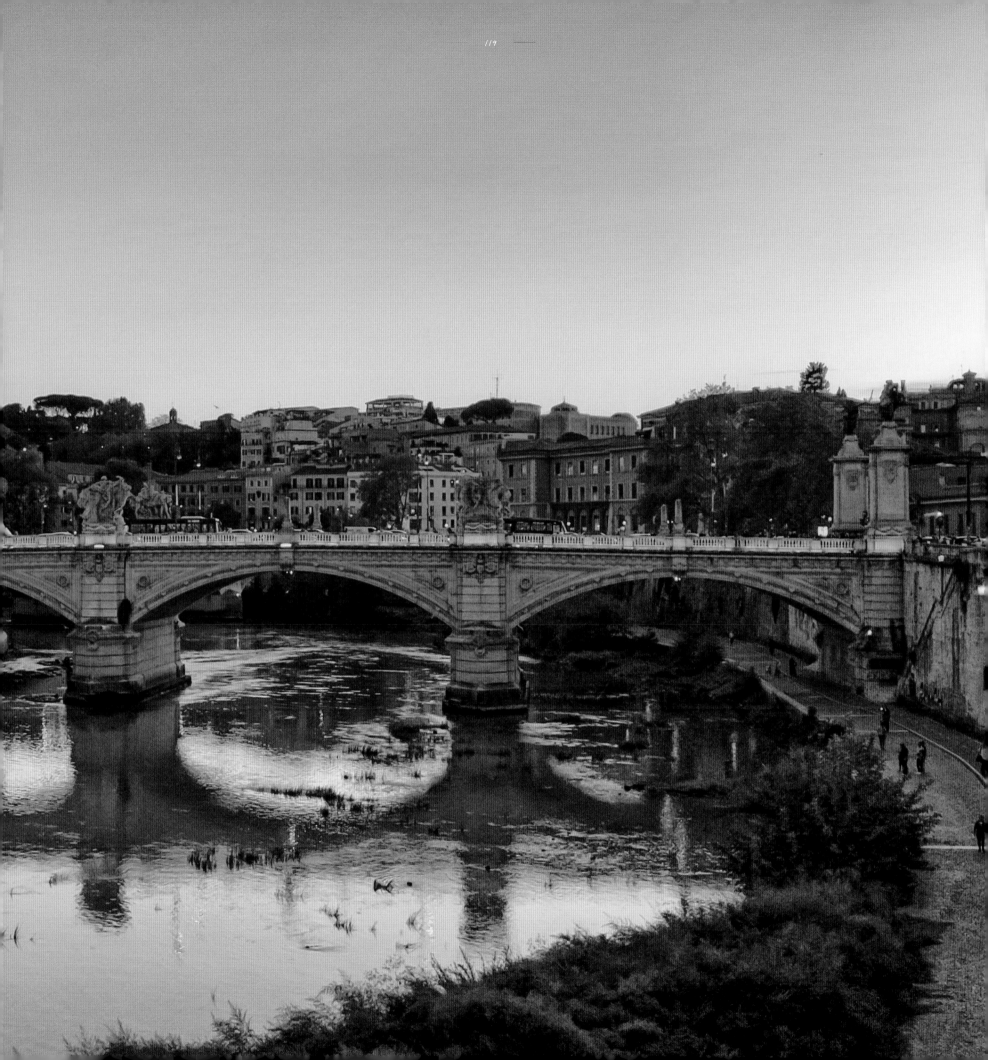

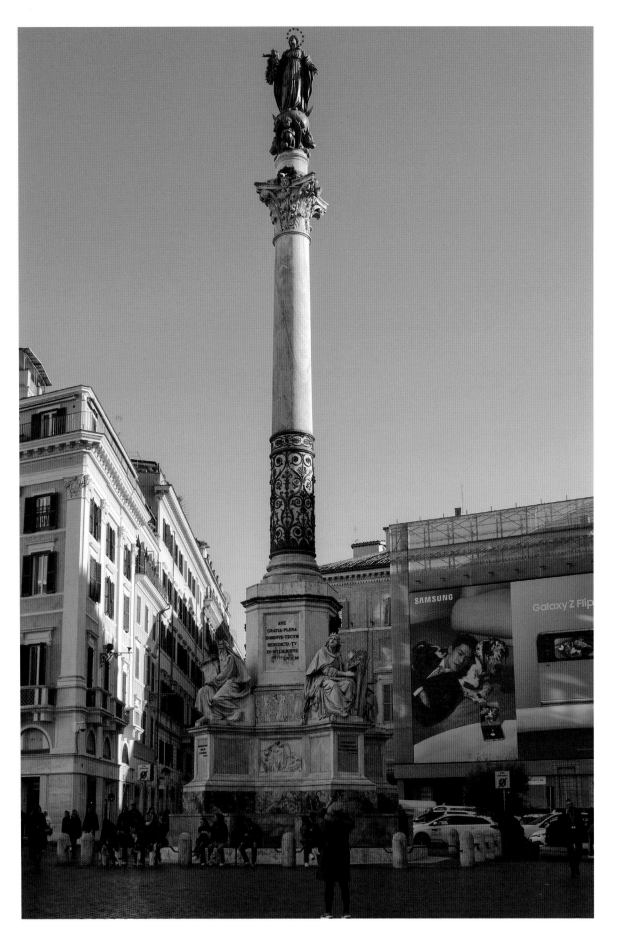

西班牙广场上的圣母无染原罪柱

The La Colonna della Immacolata (Column of the Immaculate Conception) in the Piazza di Spagna (Spain Square)

西班牙广场上的破船喷泉。西班牙广场完工于十八世纪，因阶梯旁一座西班牙驻教廷大使馆而得名。阶梯上面是山上圣三一教堂。

Fontana della Barcaccia (Barcaccia Fountain) on the Piazza di Spagna (Spain Square). Constructed during the 18th century, Piazza di Spagna derives its name from its proximity to the Spanish Embassy to the Holy See adjacent to the steps. At the top of these stairs rises up the Chiesa della Santissima Trinita dei Monti (Church of the Holy Trinity of the Mountains).

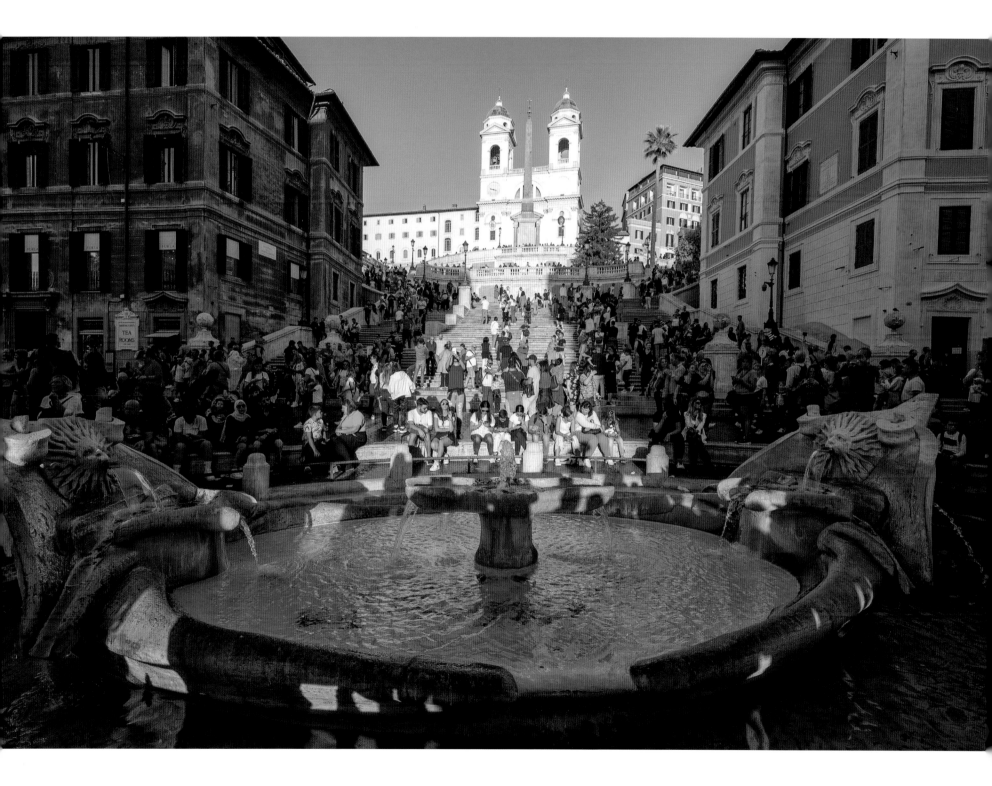

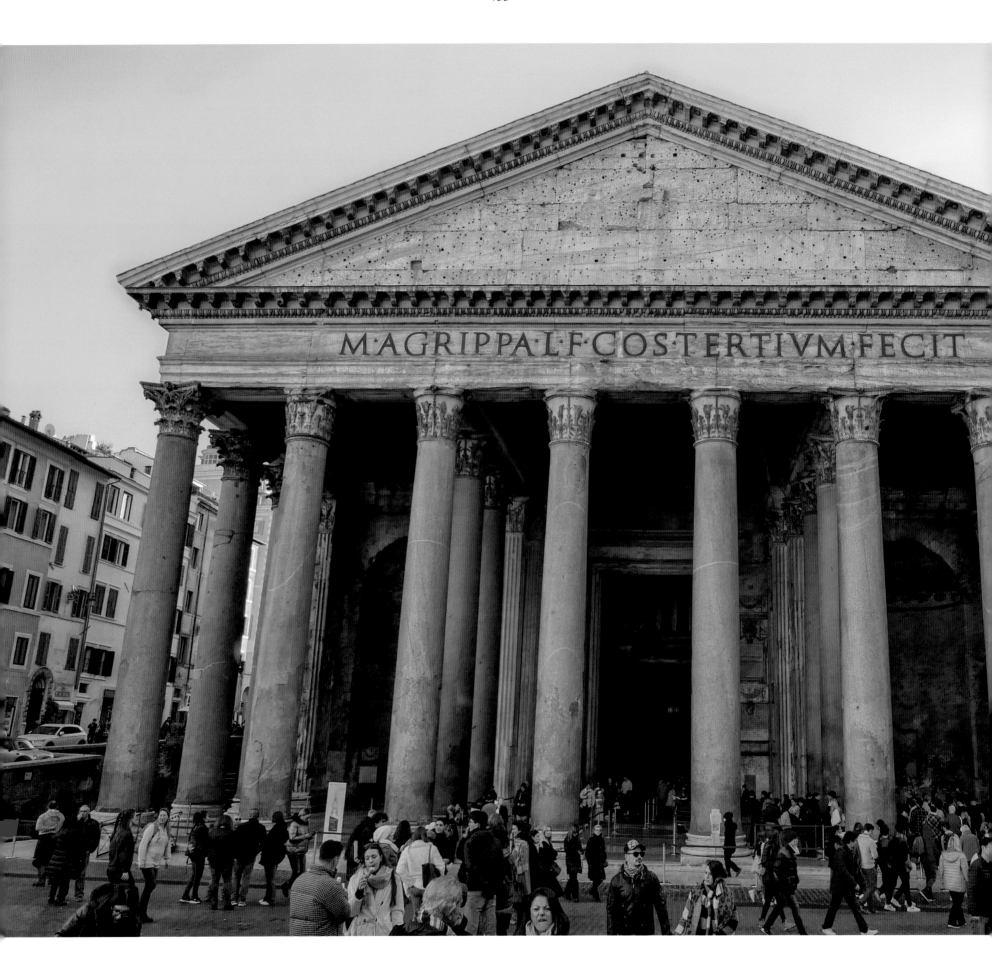

万神殿外观。它是罗马诸神的神庙和基督教的教堂，在古罗马帝国时期的建筑里，是保存得最为完好的其中一座。

Exterior of the Pantheon. The Pantheon, serving as a sanctuary for the Roman deities and as a church for Christian worship, is one of the best-preserved buildings from the ancient Roman Empire.

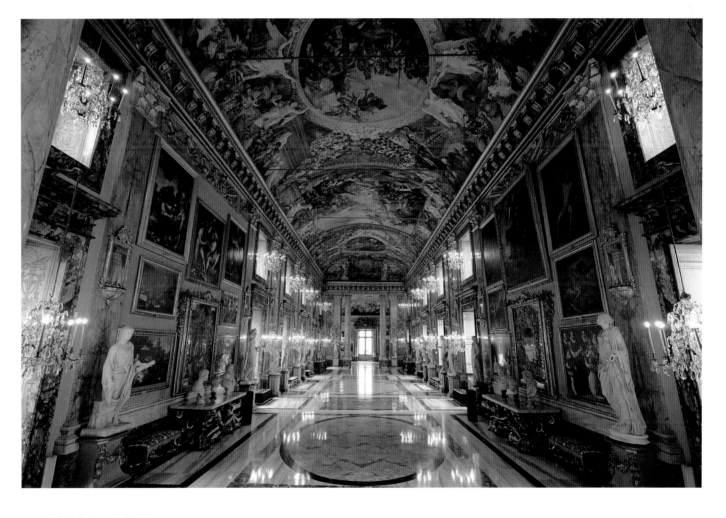

罗马科隆纳宫内画廊的大厅

The hall of the Colonna Gallery in Rome's Palazzo Colonna (Colonna Palace)

圣天使城堡，顶端竖立一座建于公元二世纪的巨形天使铜像。公元六世纪，教皇巡游经过这里，见到圣米迦勒天使显灵，城堡因而得名。

Crowned by a colossal bronze statue of an angel, Castel Sant'Angelo (San Angel Castel) took form in the 2nd century AD. It was during a pilgrimage in the 6th century AD that the Pope witnessed the epiphanic presence of St. Michael the Archangel while passing by the fortress, thus giving rise to its name.

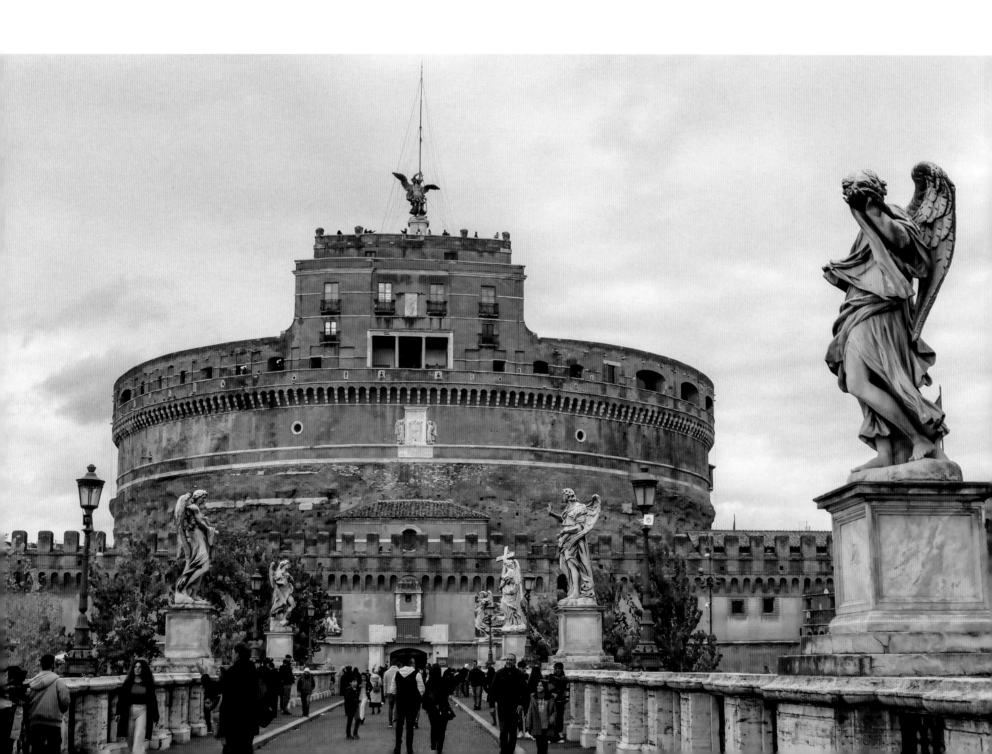

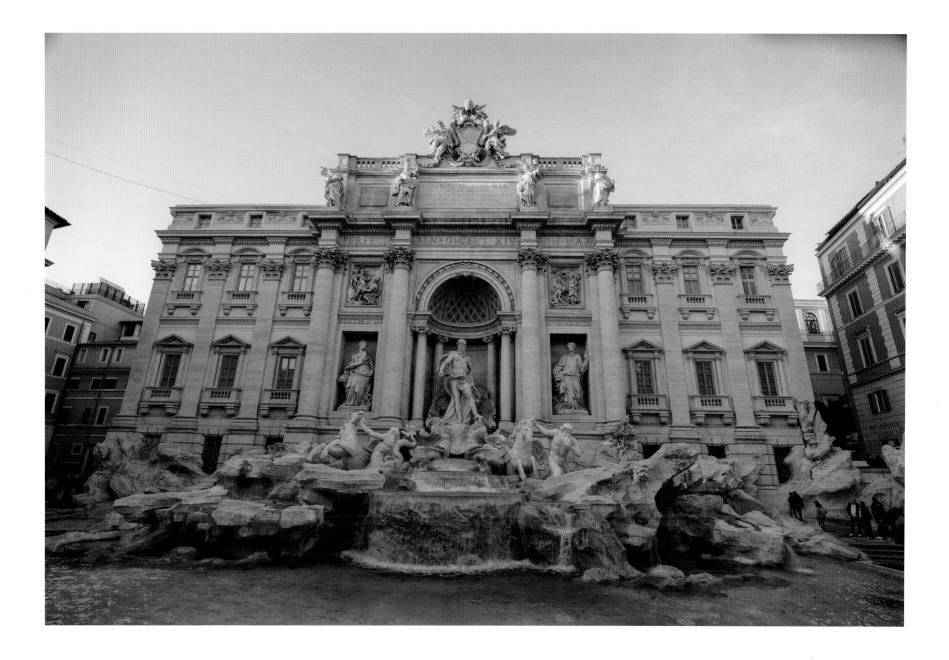

特雷维喷泉与后方的波利宫。特雷维喷泉的另一个名字更广为人知 —— 罗马许愿池。喷泉以规模庞大的礁石为基座，中央是驾驭战车的海神，左右两侧分别为代表"富裕"和"健康"的女神雕像。

Fontana di Trevi (Trevi Fountain) with the Palazzo Poli (Poli Palace) at the back. Fontana di Trevi is also known by another name that is more widely recognized, the Roman Wishing Pool. It proudly stands on a massive reef, adorned with a sea god commanding a chariot at its center, while statues of goddesses symbolizing 'Wealth' and 'Health' flank it on both sides.

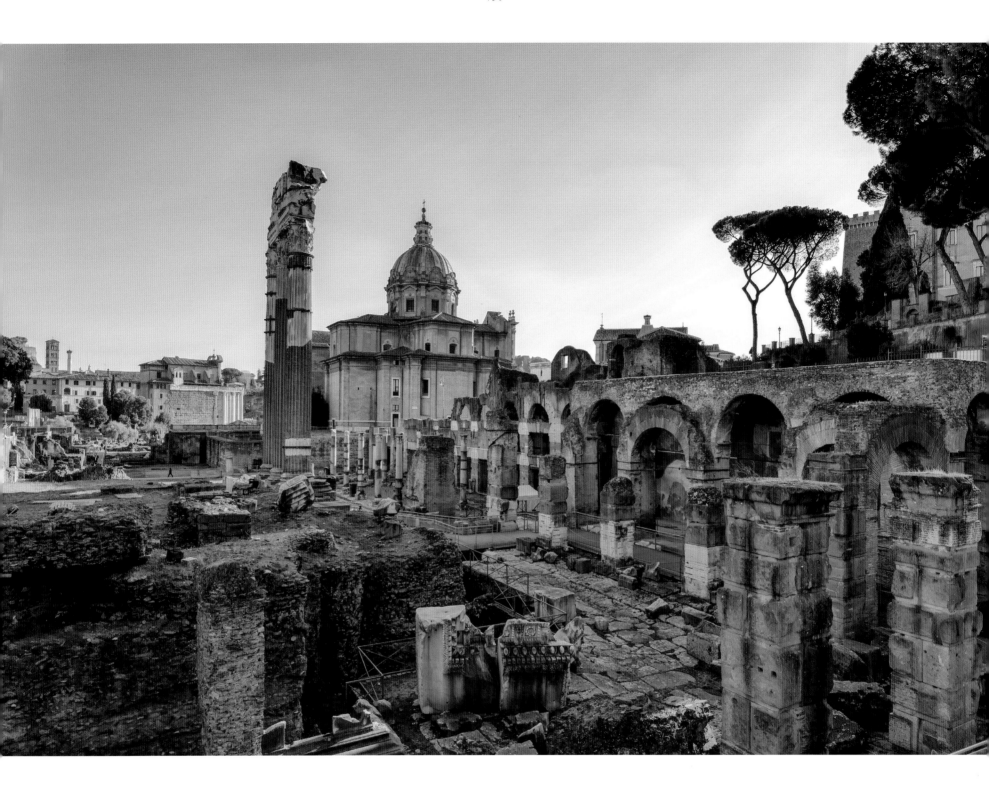

古罗马广场，为昔日古罗马帝国的中心。它位于竞技场旁边，七丘的卡比托利欧山和帕拉蒂诺山之间。从这片废墟中，仍依稀可看出当年的繁盛。

Forum Romanum (Roman Forum), the heart of the former Roman Empire, is situated next to the arena, betwixt the two of the Seven Hills, Capitoline and Palatino. From the site of ruins, it bears a faint trace of its former prosperity.

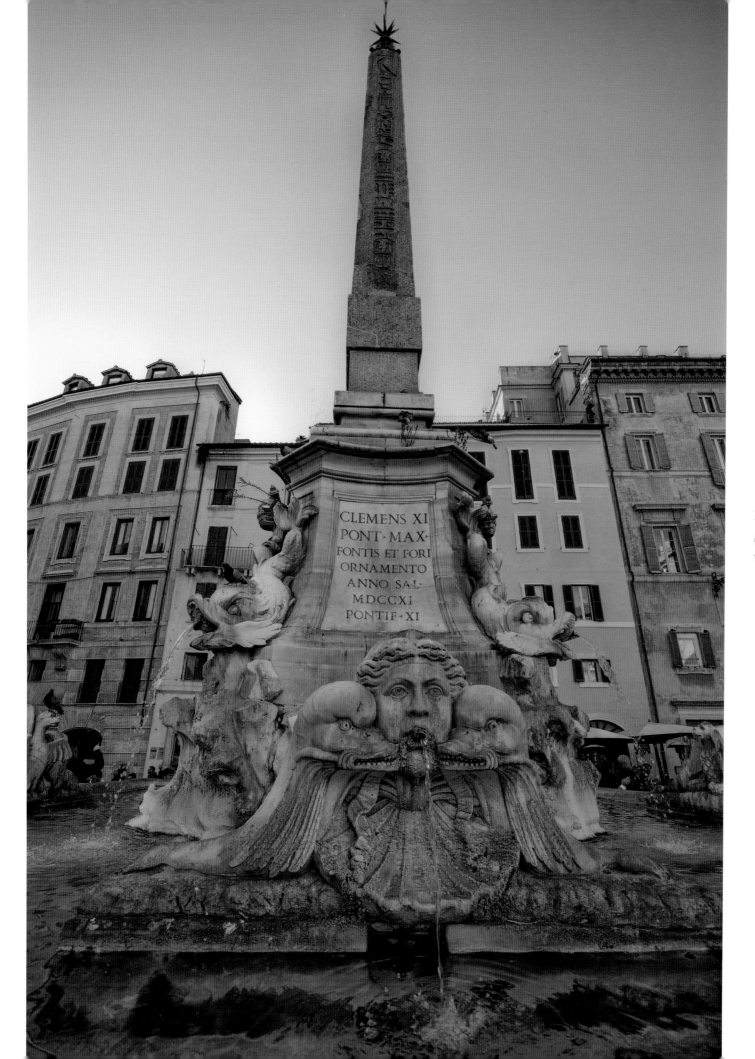

CLEMENS XI
PONT·MAX·
FONTIS ET FORI
ORNAMENTO
ANNO SAL·
MDCCXI
PONTIF·XI

万神殿前广场上的方尖碑

Obelisk in the square in
front of the Pantheon

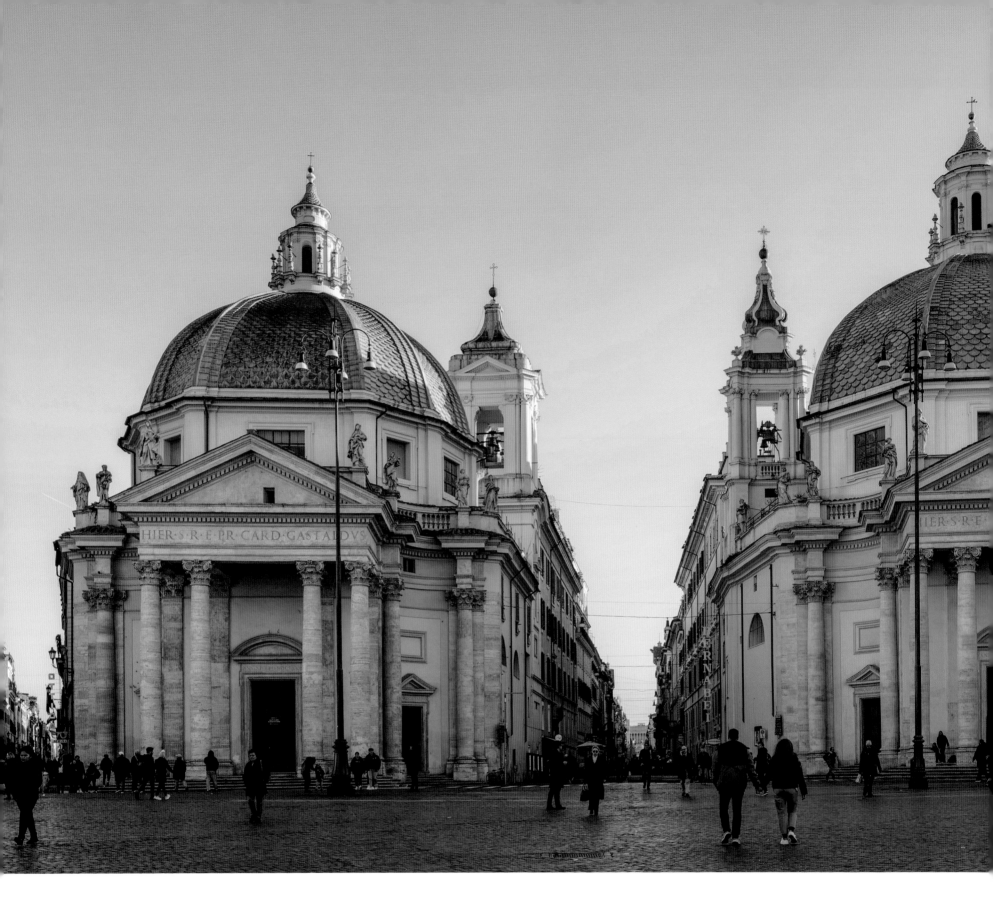

圣山圣母堂（左）和圣迹圣母堂，两者中央为科尔索大道。大道拥有两千多年的历史，北京的中轴线与之相比，也要尊称一声"老前辈"了。

The Church of Our Lady of the Holy Hill (left) and the Church of Our Lady of the Spirits (right), with the Via del Corso (Corso Street) in the center. With a history that stretches back over two thousand years, Via del Corso predates even Beijing's Central Axial Line.

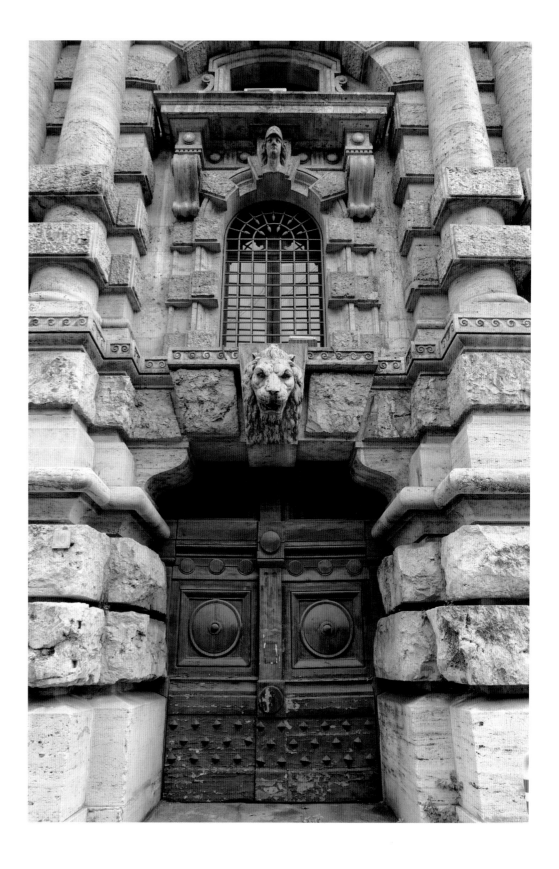

罗马正义宫一隅，现为意大利最高法院及司法公共图书馆的所在地。

A corner of the Palazzo di Giustizia (Palace of Justice) in Rome, now home to Italy's Supreme Court and the Public Library of Justice.

这块雕刻了人脸的圆形石碑"真理之口"放置在科斯梅丁圣母教堂的大门入口处，传闻把手伸入圆形石雕的嘴里，如果不讲真话，它就会把手咬断。

The Bocca della Verita (Mouth of Truth), carved in the likeness of a human face, presents a captivating sight at the entrance to the main gate of the Basilica di Santa Maria (Basilica of Saint Mary) in Cosmedin. Legend has it that the round stone sculpture will bite the test-taker's hand off if he doesn't speak with the absolute truth.

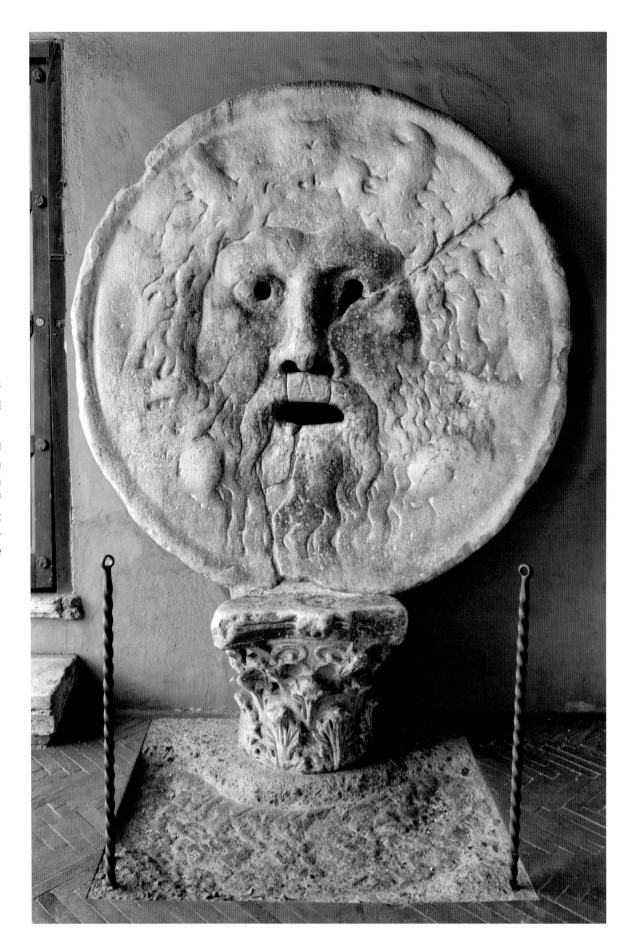

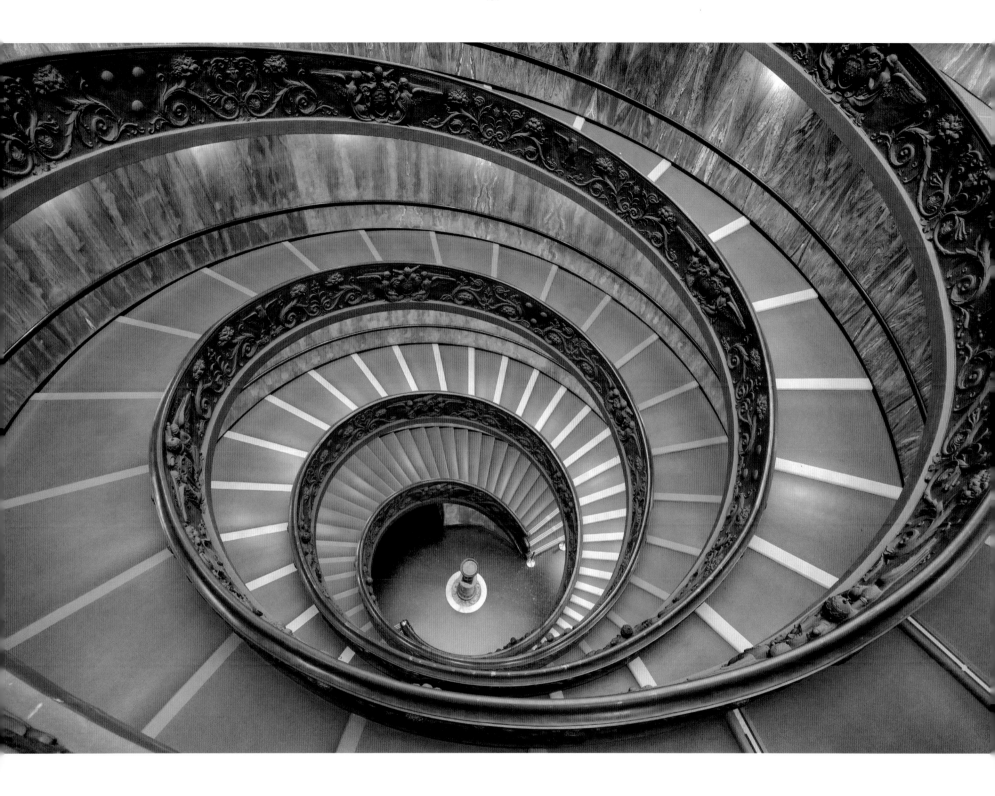

梵蒂冈博物馆内的布拉曼特楼梯，旋转楼梯的两侧墙壁为大理石材质，扶手为青铜制，外侧刻有浮雕。由下方仰望，可见到天井的顶端由多块透光彩绘玻璃组成的八角形天窗，犹如一只"天眼"，设计得相当别致。

The Bramante Staircase in the Vatican Museums features marble walls, bronze handrails and exterior reliefs. Looking upwards reveals a beautifully designed octagonal skylight adorning the ceiling, made of translucent stained glass that resembles an 'eye in the sky', quite ingenious in design.

从圣彼得大教堂顶端俯瞰圣彼得广场

View of the Piazza San Pietro (St. Peter's Square) from the top of the
Basilica di San Pietro (St. Peter's Basilica)

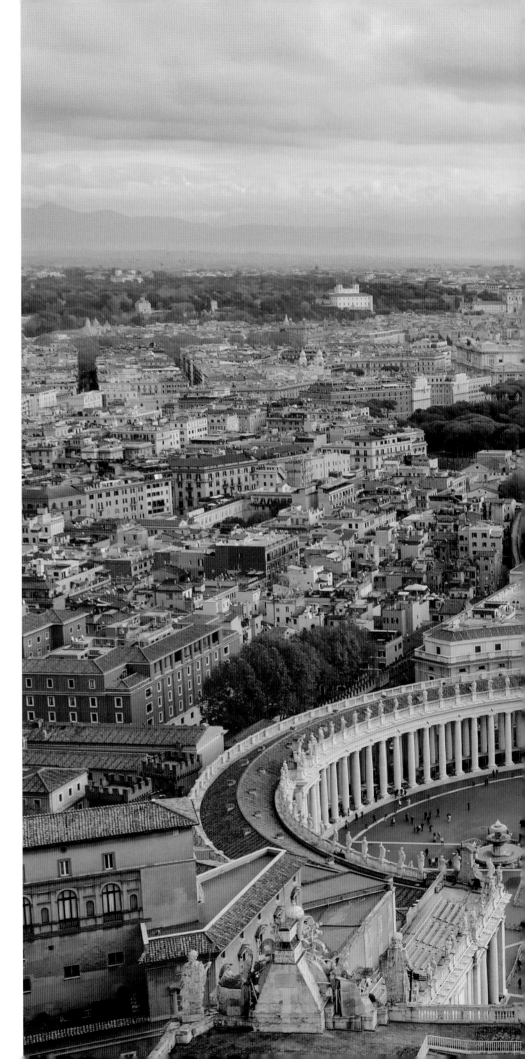

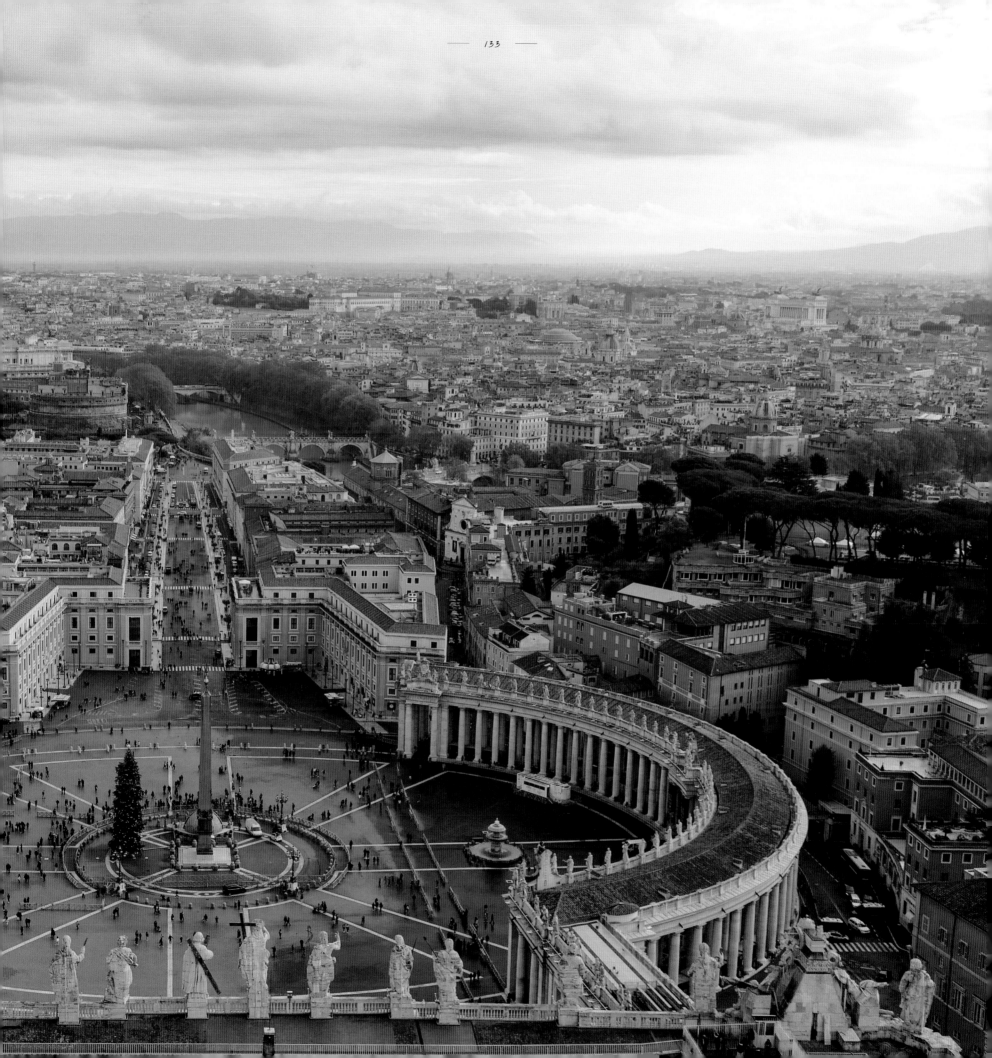

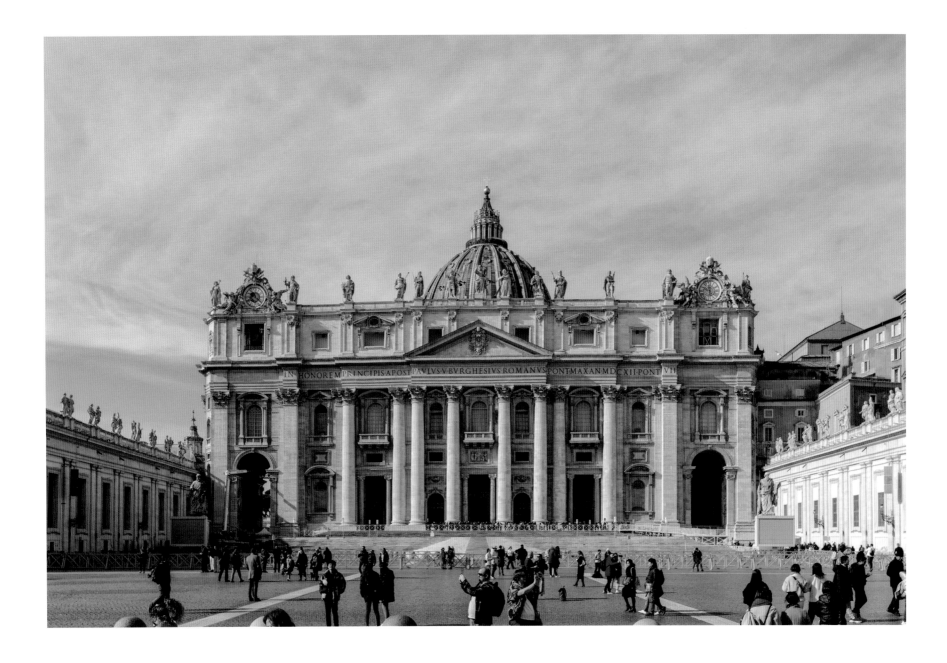

圣彼得大教堂外观。大教堂得名自耶稣"十二门徒"之首的圣彼得。

Exterior of St. Peter's Basilica. It is named after St. Peter, the first of the Twelve Apostles of Jesus.

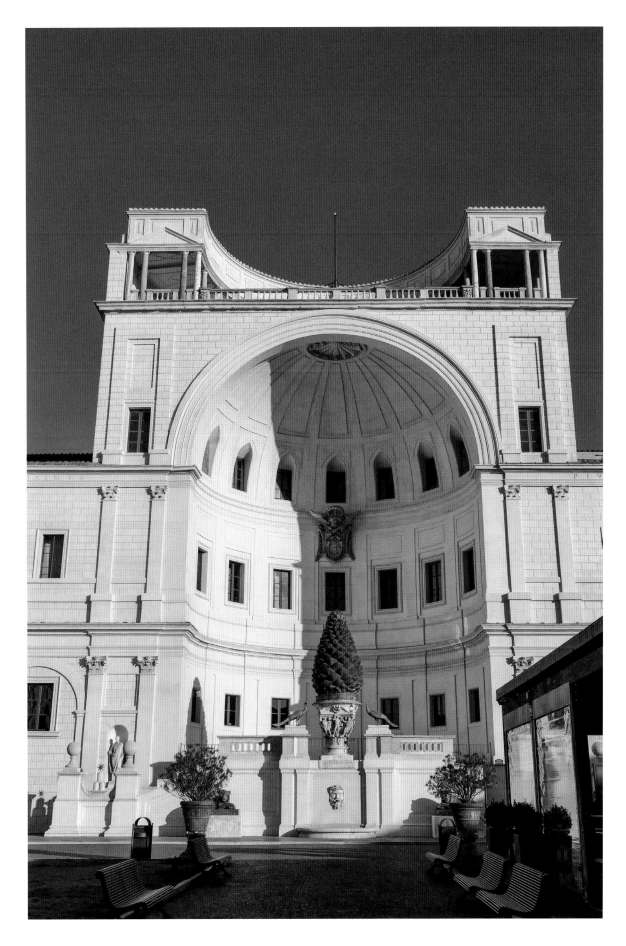

松果庭院，是原本观景台庭院的一部分，名称来自庭园中一座古罗马的巨型青铜松果雕塑，有象征丰收之意。

The Cortile della Pigna (Courtyard of the Pinecone), named after an ancient Roman bronze sculpture of a giant pinecone found in the courtyard, is part of the original Viewing Courtyard and symbolizes bountiful harvests.

加拉蒙蒂博物馆雕像长廊

Statue Gallery of the Gallamonti Museum

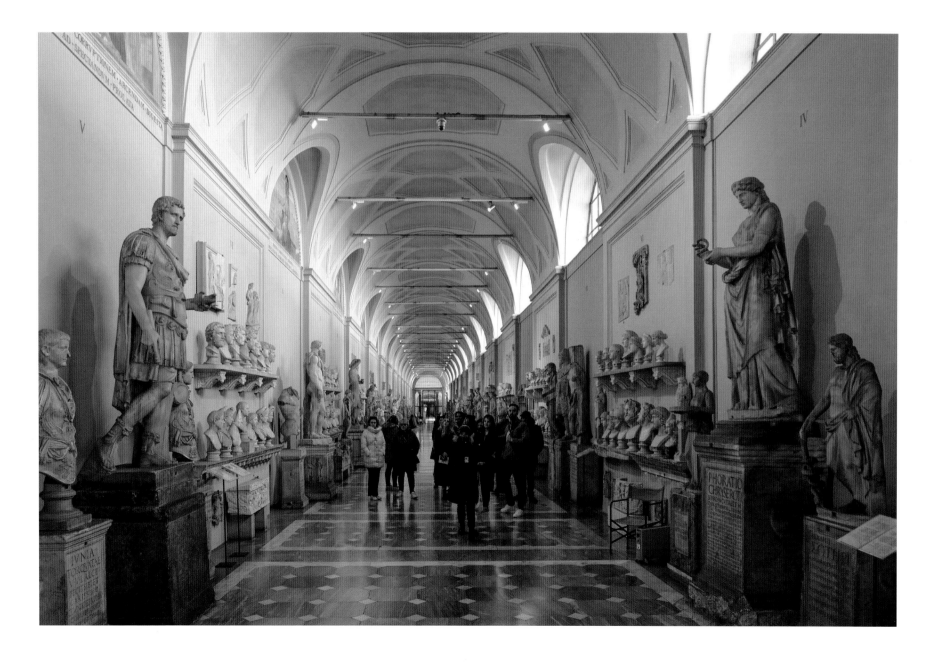

梵蒂冈博物馆地图画廊天花板的浮雕装饰华丽，长廊内如壁画般的地图不仅用拉丁文标注城市名称，就连经纬度也详细标明，简直就是一部意大利地理巨著。

The ceiling reliefs in the Galleria delle Carte Geografiche (Gallery of Maps) of the Vatican Museums are exquisitely decorated and intricate. The mural-style maps in the gallery not only show the names of cities in Latin but also their latitudes and longitudes, just like a masterpiece of Italian geography.

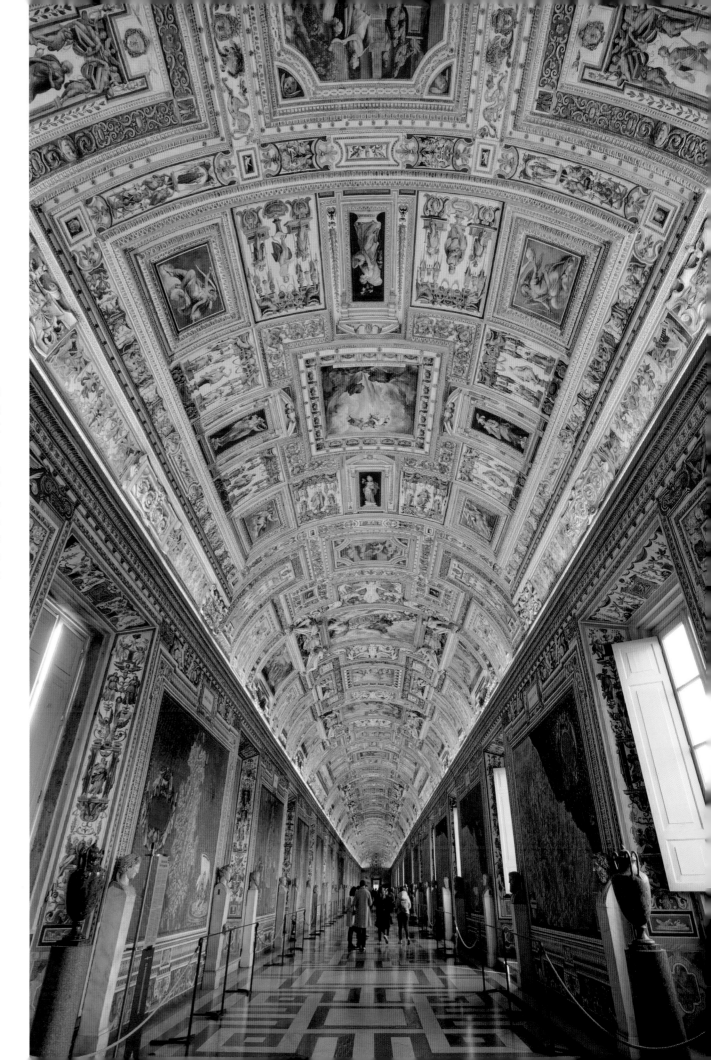

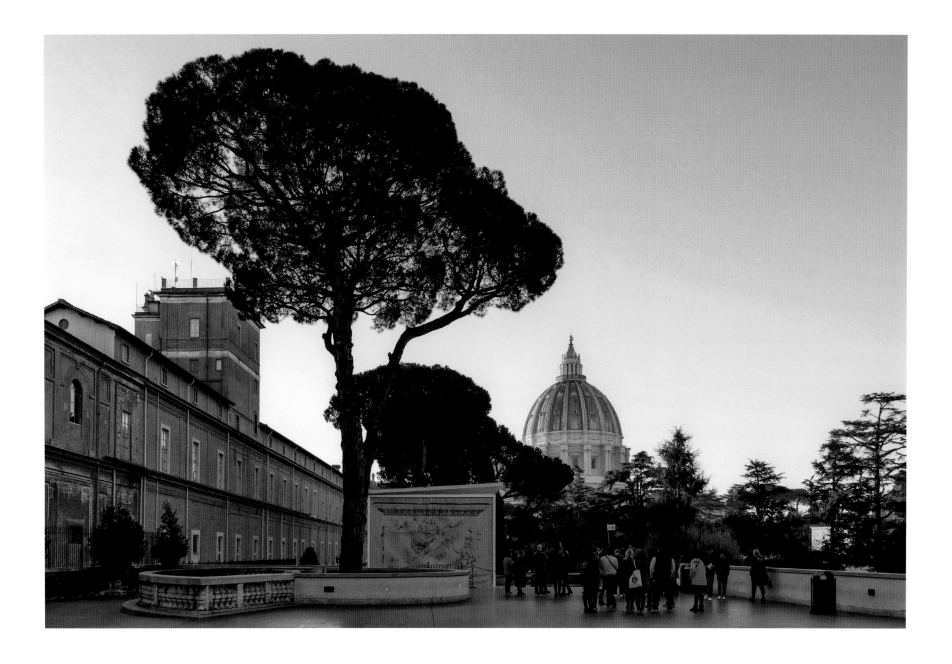

梵蒂冈一隅

A corner of the State of the Vatican City

奥尔西尼—奥德斯卡尔基城堡与湖景

The Castello Orsini-Odescalchi (Orsini-Odescalchi Castle) and the lake view

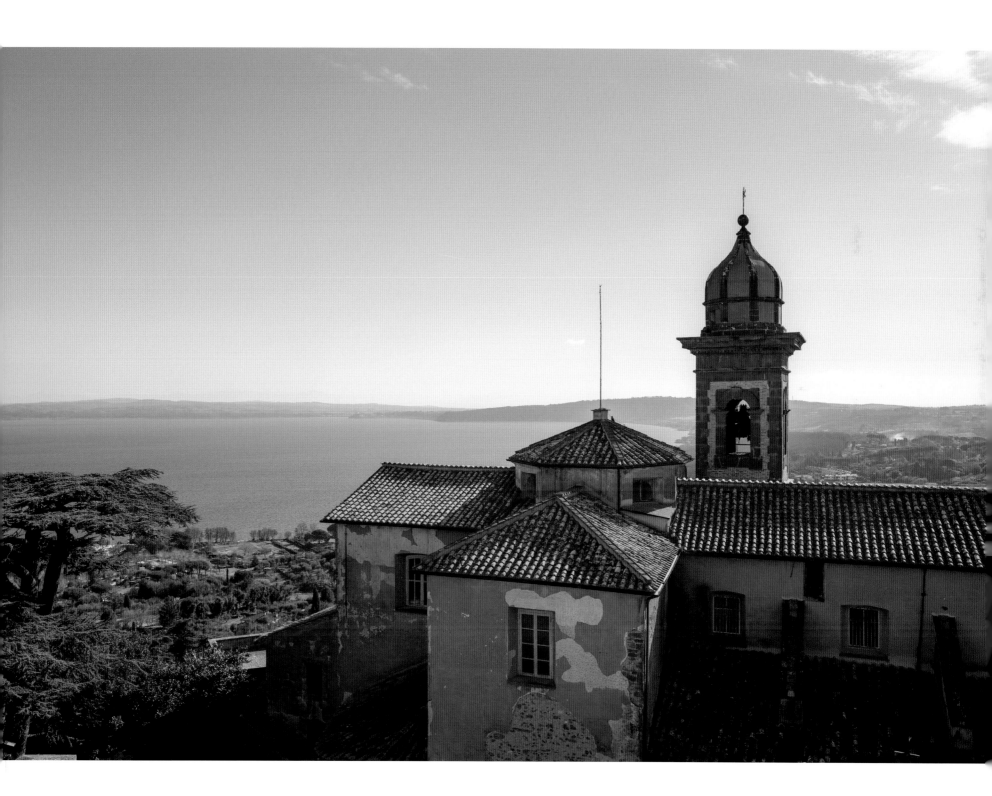

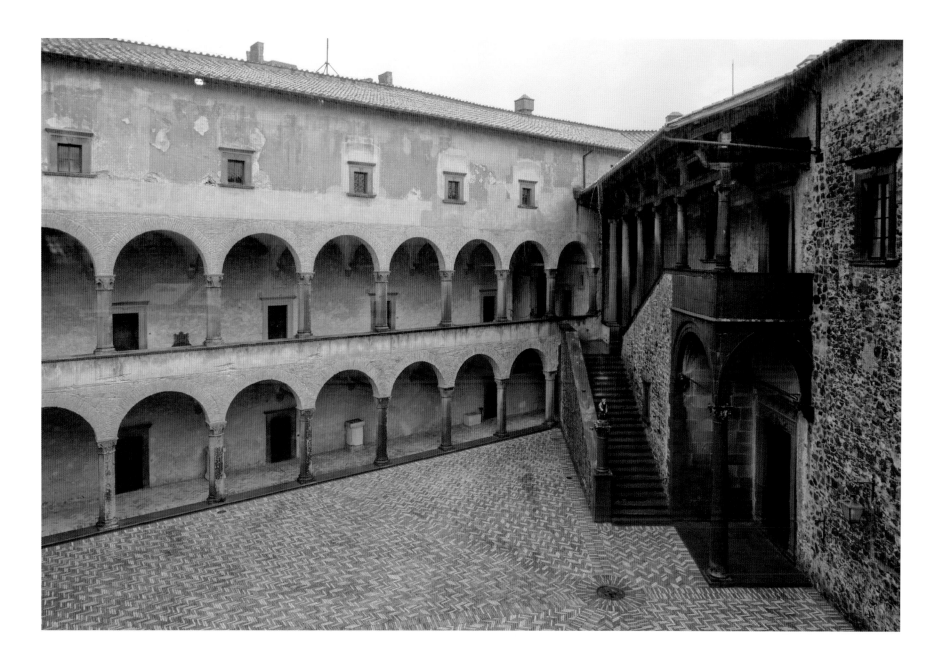

奥尔西尼—奥德斯卡尔基城堡内部，它曾是当时教皇家族的居所，又是防御城堡，如今已改为博物馆，开放给公众参观。

The interior of the Castello Orsini-Odescalchi (Orsini-Odescalchi Castle). It was once the residence of the papal family and also served as a fortified castle, but now it is a public museum.

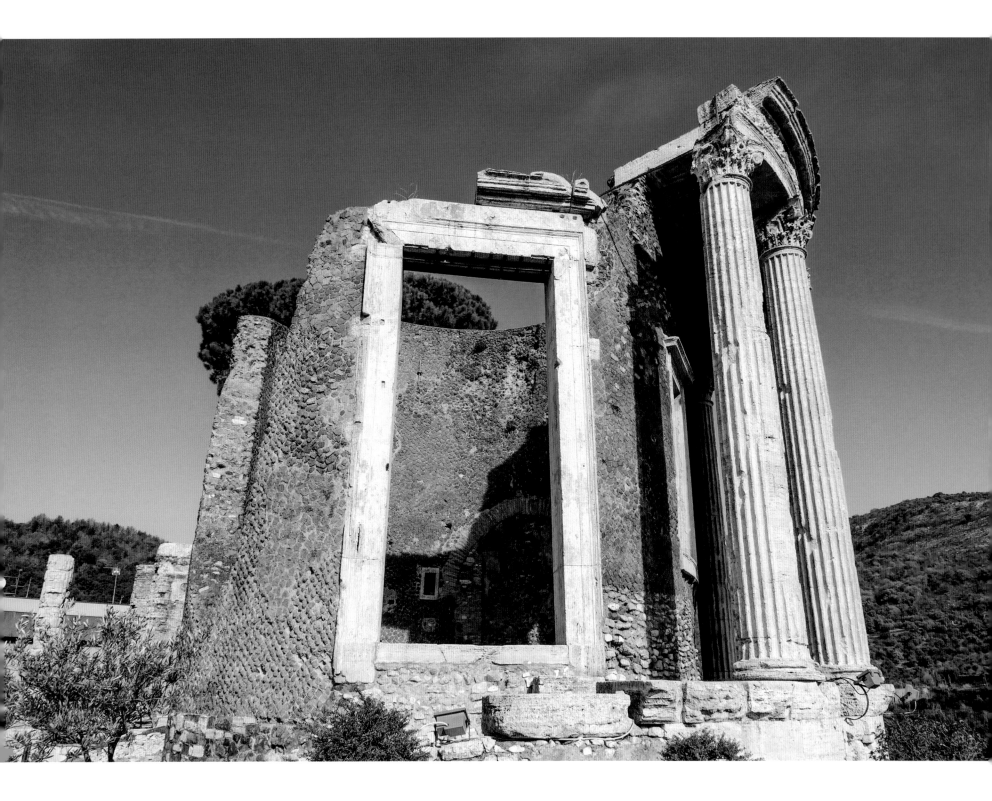

蒂沃利古罗马灶神庙遗址

The ruins of the ancient Roman Vesta Temple in Tivoli

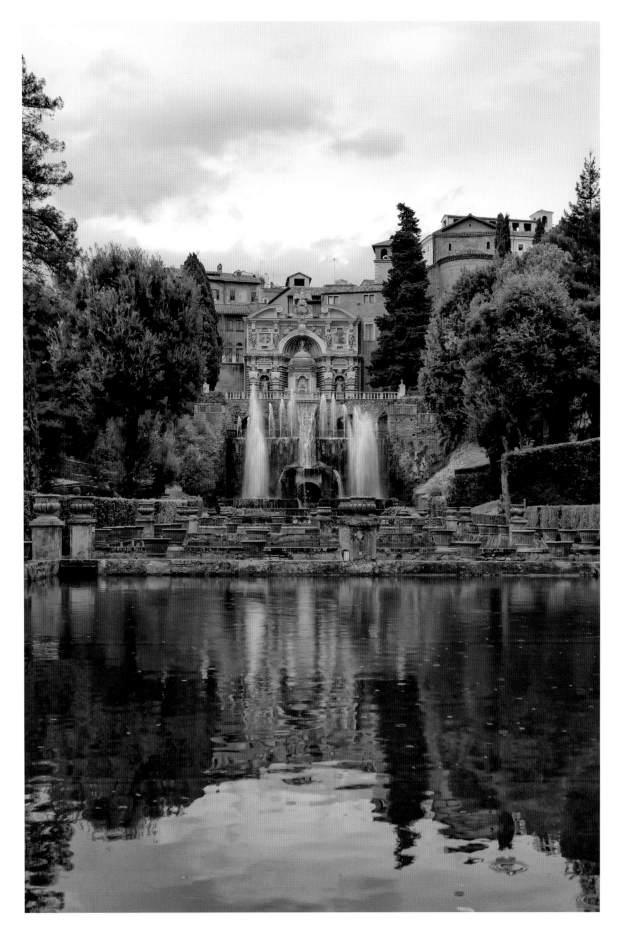

蒂沃利埃斯特别墅（千泉宫）的海王喷泉与上方的管风琴喷泉。一柱擎天、气势磅礴的海王喷泉，是园内最大的喷泉。管风琴喷泉是靠水力的运作让管风琴发出声音，每两小时会有一次管风琴演出。

The Fontana di Nettuno (Fountain of Neptune) of Villa d'Este (Palace of Thousand Springs) in Tivoli and the Fontana dell'Organo (Fountain of Pipe Organ) above it. The magnificent Fontana di Nettuno is the largest fountain around the area. The Fontana dell'Organo operates using the power of water to create the melodic sounds of a pipe organ, and there is a captivating pipe organ performance every two hours.

佛罗伦萨及周边地区

Florence and its enchanting neighbouring regions

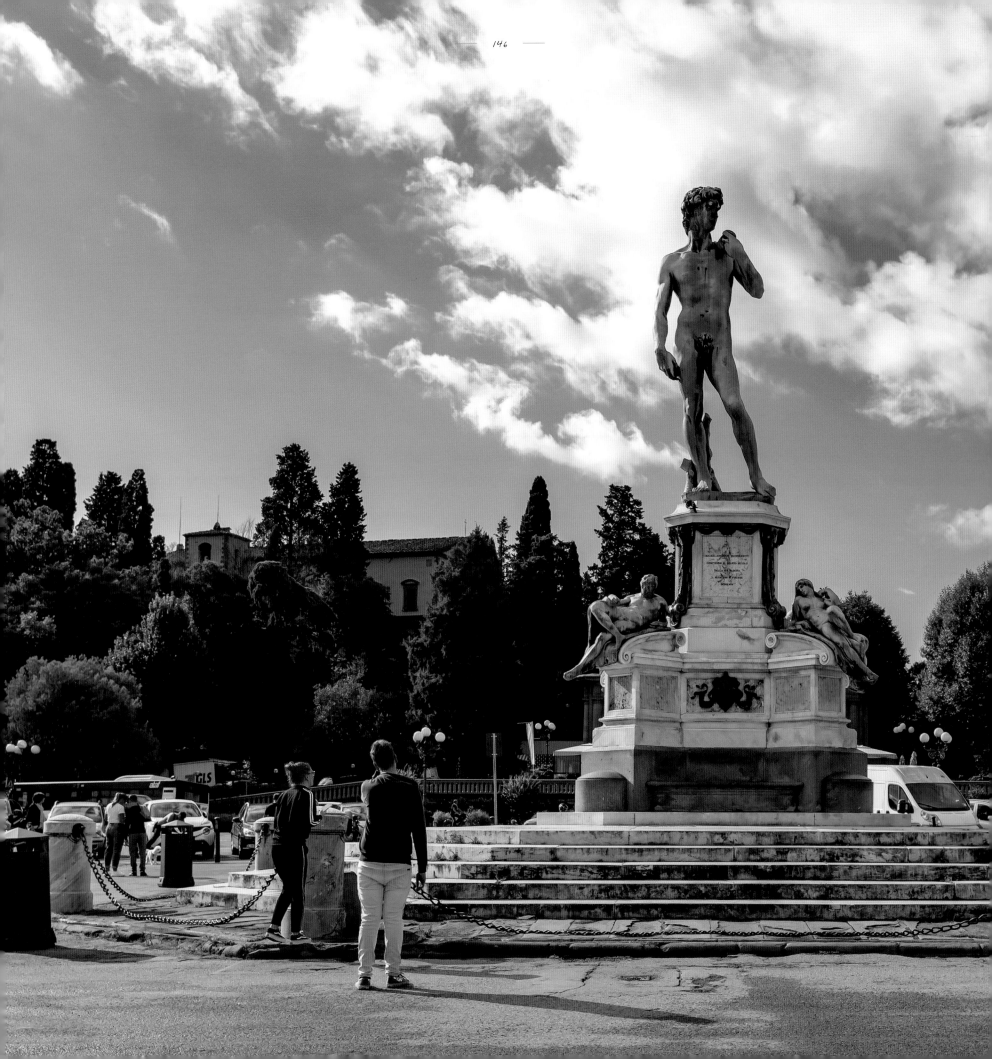

有人开玩笑说去过欧洲才知道美国没文化，去过意大利才知道欧洲没文化。一场发生在十四世纪到十七世纪的欧洲文艺复兴运动使意大利成为欧洲的文化和艺术中心，而佛罗伦萨正是这场运动的摇篮。达芬奇、米开朗基罗、拉斐尔、但丁等一大批为我们后人所熟知的大艺术家们，多与这座城市有着不可割舍的关系。

佛罗伦萨是托斯卡纳大区的首府，位于意大利中部，四面被丘陵环抱，阿诺河穿城而过。她有个诗意的译名"翡冷翠"，来源于中国著名的现代诗人徐志摩，他的用词既独特，又带有浪漫气息。历史记载，佛罗伦萨最早建于西泽大帝在位时期，后来陆续被罗马帝国、拜占庭帝国、伦巴第人等统治，后因羊毛纺织业的兴盛，经济发达，重要性逐渐提升，十二世纪更成为神圣罗马帝国皇帝特许的自治城市，建立佛罗伦萨共和国，当时国家实权掌握在最有权势的贵族手中，到了十五世纪，美第奇家族掌权，守护这座城市长达三百年。十五世纪也开启了佛罗伦萨最灿烂辉煌的时代，一代又一代艺术、科学、哲学等领域的大师将意大利文艺复兴推至成熟和高峰。

人类的历史，造就文艺复兴这个辉煌的时代，激励人们探索无穷的文艺创意，燃亮了整个人类文明的发展史。

米开朗基罗广场上的大卫像。这个米开朗基罗的大卫像，无论是艺术层面，还是情感层面，均是旷世之作。尽管眼前的雕像只是复制品，却与原件没有任何分别。

The Statue of David in the Piazzale Michelangelo (Michelangelo Square). The Statue of David, Michelangelo's outstanding masterpiece, has been infused with profound artistic and emotional significance. And even though the statue is a replica, it remains indistinguishable from the original.

Some once humorously remarked that you don't realize America is short on culture until you've visited Europe, and you don't know that Europe is uncultured until you've experienced Italy firsthand. The European Renaissance from the 14th to 17th centuries elevated Italy to the forefront of European culture and art, with Florence serving as the cradle of this influential movement. Legendary figures such as Leonardo da Vinci, Michelangelo, Raphael, Dante, and many other renowned artists are forever intertwined with this brilliant city.

Nestled snugly among rolling hills and crossed by the Arno river, Florence, the capital of the Tuscany region, is situated in central Italy. Its poetic Chinese name, '翡冷翠', inspired by the renowned Chinese modern poet Xu Zhimo, adds an artistic touch that resonates with the Italian pronunciation of Firenze. Steeped in history, Florence traces its origins back to the era of Julius Caesar and has been influenced by various empires including the Roman Empire, Byzantine Empire and Longobards. Flourishing as a hub for woollen textile production propelled this city into economic prosperity and catapulted its status and renown to new heights. In the 12th century, Florence rose to the status of a self-governing city under the authority of the Emperor of the Holy Roman Empire, leading to the establishment of the Republic of Florence. The reins of power were firmly held by the most influential nobility, and in the 15th century, dominance was assumed by the Medici family who maintained their rule for three centuries. This period also marked Florence's golden age, as successive generations of great figures in art, science and philosophy propelled Italian Renaissance to its peak.

Thanks to their influence, the Renaissance became a magnificent epoch in the annals of humanity, igniting a passion for delving into the boundless creativity of art and literature while shedding light on the development of human civilization.

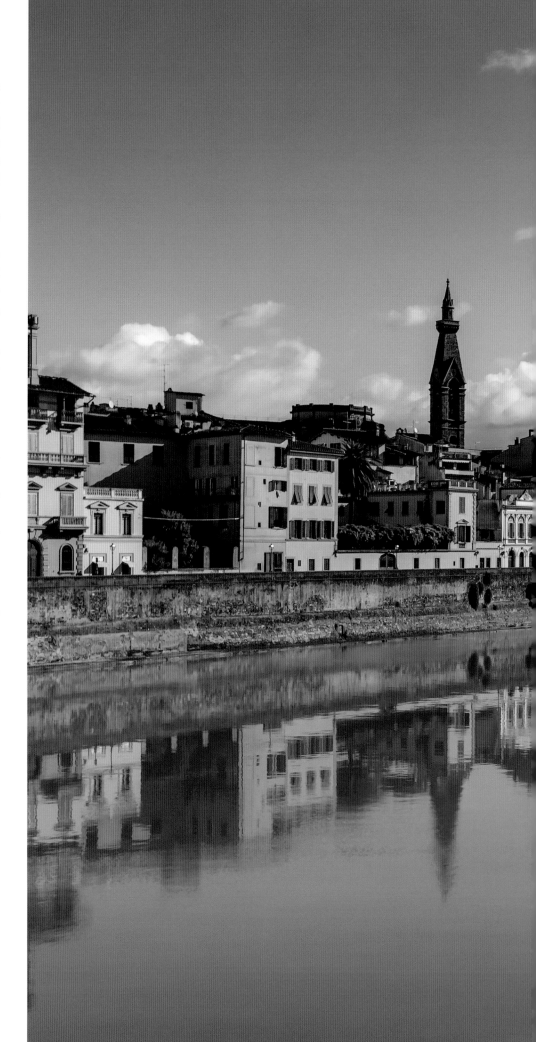

这条贯穿佛罗伦萨的阿诺河，见证了这个城市的历史兴衰。

The Arno River flows through Florence, and has witnessed the city's chequered history.

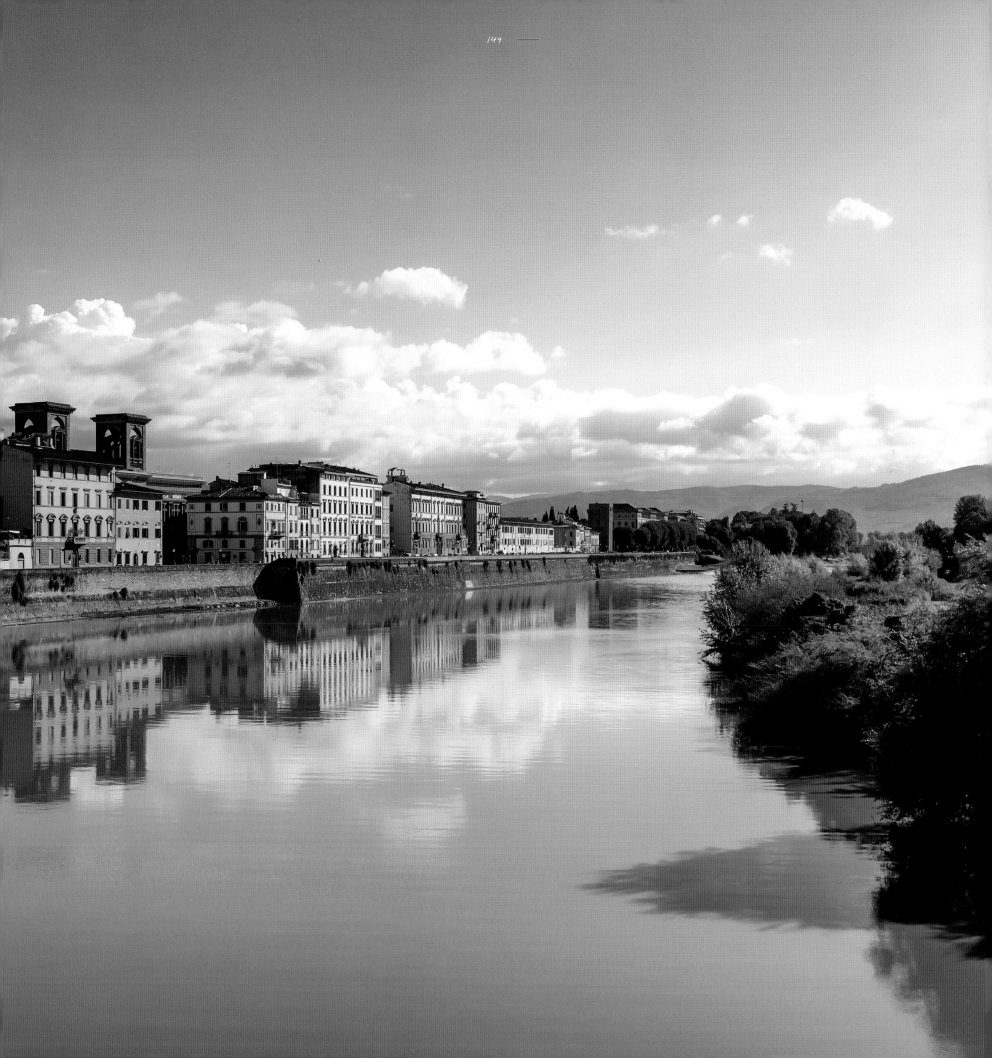

比萨的洗礼堂（左）、大教堂（中）和斜塔（右）

The Baptistery (left), the Cathedral (center) and the Leaning Tower of Pisa (right).

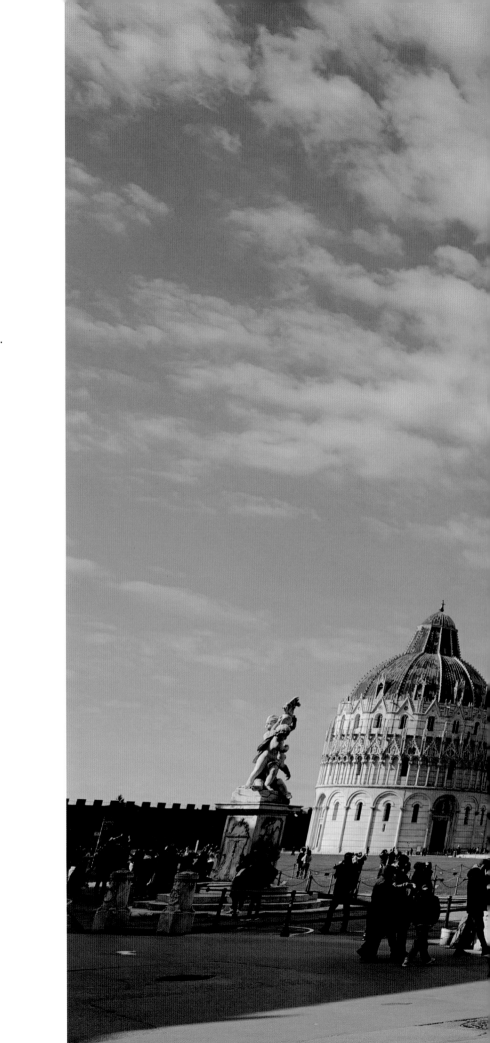

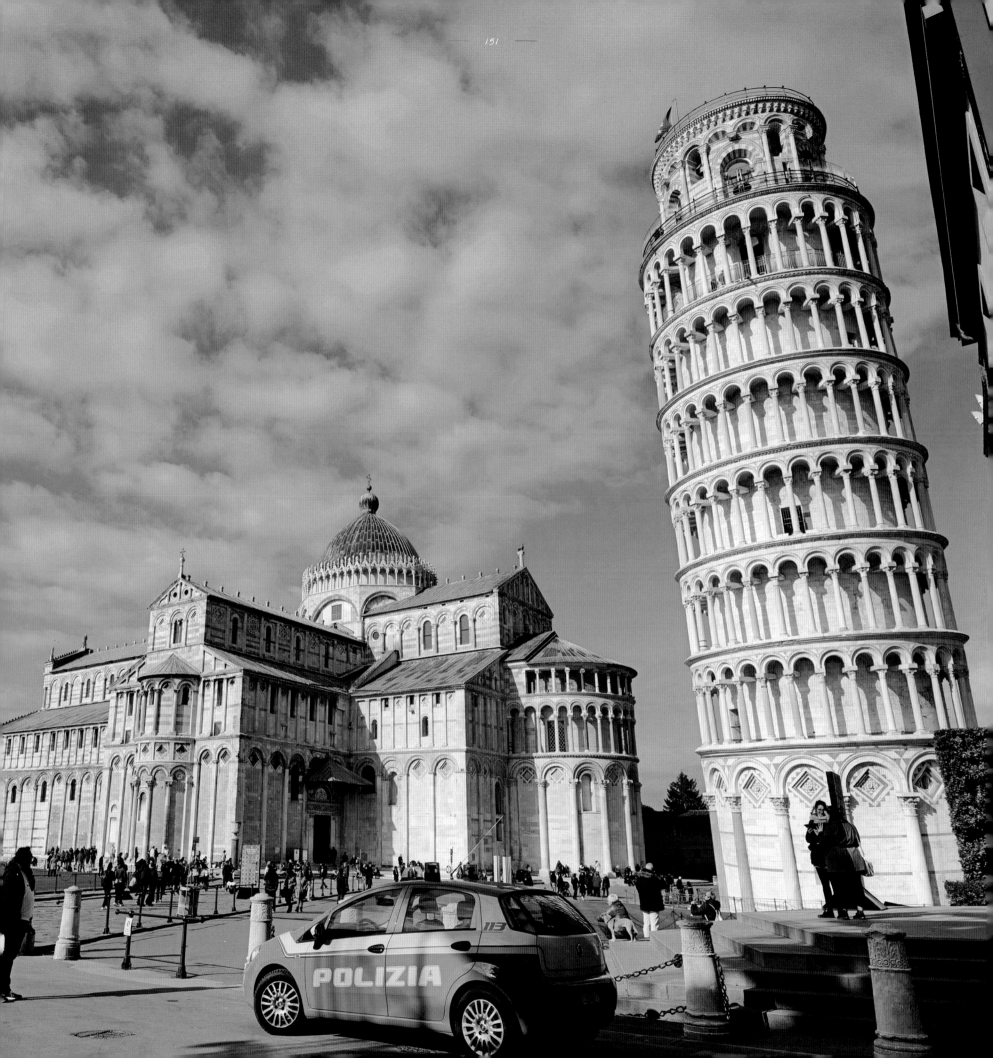

始建于一一七三年的比萨斜塔本是比萨大教堂的独立式钟楼，盛名在外，早已盖过了大教堂的光辉，它被誉为中古世界七大奇迹之一。

The iconic Torre di Pisa (Leaning Tower of Pisa) has graced this square since 1173, originally serving as the freestanding bell tower of Pisa Cathedral. Over time, it has surpassed the Cathedral in terms of renown and is now praised as one of the Seven Wonders of the Medieval World.

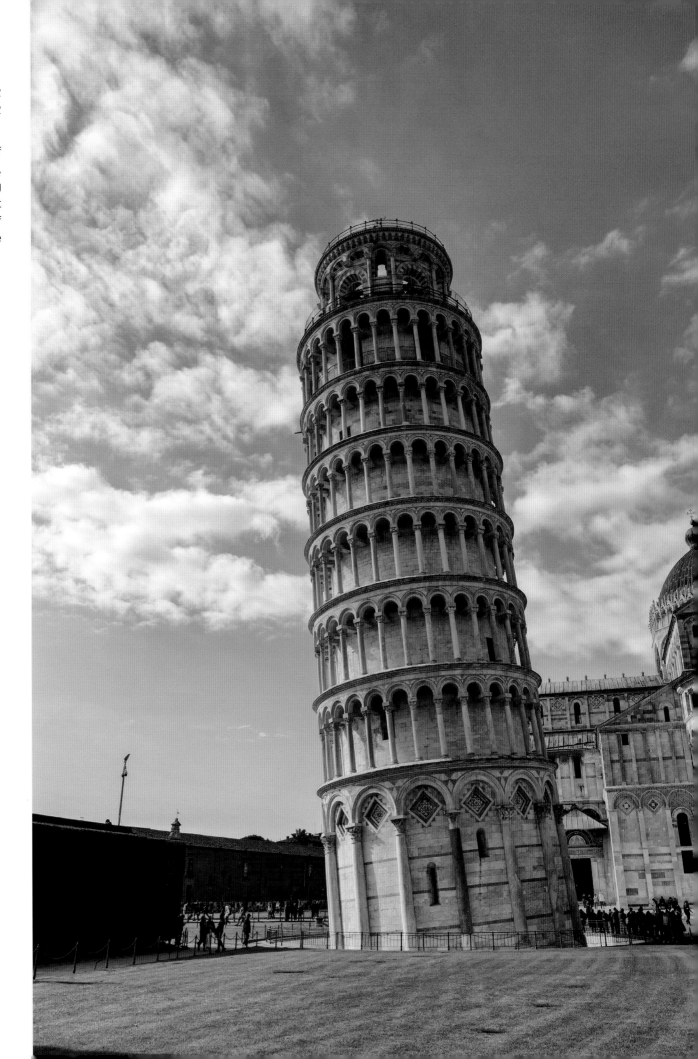

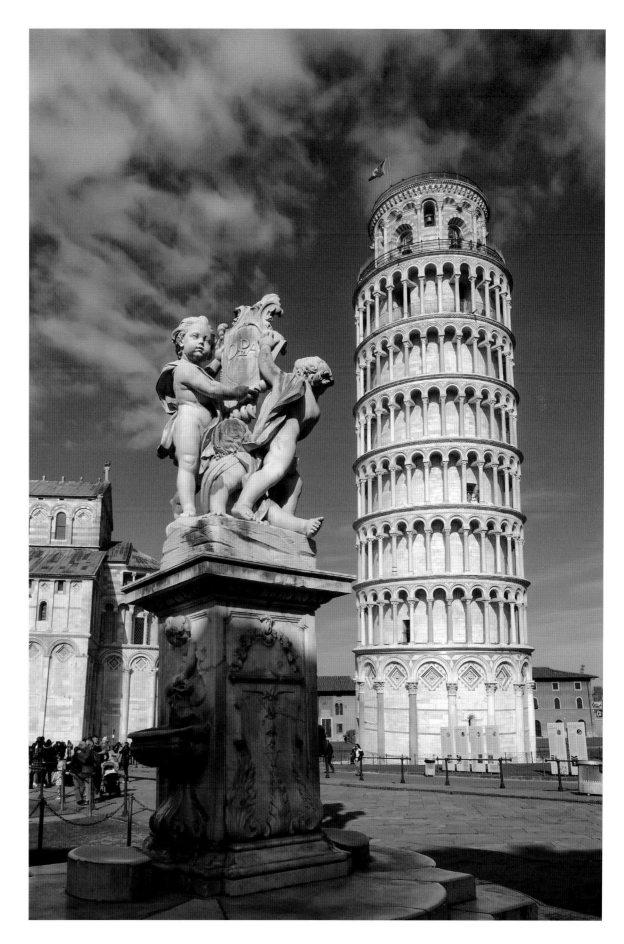

比萨斜塔和天使喷泉。比萨斜塔原是比萨大教堂的独立式钟楼，盛名在外，早已盖过了大教堂的光辉。

The Torre di Pisa (Leaning Tower of Pisa) and the Angel Fountain. The Torre di Pisa originally served as the freestanding bell tower of the Duomo di Pisa (Pisa Cathedral). Over time, it has surpassed the Cathedral in terms of renown.

锡耶纳大教堂一隅

A corner of Duomo di Siena (Siena Cathedral)

锡耶纳田野广场，中间为市政厅和曼贾塔。塔是锡耶纳最高的建筑，旅客可登上四百多级阶梯直达顶端，一览塔下的城市风情。

Piazza del Campo (Campo Square) with Palazzo Pubblico (Public Palace) and Torre del Mangia (Mangia Tower) in the middle. The tower is the tallest building in Siena, where travelers can climb over four hundred steps to the top and admire the view of the city below.

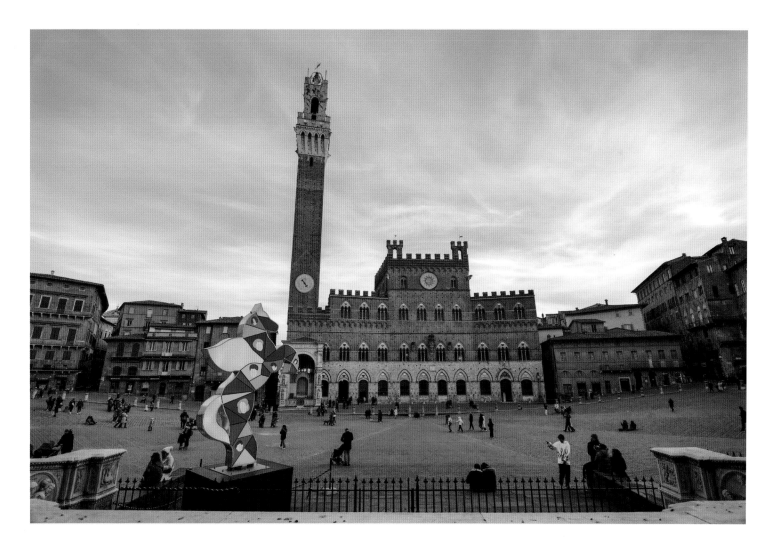

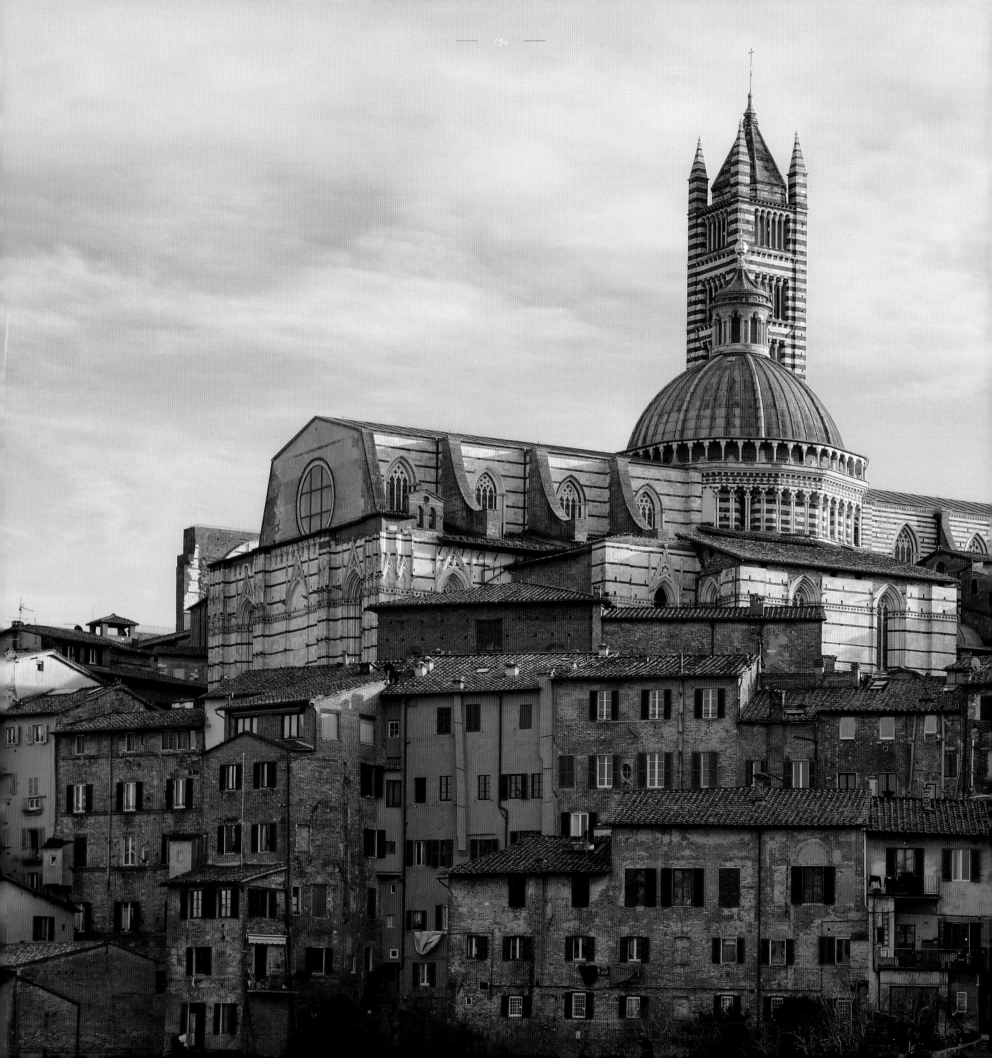

远眺锡耶纳大教堂。教堂外观以黑白色大理石修建，搭配起来有一种独特的"斑马"条纹。由于建造时期横跨两个多世纪，所以产生了不同的建筑风格。

Overlooking the Siena Cathedral. The façade of Siena Cathedral is adorned with a striking combination of black and white marble, creating a unique 'zebra' pattern. It was built over a period of more than two centuries and therefore represents different architectural styles.

博洛尼亚的海神喷泉是一座大型的雕刻艺术品，海神像为法国雕刻家詹博洛尼亚的作品。马莎拉蒂的"三叉戟"车标就来源于海神手中的武器。

The Fountain of Neptune in Bologna, a large sculptural work of art, was crafted by the French sculptor Giambologna, and Maserati's iconic 'trident' emblem draws inspiration from the weapon wielded by the mighty god of the sea.

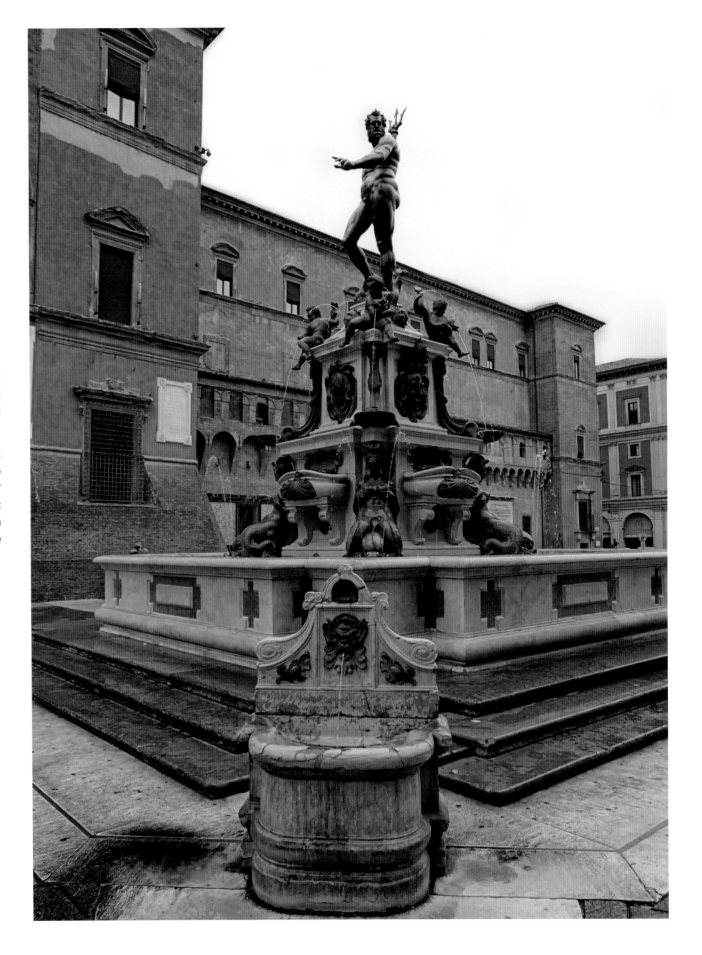

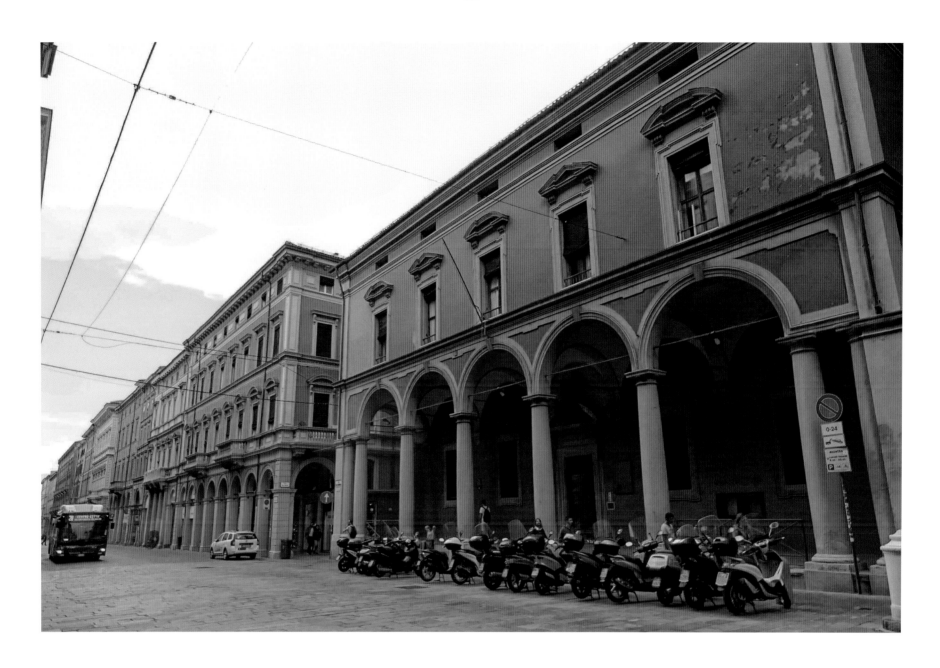

博洛尼亚几乎每座大建筑物都建有拱廊，听说中世纪时，博洛尼亚对于兴建楼房设有规定，甚至具体到拱廊的造型和高度都有标准，目的让市民出外时可免受日晒雨淋之苦。

Almost every large building in Bologna has an elaborate portico. During the medieval period in Bologna, strict building regulations were said to be in place, which even extended to the shape and height of porticoes, aiming to protect people from the scorching sun and heavy rain when they went outdoors.

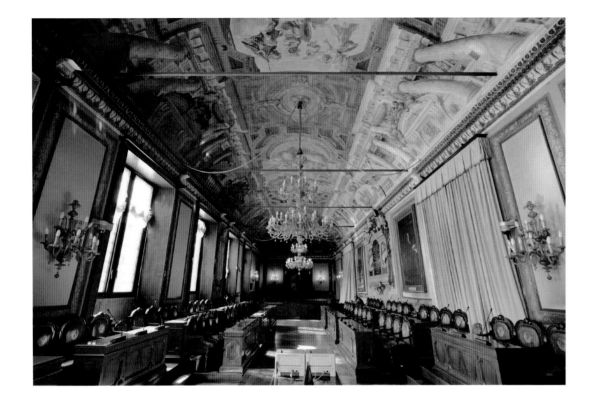

博洛尼亚的市政会议大厅

The town hall of Bologna

经常举办市集活动的圣斯德望广场周边建筑都建有拱廊

The buildings around the St. Stephen's Square, a frequent venue for bustling markets, are all equipped with porticoes.

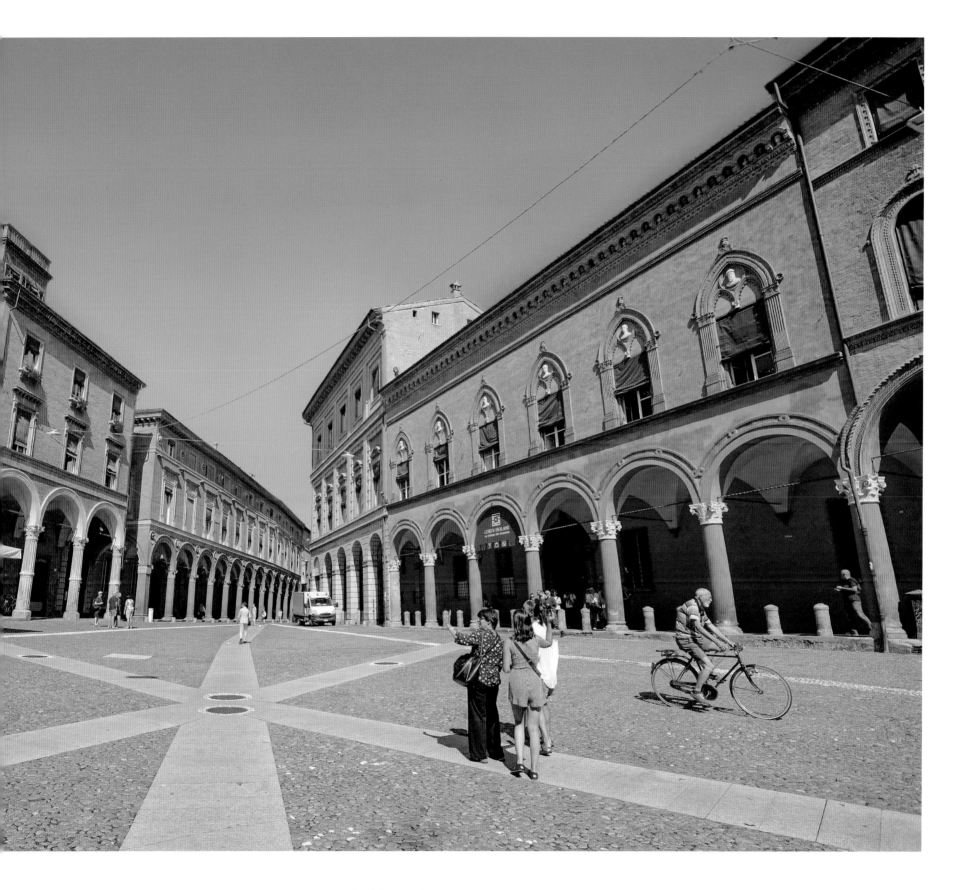

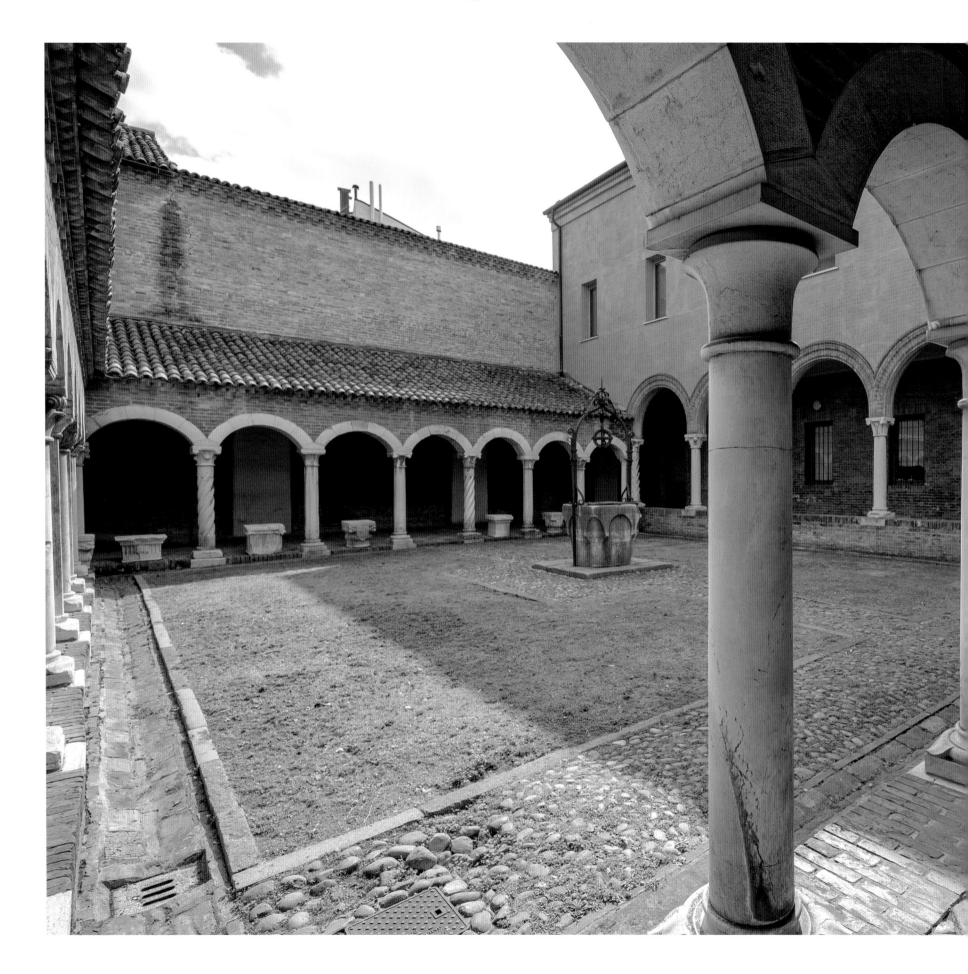

位于费拉拉的犹太教和犹太人大屠杀博物馆

The Shoah Memorial in Ferrara

费拉拉大教堂博物馆中庭

The large atrium of the Museo dell'Opera Metropolitana (Metropolitan Opera Museum) in Ferrara

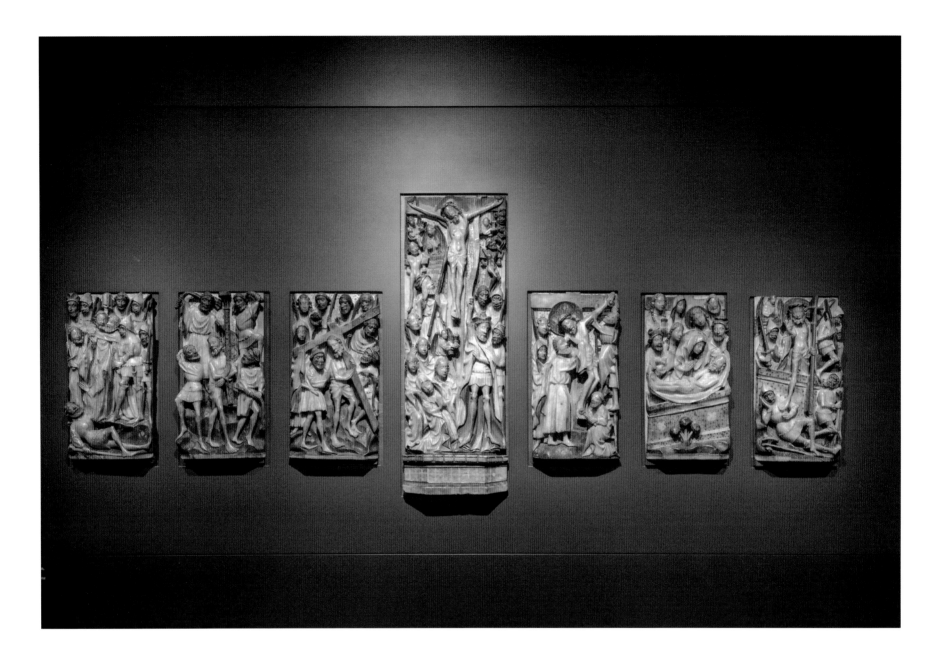

费拉拉斯齐法诺亚宫馆藏

The collections of Palazzo Schifanoia (Schifanoia Palace) in Ferrara

埃斯特城堡内的狮子塔楼，当中发生过不少"宫廷内斗"的故事。

The Lion Castle of the Este Castle witnessed many events related to the 'palace infighting'

费拉拉的埃斯特城堡始建于一三八五年，如今是当地的地标建筑。

The 1385-built Castello Estense (Este Castle), now the local landmark.

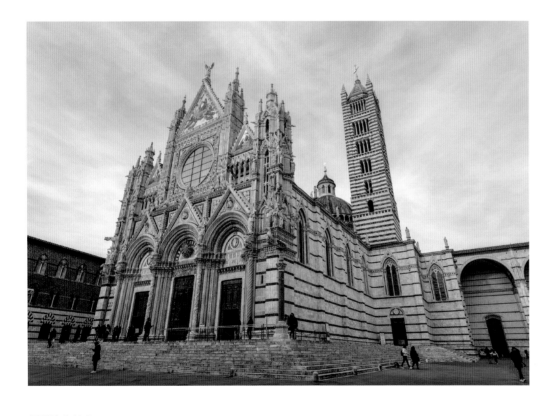

锡耶纳大教堂

The Duomo di Siena (Siena Cathedral)

5. 佛罗伦萨及周边地区 Florence and its enchanting neighbouring regions

从费拉拉市立剧院中庭看向圣嘉禄·鲍荣茂堂

Viewing the St. Charles Borromeo Church from
the atrium in the Municipal Theatre of Ferrara

埃斯特城堡中庭的雕塑

Sculpture in the atrium of the Este Castle

斯齐法诺亚宫内梅西大厅的壁画。大厅墙上满是湿壁画彩绘，内容包括十二星座、宫廷事件，以及赞扬这个家族的丰功伟绩。

Frescoes of the Messi Hall. Walls are fully covered with frescoes depicting signs of the zodiac, court events and celebrations of the family's achievements.

帕尔玛主教座堂，位于市中心的广场上，右侧是一座后期修建的哥特式钟楼，不知是否错觉，看起来有稍微的倾斜。

The Cattedrale di Parma (Parma Cathedral) is one of the landmarks in the square of the city center. To the right of the cathedral is a later Gothic bell tower which, I wasn't sure if it was my illusion or not, appeared to be slightly tilted.

帕尔玛街道，外墙用上鲜艳的颜色来粉饰。当地没有人车喧嚣声，安静闲适，充满风雅的情趣。

In the street of Parma, the exterior walls of many houses here are coated in bright colors. The area has no hustle and bustle of people and traffic, exuding a tranquil and unhurried atmosphere.

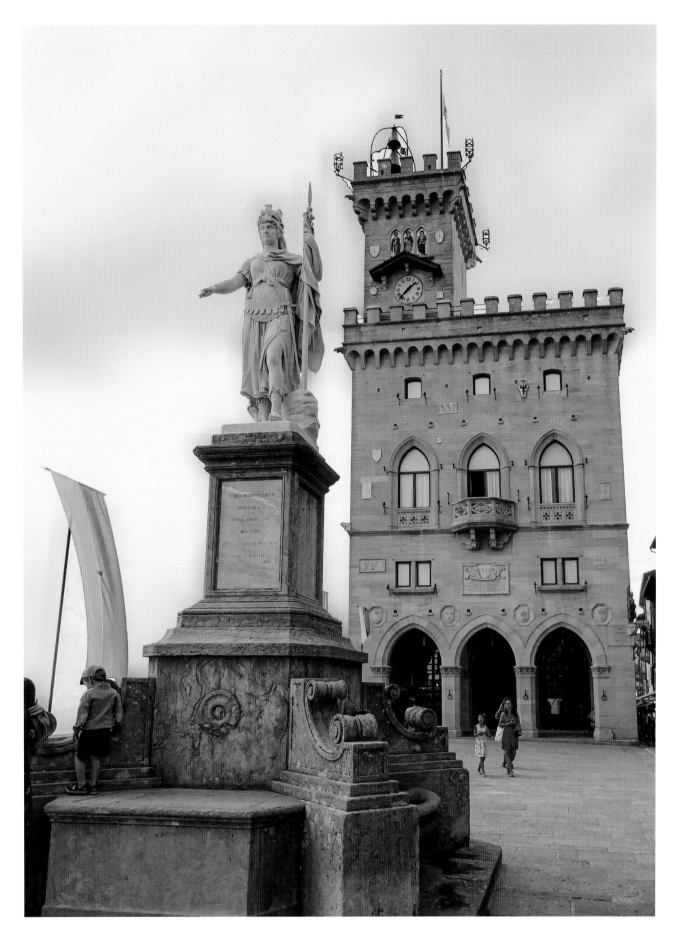

圣马力诺市政府议会机构的所在地 ——
共和国宫。共和国宫前是自由广场，一座
自由女神雕像竖立在中央。

The Palazzo Pubblico (Public Palace)
is the seat of the parliamentary
government of the Republic of San
Marino. In front of the palace lies
the Piazza Libertà (Liberty Square)
with the statue of the Goddess of
Liberty at its center.

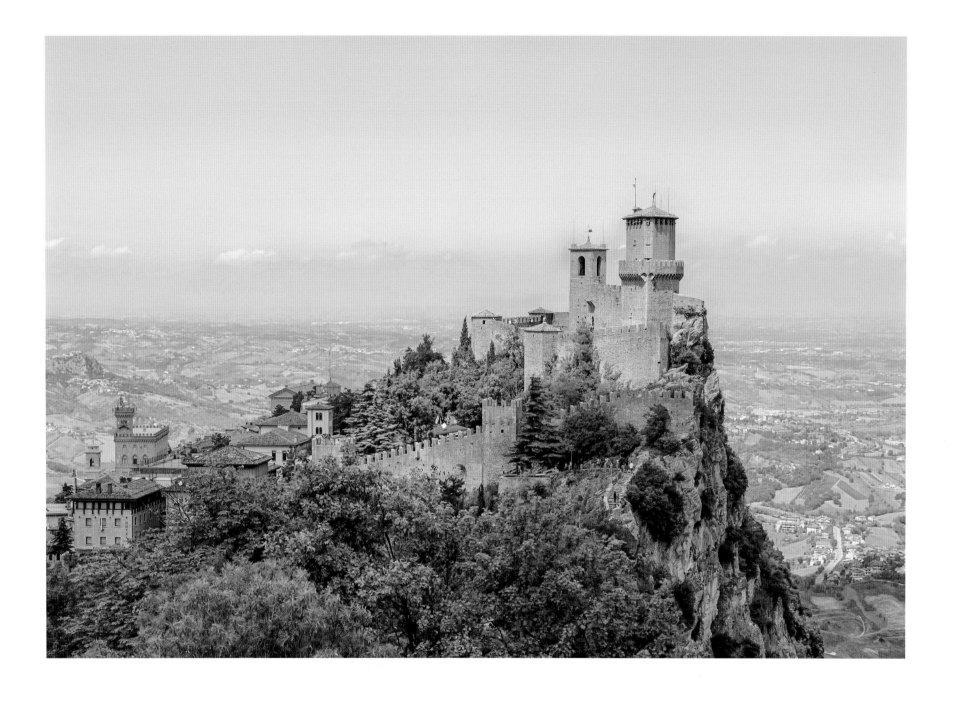

圣马力诺的国旗和国徽上有"三座城堡"的图案，正是国内三座位于山峰上的城堡，位置高且险要，其间以城墙相连。图为第一座城堡。

The national flag and emblem of the Republic of San Marino feature the design of the 'Three Castles', symbolizing the three strategically positioned, wall-connected castles perched atop precipitous peaks within the country. In the picture is the first castle.

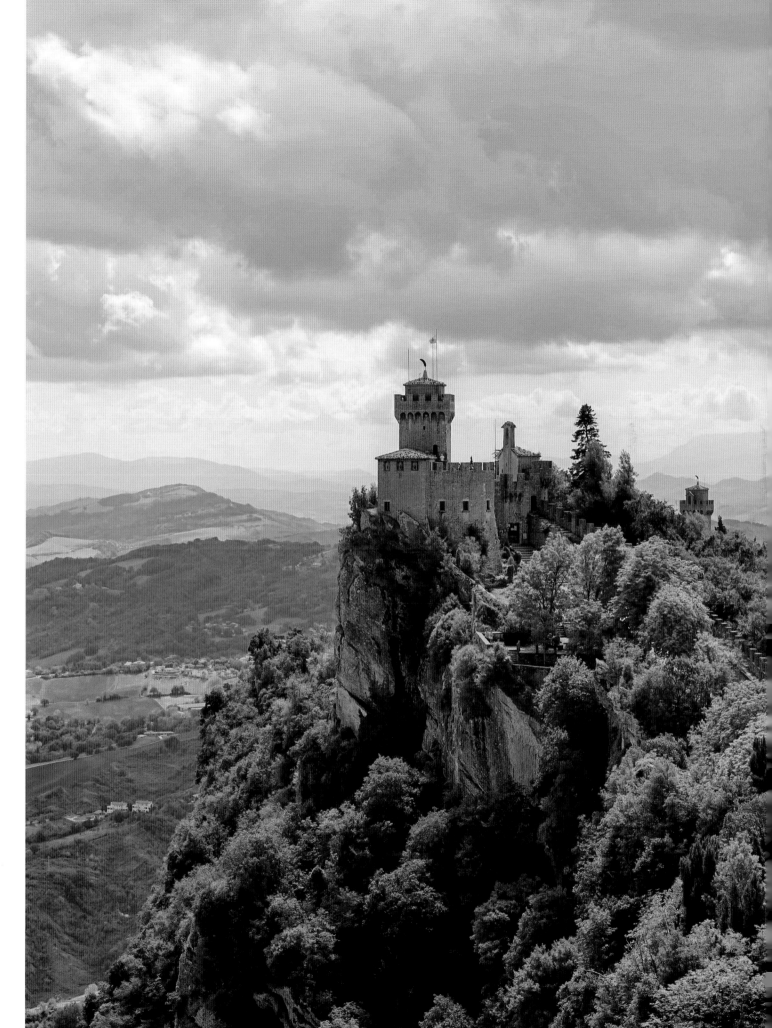

圣马力诺第二座城堡。想当年圣马力诺的人民为保卫自己的独立和自由，就是据守在这些城堡，与附近的强国对峙抗衡，其决心天地可鉴。

The second castle of the Republic of San Marino. During those years, the people of San Marino used these fortresses to protect their independence and freedom from neighboring powers, demonstrating their unwavering determination to the world.

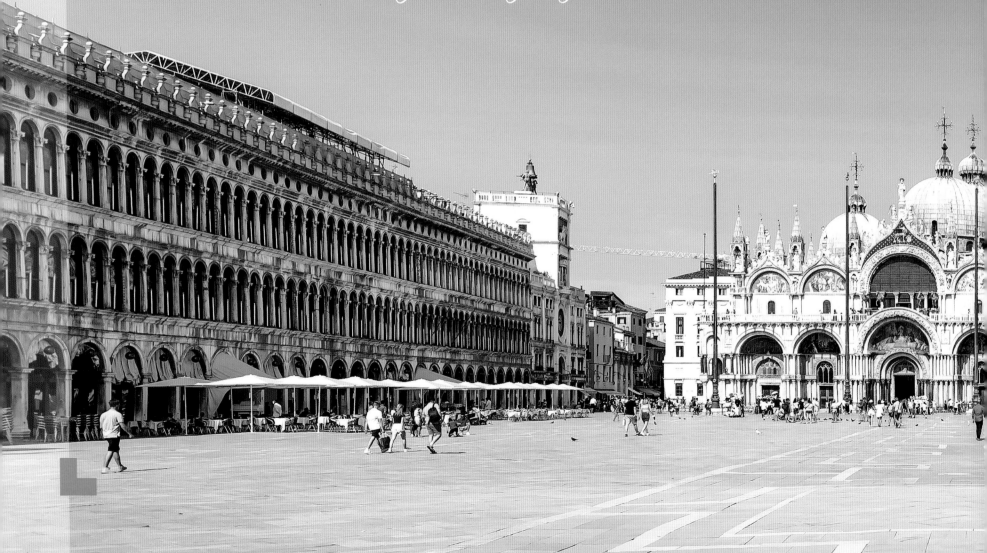

威尼斯及周边地区

Chapter 6
第六章

Venice and its
attractive neighbouring regions

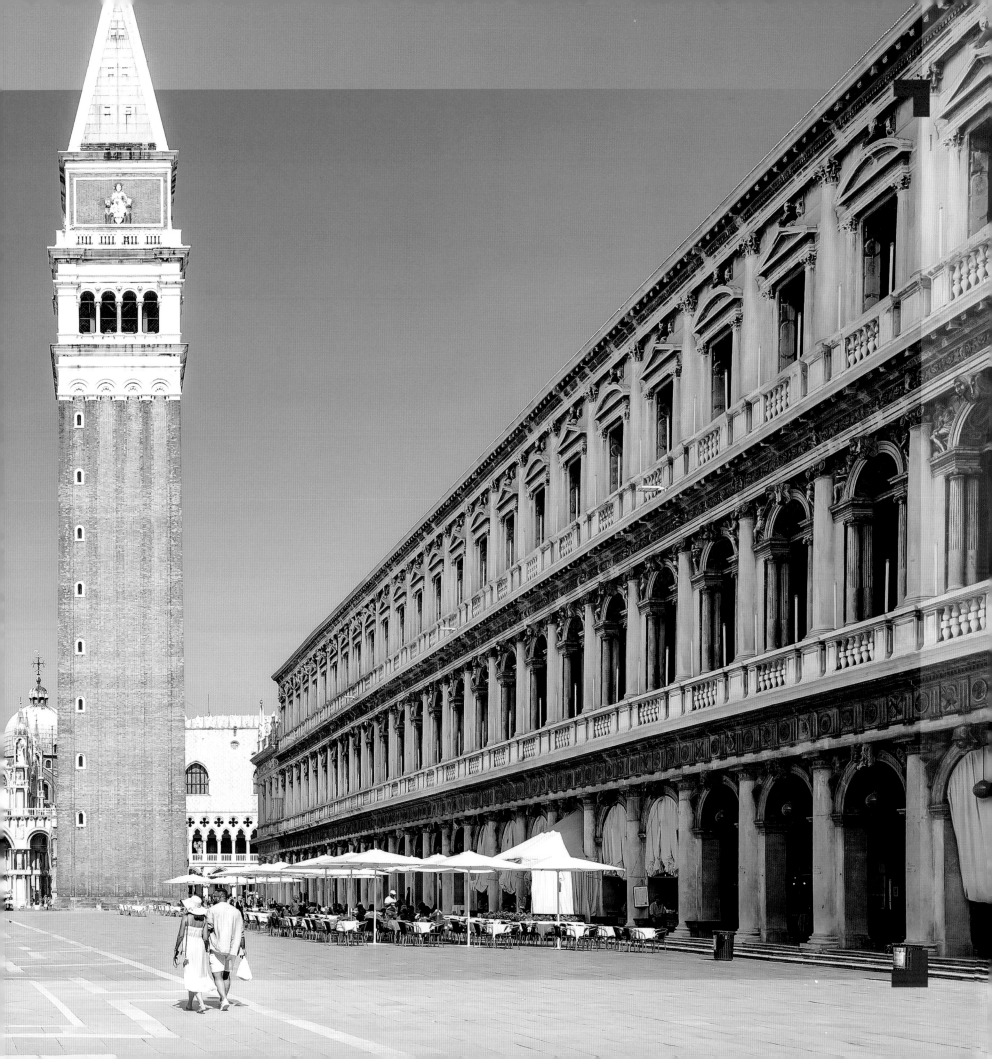

我个人对威尼斯怀抱着不一般的感情，正如二○二○年，除疫情之外，于我个人还有一种特殊情怀，这一年刚好是我和老伴结婚四十周年纪念，而威尼斯则是我们一九八○年新婚蜜月旅行地之一。在疫情阴霾还未消散的背景下重访威尼斯，对我来说已不只是故地重游那么简单了。

威尼斯本身并非一块完整的土地，而是由无数桥梁连接的一百一十八个岛屿组成，岛屿之间有条长约四公里，深约五米，宽三十到七十米的大运河，以及纵横交错的一百七十七条支流。这是一座名副其实的水城，"因水而生，因水而美，因水而兴"。

整座城市如同一座大型的博物馆，无数传统的威尼斯建筑散发特殊的妩媚风情，单看其建筑工法就相当独特：当地的居民先将木柱插进泥土内，再铺上防水性能极佳、耐海水腐蚀的伊斯特拉石，最后在石上砌砖，建起一座座房屋。厚重的大石块能够承载较轻的砖，所以不会让房屋下沉。尽管当今科技这般发达，建筑方法可轻而易举用其他材料顶替，却难以仿效威尼斯特有的古韵与魅力。

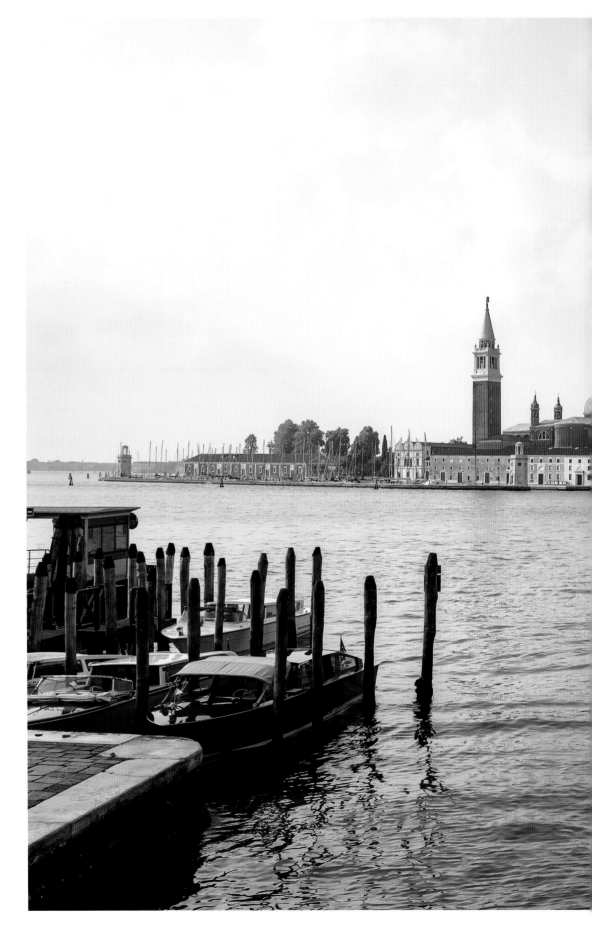

停泊岸边的贡多拉。四十年前的蜜月之旅，我与老伴第一次体验贡多拉，船夫一边划桨，一边高唱意大利情歌，尽情展露意大利人天生热情奔放和浪漫多情的性格。

Gondola moored off the shore. Forty years ago, during our honeymoon, my wife and I enjoyed a romantic gondola ride for the first time. Our boatman serenaded us with captivating Italian love songs while skillfully navigating the bow of the boat, showcasing the passionate and romantic nature of the Italians.

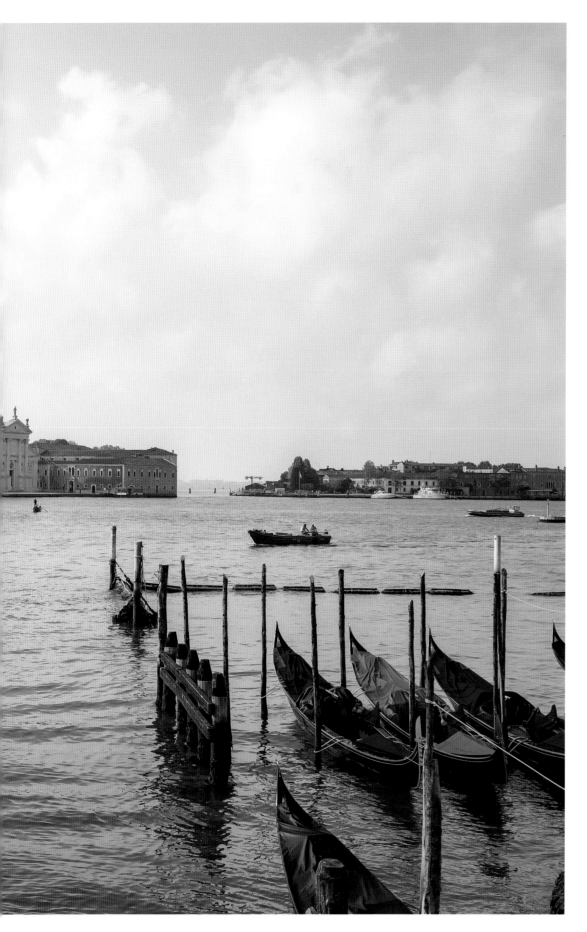

Personally, I have a deep and special fondness for Venice. In particular, the year 2020 has been ravaged by the pandemic and also holds unique significance for me as it marks my 40th wedding anniversary. Venice was one of the enchanting destinations of my honeymoon in 1980. Returning to Venice amidst this unprecedented pandemic is not just a simple revisit, but an experience filled with profound emotions and cherished memories.

The city of Venice, rather than being a solid land mass, is a mosaic of one hundred and eighteen islands interconnected by an abundance of bridges. These islands are embraced by the Grand Canal, stretching four kilometers in length and reaching depths of five meters. With widths varying from thirty to seventy meters, this waterway is accompanied by a network of one hundred and seventy-seven tributaries. It truly lives up to its reputation as 'a water city', born from the water, adorned by the water, and thriving because of the water.

The city is like a large-scale museum, filled with countless traditional Venetian structures exuding a unique charm. Its construction technique is truly extraordinary: locals first drove wooden posts into the ground, then laid Istrian Stone known for its remarkable waterproof and seawater corrosion-resistant properties, before finally laying bricks on top to construct houses. The sturdy boulders provide support for the lighter bricks, preventing them from sinking. Despite modern technological advancements and the convenience of replacing construction materials, it remains challenging to replicate Venice's old-world charm and craftsmanship.

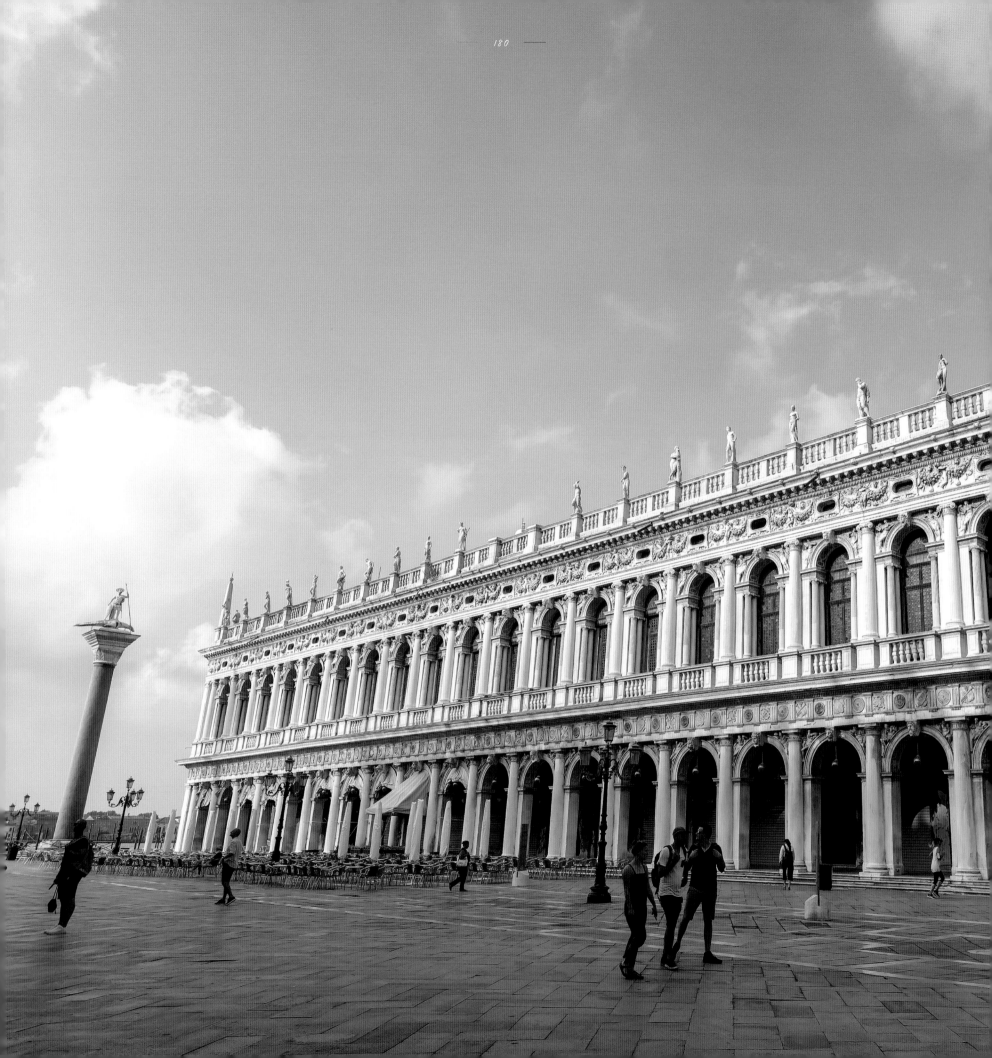

圣马可图书馆同样也是位于圣马可广场上的建筑

Biblioteca Marciana (Marciana Library) is another building in the Piazza San Marco (St. Mark's Square)

回想一九八○年的威尼斯蜜月之旅，是我首次出国。威尼斯的美无法描绘和言喻。每次到访，也总会去当年下榻的酒店看一看，努力寻回当年的回忆。

Reflecting on my enchanting honeymoon in Venice back in 1980, my first time abroad left me utterly spellbound by the beauty of this captivating city. Consequently, whenever I find myself in Venice, I make a point to revisit the very hotel that housed us during those cherished days, allowing me to bask once more in the sweetness of that time.

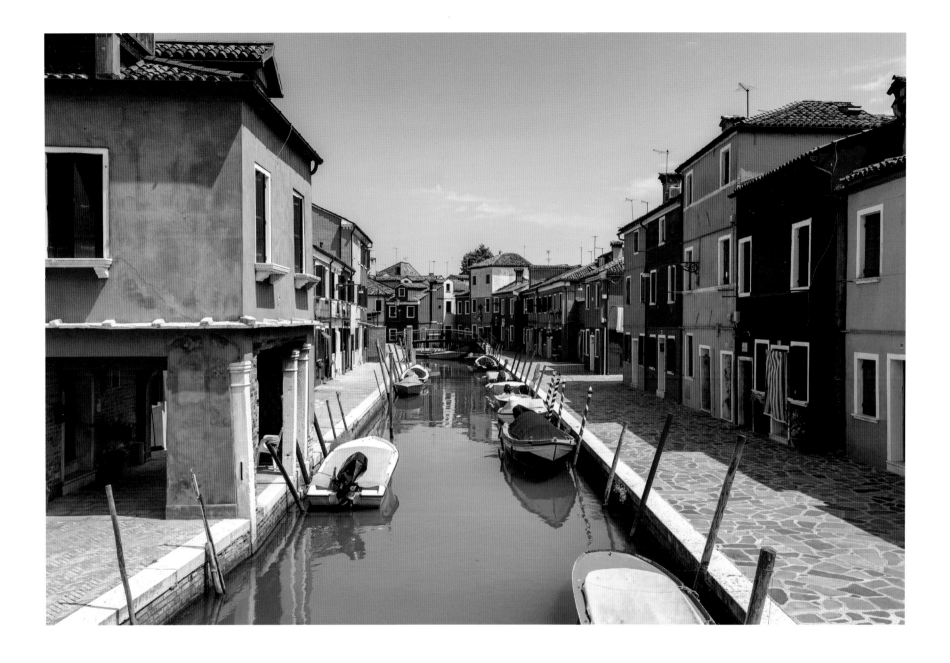

威尼斯的布拉诺岛，五颜六色的小屋，依水道和窄窄的运河而建。

Burano Island with a collection of colorful huts that line the waterways and narrow canals.

圣马可广场上的红衣女郎

A lady in red in the Piazza San Marco (St. Mark's Square)

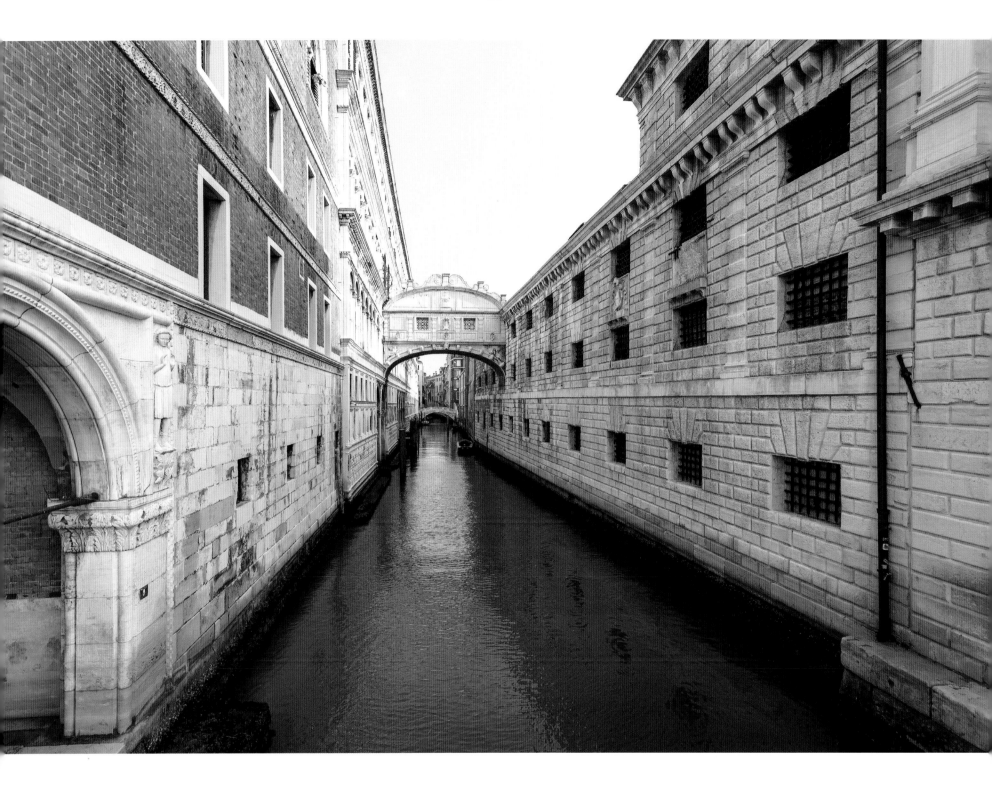

威尼斯当地也有一个传说：日落时，如果恋人们在图中叹息桥下的贡多拉上亲吻对方，将会得到天长地久的永恒爱情。

In Venice, a captivating local legend says that if lovers share a kiss on a gondola beneath the Bridge of Sighs at sunset, they will be promised enduring love that transcends time and space.

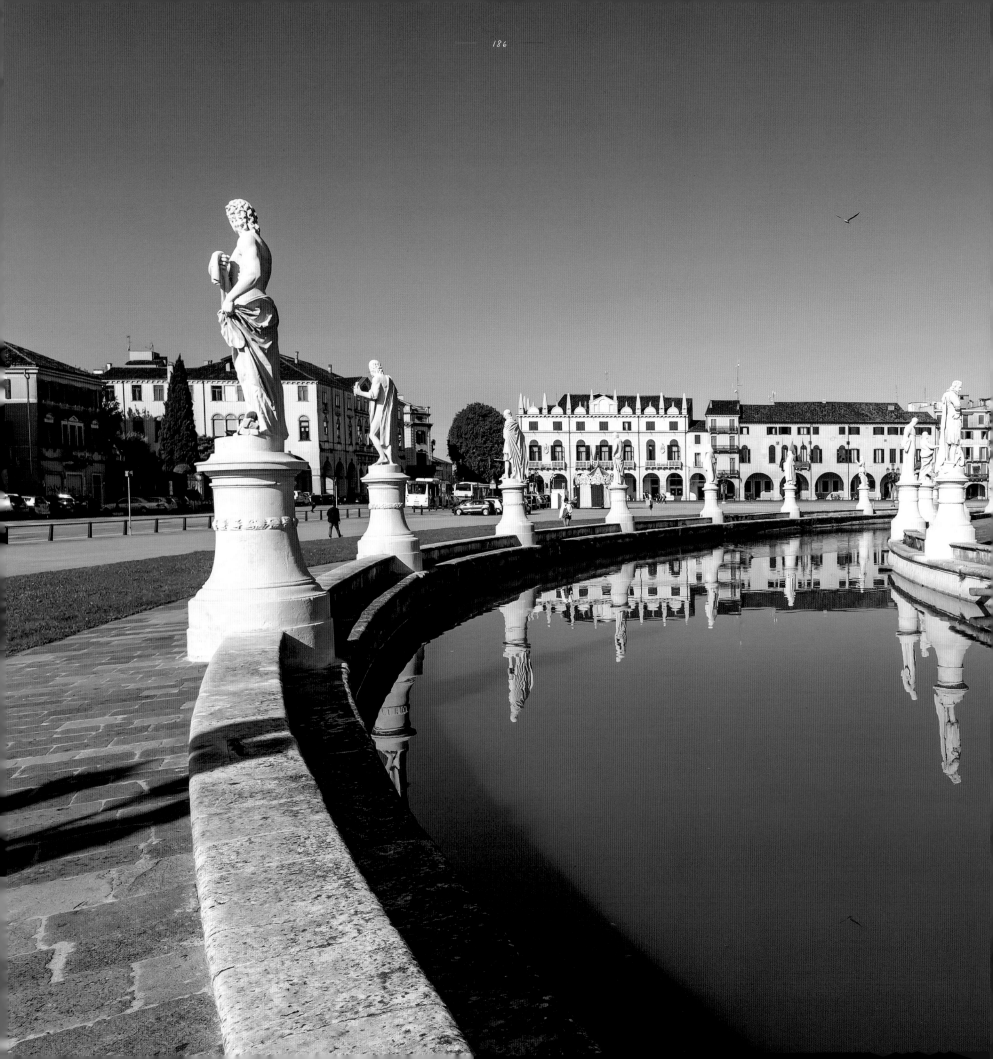

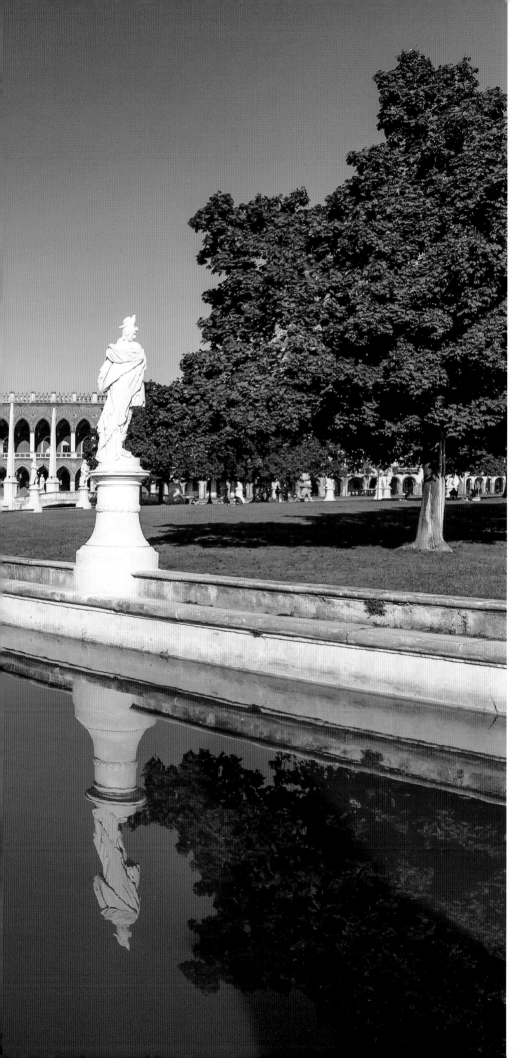

帕多瓦有一座全意大利最大的广场，名叫河谷草地广场。广场有七十八尊纯白色雕像点缀其间，其中一尊就是鼎鼎大名的伽利略。

In Padova lies Italy's largest square, Prato della Valle (Meadow of the Valley), which is dotted with seventy-eight white statues paying homage to historical luminaries such as the famous Galileo.

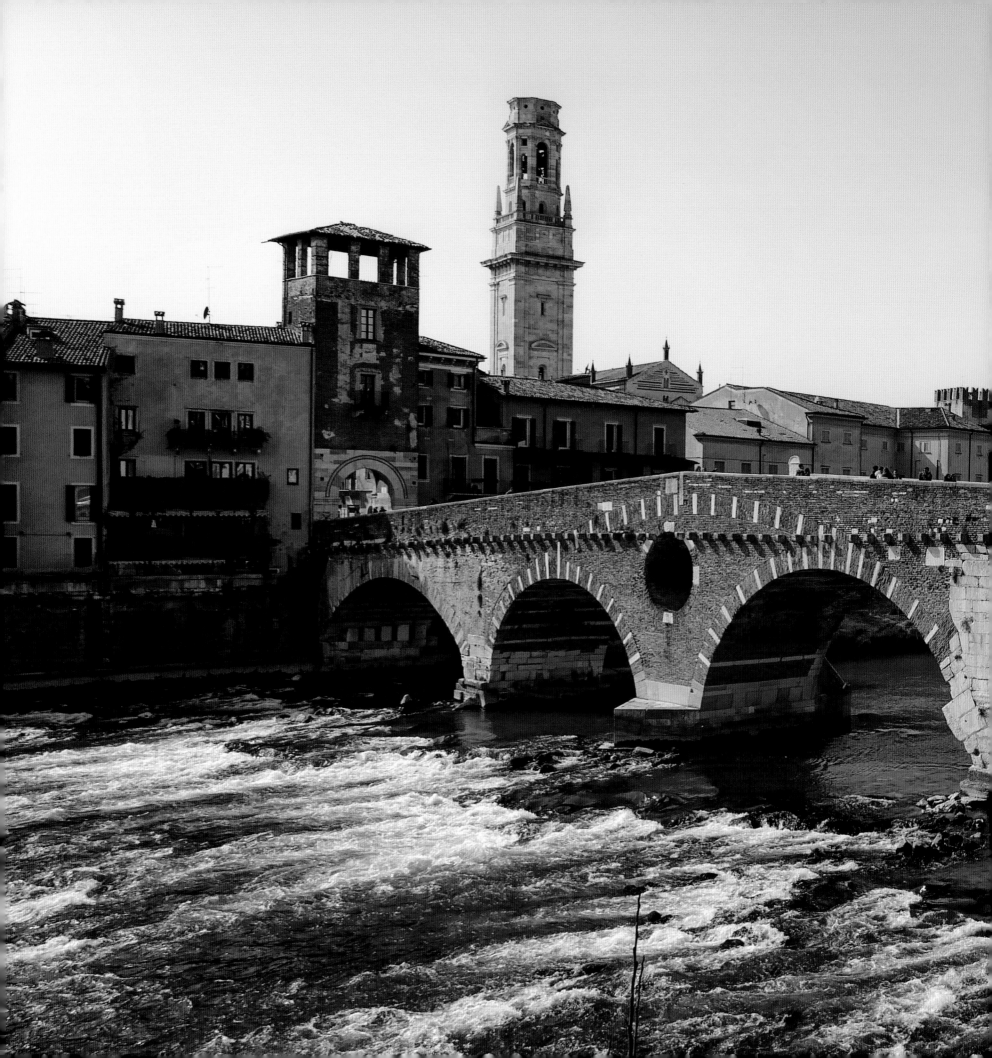

维罗纳的佩雅托桥。最初的桥身是木制的，公元前一世纪改建成石桥。

The Ponte Pietra (Stone Bridge) of Verona, a wooden bridge replaced by a stone structure in the 1st century BC.

领主广场又称为但丁广场，因为广场中心位置竖立了
一尊以史诗《神曲》流传后世的意大利诗人但丁雕像。

Piazza dei Signori (Lords' Square), also known
as Piazza Dante (Dante Square) because of
the statue of Dante Alighieri, the Italian poet
famous for his epic poem *The Divine Comedy*.

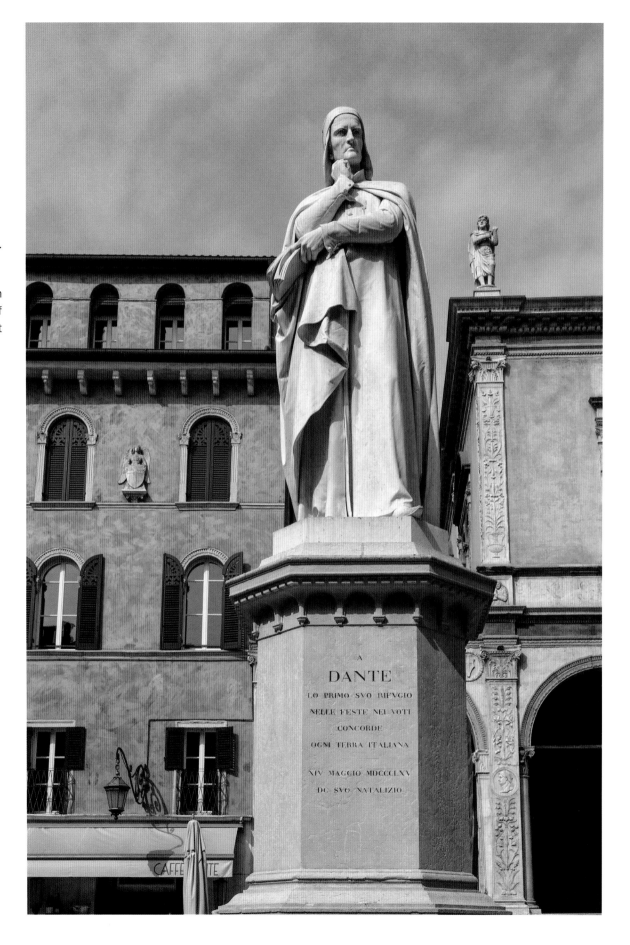

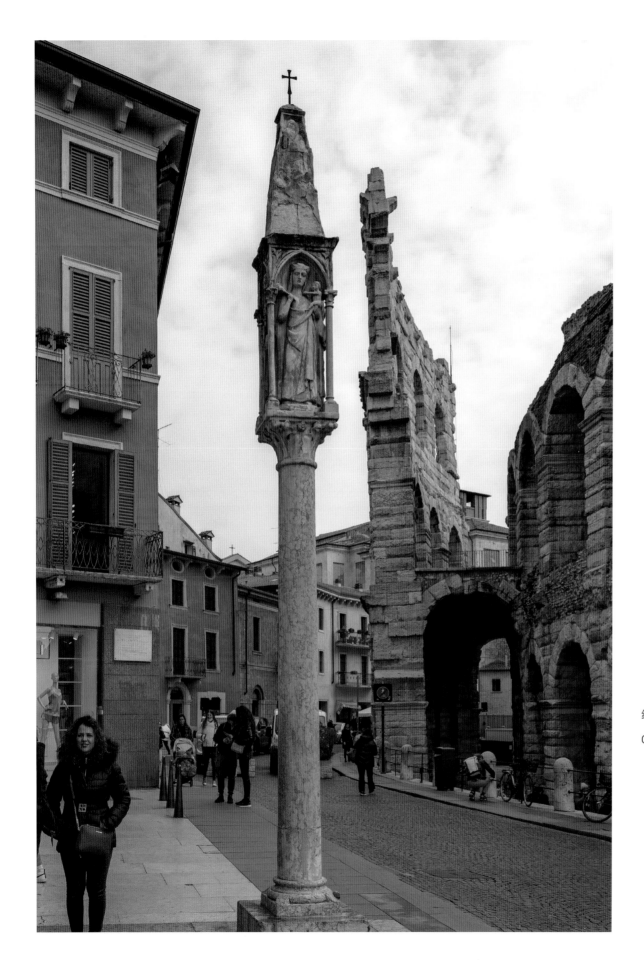

维罗纳布拉广场一侧

One side of Piazza Bra (Bra Square) in Verona

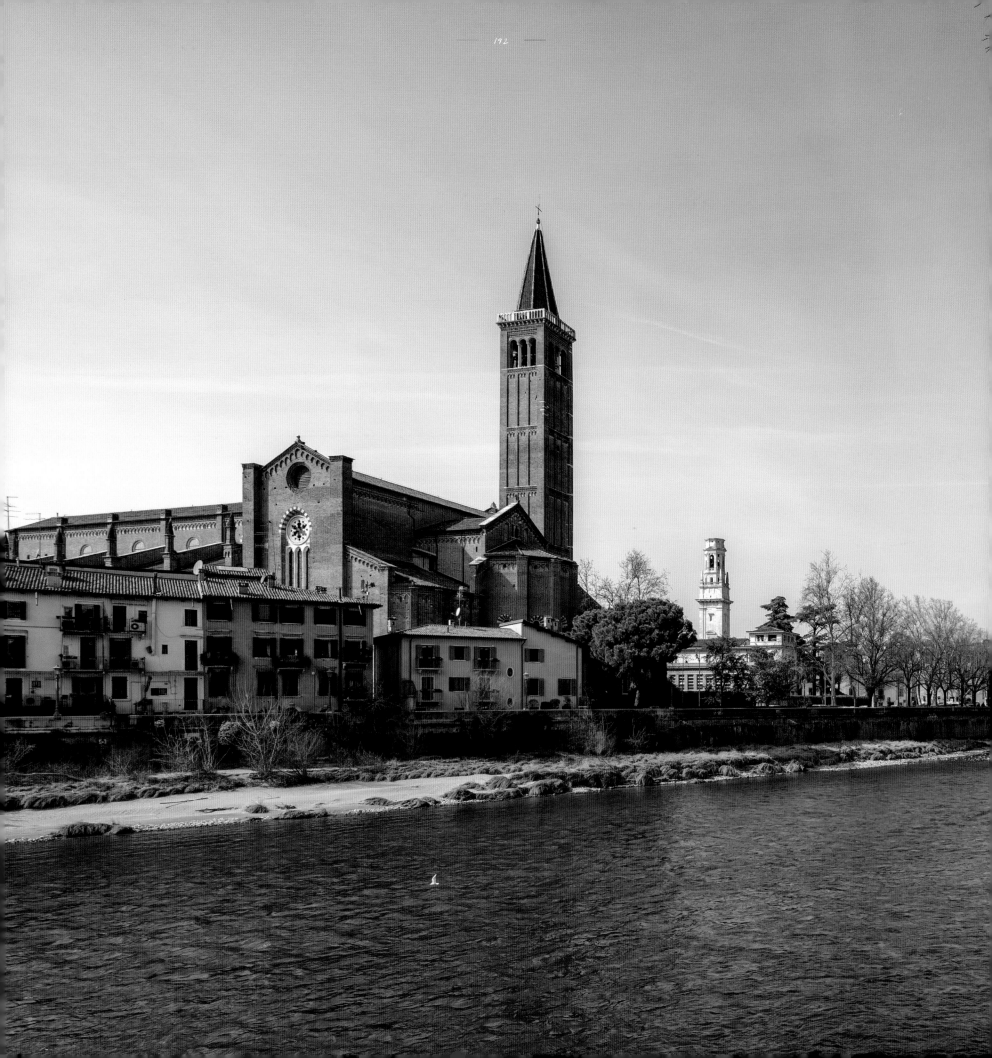

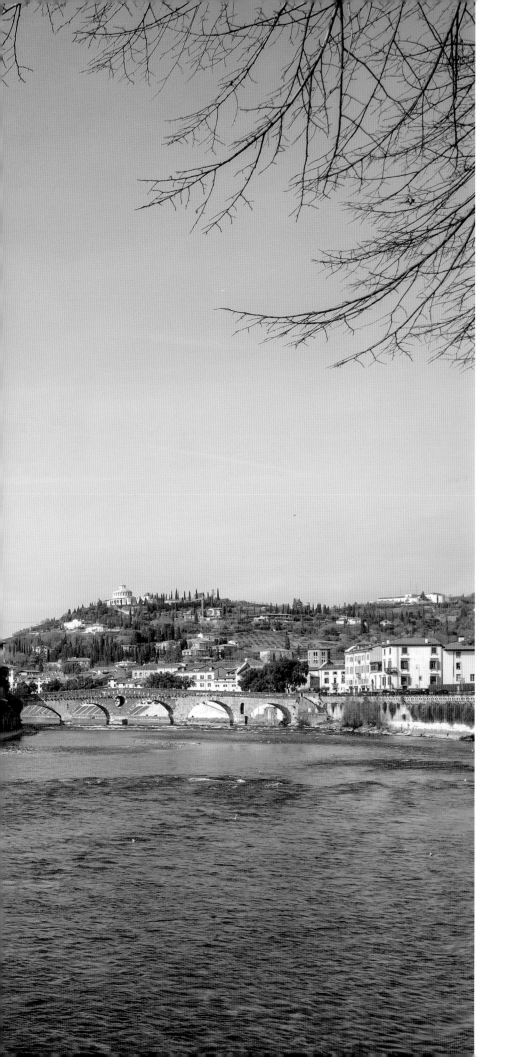

阿迪杰河

Riva dell'Adige (Adige River)

朱丽叶故居位于维罗纳市中心，一座朱丽叶青铜塑像
竖立在庭院里，她下垂的右手臂以及右胸位置显得格
外锃亮，因为据说抚摸右胸会带来好运。

The former residence of Juliet sits in the
center of the Verona. In the center of the
courtyard stands a bronze statue of Juliet, and
her drooping right arm and her right breast
appear to shine especially, as it is believed that
caressing her right breast brings good fortune.

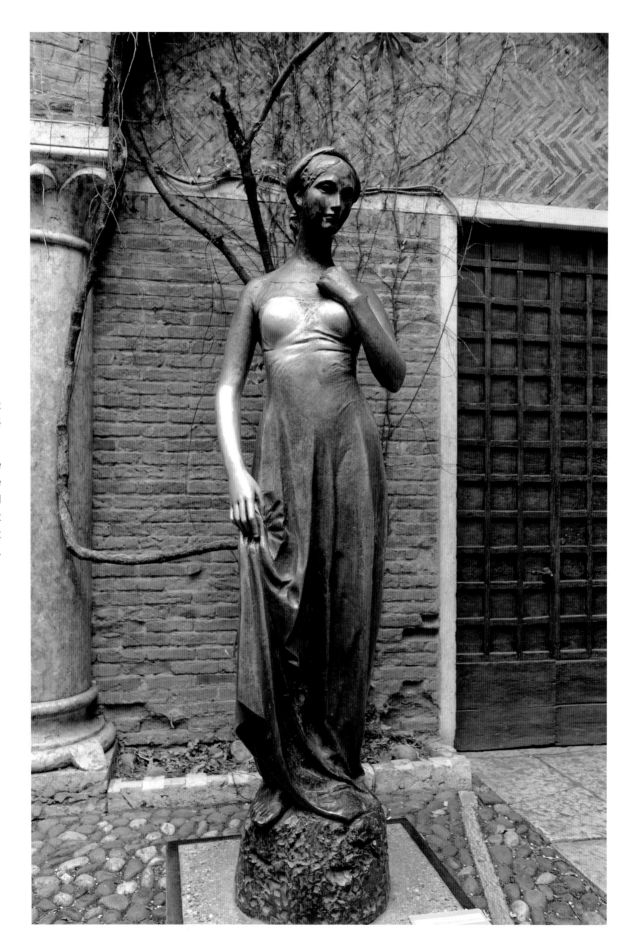

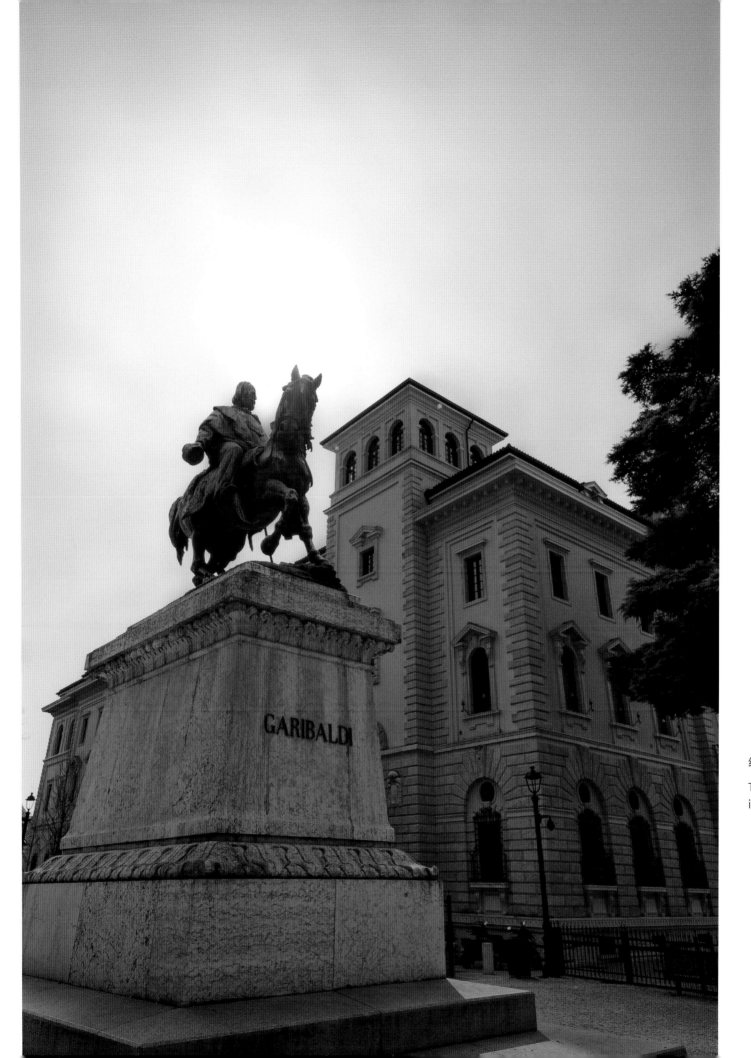

维罗纳加里波第雕像

The statue of Garibaldi
in Verona

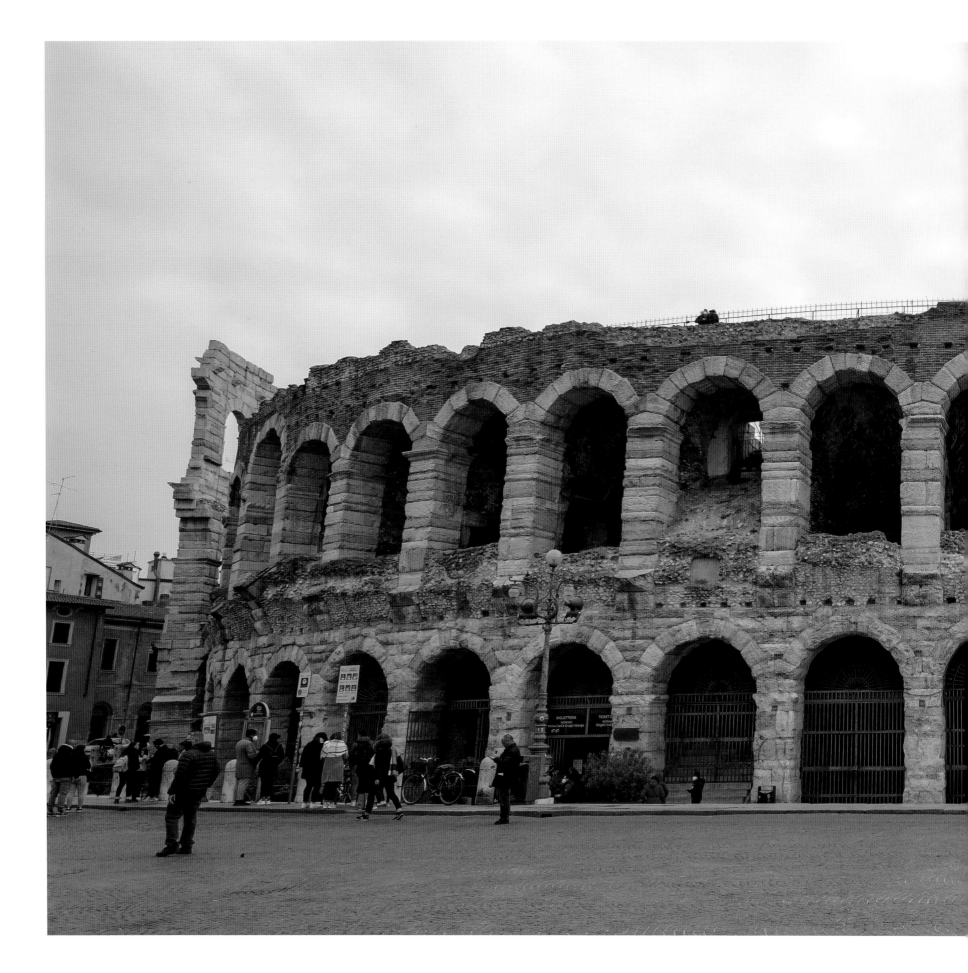

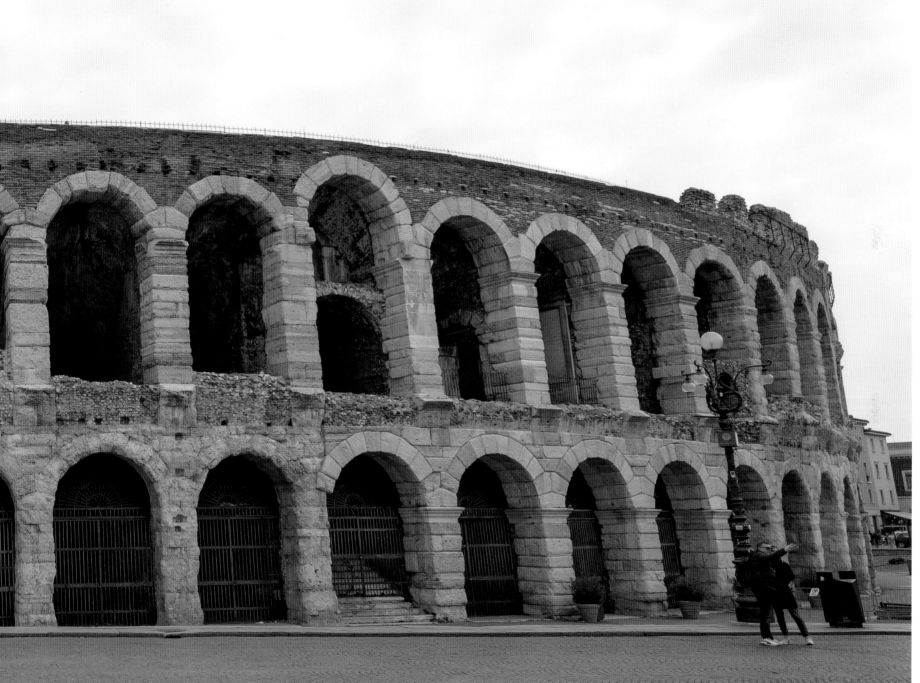

维罗纳圆形竞技场位于市中心的布拉广场上，建于公元三〇年，甚至比最著名的罗马竞技场还早。今天它依然在使用中，成为意大利最著名的大型歌剧表演场地。

The Arena di Verona (Verona Arena), still actively hosting performances today, has developed into Italy's most famous venue for grand opera. Erected in 30 AD at the heart of Piazza Bra (Bra Square), it even predates the iconic Colosseum.

多洛米蒂山区秋季美景

Autumn scenery in the Dolomites

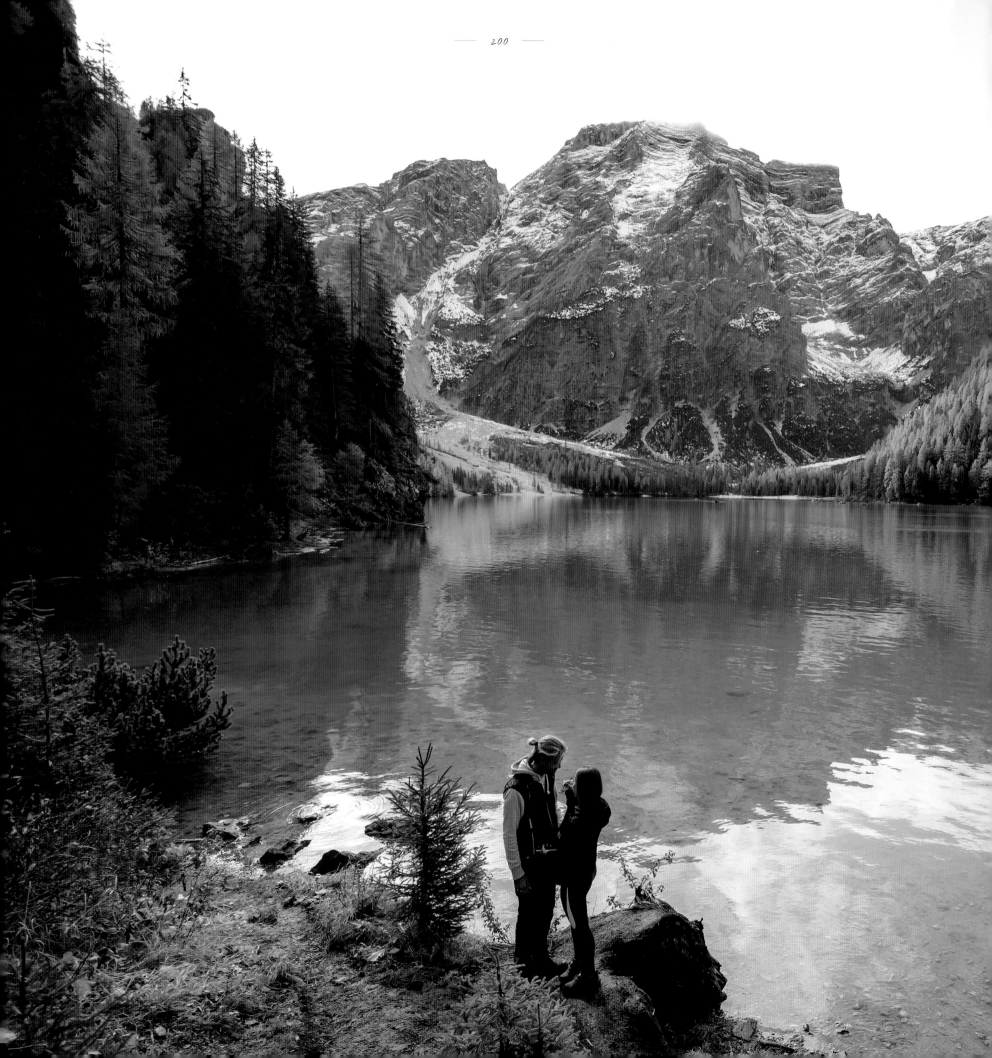

多洛米蒂的布莱埃斯湖，此湖距离奥地利边境不过三十公里。群山雪峰、山水秀丽、景色优美。

Lago di Braies (Lake Braies) in Dolomites is located less than thirty kilometers from the Austrian border. The majestic snow-capped mountains and stunning scenery create a truly enchanting landscape.

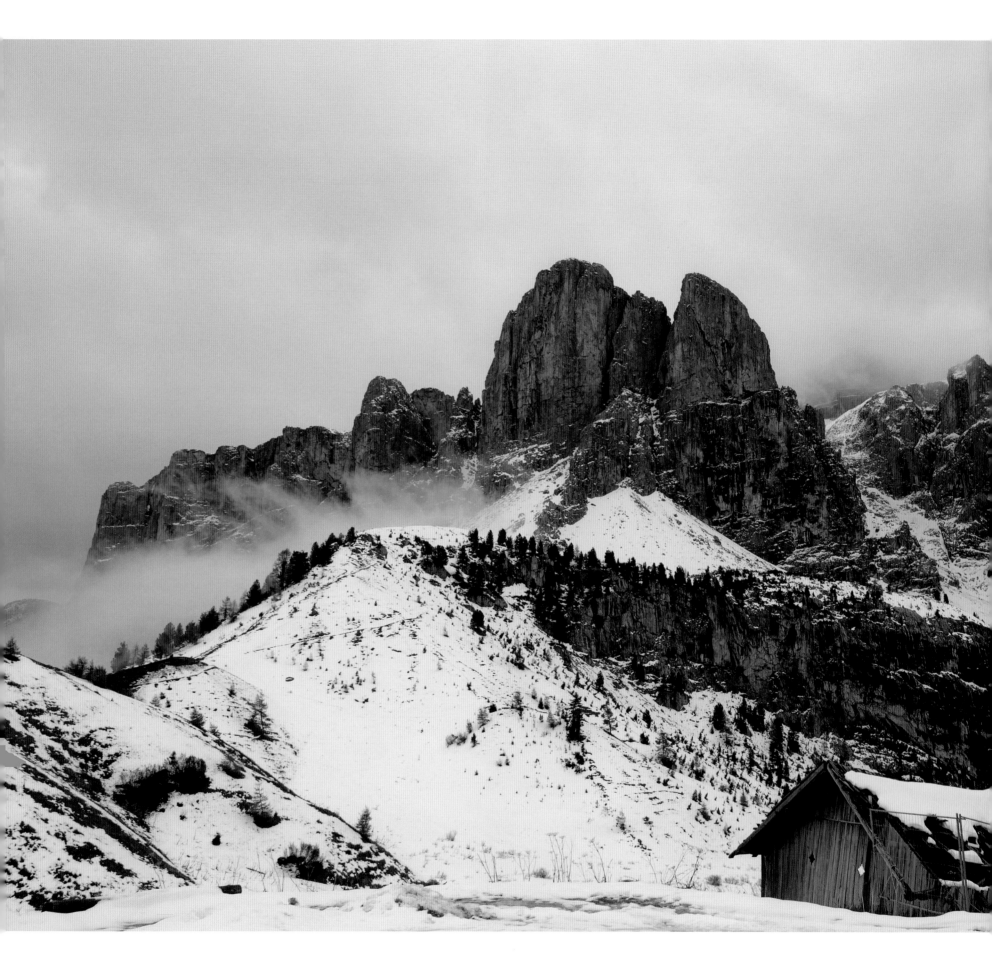

多洛米蒂山区冬景

Winter scenery in the Dolomites

的里雅斯特建于一四〇〇年的圣朱斯托教堂，朴素的外观使得巨大的玫瑰花窗更为醒目。

The 1400-built Cattedrale di San Giusto (Cathedral of San Giusto) in Trieste has an austere façade that serves as a perfect complement to its magnificent rose windows.

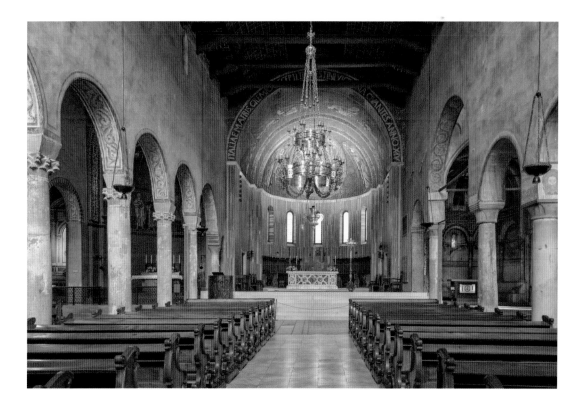

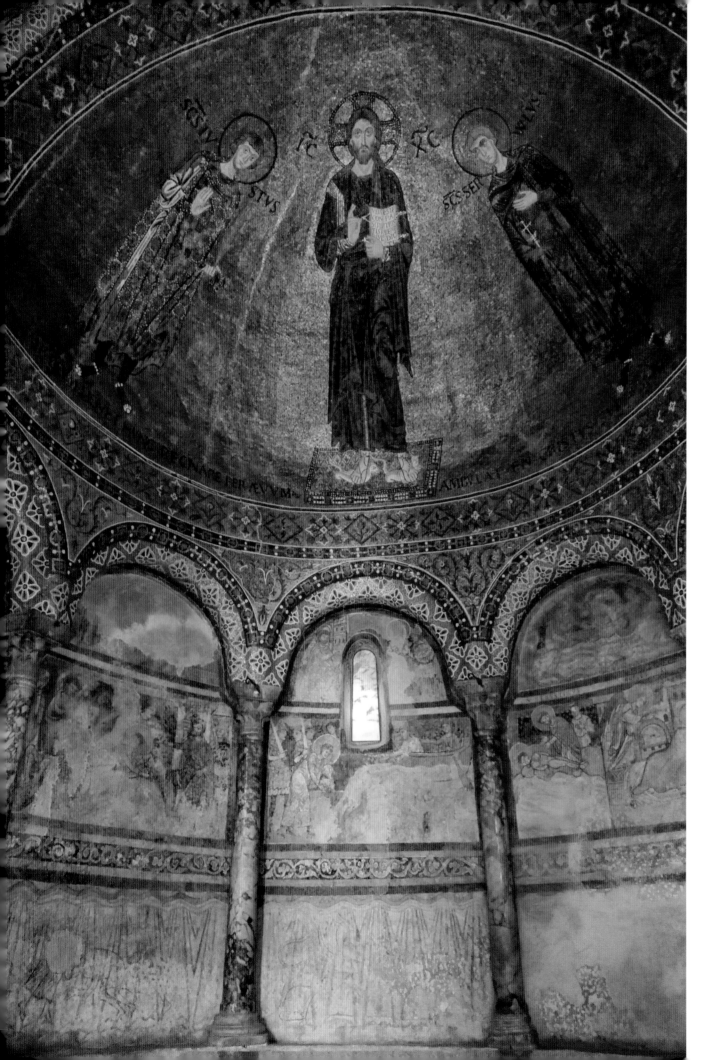

的里雅斯特圣朱斯托教堂的马赛克镶嵌画与湿壁画

Mosaics and frescoes of Cattedrale di San Giusto (Cathedral of San Giusto) in Trieste

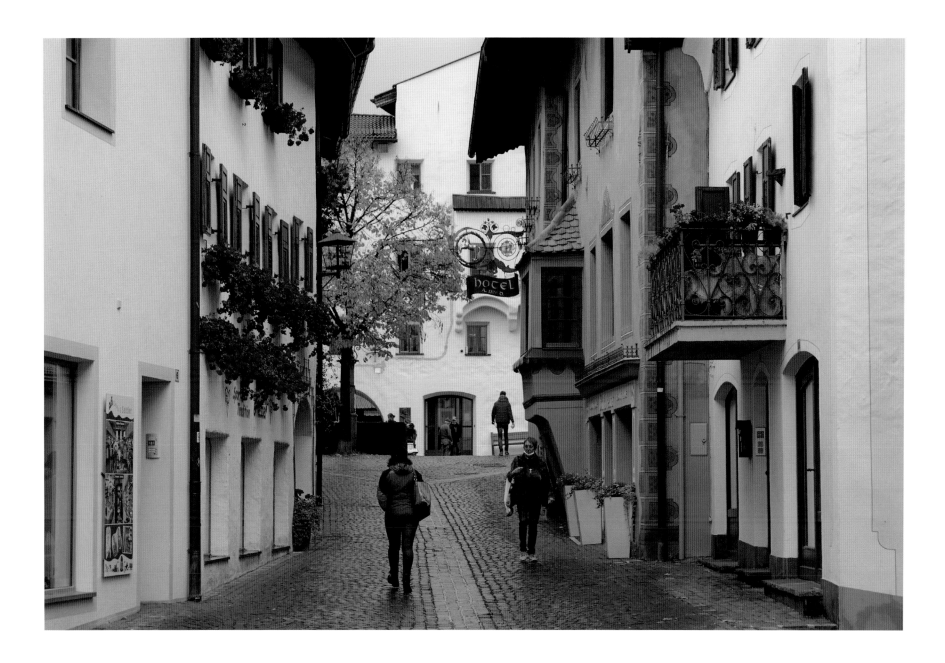

多洛米蒂山区卡斯泰尔罗托

Castelrotto in the Dolomites

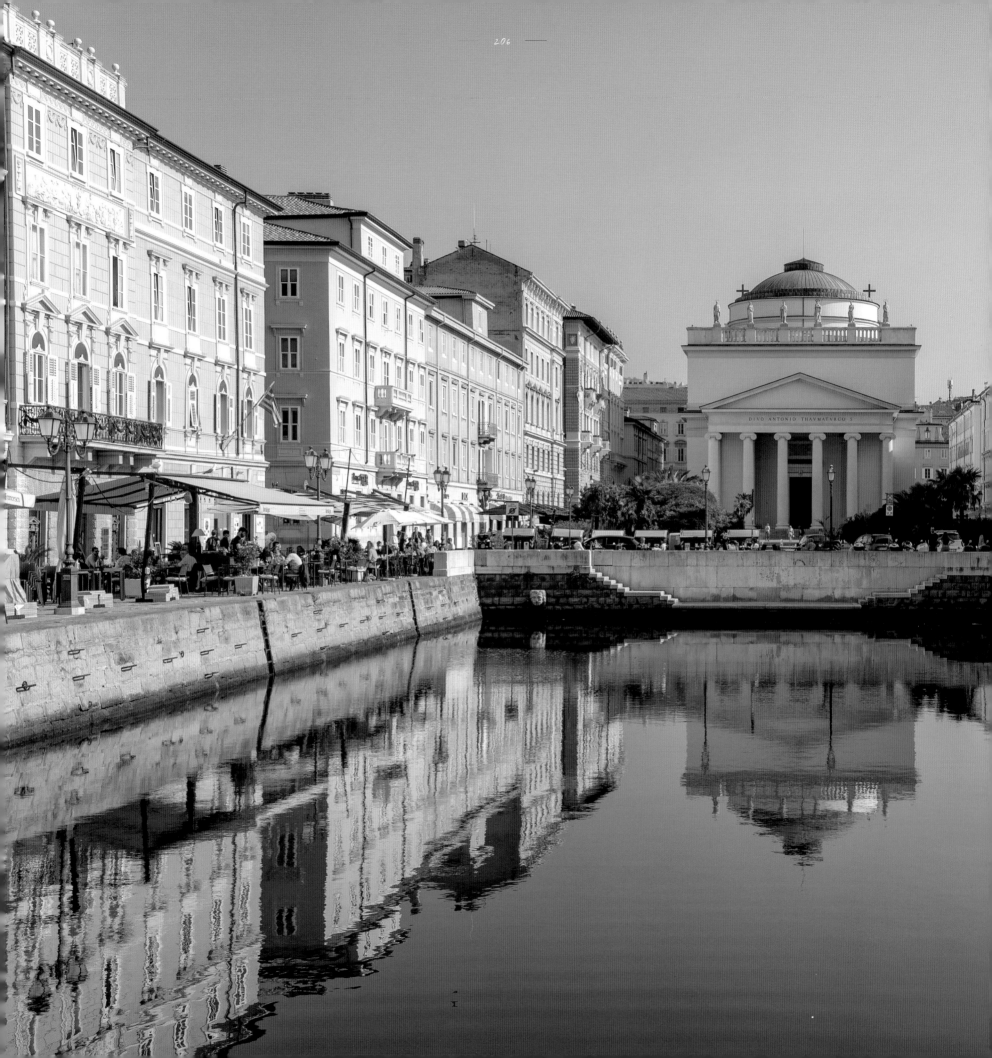

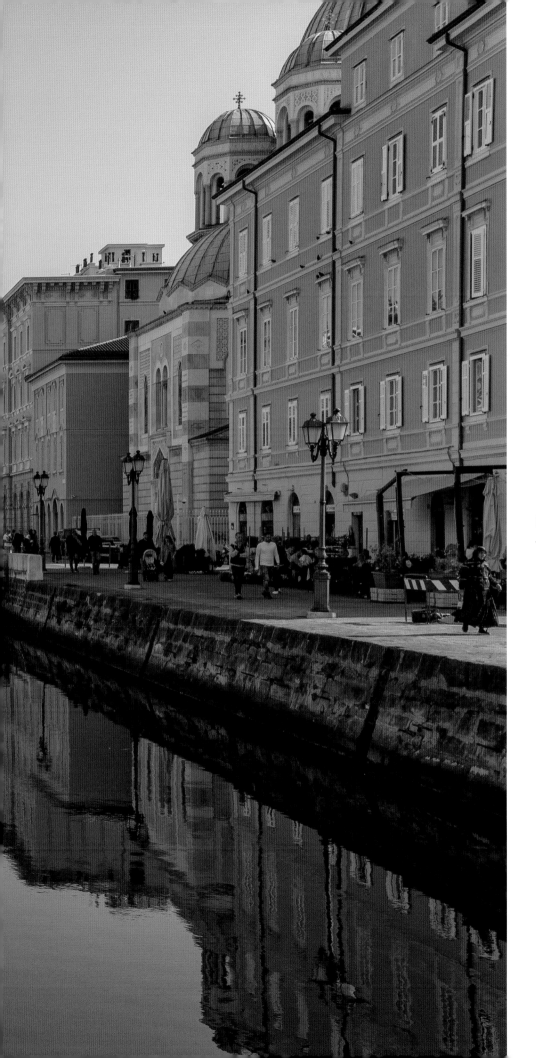

的里雅斯特大运河

The Grand Canal of Trieste

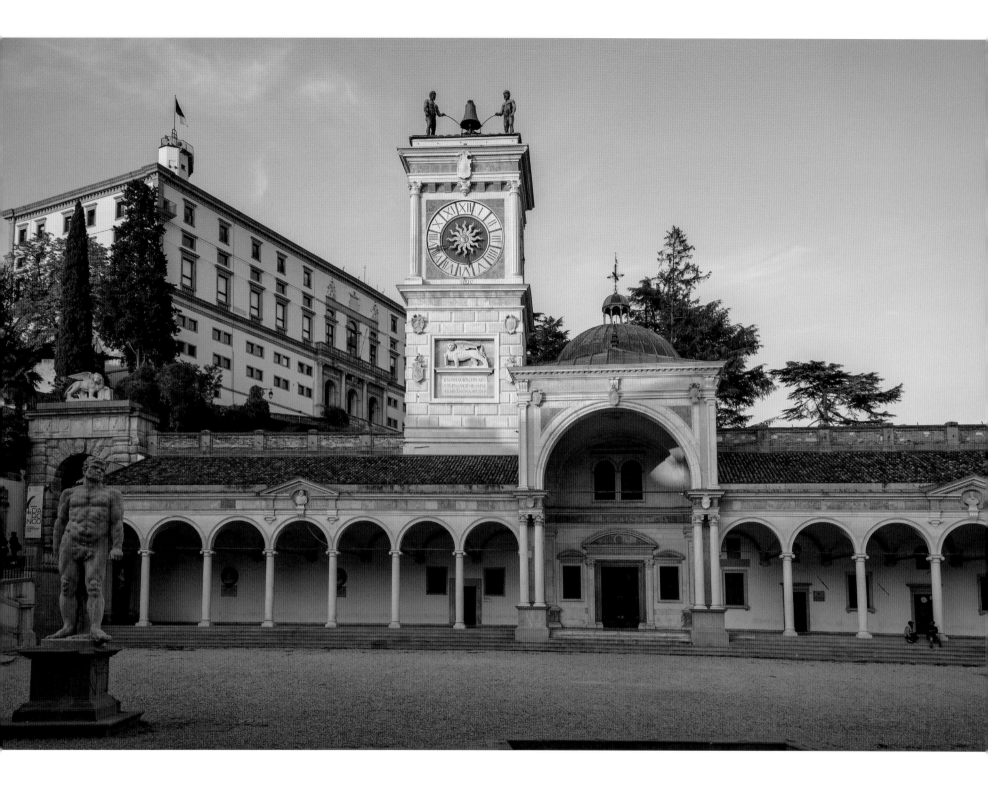

乌迪内的圣若望教堂及教堂前的圣乔凡尼长廊

Udine's Cathedral of San Giovanni, and the Loggia di Lionello (Loggia of Lionello) in front of it.

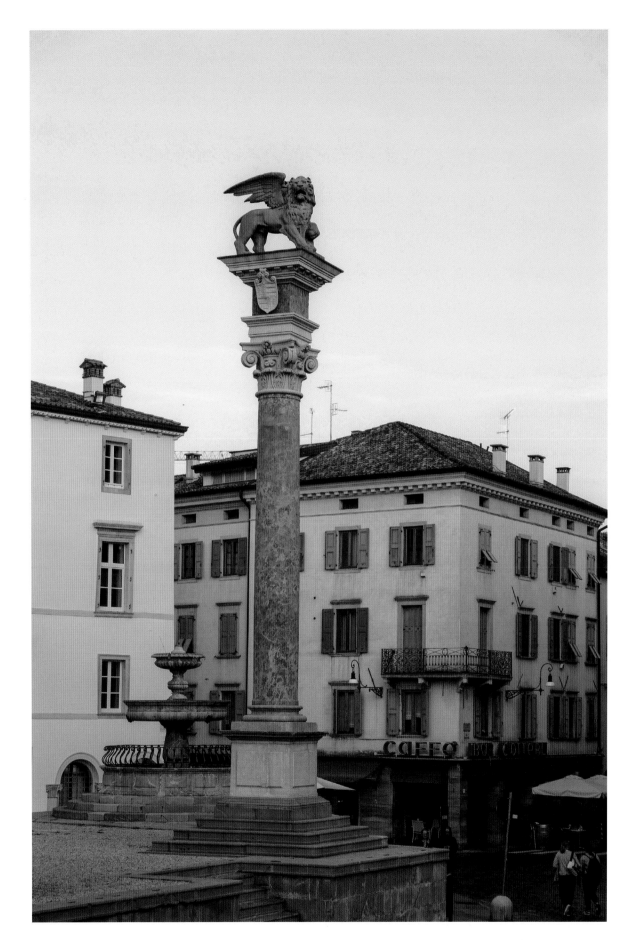

乌迪内自由广场上还矗立着正义柱、罗马神话中大力士赫拉克勒斯和卡库斯的雕塑，以及和平纪念碑等，图为圣马可之狮柱。

In the Piazza Libertà (Liberty Square) of Udine, there are the Column of Justice, statues depicting Heracles and Cacus from Roman mythology, and the Monumento della Pace (Peace Monument). In the picture is the Winged Lion of Saint Mark.

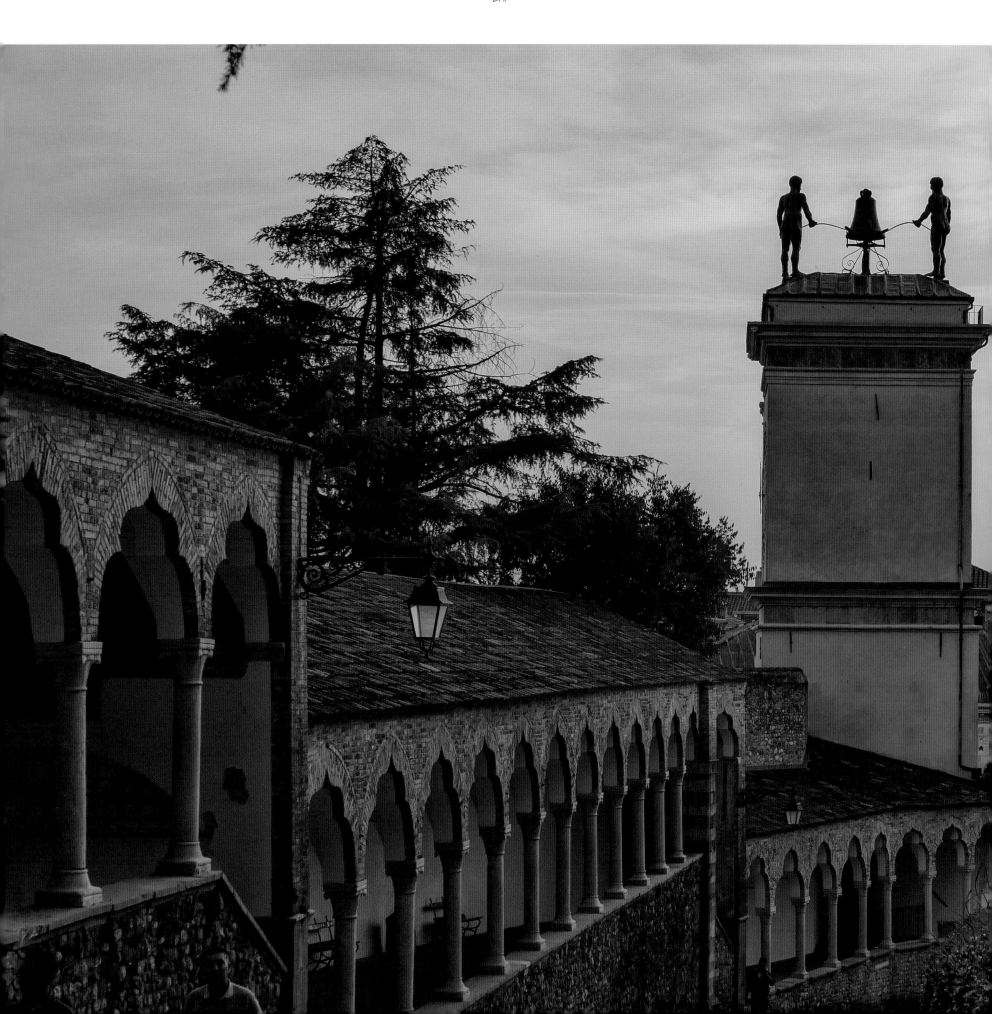

巴萨诺—德尔格拉帕镇上的雕塑

Sculptures in Bassano del Grappa

乌迪内城堡入口的斜坡与长廊，可望见圣若望教堂的钟楼及上方的敲钟摩尔人。

The ramp and corridor at the entrance to the castle in Udine provide a view of the bell tower of the Cathedral of San Giovanni and the bell-ringing Moors above.

特伦托圣维吉利奥大教堂及海神喷泉

The Cathedral of San Vigilio and the Fountain of Neptune in Trento

从特伦托布翁孔西格利奥城堡上层欣赏特伦托城貌

Viewing the townscape of Trento from the upper level of Castello del Buonconsiglio (Buonconsiglio Castle)

都灵及
周边地区

Turin and its
captivating neighbouring regions

二〇二二年春，欧洲多个国家宣布解除旅游禁令，我高兴之余，马上收拾行囊，迫不及待前往被疫情困扰一年多的意大利，这次重点游是皮埃蒙特大区的首府都灵。自古罗马时代开始，这座城市周遭便筑起围墙，形成具防御性的军事要塞，尽管多次经历战祸，古城依然保存完整。也因为罗马时期的规划，使得都灵道路笔直，城市方正。

眼见与导游相约时间已到，我从罗马大街匆匆忙忙赶回酒店，见到导游女士已气定神闲地等候着我了。她获知我今早独自漫步于古城大街小巷之间，于是建议临时调整当日的行程，由原来的市内观光、参观皇宫和博物馆等活动，改为先到郊外走走，到苏萨河谷的皮基利亚诺山山顶，参观圣米凯莱修道院（又译作圣弥额尔修道院），这是法兰契杰纳朝圣之路中，朝圣者经过意大利时的落脚点之一，并非一般旅客游览的景点，但对朝圣者来说，却是必经之地。

在都灵古城内外观光游览，尽管它的名声不及罗马、文艺气质比不上佛罗伦萨，繁华时尚更无法与米兰匹敌，但它内容多元，让旅人有更多不同的选择。尤其博物馆、艺术馆、画廊众多，汇聚古今珍品，包罗万有，如果要细心观赏，安排一个星期时间也不为多。

在都灵的最后行程，就着重参观博物馆。由于时间只剩最后一天，导游提议挑选精华中的精华，于是我们最后决定分上、下午时段参观玛德玛宫和都灵埃及博物馆这两处。在夫人宫内可以欣赏到不同的建筑风格和装饰魅力，在宫内的古代艺术博物馆，收藏逾七万件从十五世纪至十九世纪期间的绘画、雕塑、古籍、珠宝首饰，以及来自中国的瓷器等，就连大厅和房间也极尽奢华，不论天花板和地板都装饰精美的图案和绘画，当然也不乏各式各样的大小塑像，让我看得目不暇给，的确值得一游再游。

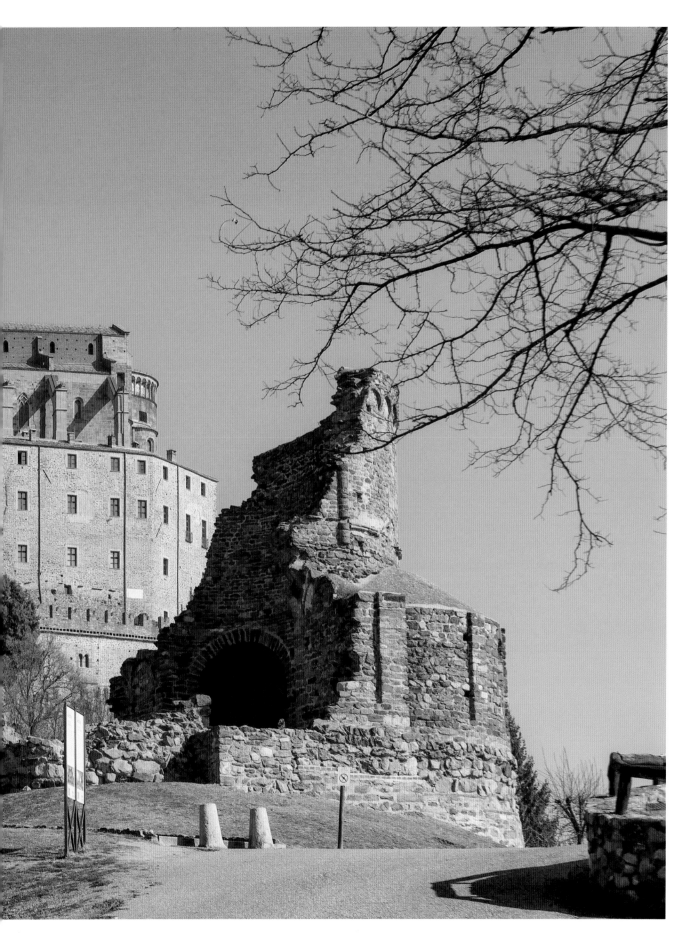

前方为提供修士们的居所，后方为圣米凯莱修道院。它俯视阿尔卑斯山山脉和波河河谷，在古罗马时期是重要的军事要塞。

In front is the place used to provide a residence for friars and behind is the Sacra di San Michele (Monastery of San Michele). Perched high above, it commands a breathtaking view of the endless stretch of the Alps and the distant Po Valley, serving as a crucial military stronghold in ancient Roman times.

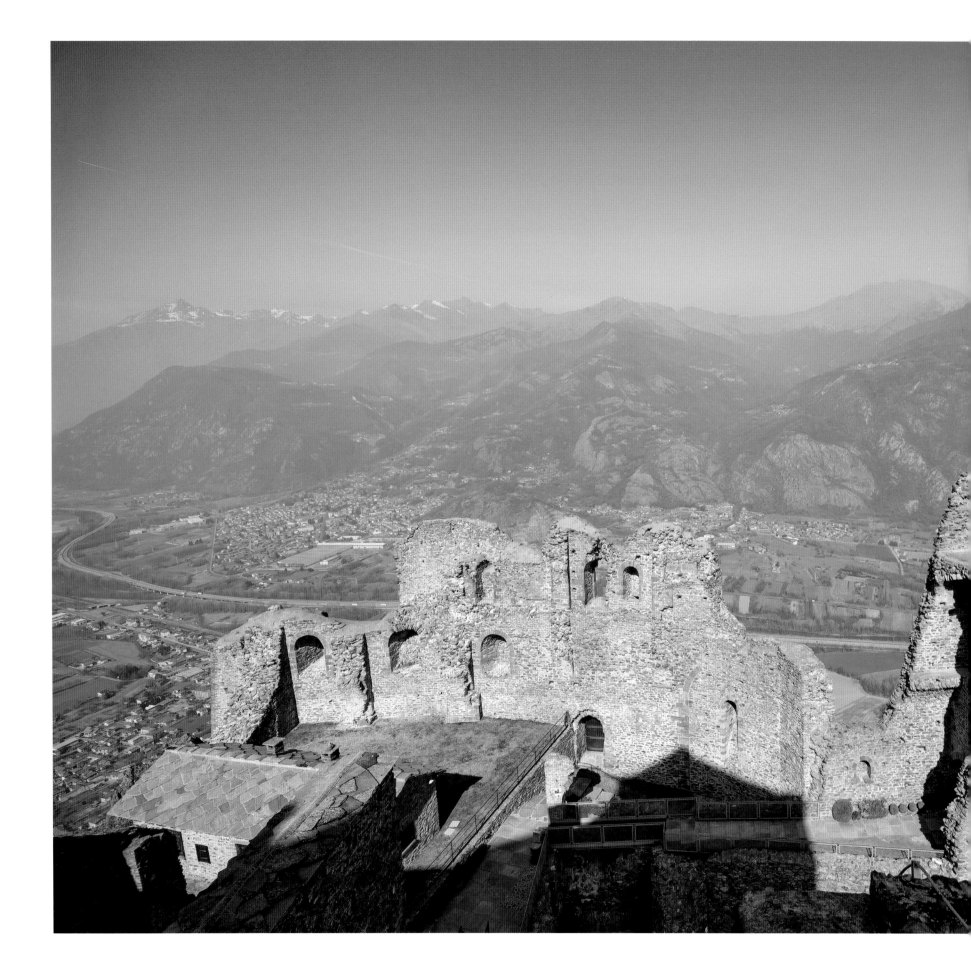

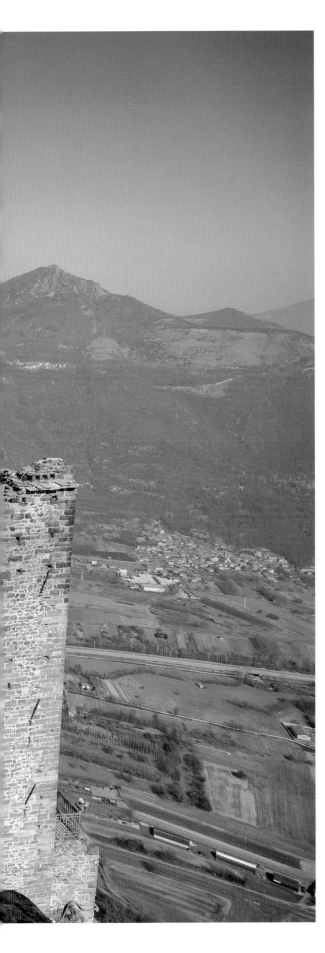

In the spring of 2022, with the jubilant announcement of travel bans being lifted across many European nations, I eagerly packed my bags and embarked on a journey to Italy, a country that had endured the grip of the epidemic for over a year. This time, my sights were set solely on Turin, the illustrious capital city of the Piedmont region. Since ancient Roman times, Turin has been protected by massive walls and strong fortifications that have withstood several wartime calamities with remarkable resilience. Furthermore, owing to the meticulous urban planning of the Romans, Turin is distinguished by its straight streets and well-organized cityscape.

As my scheduled appointment with the tour guide approached, I quickly made my way back to the hotel from Via Roma (Rome Street), where the elegant lady tour guide was waiting for me in a relaxed manner. Knowing that I had spent the early morning wandering alone through ancient streets, she proposed some temporary adjustments to our itinerary: instead of the usual city sightseeing and visits to royal palaces and museums, we could venture into the countryside for a hike up Pirchiriano hill in Val di Susa (Susa Valley), home to the Sacra di San Michele (Monastery of San Michele), one of the important stops along Italy's Via Francigena pilgrimage route. While not traditionally considered a tourist attraction, it holds great significance for pilgrims.

During the city tour of Turin, which may not have the same level of fame as Rome, artistic charm as Florence or opulence as Milan, it offers an abundance of options. In particular, it boasts a wealth of museums and art galleries that seamlessly blend ancient and modern characteristics in a myriad of treasures. To fully savor its delights, a schedule for a week or more would be ideal.

During our visit to Turin, with only one day remaining, we opted for a museum tour and selected the considered best two prestigious museums, the Palazzo Madama (Madame Palace) in the morning and the Museo Egizio (Egyptian Museum) of Turin in the afternoon, guided by my tour guide.Palazzo Madama contains a variety of architectural styles and decorative charm, and in its Ancient Art Museum, it houses an impressive collection of over seventy thousand paintings, sculptures, ancient books, jewelry and porcelain from China spanning the 15th to 19th centuries. The halls and rooms also exude an extraordinary air of luxury, with ceilings and floors covered in intricate patterns and exquisite paintings, as well as statues of various sizes. The collection of architectural decoration is so dazzling that it never fails to captivate my gaze, making it a truly enriching visit.

圣米凯莱修道院高处景致

View from the Sacra di San Michele (Monastery of San Michele)

圣米凯莱修道院教堂内的壁画

Frescoes in the church of the Sacra di San Michele (Monastery of San Michele)

圣米凯莱修道院的教堂

The church of the Sacra di San Michele (Monastery of San Michele)

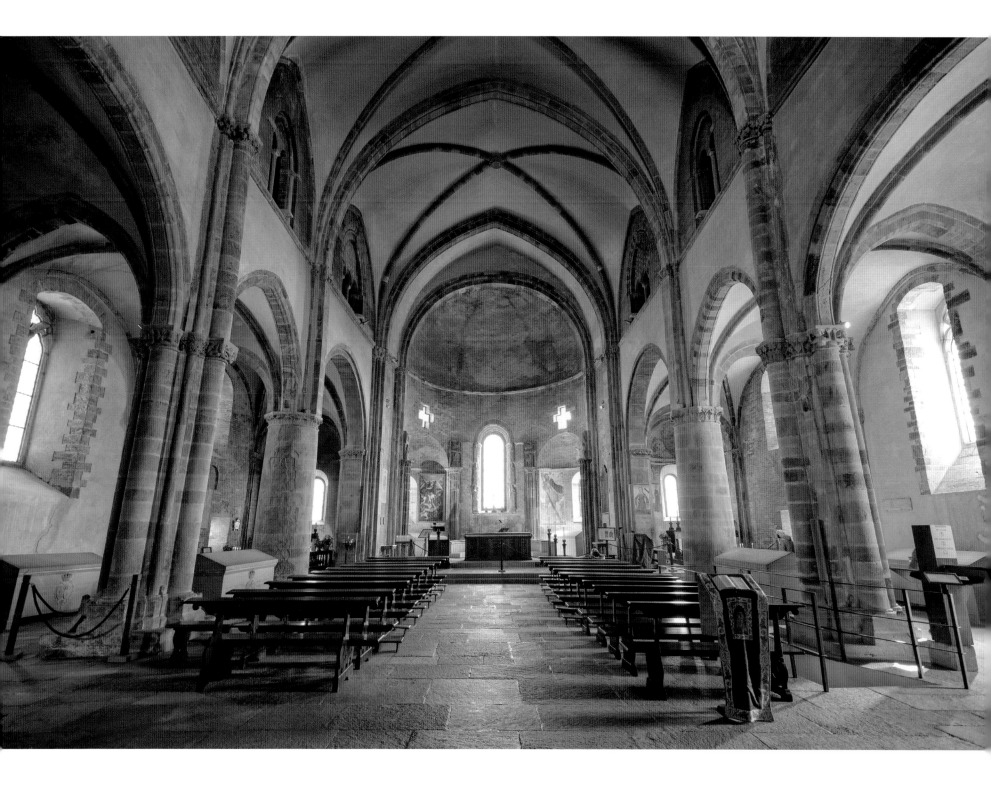

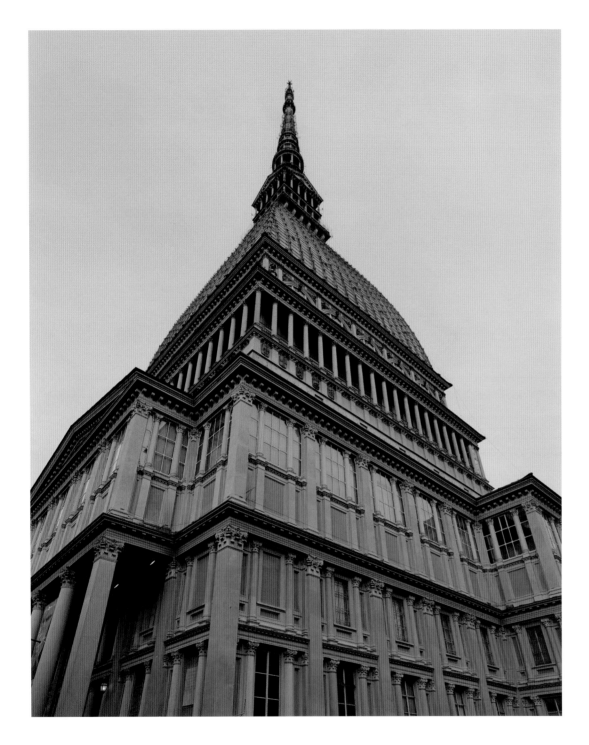

都灵安托内利尖塔如今为国家电影博物馆

Turin's Mole Antonelliana has been transformed into the National Film Museum

都灵萨伏依皇室礼拜堂内部，圆形小教堂中央祭坛上方如层层堆叠的圆顶。

Inside Turin's Cappella della Sacra Sindone (Chapel of the Holy Shroud) is a beautiful dome with a cascading design positioned above the central altar.

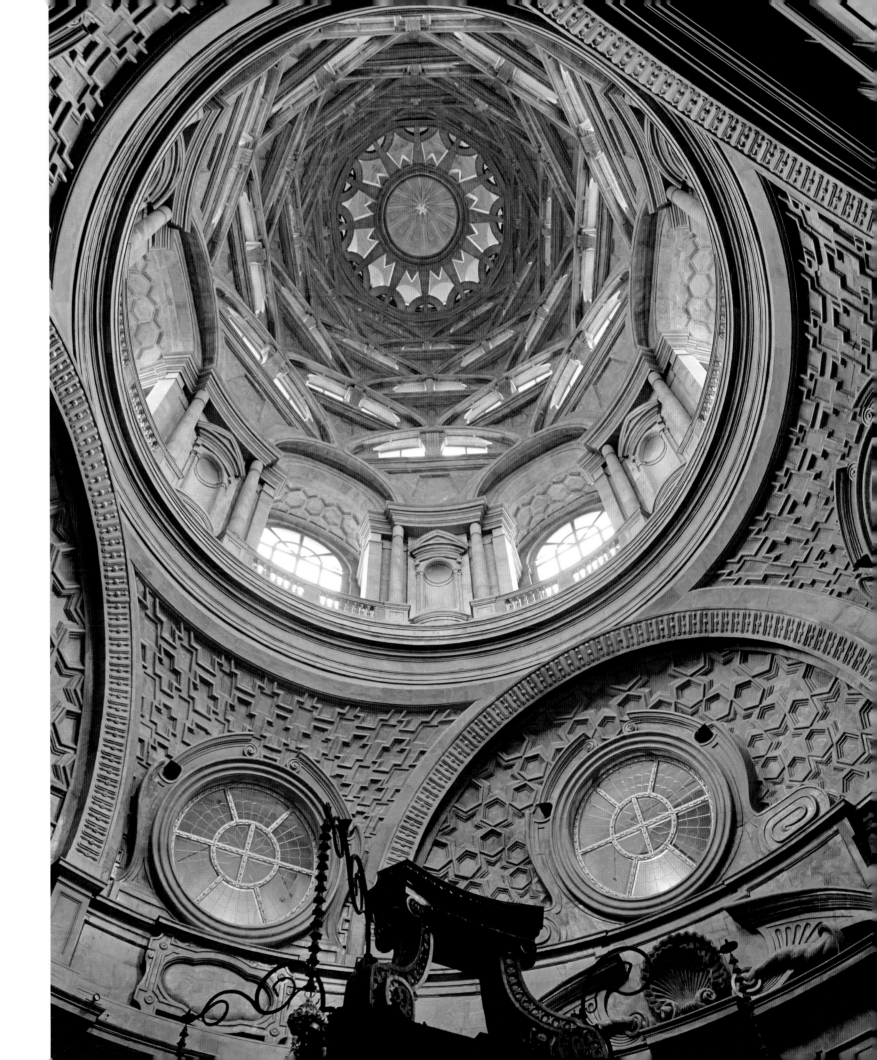

维纳利亚宫。它始建于一六七五年，是欧洲最美的巴洛克建筑代表之一，据说巴黎的凡尔赛宫一部分设计灵感也来自这里。

Reggia di Venaria (Palace of Venaria), which took shape in 1675, stands as one of the most beautiful Baroque architectural representations in Europe and is said to have served as an inspiration for the famous Palace of Versailles in Paris.

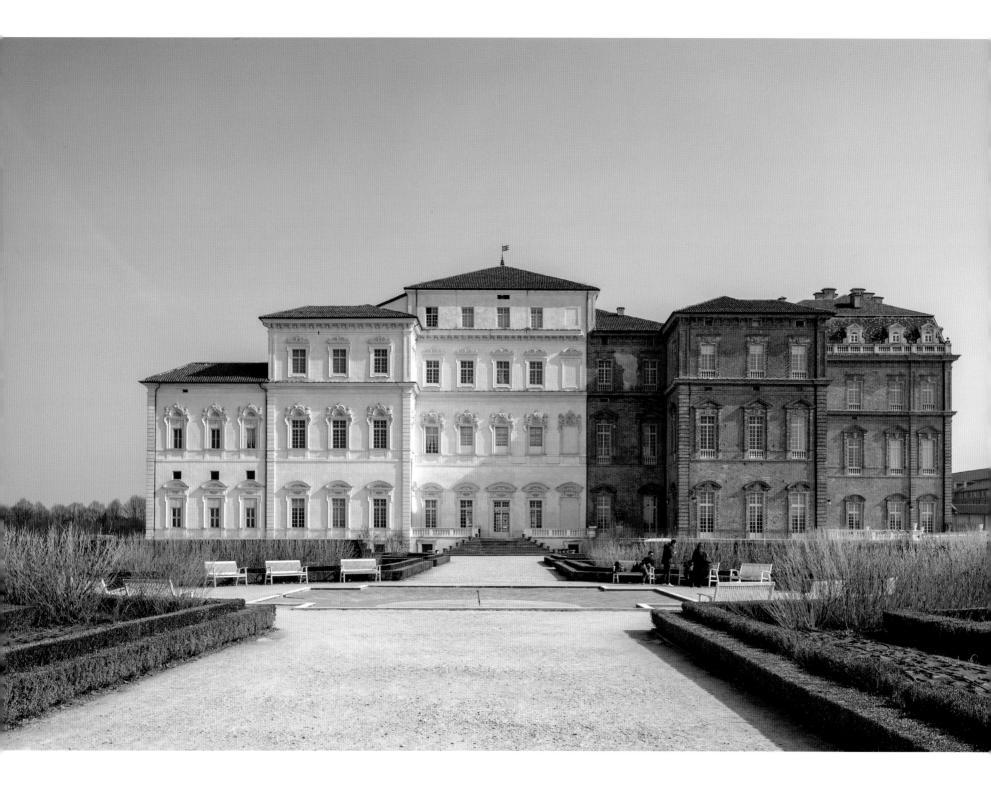

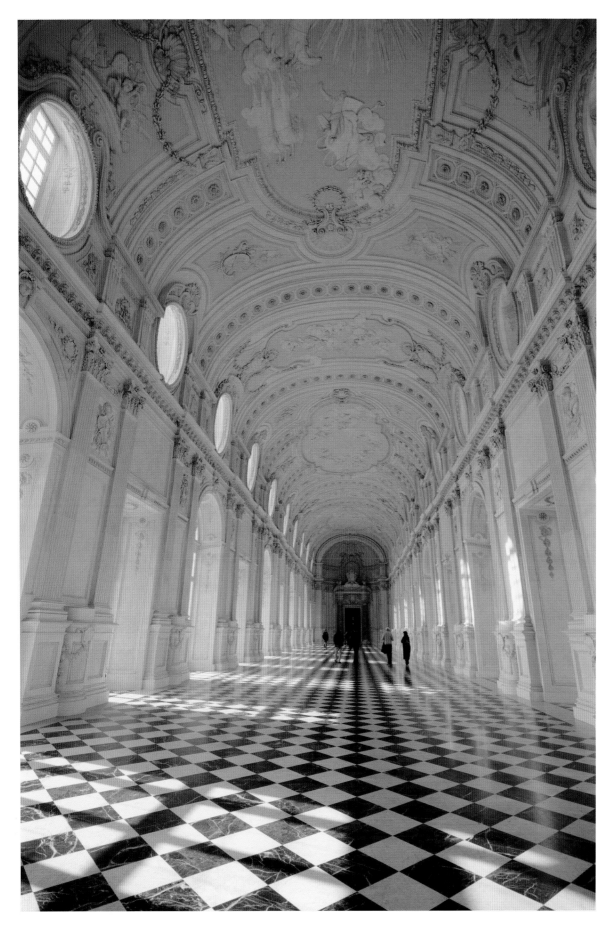

维纳利亚宫梦幻般的雪白长廊

The dreamy white corridor in the Reggia di Venaria (Venaria Palace)

从苏佩尔加山的教堂前方的观景平台看都灵市貌

The breathtaking panorama of Turin unfolds from the sightseeing platform in front of the church atop Mount Superga

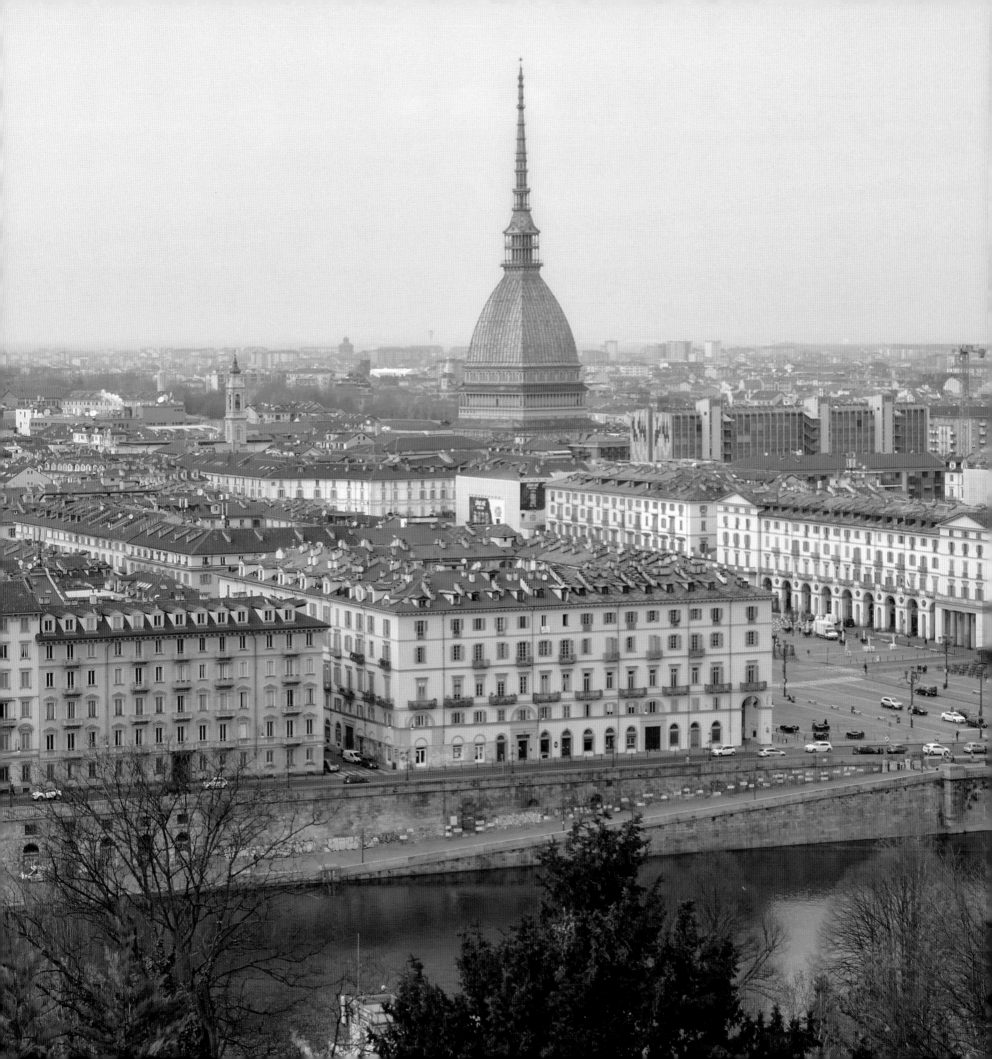

都灵夫人宫内著名馆藏：西蒙 · 特罗格的雕塑，中及左为所罗门的审判，右为艾萨克的牺牲。

Palazzo Madama (Madame Palace) houses a notable collection of Simon Trogg's sculptures, including *The Judgment of Solomon* displayed in the center and on the left, and *The Sacrifice of Isaac* on the right.

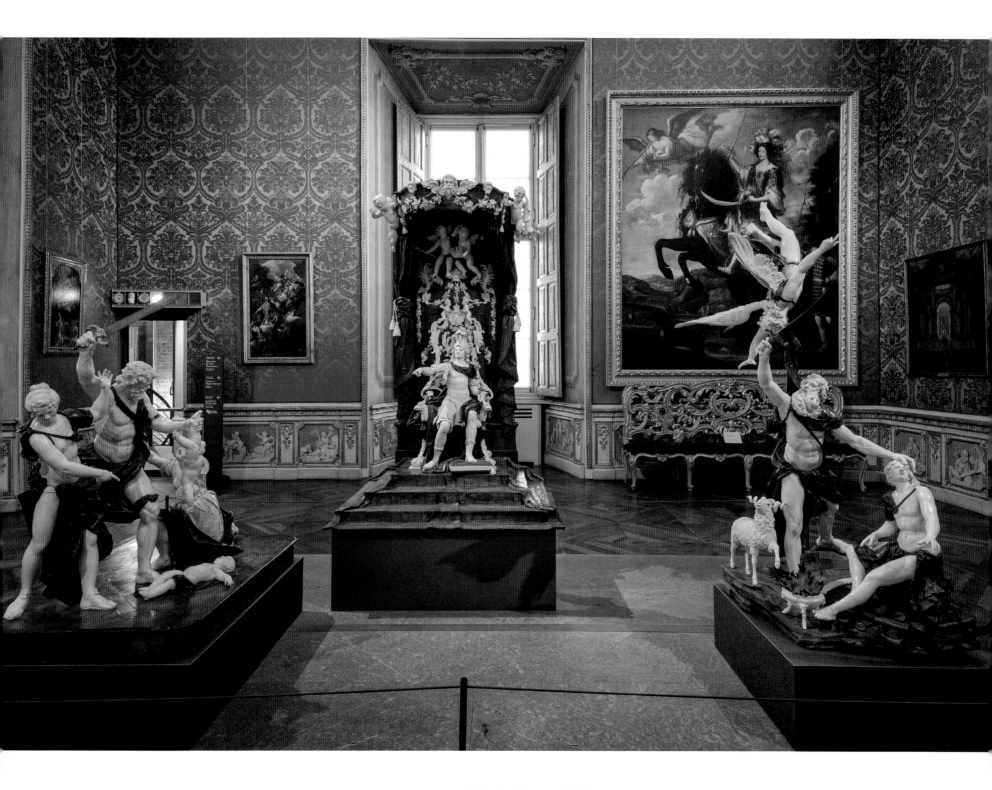

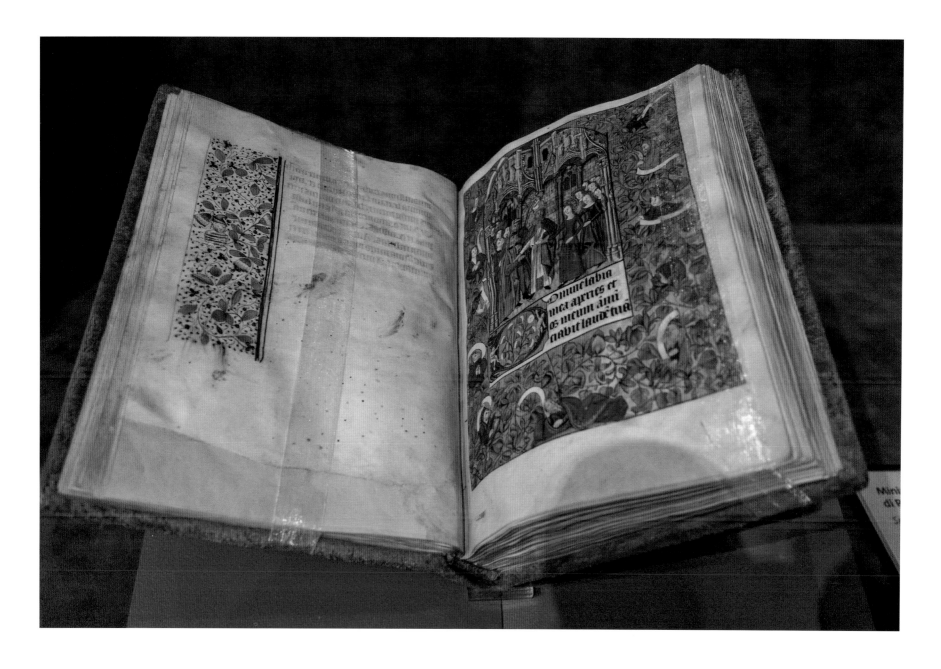

夫人宫馆藏：精美且珍贵的手抄本

The collection of Palazzo Madama (Madame Palace) : exquisite and precious manuscripts

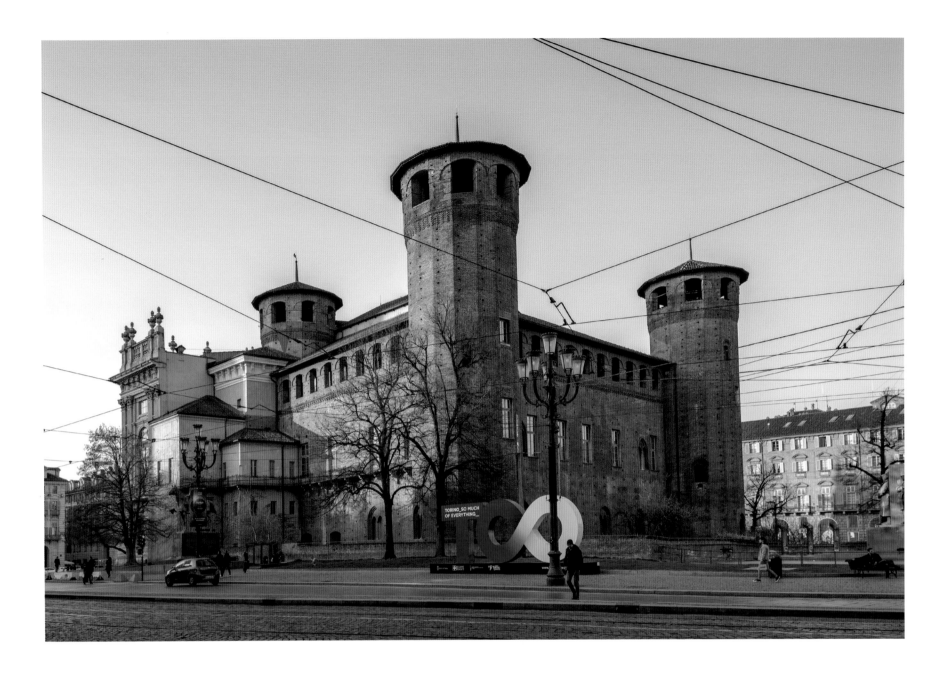

夫人宫由前后两座不同时代和风格的建筑构成，这是夫人宫的背面。

Palazzo Madama (Madame Palace) is a harmonious fusion of two buildings with distinct architectural styles from different eras, one in the front and one in the back. In the picture is the back of the Palazzo Madama.

从夫人宫看都灵王宫。都灵王宫分为好几个部分，如大厅、房间、画廊、图书馆、兵器库，以及考古博物馆等，应有尽有。

View of Palazzo Reale (Royal Palace) from the Palazzo Madama (Madame Palace). Divided into a number of sections, including grand halls, lavish chambers, captivating galleries, extensive libraries, a formidable arsenal and even an archaeological museum, the Palazzo Reale has everything that visitors can expect in a museum.

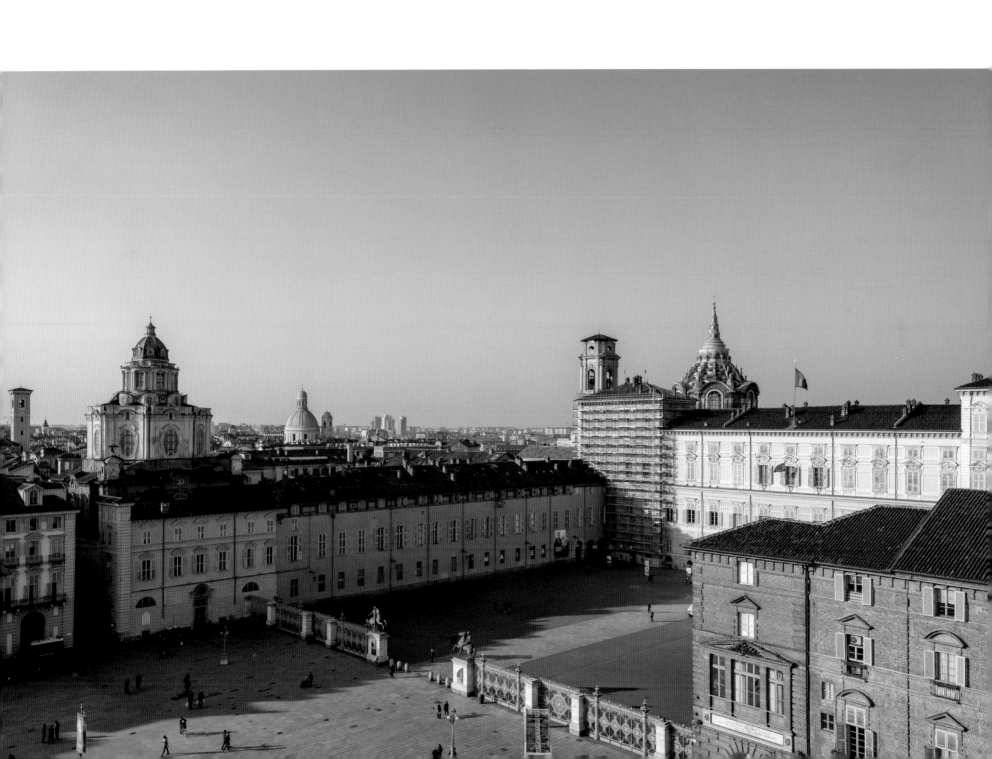

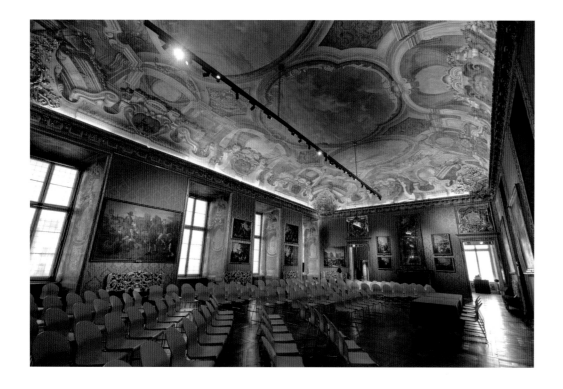

夫人宫一隅

A corner of Palazzo Madama (Madame Palace)

都灵城堡广场，左方为夫人宫。

Turin's Piazza Castello (Castle Square) , and the Palazzo Madama (Madame Palace) on the left.

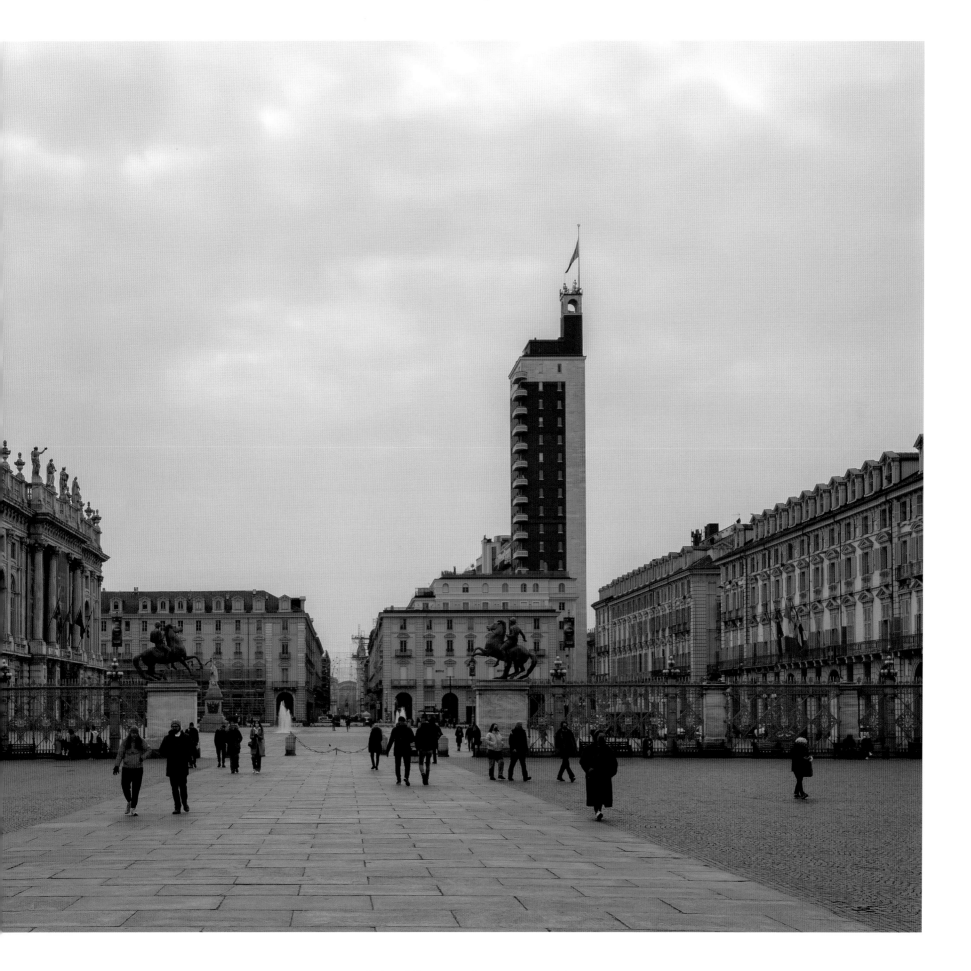

7. 都灵及周边地区 Turin and its captivating neighbouring regions

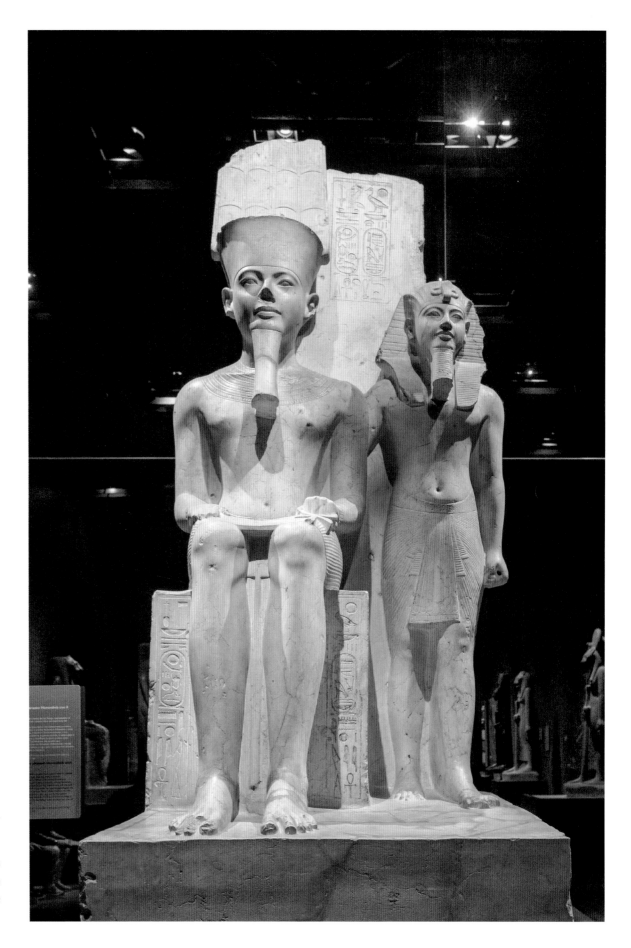

法老霍伦赫布（右）和阿蒙神（左）的雕像，其中阿蒙神的尺寸较大，显示神明较法老更重要。

As for statues of the pharaohs Horemheb (right) and the god Amun (left), the larger size of the god Amun indicates that gods are more important than pharaohs.

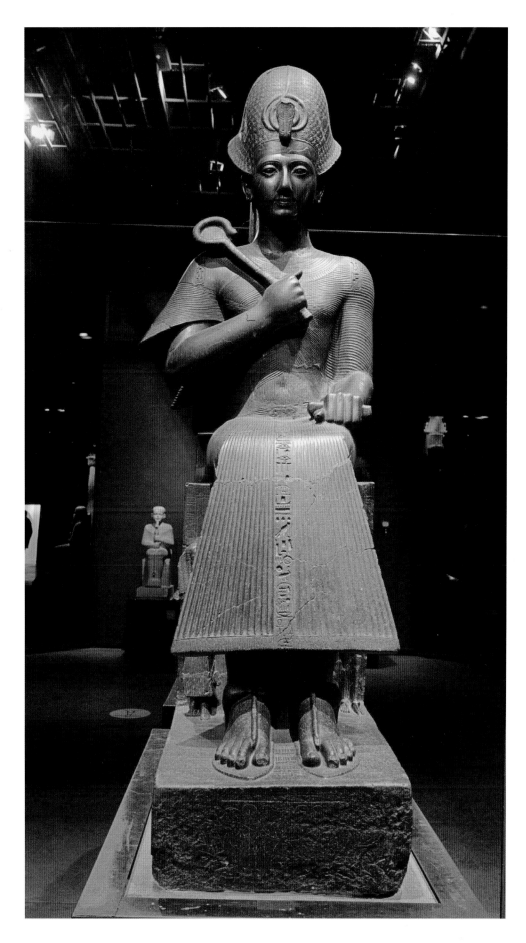

埃及博物馆馆藏：拉美西斯二世黑色花岗闪长岩雕像

The collection of Museo Egizio (Egyptian Museum): a magnificent black granodiorite statue of Pharaoh Ramesses II

位于都灵的意大利复兴运动国家博物馆

The Museo del Risorgimento in Turin

五渔村蒙泰罗索阿尔马雷小镇一隅。五渔村被认为是一条最美的徒步风景线，用双脚漫步，方能领略它真正的美丽。

A corner of Monterosso al Mare in Cinque Terre. Famed as one of the most beautiful natural walks, taking a leisurely stroll along it would allow visitors to discover its authentic charm.

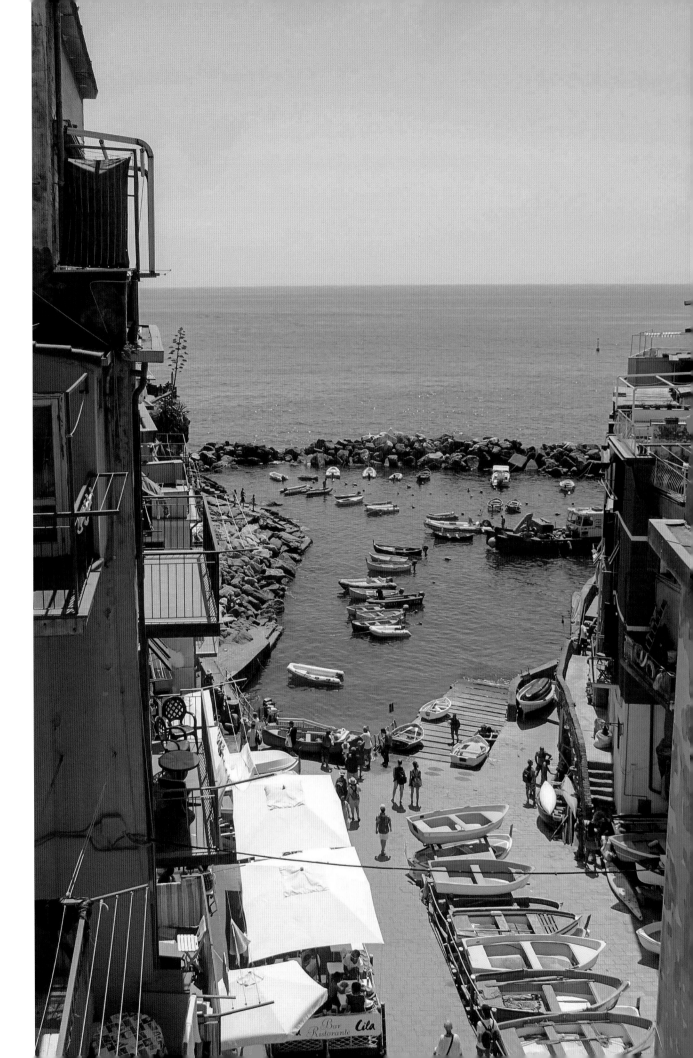

里奥马焦雷一隅。小小的海湾停泊了各色舢舨，山坡上五颜六色的房子顺山势迭砌而上，立体感强烈。

A corner of Riomaggiore. Colorful sampans were moored in the small bay, while houses of diverse hues were constructed along the slope of the hillside, creating a striking three-dimensional impression.

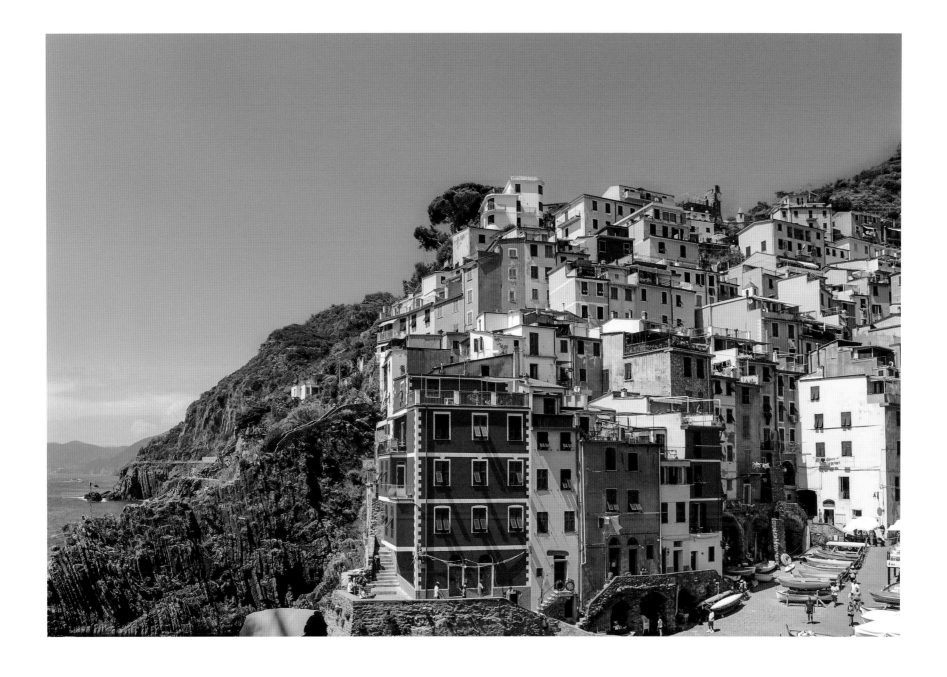

里奥马焦雷的房子建在山坡上，颜色鲜艳活泼。这些房子大多面朝大海，村民们安坐家中就能享受到和煦的阳光和无敌海景，实在非常幸福。

The vibrant-hued cottages of Riomaggiore are cozily tucked into the hillside. Most of these residences are oriented towards the ocean, giving its villagers the exquisite delight of luxuriating in the enveloping warmth of sunlight while relishing an unparalleled view of the water.

渡轮行经韦尔纳扎时，抬头一看，有座建在岩山上的堡垒，现在已改成提供餐饮、欣赏海景的地方。

As the ferry sailed past Vernazza, our attention was captivated by a fortress nestled on a rugged hill, now transformed into an idyllic destination to indulge in delicious meals and relish the breathtaking sea views.

菲基纳海滩是五渔村最大的海滩，上头满是色彩斑斓的阳伞，仿佛一条条彩练。

The largest beach of Cinque Terre, Spiaggia di Fegina (Fegina Beach) is liberally dotted with numerous beach umbrellas one next to another, seemingly like colorful ribbons from a distance.

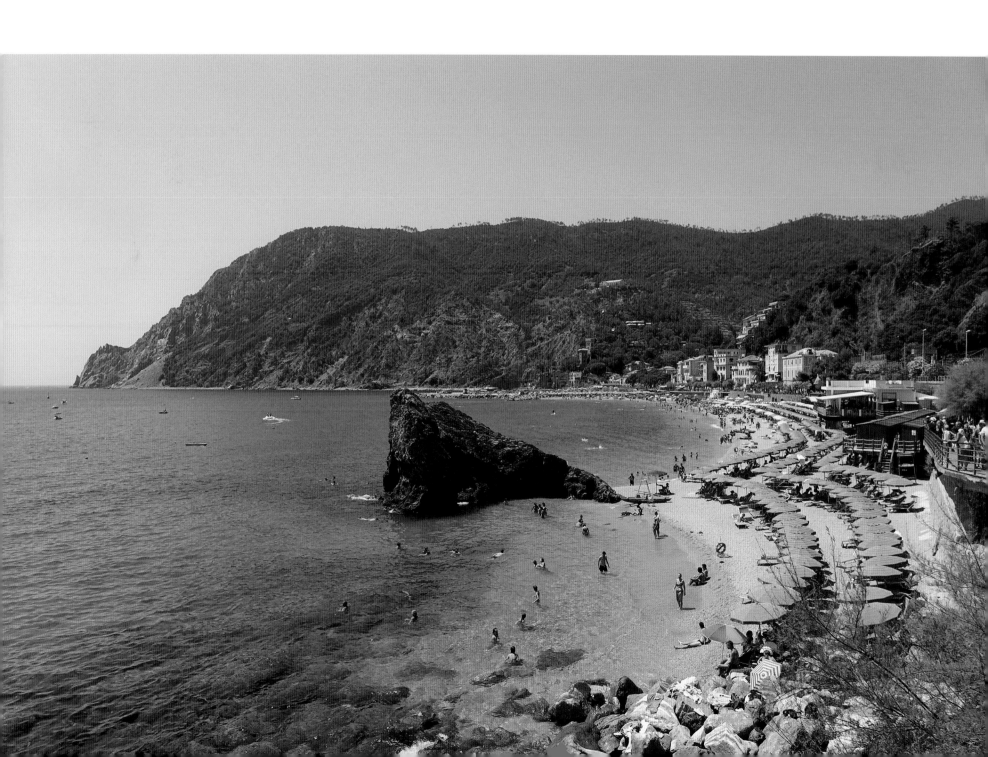

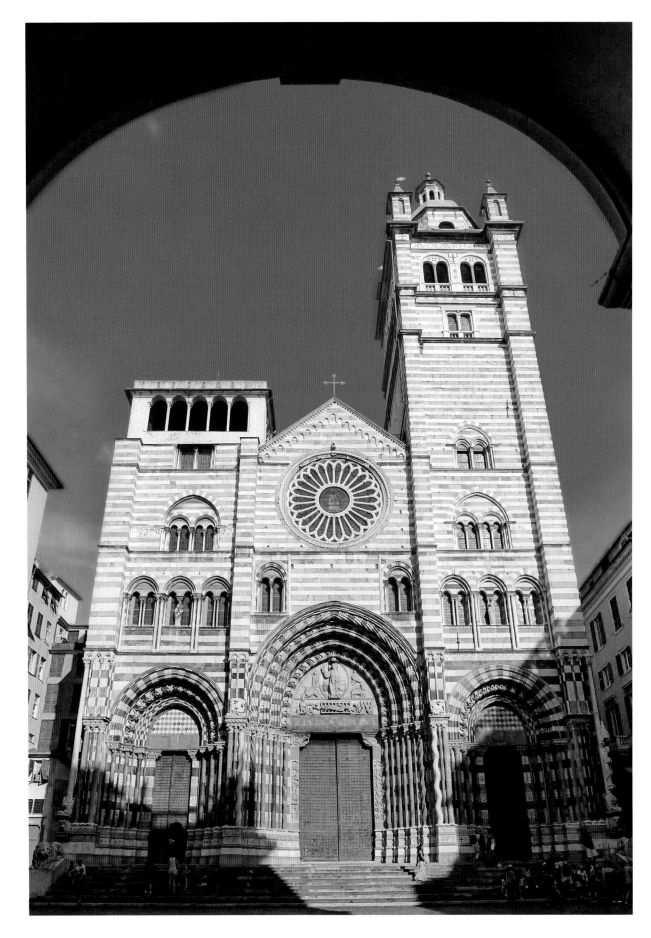

热那亚古城北面的圣洛伦佐大教堂，是罗马式和哥特式的混合风格建筑，黑白双色条纹镶嵌工艺，典雅大方，颇接近伊斯兰文化。

In the north of historic Genoa is the Duomo di S. Lorenzo (Cathedral of St. Lawrence). It is a beautiful fusion of Romanesque and Gothic architectural styles, with Genoa's unique black and white striped mosaic pattern both inside and out, creating an elegance quite close to Islamic culture.

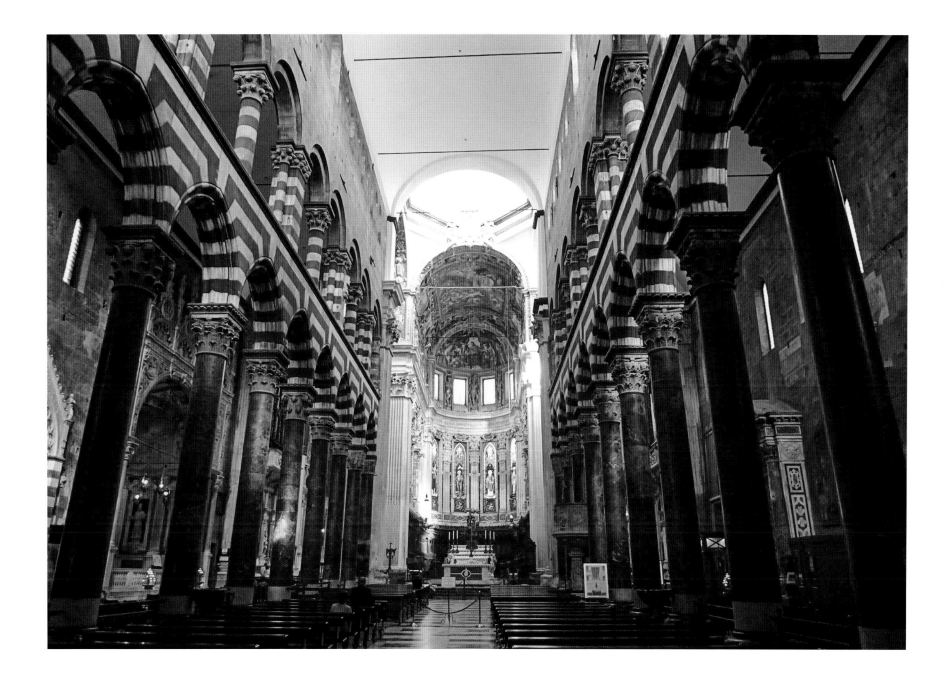

圣洛伦佐大教堂内部景致，设计都是热那亚特有的黑白双色条纹镶嵌工艺，典雅大方，颇接近伊斯兰文化。

The interior of the Duomo di S. Lorenzo (Cathedral of St. Lawrence), with Genoa's unique black and white striped mosaic pattern both inside and out, creating an elegance quite close to Islamic culture.

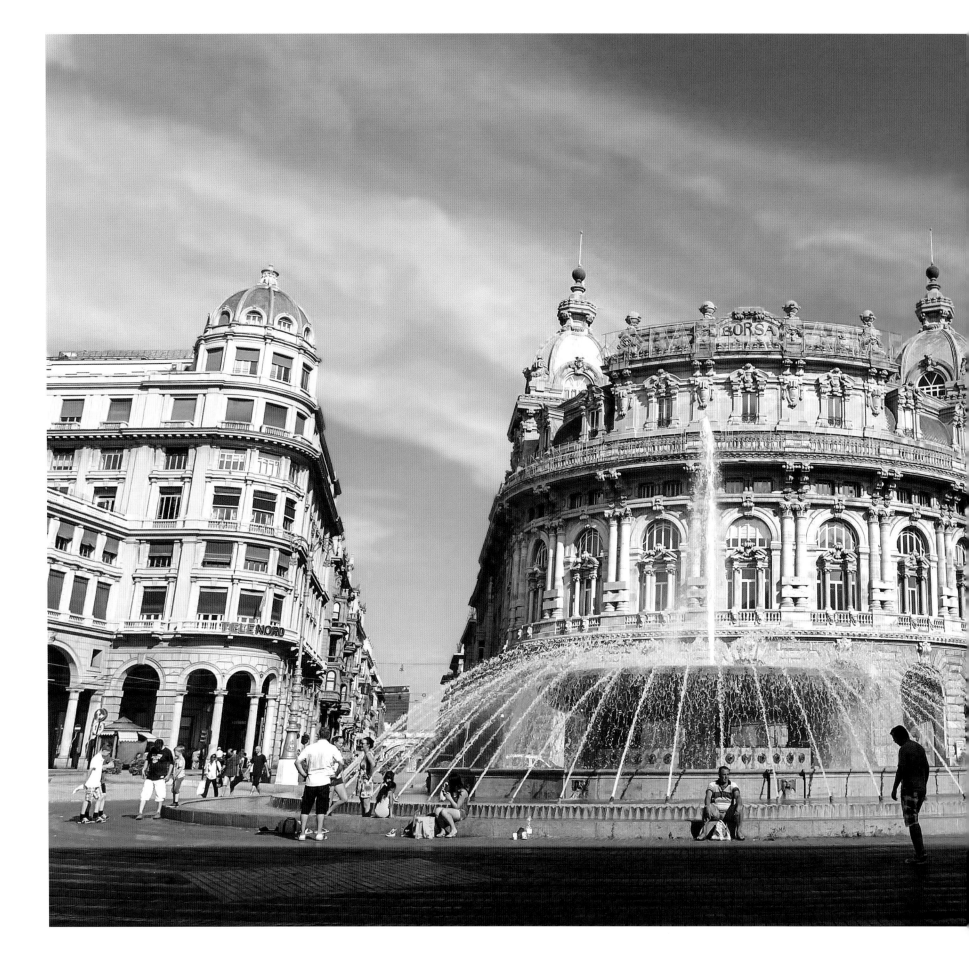

热那亚费拉里广场中央的巨大喷水池，是旅客必经和打卡之处。

Huge fountain in the center of Piazza De Ferrari (Ferrari Square), a captivating sight for tourists and a perfect spot for capturing stunning photographs.

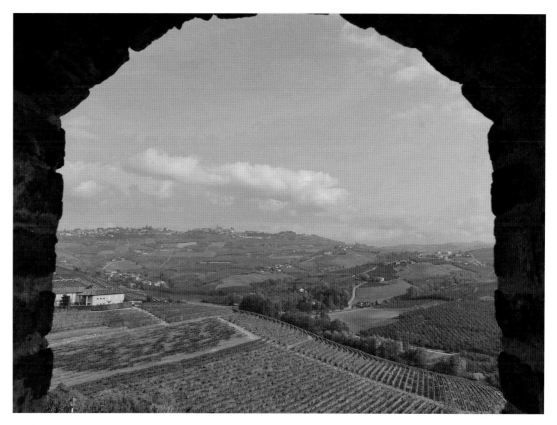

从世界遗产格林扎纳卡佛城堡望向四周的葡萄园

A view of the vineyards around from the Castello di Grinzane Cavour (Grinzane Cavour Castle), a World Heritage Site.

米兰及周边地区

*Milan and its
picturesque neighbouring regions*

米兰这座伦巴第大区的首府，大家会想到什么呢？实在很难用一句话以概之，这座城市融合了古老与现代、传统与时尚、文艺与奢华，众多对立冲突的元素意外地调和成为一个"美"字，可以说米兰的美无处不在。

过去米兰曾是古罗马帝国时期最繁荣的城市之一，甚至在公元二八六至四〇二年之间一度成为西罗马帝国的首都，拥有非常丰富的文化遗产。自古以来就是意大利的经济中心，到十九世纪后期又摇身一变，成为工业重镇。

位于意大利北部的米兰面积约一百八十平方公里，人口有一百三十多万，早在公元前四百年便已有人定居米兰一带，历史相当悠久，且经历高卢人、罗马人、伦巴第人、摩尔人等的建设和发展，如今不仅仅是时尚之都，也是意大利仅次于罗马的第二大城市，在全国的金融、经济、工业等领域都占有相当重要的位置，是全国最繁荣富庶的城市之一。

一直以来，这座城市的街头巷尾，总是熙熙攘攘，一派繁忙的景象，呈现活力四射的动感之都。除了城中心的米兰大教堂外，当地以及周边区域的旅游景点还多着呢！

When we think about the capital of Lombardy, what comes to mind? It's impossible to fully summarize its essence in just one sentence. Milan is an exquisite blend of antiquity and modernity, tradition and fashion, literature and luxury. These seemingly contradictory elements unexpectedly but harmoniously converge into the embodiment of beauty, and the beauty of Milan permeates everywhere.

Widely known as one of the most prosperous cities in the ancient Roman Empire, Milan even rose to the prestigious position of capital of the Western Roman Empire from 286 AD to 402 AD and boasts a rich cultural heritage. Since antiquity, it has been Italy's unmatched economic center, and it underwent a remarkable transformation in the late 19th century to become a prominent industrial hub.

Milan, situated in the northern part of Italy, covers an area of around one hundred and eighty square kilometers and is home to a population exceeding 1.3 million. Dating back to as early as 400 BC, this magnificent city has been inhabited by various peoples including the Gauls, Romans, Lombards, Moors and others. As a result, it possesses a rich historical legacy characterized by extensive construction and development. Today, it stands out not only as a fashion mecca but also as Italy's second largest metropolis after Rome, while emerging as one of Italy's most prosperous cities with significant influence in finance, economy and industry.

The bustling streets and winding alleyways of the city are always abuzz with continuous activity, making it a vibrant and dynamic metropolis. Alongside the majestic Duomo di Milano (Milan Cathedral) situated at its heart, there is an abundance of highly recommended tourist attractions in and around the city!

米兰大教堂广场可以说是疫情变化的"寒暑表"：每当疫情严重时，广场就空无一人，遍地的野鸽早已远飞他处，徒留一座意大利国王维托里奥·埃马努埃莱二世的骑马雕像。

The Piazza del Duomo (Cathedral Square) in Milan served as a reliable 'barometer' for measuring the epidemic's severity: during the worst times, the square was deserted with no visitors, not even the wild pigeons that used to inhabit it. A statue of King Vittorio Emanuele II astride a horse in the square bore witness to the impact of the epidemic.

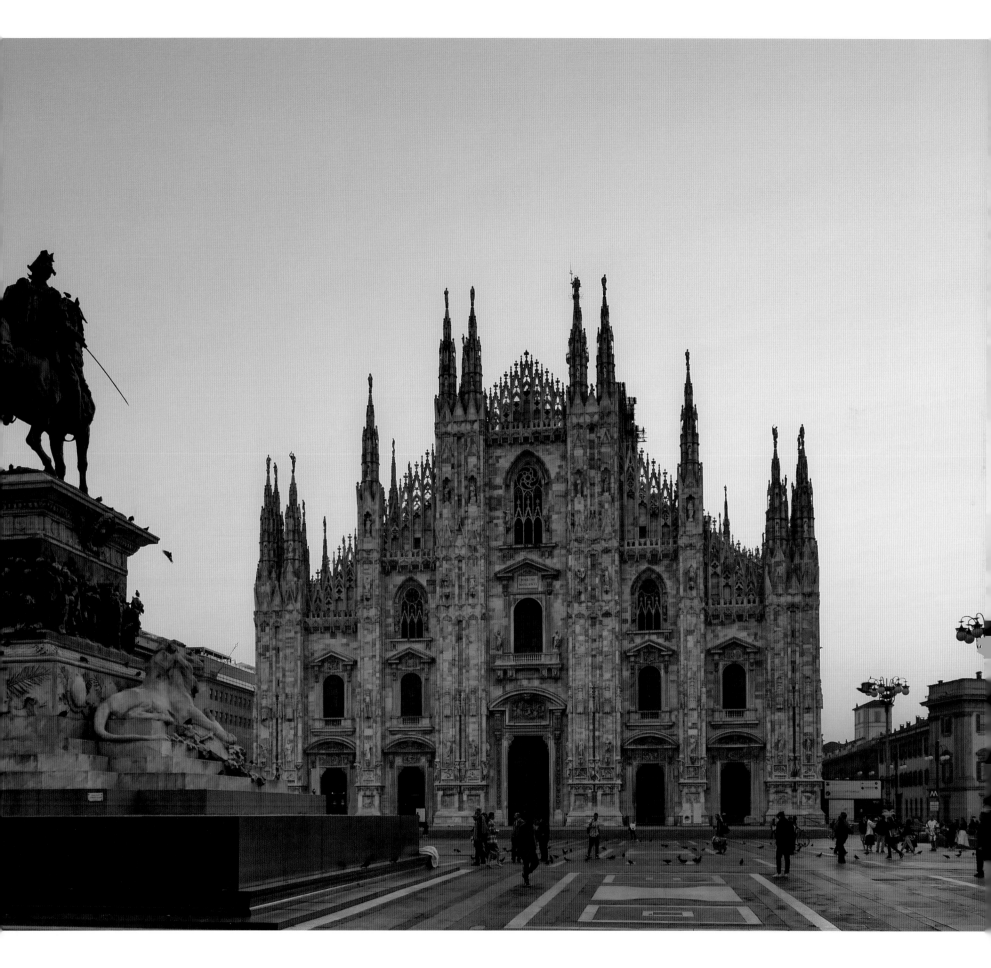

8. 米兰及周边地区 Milan and its picturesque neighbouring regions

米兰大教堂是欧洲第三大教堂，仅次于梵蒂冈圣彼得大教堂和西班牙塞维利亚主教座堂教堂，最值得欣赏是精美绝伦的壁画和彩绘玻璃窗。

The Duomo di Milano (Milan Cathedral) ranks as the third largest cathedral in Europe, after the Basilica di San Pietro (St Peter's Basilica) in Vatican and the Catedral de Santa María de la Sede de Sevilla (Cathedral of Seville) in Spain. The most worth appreciating features are its exquisite frescoes and stained glass windows.

米兰大教堂应算是世界上雕塑和尖塔最多的建筑，除尖塔上的雕塑外，外墙同样布满大大小小的雕像，人物与宗教故事有关，每座都姿态万千，惟肖惟妙。

Undoubtedly, Duomo di Milano (Milan Cathedral) should be recognized as a structure boasting the most sculptures and spires in the world! Not only are its steeples embellished with sculptures, but the exterior walls are also covered with statues of various sizes, each depicting characters from religious stories and displaying a myriad of postures and expressions.

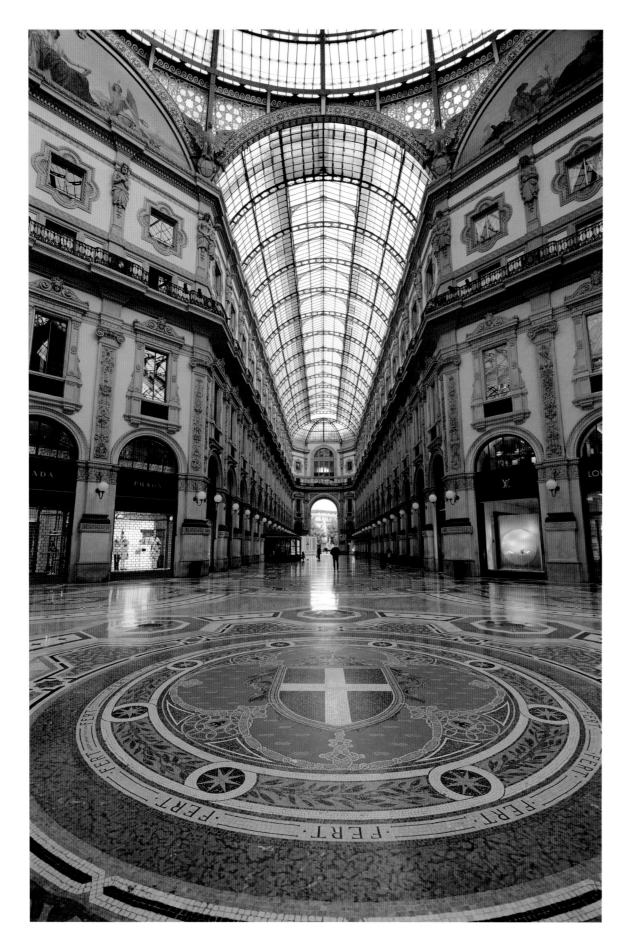

米兰埃马努埃莱二世拱廊完成于 1877 年，被认为是世界上最古老的购物中心，拱廊的名字源于意大利统一后的第一任国王维托里奥·埃马努埃莱二世。

The Galleria Vittorio Emanuele II (Vittorio Emanuele II Gallery) in Milan, completed in 1877, is renowned as the oldest shopping center in existence. It takes its name from Vittorio Emanuele II, who became Italy's first king after unification.

米兰五十公里外有个科莫湖，而与湖同名的古罗马时代小镇科莫城就在科莫湖西南端，是欧洲出产丝绸的中心之一，其制品之精良，深受欧洲时尚名牌的垂青。

The beautiful Lago di Como (Lake Como) is located fifty kilometers from Milan, and the charming ancient Roman town at the southwestern end of Lake Como shares its name. It is renowned as one of Europe's leading centers for silk production, with its exceptional quality being highly sought after by European fashion brands.

科莫大教堂

The Cathedral of Como

加尔达湖区，里瓦德尔加尔达一隅。

A beautiful view of Riva del Garda around Lake Garda

加尔达湖区，纳戈 – 托尔博莱的圣维吉里奥教区教堂内部。

Inside the Chiesa Parrocchiale di San Vigilio (Parish Church of St. Vigilius) of Nago-Torbole around Lake Garda

加尔达湖区的阿科小镇，山上城堡景观绝佳，从四方八面可以望见下方的平原、湖泊、河流、挺拔的岩石山，以及顺着山势一层层绿油油的葡萄园梯田，当然还有阿科小镇的全貌。

In the picturesque town of Arco by Lake Garda, the panoramic views from the castle at the top of the hill are truly breathtaking: vast plains, sparkling lakes, rushing rivers, majestic rocky mountains, and lush green vineyard terraces cascading down hillsides. The charming town of Arco itself is laid bare before my eyes, adding to the beauty of the scene.

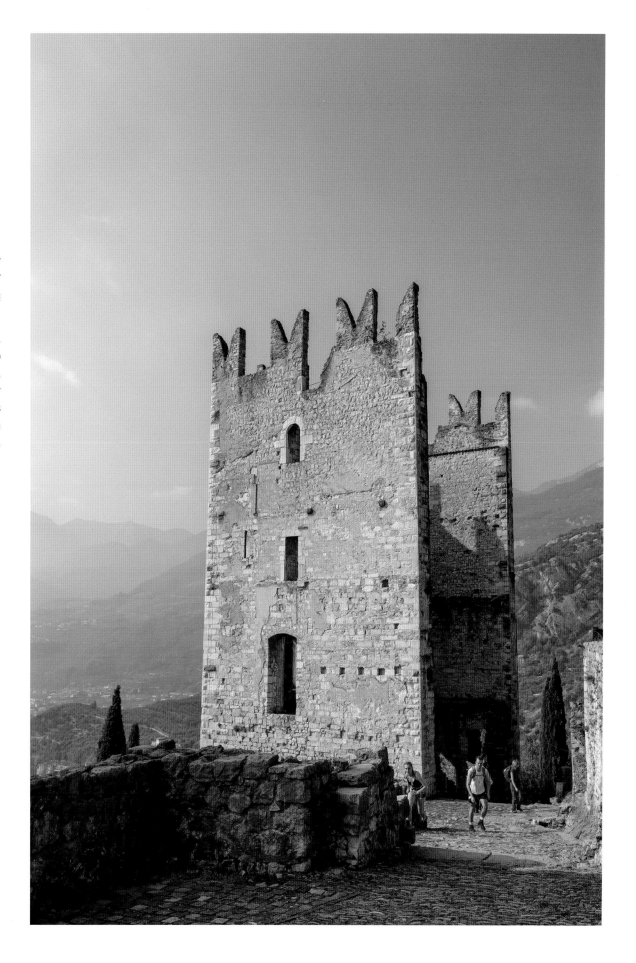

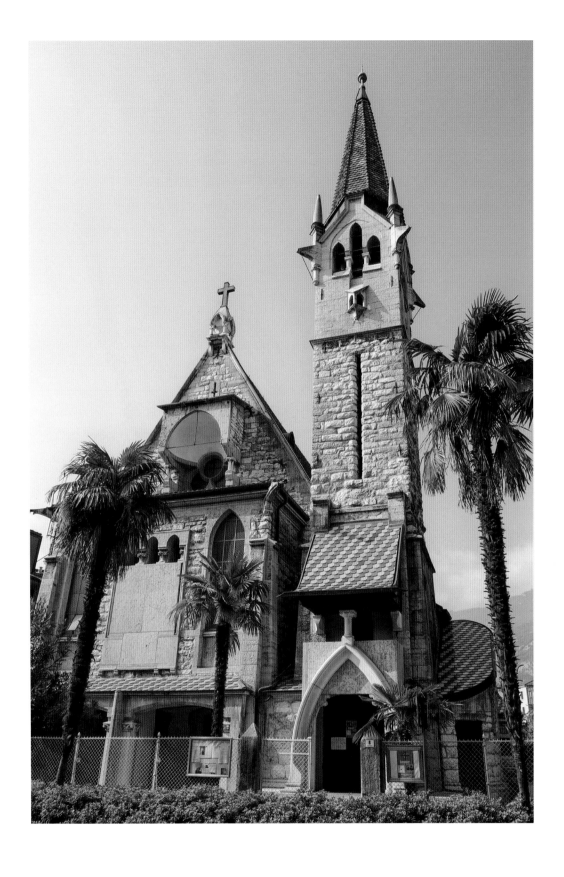

阿科小镇福音教会

The Evangelical Church of Arco

纳戈一托尔博莱。居住人口不到三千人，窄窄的街巷内隐藏了色彩鲜艳的三、四层楼高平房，以廊桥连接两座房屋。

Nago-Torbole is home to a small population of less than three thousand residents. The charming narrow streets and winding alleys are lined with three or four-storey houses, bright in color and connected by covered bridges.

马焦雷湖是意大利第二大湖，是意大利和瑞士的界湖。在面积约两百多平方公里的马焦雷湖中，湖中有三个小岛呈"品"字型排列：母亲岛、贝拉岛和渔夫岛，图为三岛最大的母亲岛，属博罗梅奥家族所有。

Lake Maggiore proudly holds the title of Italy's second largest lake and serves as a border between Italy and Switzerland. The three small islands in Lake Maggiore, Isola Madre (Mother Island), Isola Bella (Bella Island) and Isola dei Pescatori (Superior Island), are artfully arranged in the shape of a Chinese character '品' within its approximately two hundred square kilometer area. The picture depicts the largest of the three islands, Isola Madre (Mother Island), which is owned by the Borromeo family.

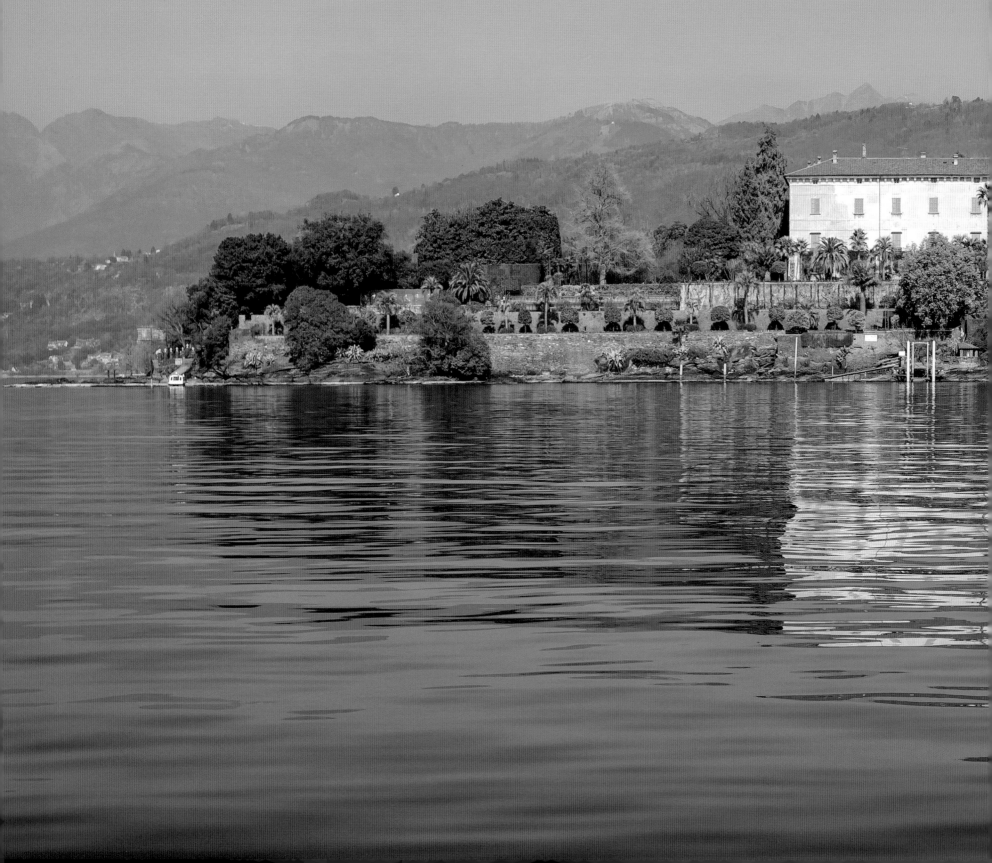

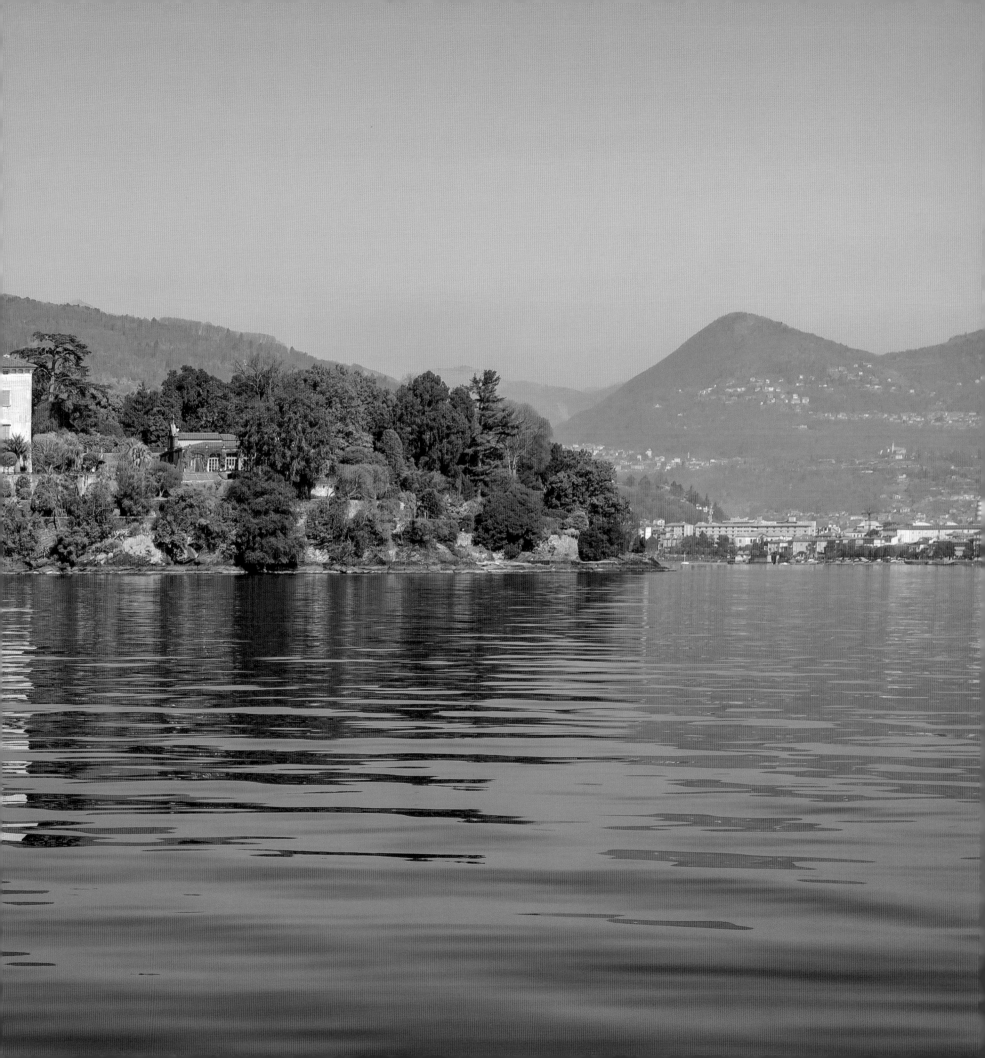

三岛中面积最小的渔夫岛，上面有一座圣维克多教堂，里面还保留着十一世纪建成的尖拱塔，以及创作于十六世纪的壁画。

The most fascinating spot on Isola dei Pescatori (Superior Island), the smallest of the three, is the Chiesa di San Vittore (Church of San Vittore) which still houses the 11th-century bell tower and 16th-century frescoes.

贝拉岛，又有"美丽岛"之称。

Bella Island, also known as Pretty Island.

8. 米兰及周边地区 Milan and its picturesque neighbouring regions

奥尔塔圣朱利奥小镇莫达广场上这座两层楼带拱廊的精巧房子为旧市政大楼，建于一五八二年，楼下的拱廊有多根柱子，连接两层楼的是外露的锻铁楼梯，上层原是市政府的办公地方，屋顶上还有一座迷你钟塔，是古镇的象征。

Located on the Piazza Motta (Motta Square) of Orta San Giulio, there is the former town hall, an exquisite two-storey house with a portico that holds great historical significance dating back to 1582. The structure features a ground floor portico adorned with several columns, an exposed wrought-iron staircase connecting the two floors, and an upper floor that once functioned as the town hall. Additionally, its roof is crowned with a miniature bell tower, symbolizing the enchanting charm of this ancient town.

奥尔塔圣朱利奥小镇市政厅

The town hall of Orta San Giulio

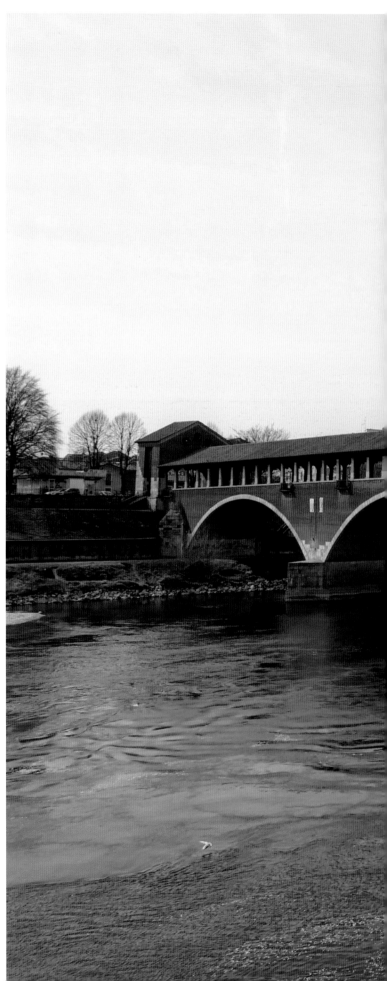

帕维亚有座老廊桥，是该城的标志性建筑之一，连接城市南北两部分。

In Pavia there is the venerable Ponte Coperto (Corridor Bridge), one of the city's iconic landmarks, linking the northern and southern parts of the town.

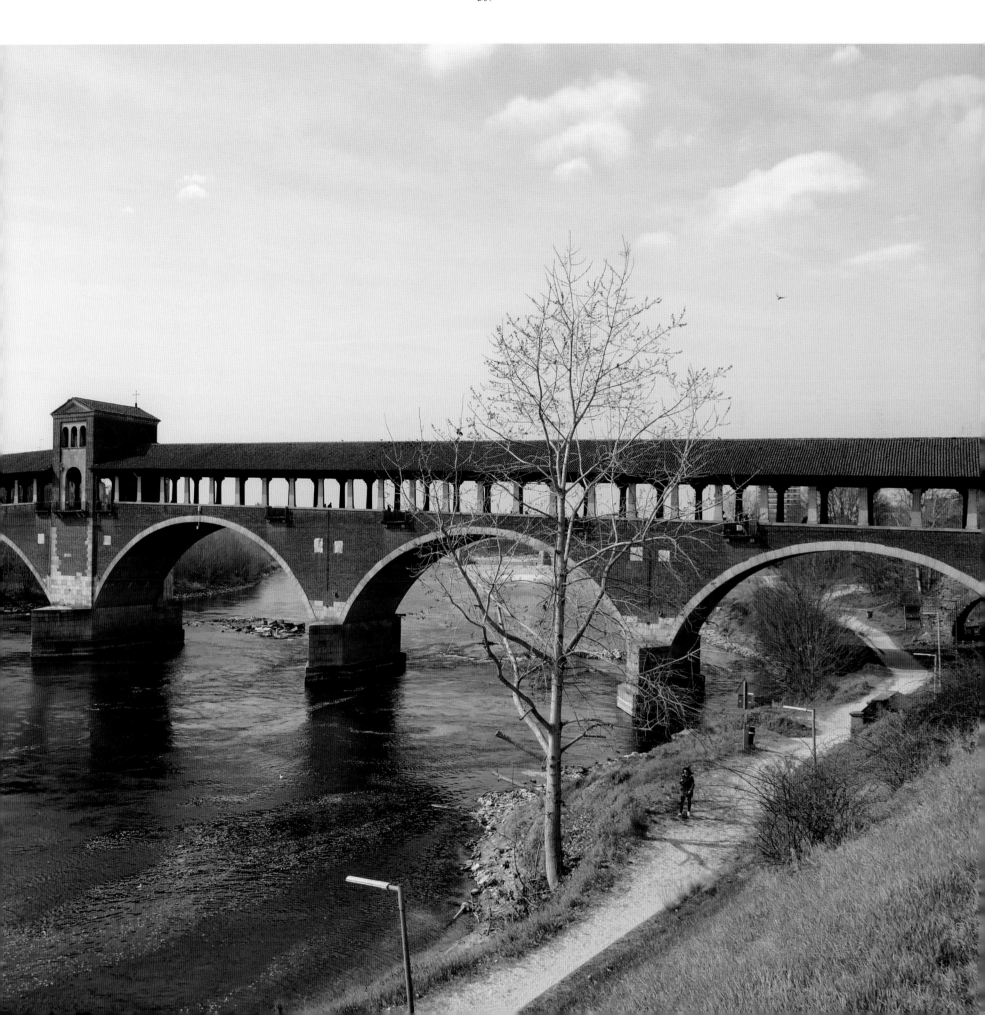

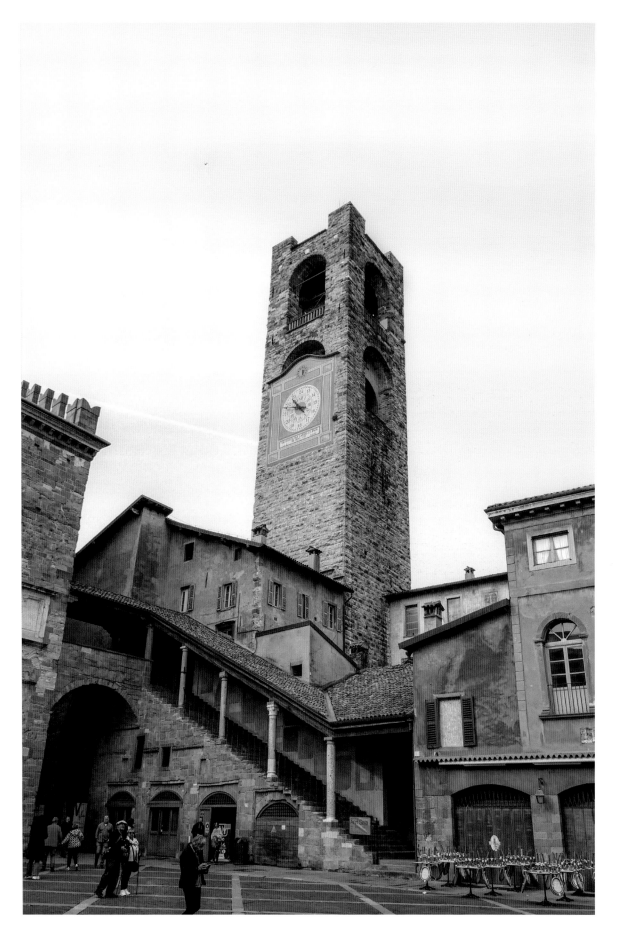

贝加莫老广场上有一座建于十一至十二世纪间的城市塔，当地人称"大钟"。塔楼顶端装有伦巴第大区最大的一座钟，最初由当时本地实力强大的苏阿尔迪家族建造，有条华丽带有廊柱的阶梯。在二十世纪下半叶，这座建筑变成了旅游景点。

The Torre Civica (Civic Tower) in the Old Piazza of Bergamo (Bergamo Square), also known as the 'Big Bell', was built between the 11th and 12th centuries. It is topped by the largest bell in Lombardy and features an ornate, colonnaded staircase. Originally constructed by the powerful Suardi family, this building has become a popular tourist attraction since the second half of the 20th century.

几乎每座意大利城市都少不了教堂，贝加莫圣母圣殿始建于十二世纪，因为资金问题，延误到十四世纪才完工。图中的科莱奥尼礼拜堂属于圣母圣殿的一部分，修建于一四七二至一四七六年，可说是伦巴第文艺复兴的代表作。

The Church is essential to almost every town and city in Italy, and the Basilica di Santa Maria Maggiore (Basilica of St. Mary of Maggiore), originally planned for the 12th century but delayed until the 14th century due to financial reasons, fortunately avoided a ruinous fate. The Cappella Colleoni (Colloni Chapel) in the picture, built between 1472 and 1476 as part of the basilica, stands as a testament to Lombard Renaissance mastery.

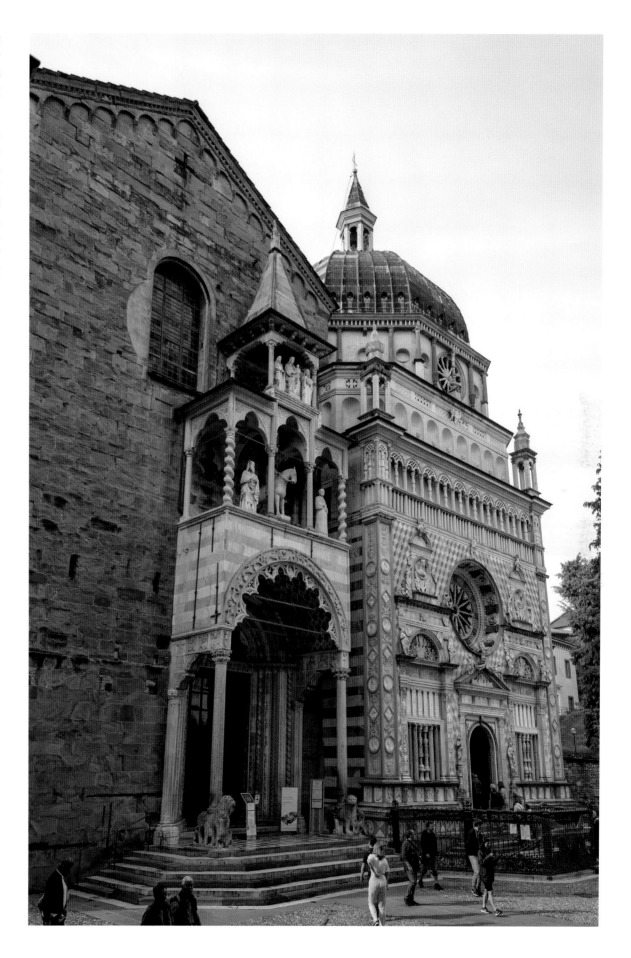

8. 米兰及周边地区 Milan and its picturesque neighbouring regions

加尔达湖区罗韦雷托一隅

A corner of Rovereto by Lake Garda

布雷西亚旧主教座堂内部

Inside the Duomo Vecchio di Brescia (Old Cathedral of Brescia)

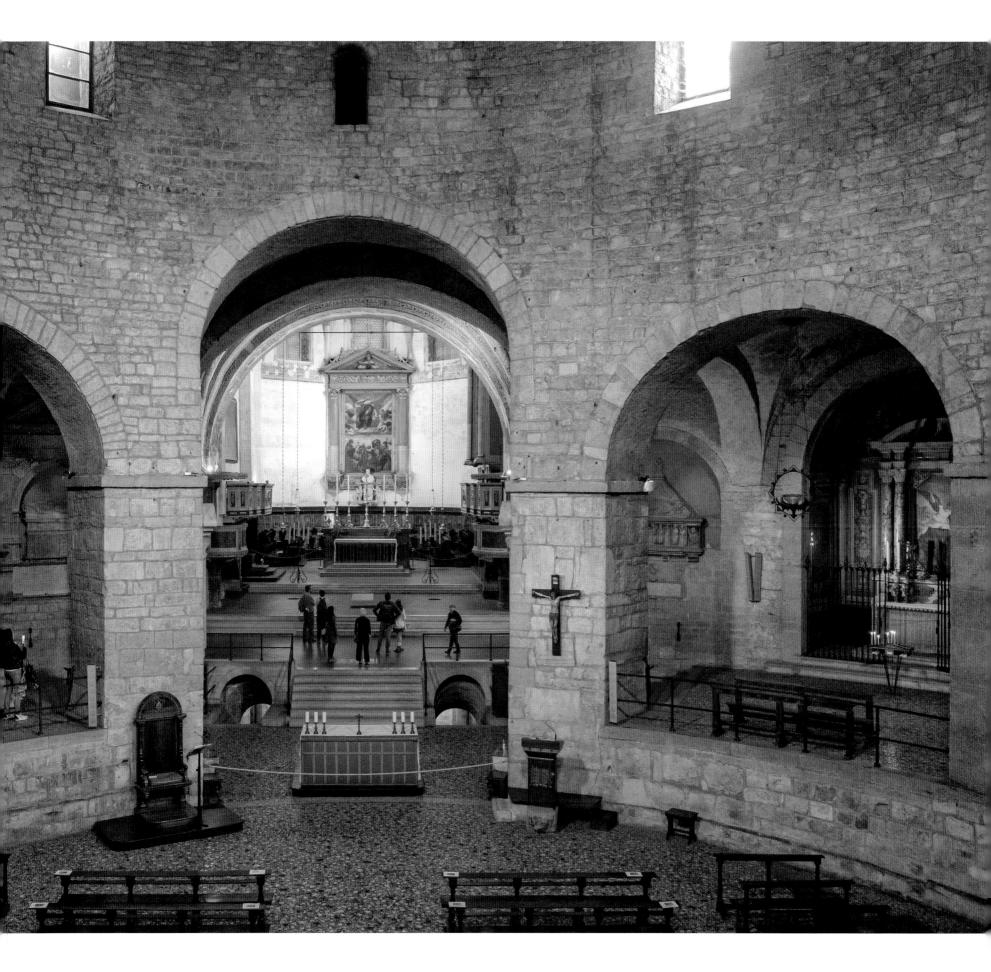

8. 米兰及周边地区 Milan and its picturesque neighbouring regions

布雷西亚城堡既是城市象征，也是意大利最大的堡垒之一，耸立在城中最高的山丘上。

The Castello di Brescia (Brescia Castle), serving as both a symbol of the city and as one of Italy's largest fortresses, proudly sits atop the highest hill in the city.

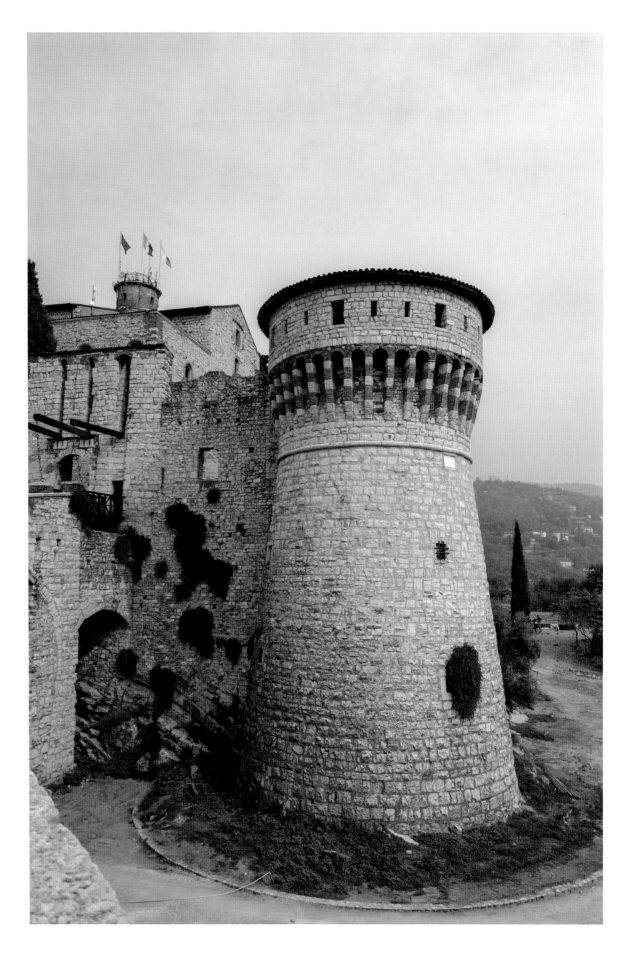

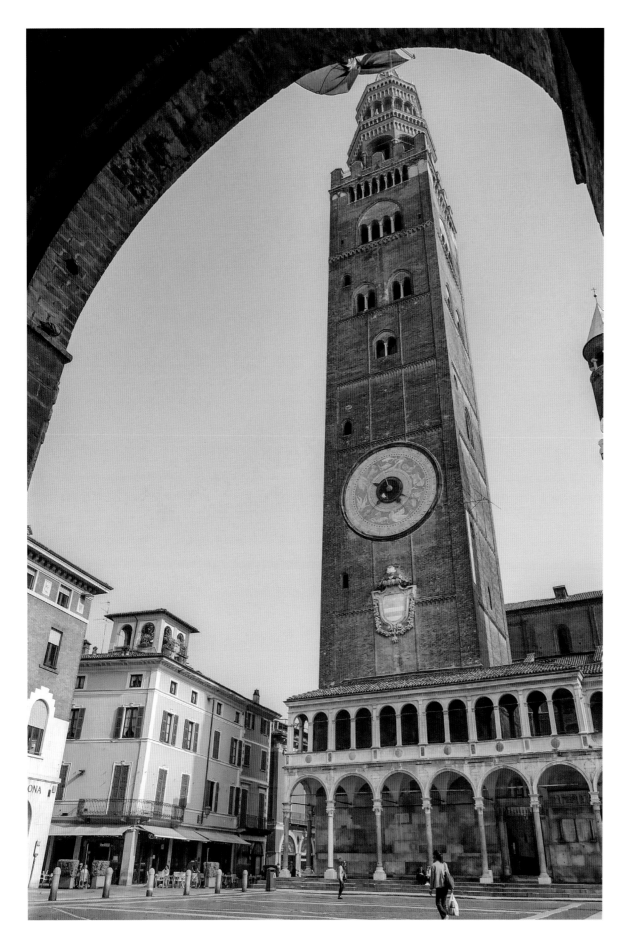

克雷莫纳是个清幽的小镇。中心广场的克雷莫纳大教堂隔壁就是钟楼，它是意大利最高的钟楼，同时也是世界第三高的砖砌钟楼，有一百一十二点七米高。

The town of Cremona, secluded and refined. Next to the Duomo di Cremona (Cremona Cathedral) is the Torrazzo di Cremona (Tower of Cremona) of 112.7 meters high, the tallest in Italy and the third tallest brick bell tower in the world.

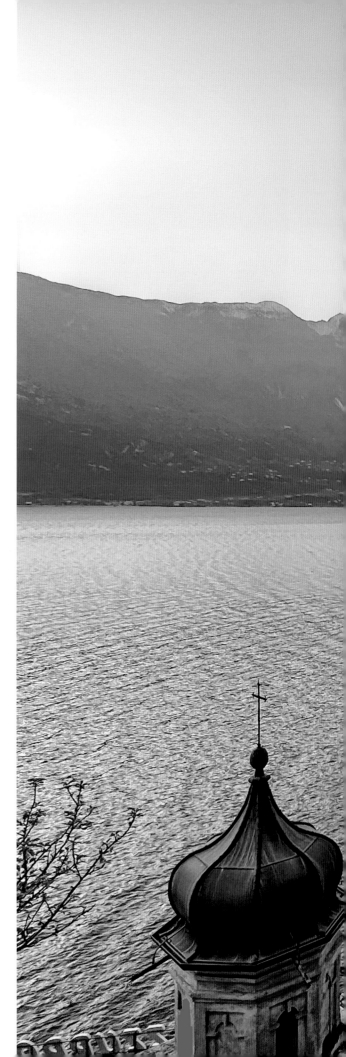

柠檬小镇是加尔达湖畔一座风景如画的小镇

The Limone sul Garda (Lemon Town) is a picturesque town by Lake Garda

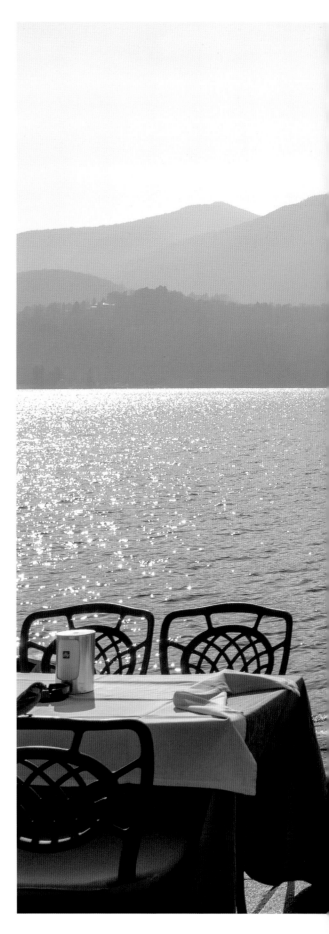

奥尔塔圣朱利奥古镇就在奥尔塔湖。湖中央有个小岛，叫圣朱利奥岛。从莫达广场可看清岛上的建筑群。那是一座女性修道院，修道院还为旅客提供住宿。

The small town of Orta San Giulio is nestled cozily beside Lago d'Orta (Lake Orta). The lake has a small island at its heart, St. Giulio Island. Piazza Motta (Motta Square) provides a clear view of the architectural complex on the island. It is a convent, which also provides accommodation for travelers.

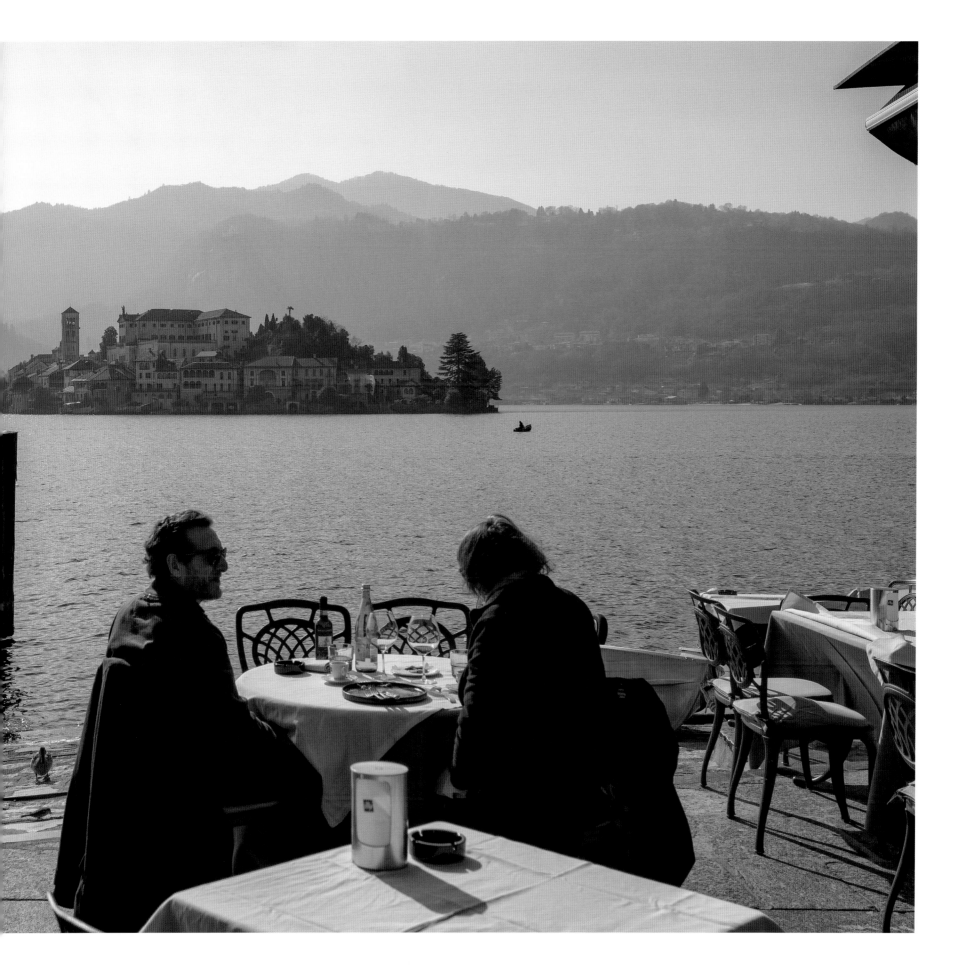

8. 米兰及周边地区 Milan and its picturesque neighbouring regions

离岛

The alluring Italian islands

Chapter 9
第九章

过去十年，我曾经或单枪匹马、或结伴同游意大利的西西里岛三次，每次的感受都不同，却有着同样的结论：如果没到过西西里，就不算游过意大利；只有到过西西里，才会发现意大利真正的美丽。它被称之为"意大利南方的珍珠"。

西西里岛是地中海最大岛屿，意大利南部一个自治区，形状有如一把三角尺，面积比台湾本岛还要小三分之一，只有两万五千多平方公里，人口约五百万人。意大利的形状像一只靴子，而西西里岛的位置则在靴尖，与意大利本岛最接近之处，如果乘坐渡轮从南部的雷焦卡拉布里亚出发，只需四十多分钟就抵达对岸的墨西拿了。也由于它是欧洲和非洲的"中途岛"，占据非常重要的战略位置，自古以来，饱受多个国家的争夺和占领，并承受东西两方文化的冲击和融合，两千五百年来，留下的是数不尽的历史痕迹和神话传说。不单有古希腊的神殿遗迹，也有不少阿拉伯诺曼式的建筑。

同时这里亦是意大利黑手党的发源地，五十年前电影《教父》的故事情节就发生在这个岛上，因此很多人觉得当地治安不好，时有抢劫，认为西西里岛不宜旅游。不过我们为了探索西西里的文化遗产，"偏向虎山行"。甚至于当我游过之后，每每产生一游再游的冲动。

几次的访游，我与旅伴们登山涉水，先登上欧洲最活跃的活火山 —— 埃特纳火山，再乘快艇畅游地中海，还先后游遍古城锡拉库萨、阿格里真托和陶尔米纳。最后来到西西里的首府巴勒摩。行程中见识过古城、古迹、神殿遗址、考古博物馆，和大大小小不同风格的教堂。再加上众多古希腊、古罗马神话和传说的点缀，让各个景点的精彩度倍增。

西西里岛卡塔尼亚的埃特纳大街，街道两旁的建筑外墙装饰了不同风格型态的雕塑，墙身精细的雕花和铁栏杆等，把这座火山之城衬托得更为细致典雅。

The Via Etnea (Etna Street) of Catania in Sicily is adorned with a variety of sculptures on the exterior walls of buildings on either side, as well as intricate carvings and iron railings, all contributing to the heightened elegance of this volcano-surrounded city.

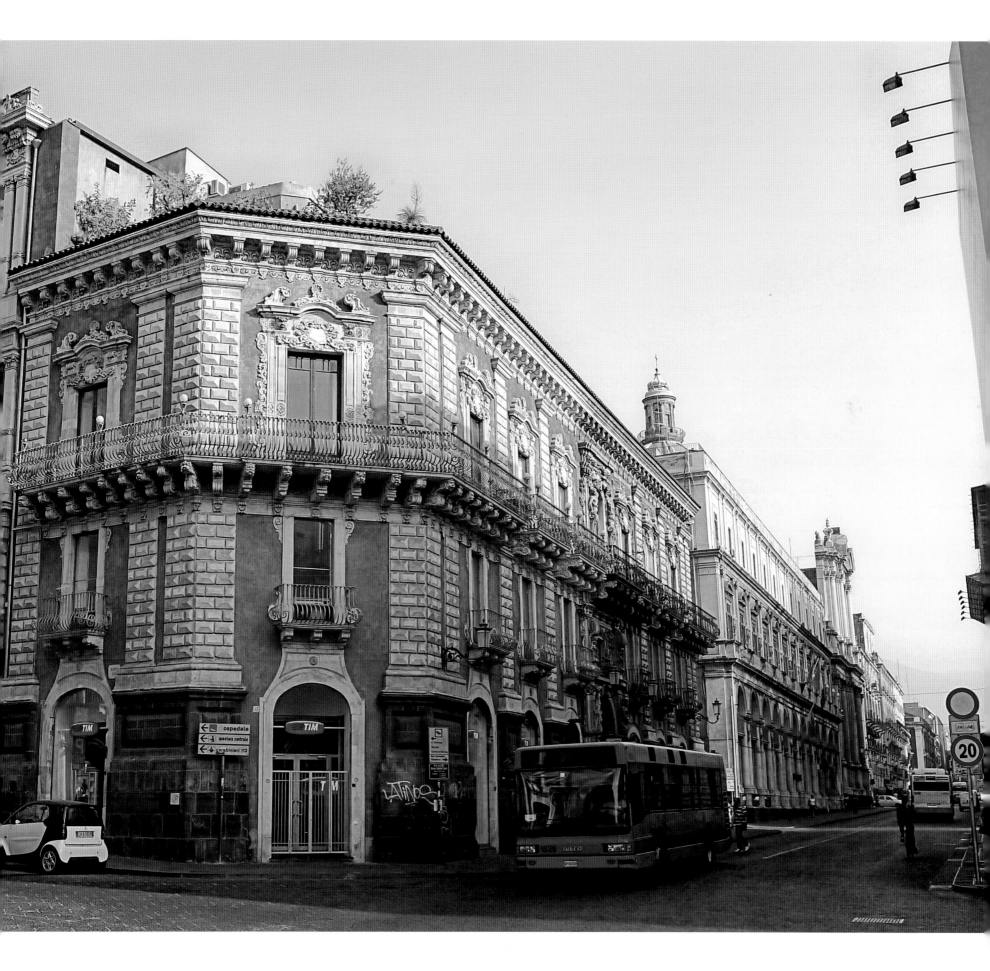

Over the past decade, I have had the pleasure of visiting the beautiful island of Sicily in Italy on three separate occasions, whether it be by myself or with dear friends. Each visit has gifted me with unique experiences, yet they all led me to the same realization: a journey to Italy is incomplete without the exploration of Sicily; it is only through a visit to Sicily that the true splendor of Italy will be revealed. Indeed, Sicily is highly praised as 'the pearl of southern Italy'.

Sicily, the largest island in the Mediterranean Sea, is an autonomous region in the southern part of Italy. Shaped like a triangular ruler and approximately one third smaller than Taiwan, it covers just over twenty-five thousand square kilometers with a population of about five million. Positioned at the tip of Italy's boot-shaped peninsula, Sicily is easily accessible from Reggio Calabria in the south via ferry, taking just over forty minutes to reach Messina on the opposite side. Because of its location as the 'halfway island' between Europe and Africa, this place holds a crucial strategic significance. Throughout history, it has been invaded and occupied by numerous countries, enduring the collision and amalgamation of Eastern and Western cultures. As a result, it has left behind an abundance of historical traces, myths and legends over the past twenty-five thousand years. There are not only the remains of ancient Greek temples but also a wealth of Arabian Norman architecture.

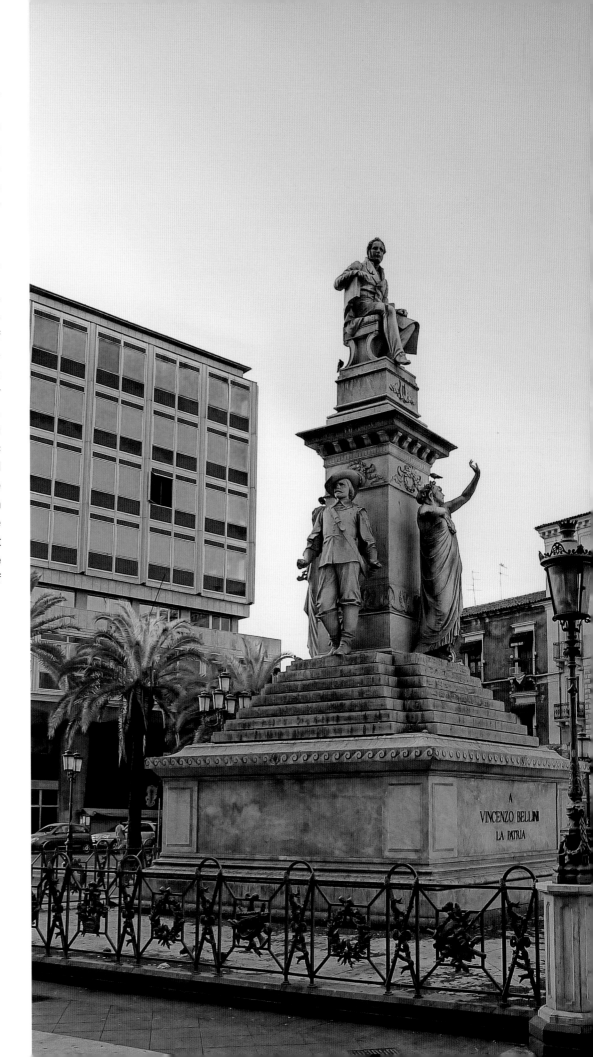

西西里岛卡塔尼亚的贝里尼纪念碑，位在古罗马竞技场遗址前方，纪念的是这座城市的知名歌剧作曲家贝里尼。

The Bellini Monument of Catania in Sicily, located in front of the site of ancient Roman Colosseum, commemorates the city's famous opera composer, Bellini.

Being the birthplace of the Italian Mafia and the setting for the movie *The Godfather* fifty years ago, Sicily is often perceived as lacking in public security due to frequent robberies, leading many to believe it is unsuitable for tourism. However, despite these concerns, I decided to visit Sicily in order to explore its cultural heritage. After experiencing it firsthand, I am constantly drawn back to its charm.

During several trips, my fellow travelers and I have had the amazing experience of conquering mountains, including Mount Etna, Europe's most active volcano. We also enjoyed a thrilling speedboat journey around the Mediterranean Sea and explored the ancient cities of Siracusa, Agrigento and Taormina. Our ultimate destination was Palermo, the captivating capital of Sicily. Throughout our travels, we encountered a number of ancient cities, monuments, temples, archaeological museums and churches in various sizes and styles. The allure of each site was further enhanced by the rich myths and legends from ancient Greece and Rome.

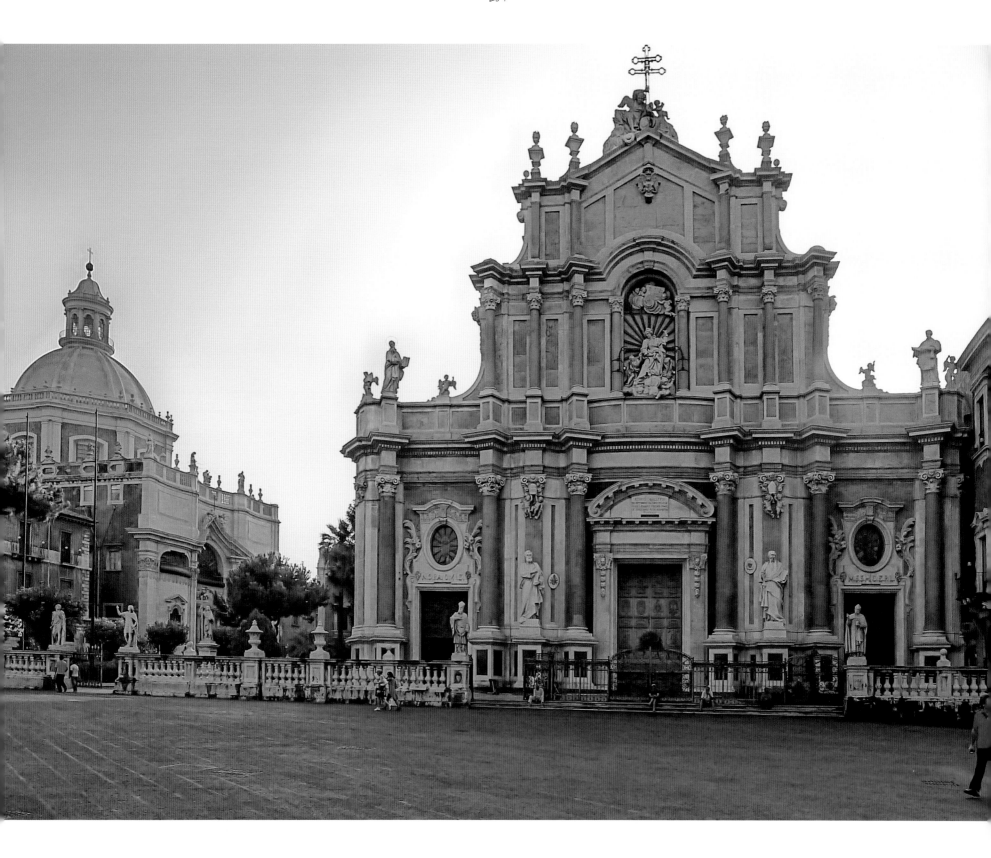

卡塔尼亚的圣阿加塔主教座堂，它使用当地特有的黑色火山岩建成。

The Cattedrale di Sant'Agata (Cathedral of Saint Agatha) in Catania is constructed using the black volcanic rock indigenous to the area.

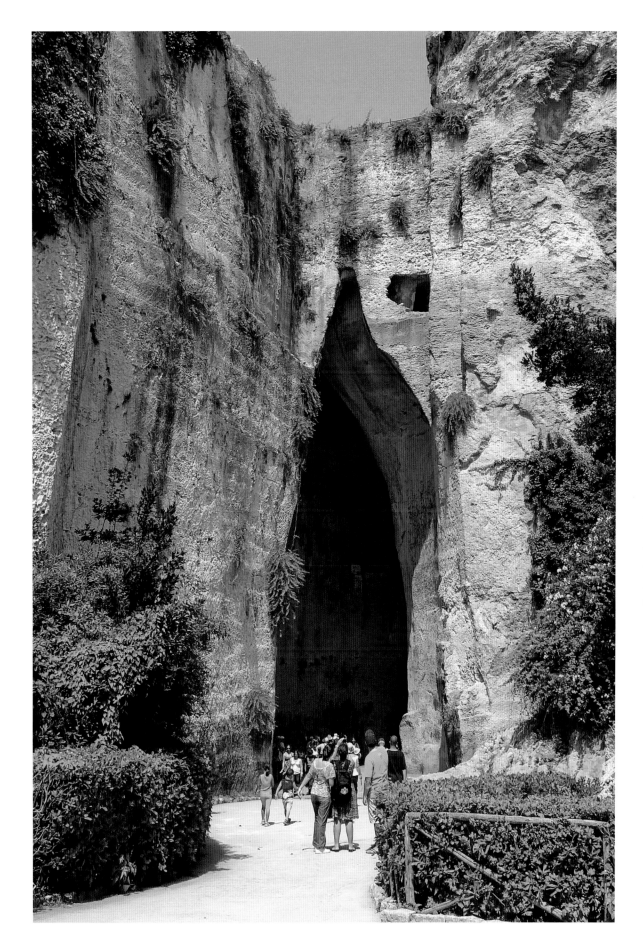

狄奥尼西奥斯之耳。话说此耳状岩洞是古希腊国王狄奥尼西奥斯的得意之作，他知道岩洞有传音效果，故意将犯人拘押在洞内，凭借岩洞传音来窃听犯人们交谈中的秘密。"隔墙有耳"，原来就是源自此岩洞故事。

Orecchio di Dionisio (Ear of Dionysus). It is said that this ear-shaped cave was the satisfied work of the ancient Greek king Dionysus. He knew that the cave had an acoustical effect, so he intentionally detained prisoners inside it, using the cave's acoustics to eavesdrop on their conversations and uncover their secrets. 'Walls have ears' actually originated from this story of the cave.

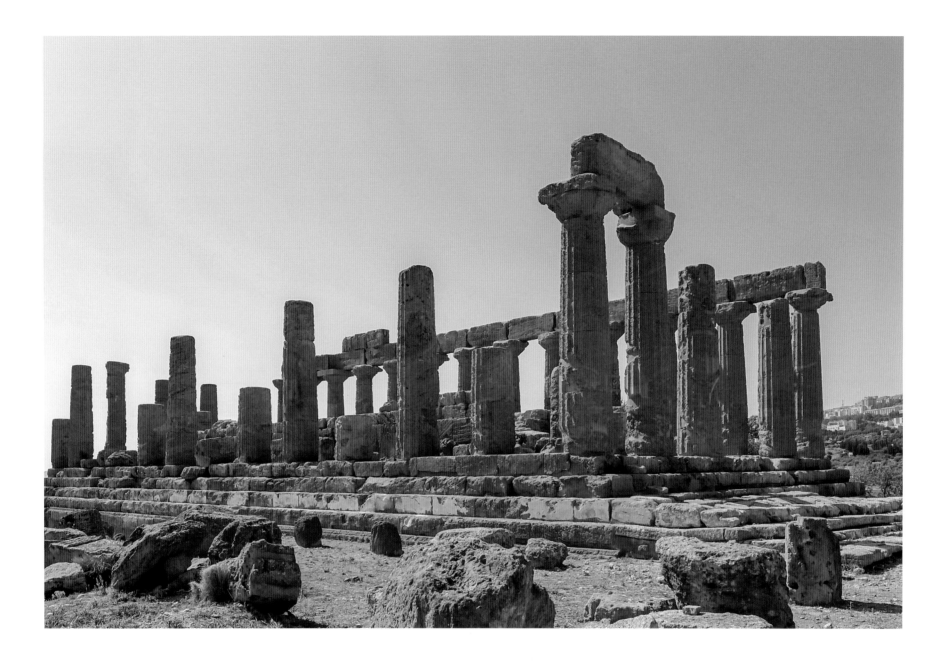

朱诺神殿位于西西里岛阿格里真托的神殿谷内，神殿谷是希腊以外保存最完好的古希腊神殿群。朱诺神殿上部结构已全然消失，只留下约三十根巨大圆柱。

Located in the Valley of Temples in Sicily, the Tempio di Giunone (Temple of Juno) of Agrigento stands as the best-preserved collection of ancient Greek temples beyond the borders of Greece. The Tempio di Giunone has experienced the complete disappearance of its upper structure, leaving behind only approximately thirty colossal columns.

陶罗山上的古希腊剧场遗迹。剧场本身呈半圆形，直径达一百二十米，观众席的石阶座位部分已损毁，舞台后的布景台早已坍塌了一大片，只剩下多根廊柱。

The ruins of the ancient Greek theater sit on Mount Tauro, boasting a semi-circular structure with a diameter of one hundred and twenty meters. The damaged stone steps of the audience seating bear witness to the inexorable march of time, and a section of the backdrop behind the stage has crumbled, leaving only a few columns standing tall.

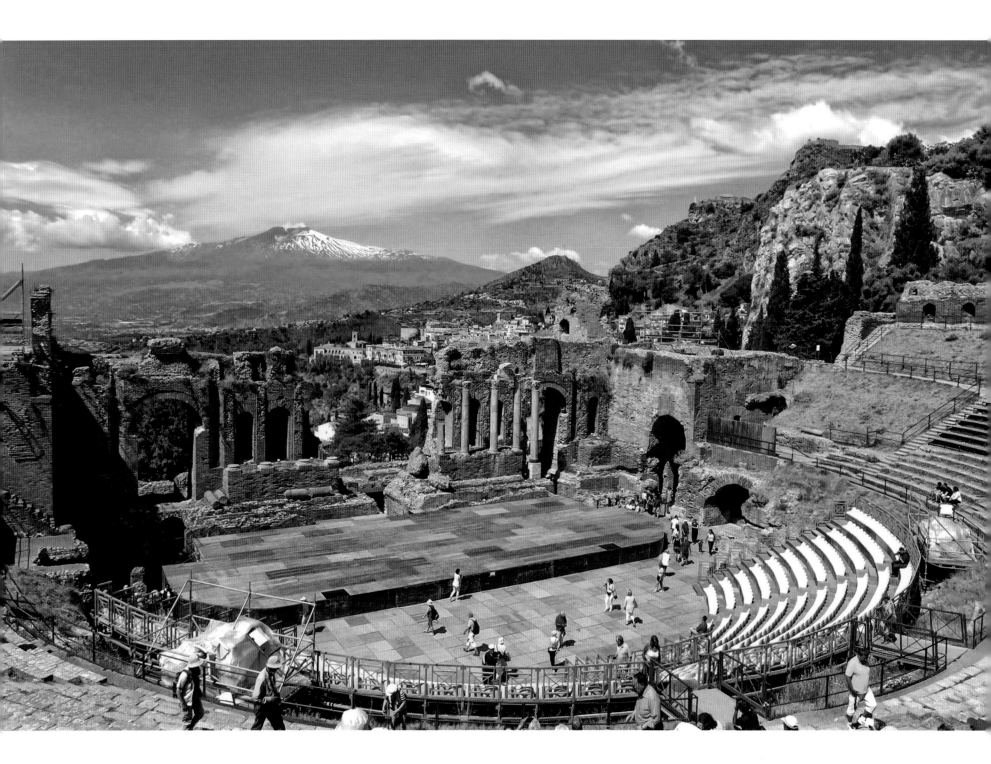

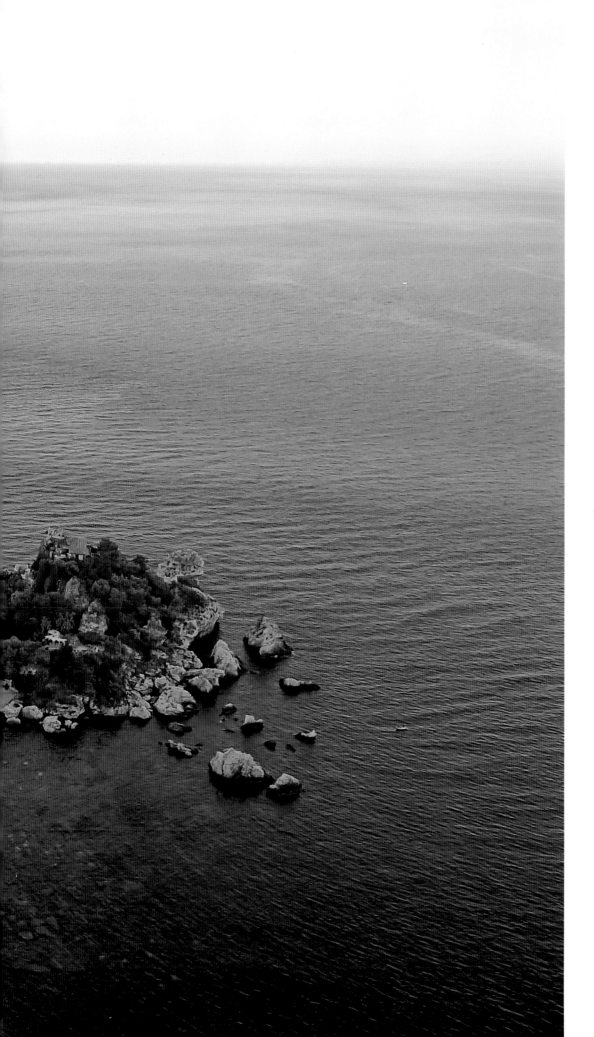

陶尔米纳的美丽岛以沙堤与本岛相连

The Isola Bella (Bella Island) of Taormina is connected to the mainland by a sandbar

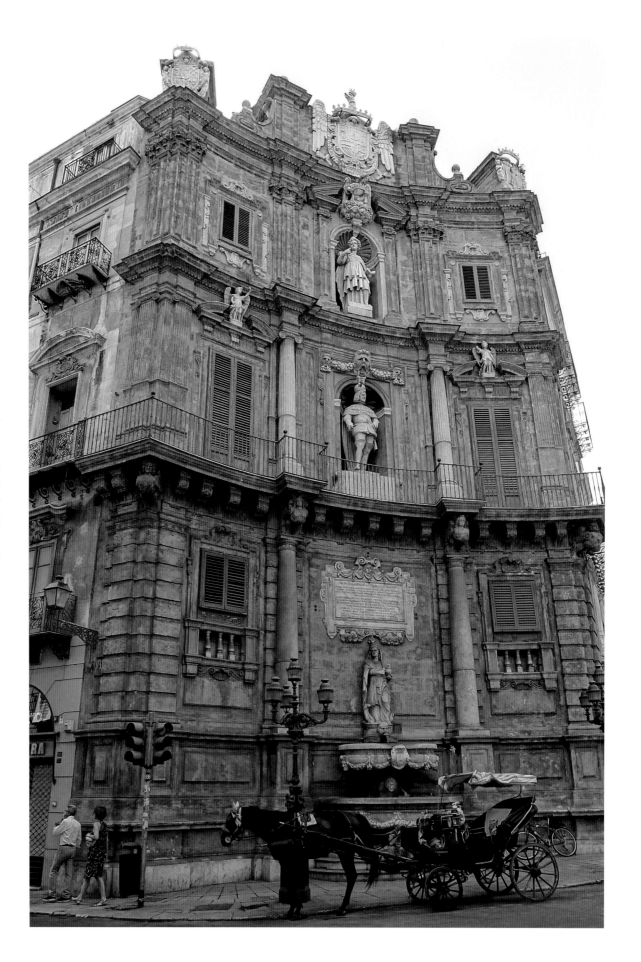

巴勒莫的四角广场，又叫做"四首歌广场"。它特别之处是广场四个圆角各有一栋弧形的巴洛克式建筑，每栋都有三层艺术雕像，中层是曾统治过西西里的西班牙国王，最高一层则分别是四位守护圣者。

The Quattro Canti di Citta in Palermo, also known as Teatro del Sole, is characterized by four curved Baroque buildings at each corner of the square, with three levels of artistic sculptures. The middle level depicts Spanish kings who once ruled over Sicily, while the top level showcases four guardian saints.

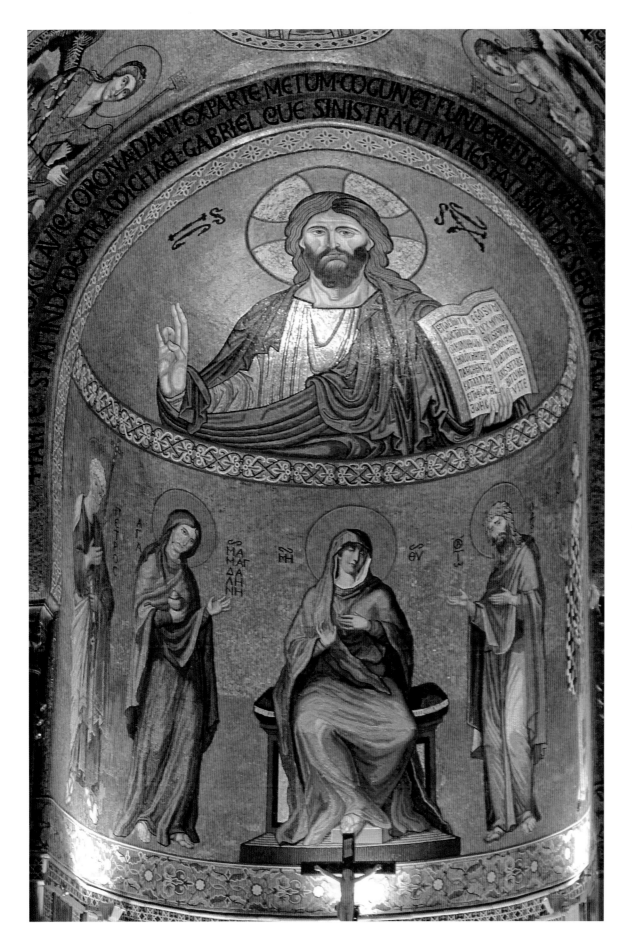

巴拉丁礼拜堂位于巴勒莫诺曼王宫内，全能基督像从高处俯视信徒，令人震慑。周围壁画是用彩石砌成，金光闪闪，讲述着圣经神话故事。

Inside the Palazzo dei Normanni (Norman Palace) of Palermo, the statue of Christ Almighty in the Cappella Palatina (Palatine Chapel) gazes down upon the worshipers, filling them with a deep sense of reverence. The surrounding murals, crafted from colored stones and shimmering with gold, depict biblical stories and mythological tales.

撒丁岛卡利亚里的市集摊商

Market vendors of Cagliari in Sardinia

撒丁岛鹿港海滩看日出

Enjoying the sunrise from the Beach of Port Cervo in Sardinia

喷泉上半人半马的两足怪兽雕像是陶尔米纳的象征

The statue of a two-footed monster, half-man and half-horse, standing on the fountain, is a symbol of Taormina.

撒丁岛萨萨里省的阿尔扎凯纳的彩绘阶梯，直达上端的教堂，这是当地居民为了庆祝小镇成为自治直辖市一百周年所设置。

Painted Stairs in Arzachena of Sassari, Sardinia, lead directly to the church on the top, serving as a testament to the local residents' commemoration of the town's centennial as an autonomous municipality.

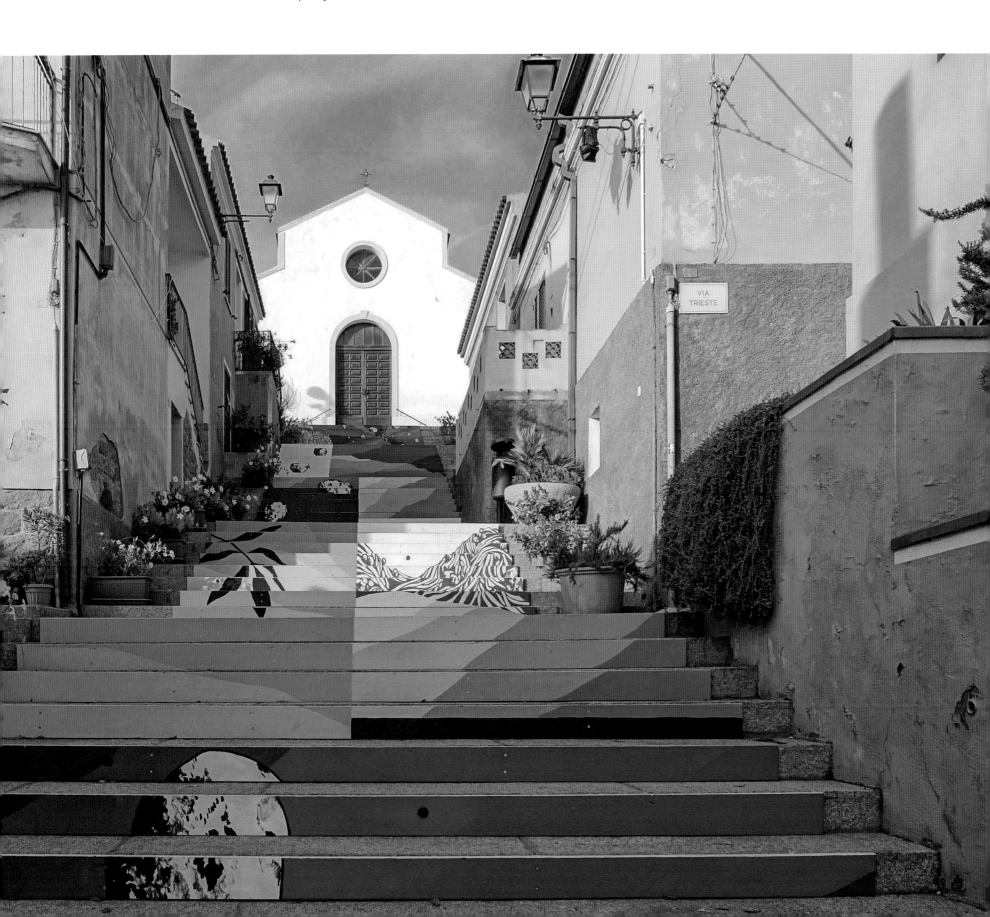

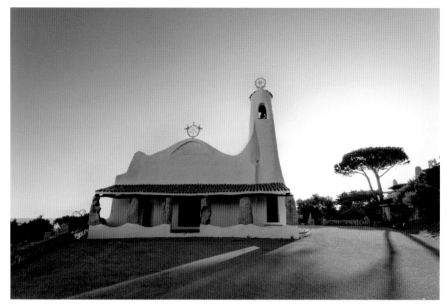

鹿港的海洋之星圣母教堂，它的特色是醒目的白色钟楼、波浪型立面和以不规则石块做为门廊柱子。

The Church of Stella Maris in Port Cervo is characterized by its striking white bell tower, wave-shaped façade, and porch pillars crafted from uniquely irregular stones.

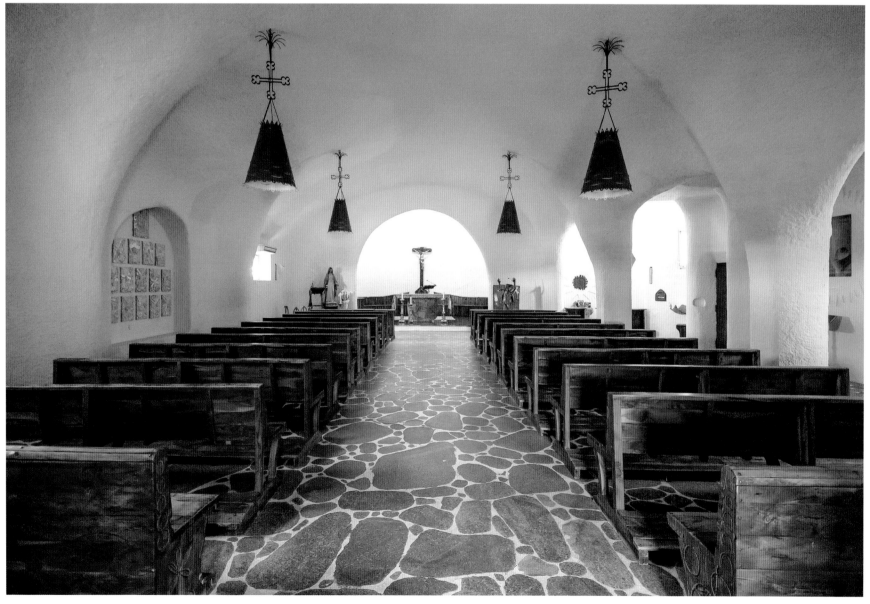

奥里斯塔诺街景。镇上的大街小巷，路上行人很少，街道上悬挂可爱的彩灯，环境清新雅致。

Street view of Oristano. The main streets and winding alleys of the town are rarely crowded with pedestrians, and delightful colored lights adorn the streets, casting a refined and elegant ambiance.

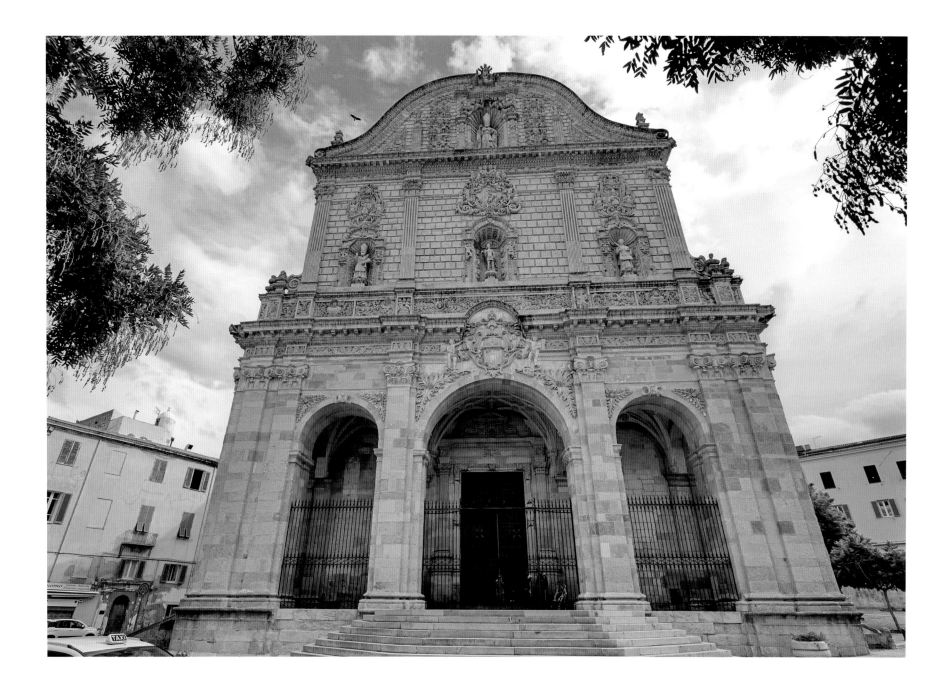

萨萨里主教座堂。它建于十二世纪，外墙的雕刻很精致。教堂原为罗马式风格，不过陆续增添了哥特式、文艺复兴、巴洛克和新古典主义的元素。

The 12th-century Cattedrale di San Nicola (Cathedral of San Nicola) with delicate exterior carvings. Originally in Romanesque style, the church gradually added elements of Gothic, Renaissance, Baroque and Neoclassical styles.

撒丁岛阿尔盖罗一隅
A corner of Alghero, Sardinia.

圣玛利亚大教堂，建于十三世纪，是卡利亚里大主教的所在地。

The 13th-century Cattedrale di Santa Maria (Cathedral of St. Mary), the seat of the Duomo di Cagliari (Cathedral of Cagliari).

撒丁岛首府卡利亚里的街道

The street of the capital city
Cagliari in Sardinia

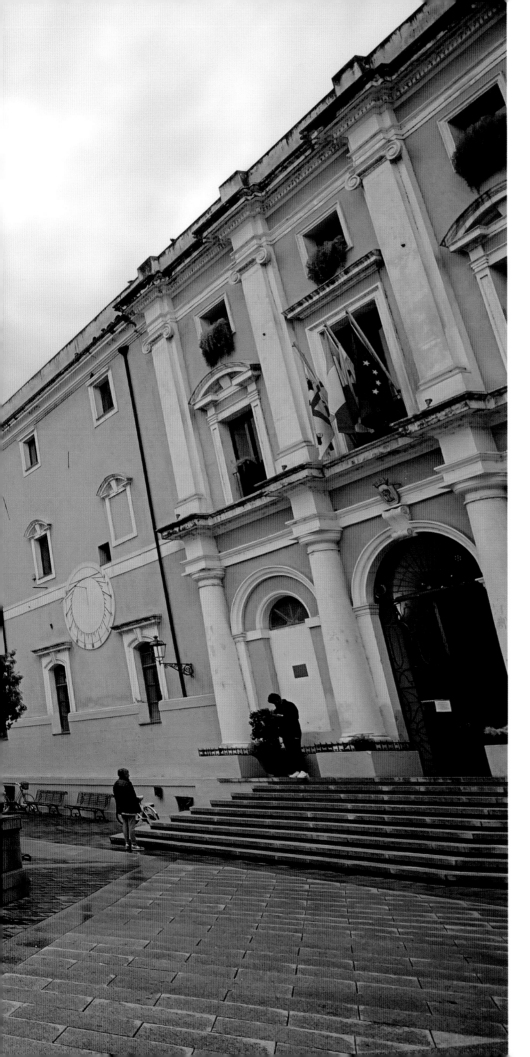

奥里斯塔诺广场中央的女神雕塑，纪念的是撒丁岛历史上一位女英雄 Eleonora d'Arborea。

The statue of the goddess in the center of Oristano Square commemorates a female hero in the history of Sardinia, Eleonora d'Arborea.

马达莱纳群岛的加里波第纪念碑。加里波第是意大利人民心中的民族英雄，是家喻户晓的革命家、政治家和军事家。意大利统一后，加里波第选择来到小岛长居，直至逝世。

The Garibaldi Monument stands proudly in the Maddalena Archipelago, commemorating a national hero who holds a revered place in the hearts of the Italian people. Renowned as a revolutionary, politician and military leader, Garibaldi made the small island his home after Italy's unification until his passing.

GIVSEPPE GARIBALDI
LA MADDALENA

4 LVGLIO 1907

BANCO DI SARDEGNA

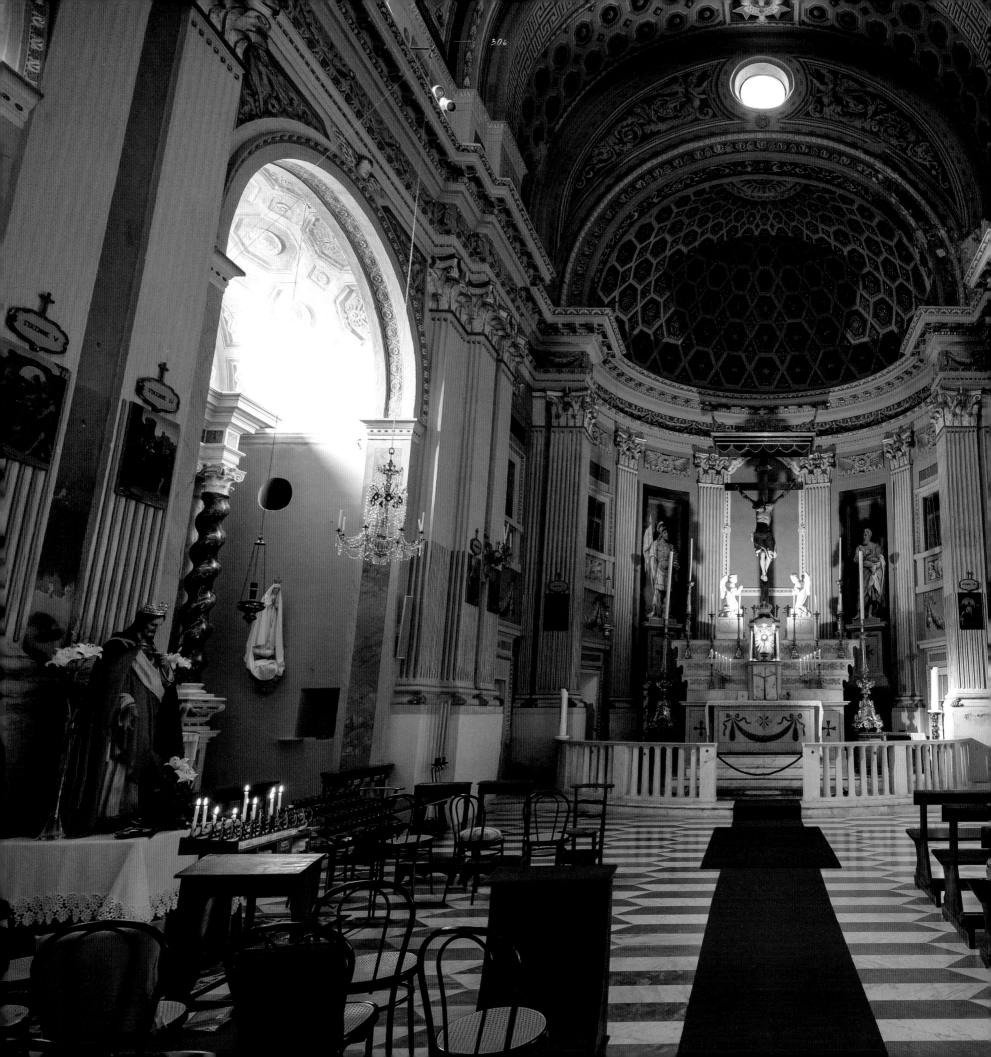

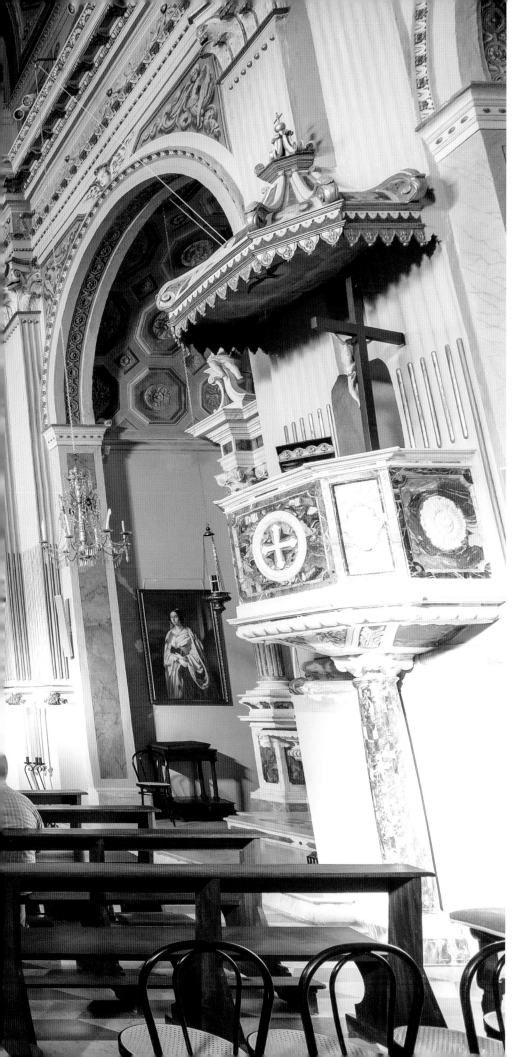

卡利亚里圣十字教堂内部

Inside the Cathedral of Santa Croce in Cagliari

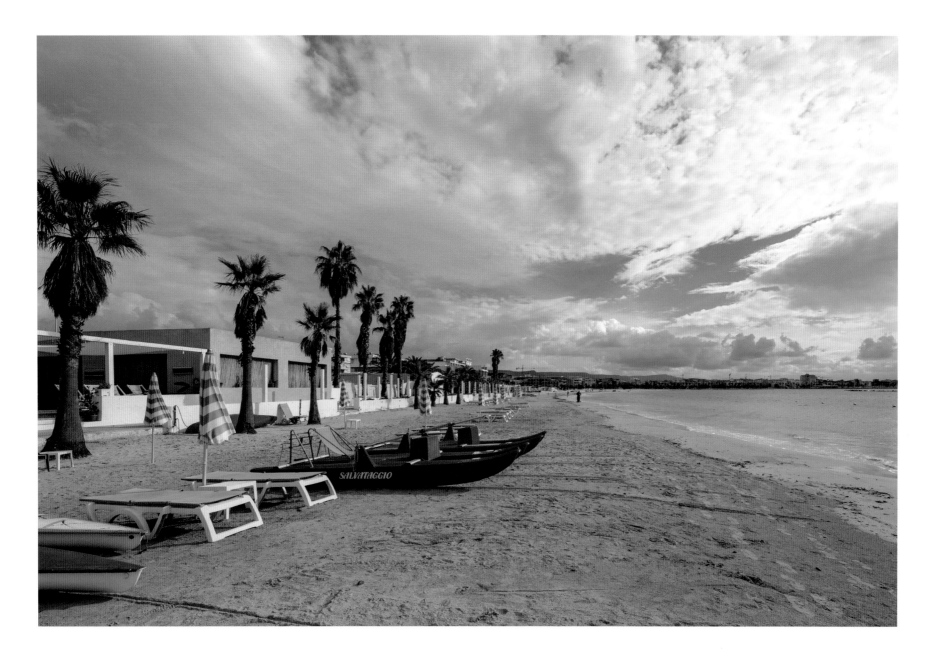

撒丁岛阿尔盖罗海滩

Alghero Beach, Sardinia.

撒丁岛卡利亚里的圣雷米堡

The Bastione di Saint Remy (Bastion of St. Remy) in Cagliari, Sardinia.

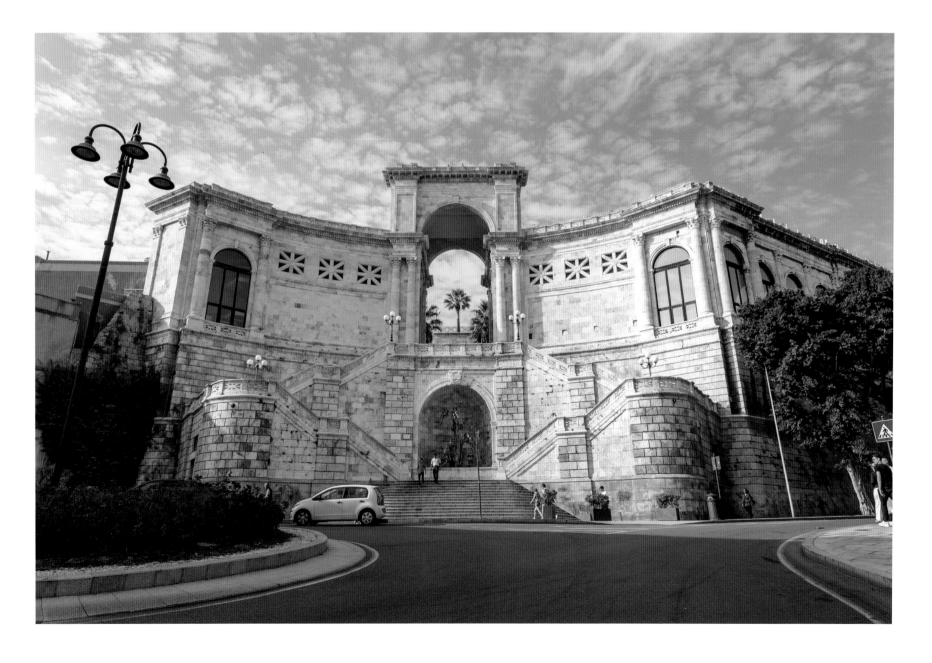

撒丁岛第二大城萨萨里一隅

A corner of Sardinia's second largest city, Sassari.

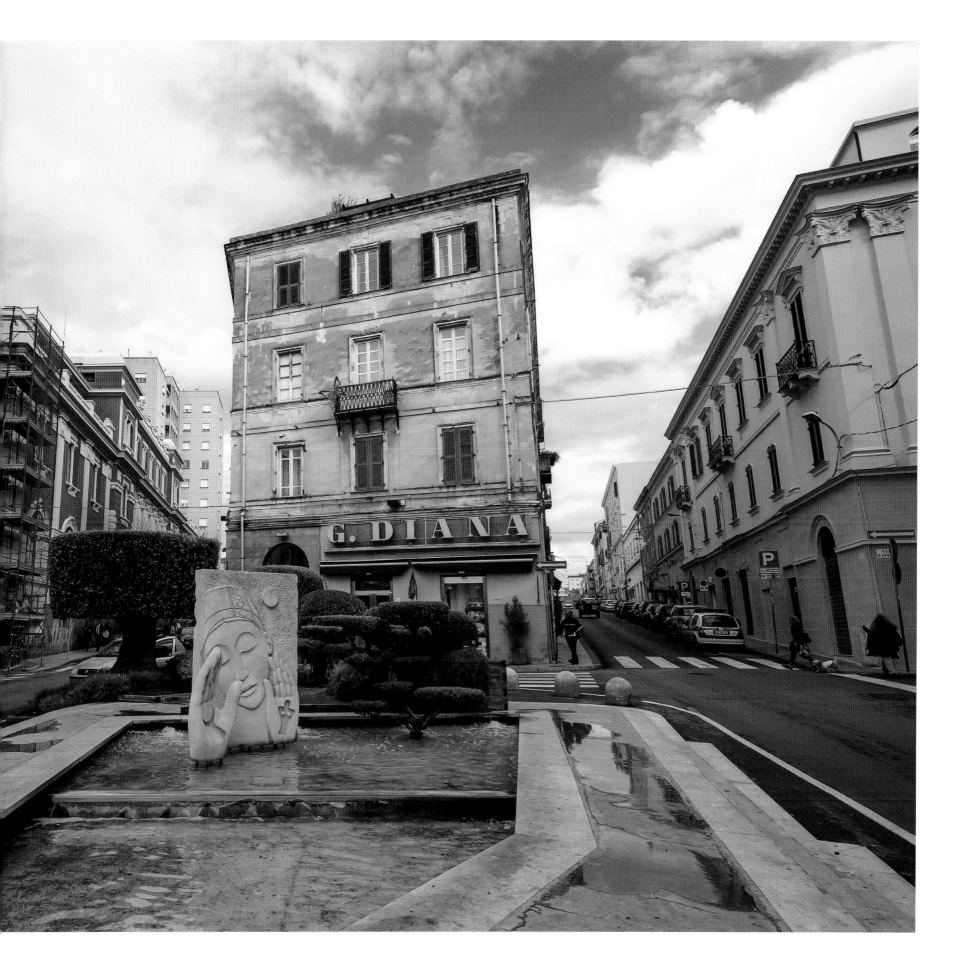

Il Bel Paese

定格 · 意大利

邓 予 立 摄 影 集
Yu Lap Tang

责任编辑
郭子晴 Elise Kwok
黄杰华 Thomas Wong

装帧设计
Sands Design Workshop

排 版
Sands Design Workshop

印 务
刘汉举 Eric Lau

出 版
中华书局（香港）有限公司
香港北角英皇道 499 号北角工业大厦 1 楼 B 室
电话：(852) 2137 2338
传真：(852) 2713 8202
电子邮件：info@chunghwabook.com.hk
网址：http://www.chunghwabook.com.hk

发 行
香港联合书刊物流有限公司
香港新界荃湾德士古道 220-248 号
荃湾工业中心 16 楼
电话：（852）2150 2100
传真：（852）2407 3062
电子邮件：info@suplogistics.com.hk

印 刷
迦南印刷有限公司
葵涌大连排道 172-180 号金龙工业中心第三期 14 楼 G/H 室

版 次
2024 年 7 月初版
©2024 中华书局

规 格
12 开（280mm×280mm）

ISBN
978-988-8862-16-0